Re-imagining the City

Re-imagining the City:
Art, globalization and urban spaces

Edited by
Elizabeth Grierson and Kristen Sharp

intellect Bristol, UK / Chicago, USA

First published in the UK in 2013 by
Intellect, The Mill, Parnall Road, Fishponds, Bristol, BS16 3JG, UK

First published in the USA in 2013 by
Intellect, The University of Chicago Press, 1427 E. 60th Street,
Chicago, IL 60637, USA

A catalogue record for this book is available from the
British Library.

Editors: Elizabeth Grierson and Kristen Sharp
Cover designer: Ellen Thomas
Copy-editor: MPS Technologies
Production manager: Bethan Ball
Typesetting: Planman Technologies

ISBN 978-1-84150-731-6

Printed and bound by Hobbs, UK

Table of Contents

Acknowledgements

The editors would like to thank Intellect Ltd., UK, and particularly Bethan Ball, production manager, and Heather Owen, copy editor, as well as the anonymous reviewer for their thoughtful comments on the manuscript and support for the publication.

We also acknowledge and thank RMIT Global Cities Research Institute, particularly Professor Manfred Steger, for their support of this project from the beginning and for hosting the 2009 research symposium, *Art and Globalization: Urban futures and aesthetic relations*, which provided the original impetus for this edited volume. Thanks to the School of Art, RMIT University for their support of this publication and Rupa Ramanathan, research assistant, who helped with the collation of the myriad of images in the text.

We thank the outstanding authors for their scholarly and immensely readable contributions to this book and for their patience and commitment throughout the project, and we gratefully acknowledge the artists and institutions who generously allowed us to reproduce their images.

Finally Kristen personally thanks her husband, Philip Samartzis, and Elizabeth thanks her partner, Nicholas Gresson, for all their support throughout the process of research and publication, and we welcome to the world Kristen and Philip's baby son, Nicholas Konstantin Samartzis, whose arrival on 15 March 2013 made this a perfect project.

Foreword

This anthology offers a remarkably versatile and vibrant series of chapters on the role of creative practices in the necessary process of rethinking urban space. Indeed, under early conditions of globalization, the changing relationships between art, language, communications and urban space inspired in the 1980s what came to be known as the 'spatial turn' and 'cultural turn' in the social sciences. Combined with a rekindled interest in the crucial role of aesthetic practices in reconceptualizing social life, this new wave of transdisciplinary scholarship on 'space' and 'cities' has emphasized the active constitution of urban space through conscious human agency within historically-specific frameworks of structural constraints.

As a result of these innovative intellectual efforts, it became increasingly untenable to carry on with conventional analyses that treated space merely as a neutral background upon which, or against which, various social processes play themselves out. Rather, social theorists trained in 'spatial thinking' have insisted that cities – especially the 'global city' of our age – contain multiple and intersecting layers of discursive and artistic expression and experience which reflect the shared interpretation of concrete 'places' shaped through contingent and evolving social relations. Grasping this new spatio-aesthetic dimension requires researchers to 're-imagine the city' – a formidable task shouldered by the contributors of this book.

Focusing on the role of aesthetic practices and contesting discourses in urban formation, this study offers exciting insights into crucial contemporary dynamics of 'place-making' in our increasingly over-crowded and suburbanized cities. The contributors to this collection realize that exploring the predispositions of the myriad of artistic narratives and practices related to urban formation calls for new theorizations of 'globalization'. Indeed, as conventional time-space constellations have undergone significant alterations, it is crucial to gauge the impact of change on the constitution of society and our human consciousness. Observing that the rising global imaginary becomes expressed and articulated in strikingly new ways, the contributors of this book remind us of the central role of human creativity in shaping alternative urban communities capable of responding to the multiple global crises of the early twenty-first century. And, yet, the spirit of this volume works against attempts to colonize the meaning of globality as a singular relation to space and the direction of globalization as a predetermined trajectory.

Finally, the contributors' attempt to link creative practices and urban space dovetails with important academic efforts to connect more closely language-based with space-based and aesthetic literatures in the critical social sciences. In a globalizing world, where conventional European disciplinary frameworks are rapidly losing their rationale, it has become imperative to go beyond simply paying lip service to the new requirements of inter- and transdisciplinarity. This study represents one such initiative to unsettle established disciplinary territories. It has been designed specifically to bring together artists, art historians, philosophers, architecture faculty, political geographers, cultural theorists, urban studies scholars and media and communications experts in a fruitful exchange of ideas. Such a daring enterprise allows for the further cross-fertilization of literatures that have, for far too long, reproduced themselves in relative isolation. In this sense, then, this collection of chapters also makes an important contribution to the growing field of global studies, in which concrete research questions related to globalization take precedence over circumscribed concerns with disciplinary markers and traditions.

Manfred B. Steger
Professor of Global Studies
RMIT University

Chapter 1

Situating Art, Urban Space and Globalization

Elizabeth Grierson and Kristen Sharp
RMIT University

Predictions and Questions

The prediction is that 70 per cent of the world's population will be urban by 2050. What will this world be like and what kinds of spaces will humans be making for themselves? Is it possible to imagine such a future if the present reveals itself only partially and the past is soon forgotten? Can art and design play a role in defining the urban and identifying relationships with it? These questions and more inform this collection, which brings together diverse approaches to re-imagining what cities might be like, or are like, and how humans may inhabit such spaces in conditions of escalating urbanization. If the human subject has been undergoing transformations of identity as *Homo economicus* in rationalist forces of the global knowledge economy, or *Homo digitus* through economies of cyber-networks, then new questions need to be asked about being human in such a world and about the kinds of communities, identities and relationships that twenty-first-century urban and global conditions are inscribing. How does the human subject relate to time, space, place and being, now and in the urban future?

Re-imagining the City: Art, globalization and urban spaces raises these questions, and more, for discussion. It investigates art as an innovative, symbolic and material expression of global and urban conditions, and considers the critical disputes characterizing globalization and urbanization of the twenty-first century. It considers how contemporary processes of globalization are transforming cultural experiences in urban space, and how cultural productions in art, design, architecture and communications media may be contributing to the re-imagining of place and identity. Accounts of art forms, projects and events offer a way into understanding the micro-politics of local and global processes of urbanization through which cities may be finding their shape and distinctive characters.

In the economies of twenty-first-century globalization there is an emphasis on creativity as a key driver of innovative production. This suggests that different forms of art, architecture, design and media communications have a significant role to play in the way cities are imagined and inhabited. Analysis of this terrain shows that such creative enterprises carry the potential to activate spaces in which they are situated and these activations can, in turn, raise questions about the politics of place and its inhabitants.

Globalization

Over the past twenty or more years there have been many predictions about the passage and changes of globalization. Accounts of globalization provide different ways of understanding the economic, social and cultural changes and environmental benefits, or harms, of a global world. In 2006, Nobel laureate economist Joseph Stiglitz predicted that '[m]aking globalization work will not be easy'. Stiglitz had just left the World Bank and had seen at first hand the uneven economic distributions and how poverty was increasing, and he was considering that the process of haphazard changes in response to global crises was not the best way to change the global system (Stiglitz 2006: xi). This raises the question of whether the global system is something that can be qualified and changed. Is it something that can be understood through providing organizing accounts and terms, such as deterritorialization and hybridization, as offered by Pieterse (2009) and Tomlinson (1999)? Or is it a more 'abstract empire' as George Soros had suggested (1998), a diffused condition that cannot be grasped as a whole and therefore cannot be fully realized, understood or regulated? However it may be articulated and envisaged, there can be no doubt that globalization is a contradictory term accompanied by a myriad of theoretical accounts and practical investigations to give it form and purpose.

The cultural processes of contemporary globalization are of particular interest in this collection. However, the cultural cannot be divorced from issues of the economy as today there is a conflation of economic and cultural frameworks by which the social is understood. Cultural production, including art, is inevitably connected to state and economic apparatus. Since the advent of the digital, the globalized world is an interconnected space of instant communications, consumer networks and financial patterns, in which local actions can have global effects. This brings the local and global into alliances unprecedented in previous centuries. In writing on cultural globalization in the late 1990s, globalization theorist John Tomlinson drew attention to the interlinking states that have come to characterize the twenty-first century:

> A world of complex connectivity (a global market-place, international fashion codes, an international division of labour, a shared eco-system) thus links the myriad small everyday actions of millions with the fates of distant, unknown others and even with the possible fate of the planet. ... The way in which these 'cultural actions' become globally consequential is the prime sense in which culture matters for globalization.
>
> (Tomlinson 1999: 25–26)

Thus local actions can have global effects and, likewise, the global system has an impact on the local – an important underlying theme in this book. The argument here is that art, architecture, landscape architecture, various forms of design, cultural events, media technologies and communication practices have a role to play in the making of place in these conditions. Further, the sense of belonging in urban space can be re-imagined through

art in its widest form at the local level to raise questions of global significance for space, place and human habitation.

Aims and Approaches

This book is considering the role of creative practices and their potential for opening new understandings of urban space. Art is discussed in an expanded, aesthetic field to include fine art, architecture, design, cultural events and media communications. These aesthetic processes have the potential to activate and imagine the human subject and its relationship to place. The aim is to bring recognition to place as a physical environment or a set of social or cultural relationships, as well as a perceptual and personal space. A re-imagining process can be at work which can be identifying more than the immediate surroundings. Place in this sense can be more than spatial. This process may open new awareness and understanding of place as a personal or political site or set of conditions. Place can be equally psychic, historical, emotional, geographical or physical (Cresswell 2005). Artworks are therefore important signs and signifiers in and of place (Kwon 2004; Lippard 1998). As discussed in a book on contemporary jewellery (Baines et al. 2010), place is the *topos* of human habitation in which perceptions of the human subject in relation to local and global issues can be activated, with the artwork acting as a trigger point for new ways of seeing, relating and experiencing.

Through a series of narratives, and innovative accounts, underpinned by theoretical and philosophical commentary, this book investigates and re-casts how art and other forms of cultural production can work in relation to the urban, and how cities can be understood in this rapidly urbanizing world of today. Through a series of empirical examples, the city emerges as a multifaceted and diverse space. While attention is drawn to the specificity of these examples, the commonalities that exist between contemporary urban spaces are also evident. Terms such as 'Western' and 'Eastern' are no longer useful, if they ever were, for understanding the complex relations between local, urban sites and global interactions. Contemporary cities are undergoing significant transformations and growth, and new frameworks are required in order to understand these changes: new more flexible understandings of place (Massey 1994) and global/local relationships (Robertson 1992). The concept of 'cities' also requires reconsideration to take account of their different lineages and different histories, particularly in light of the different characteristics of cities in the regions of Asia-Pacific and Europe, from which this book draws its material and finds its critical edge. Cities that were based previously on manufacturing are characterized now by informational, service and creative industries. It could be said that where they were once grey and bleak, filled with factories and dark smoke stacks, they become vibrant and alive with colourful communities. However, this description may be too simplistic for it can be said also that where they were once alive with local culture, they become globally repetitive, sterile and one-dimensional. Furthermore, in lieu of factory smoke, escalating forms of environmental

pollution by way of plastic and polystyrene, the by-products of the new creative cultures, increasingly mar the edges of idealistic dreams of progress or betterment.

The concern is to identify, understand and re-imagine these urban configurations better and, through the re-imagining processes, to articulate how creative enterprises operate in the urban, and how new forms of knowledge, perceptions and understandings about cities and their environs may arise. The nature of cultural production is such that as much as it can shape and contribute to the discourse and aesthetic and cultural experience of cities, it is simultaneously shaped through the social, political and economic contours of the urban condition. The proposition is that diverse forms of cultural and creative production have a key role to play in identifying processes, and in the interrogation of the conditions in which cultural production occurs. Such forms can aid the formation and transference of knowledge in urban spaces; and through these forms of cultural production processes of urbanization may be better understood. The aim is to explore the shaping powers of aesthetic production and aesthetic knowing and modes of being in the rapidly-urbanizing world of the twenty-first century.

The book grew from a symposium on *Art and Globalization: Urban Futures and Aesthetic Relations,* which was held at RMIT University, Melbourne, in August 2009. The symposium was organized by the School of Art in association with the RMIT Global Cities Research Institute, Globalization and Culture programme, and convened by Elizabeth Grierson and Kristen Sharp, the two editors of this book. The aim of the symposium was to investigate the impacts of globalization by focusing on aesthetic relations as a key conduit for the expression of, and contribution to, the transformations of cities in context of twenty-first-century globalization. The papers presented at the symposium came from a range of research interests including fine art, art history, cultural studies, media studies, sociology, urban geography, media communications, design, landscape architecture, built environment and planning. Similar transdisciplinary research is informing this present book, which draws together diverse disciplines and project examples to highlight the complex interactions in contemporary processes of globalization as experienced in the urban context.

Context and Literature

The research in this collection both complements and enlarges previous literature in the field of art and the urban. In devising and selecting themes for this book, the editors were mindful of the range of literature in specific fields of urbanization, and globalization, as they set out to reposition art, place and the city in the light of discourses of both urbanization and globalization.

Urbanization, in the context of globalization, is an expanding area of research in the humanities. However, the focus is rarely around art practice in urban spaces, notable exceptions being work by Malcolm Miles such as *Cities and Cultures* (2007) and *Art, Space and the City* (1997), and Miles' work with Tim Hall, *Interventions* (2005). Other

texts introduce art practice in context of globalization, but not specifically in the urban context. These include, for example, *Globalization and Contemporary Art*, Jonathan Harris (2011); *Contemporary Art and the Cosmopolitan Imagination*, Marsha Meskimmon (2010); *Art and Globalization*, James Elkins, Zhivka Valiavicharska and Alice Kim (2010); *Belonging and Globalisation: Critical essays in contemporary art and culture*, Kamal Boullata (2008); and *Over Here: International perspectives on art and culture*, Gerardo Mosquero and Jean Fisher (2007). *Re-imagining the City* takes the theme of urbanization further through attention to aesthetic production in relation to the urban.

A seminal text for researchers concerned with space and place is Henri Lefebvre's *The Production of Space* (1991); and on aesthetics, the much cited work by Nicolas Bourriaud, *Relational Aesthetics* (2002). Then there are books written specifically on the politics of aesthetics and design, such as Tony Fry's *Design as Politics* (2011); and those collating research on the transformations of urban settings, such as *Fluid City: Transforming Melbourne's urban waterfront*, Kim Dovey (2005), or locally-produced books profiling specific city regeneration projects, such as, *NewcastleGateshead: The making of a cultural capital*, Whetstone et al. (2009). These, and more, raise important questions to do with city regeneration, cultural capital and aesthetics and the way forward for twenty-first-century urban planning and design.

Academic research institutions have proliferated over the past decade, focusing on changes to the urban environment in a global context. RMIT University, Melbourne, has two such research institutes, the Global Cities Research Institute and the Design Research Institute. These institutes support a wide range of global and transdisciplinary research projects, which lead to events and publications exploring the role of art, culture and design in urban environments. Examples include *Outer Site: The intercultural projects of RMIT Art in Public Space,* Geoff Hogg and Kristen Sharp (2010) profiling public art projects in international, educational settings; and *Urban Aesthetics*, Elizabeth Grierson (forthcoming), applying Heidegger's philosophies to urban dwelling. *Re-imagining the City* extends themes raised in those books, by focusing on a range of examples and dialogues between art and the city.

The field of globalization is rich with literature giving accounts of globalization and global studies, many of which have informed the writers in this collection. Most notably, there is the work by Manfred Steger, *The Rise of the Global Imaginary: Political ideologies from the French Revolution to the War on Terror* (2008) and *Globalism: The new market ideology* (2002); Paul James, *Globalization and Culture, Vols.1-4* (2010), *Globalism, Nationalism, Tribalism: Bringing theory back in* (2006), and with Tom Nairn, *Global Matrix: Nationalism, globalism and state-terrorism* (2005); and Joseph Stiglitz, who brings an economic perspective to issues of globalization with his *Making Globalization Work* (2006) and *Globalization and its Discontents* (2002).

Despite these diverse accounts of globalization, the emphasis has been on the economic and political dimensions of global processes. The cultural dimensions of globalization have been relatively minimal. Critical exceptions include, *Understanding Cultural Globalization* by Paul Hopper (2007), Jan Nederveen Pieterse's *Globalization and Culture: Global mélange* (2009),

Globalization and Culture by John Tomlinson (1999) and Jan Aart Sholte's *Globalization: A critical introduction* (2000). In these, the emphasis is largely on European and North American perspectives. *Re-imagining the City* allows for a multi-faceted exploration of the diverse interactions of globalization through a range of examples from the Asia-Pacific region, including Australia, alongside Europe.

From the 1990s, some seminal texts on globalization appeared, most notably Anthony Giddens' series on BBC, *Globalisation* (1999); *The Crisis of Global Capitalism: Open society endangered* by George Soros (1998); Arjun Appadurai's *Modernity at Large: Cultural dimensions of globalization* (1996); Paul Hirst and Grahame Thompson's *Globalization in Question: The international economy and the possibilities of governance* (1996); *The Rise of the Network Society*, Manuel Castells (1996); Roland Robertson's *Globalization, Social Theory and Global Culture* (1992); and works by Mike Featherstone, including, *Undoing Culture: Globalization, postmodernism and identity* (1995), *Cultural Theory and Cultural Change* (1992) *and Global Culture: Nationalism, globalization & modernity* (1990).

Re-imagining the City draws from this literature to situate art practices in global urban spaces and, thus, contribute to a re-thinking of identity in the context of global dynamics. The cities examined here include Melbourne, Canberra, Sydney, Auckland, Port Moresby, Singapore, Beijing, Shanghai, Osaka, Jogjakarta, El Paso-Juarez, Liverpool, London, Amsterdam and Hamburg. While there are not many books with a combined focus on art, globalization and urbanism, those published particularly in the 1990s and earlier 2000s tend to focus on the trans-Atlantic region. This book determines to work through wider transdisciplinary examples and interpretations of aesthetic and cultural concerns in urban environments of other regions.

Themes and Structure

There are a number of recurring themes in this collection situating discourses of globalization, urbanization, aesthetics, meaning-making, place and processes of re-imagining. From this starting point the book is intended to enliven and bring together discourses of the global knowledge economy and aesthetic interventions in public spaces in an understandable fashion.

Throughout there is a concern for the ways art and aesthetics may function in the quotidian spaces of urban dwelling. Cities can be considered as mediating spaces with the theme of aesthetics drawing attention to the value of knowing ourselves and the world through perceptual relations. Through art works and projects, specific responses in the present may come into close relations with historical precedents and possible futures. Thus, to know aesthetically is to perceive and understand, through the senses, the shaping contexts of our experiences of time and place, self and world. Taking the concept of aesthetics into proximity with domains of cultural practice in the social sphere is a way of bringing together the kinds of experience, attitudes, ideas and products that are considered politically to be connected

with the arts, creativity and innovation as drivers of contemporary global economies. The concern for such drivers is something that the writers in this collection investigate in a range of ways, with particular interest in aesthetics as an activating force and a way of bringing attention to processes of place-making.

The book is organized thematically. It starts with a foreword authored by Manfred Steger, Professor of Global Studies and Director of the Globalism Research Centre at RMIT University, Melbourne, followed by this chapter, *Situating Art, Urban Space and Globalization* by Elizabeth Grierson and Kristen Sharp, which serves to introduce and situate key themes and approaches positioning the collection in context of other literature to show how it both complements and adds to research in the field. This is followed by twelve invited chapters, and a concluding account by cultural theorist, Chris Hudson, responding to the collection as a whole.

The twelve chapters following the introduction are organized into four sections in order to highlight key themes. The first thematic section is 'Art and Urban Place', followed by 'Transforming Spaces and Experiences of the City', then 'Exchange and Transaction' and finally 'Interventions in Public Space'. The contributors are experienced writers and researchers in the art, design, architecture, cultural studies, philosophy, and media communications fields. Through the perspectives of different disciplinary experiences, their accounts deal in diverse ways with processes of re-imagining the city. Some draw from sustained engagement with urban-based, cultural research, others from practice-led fields of art, design, architecture and communications, and others through a more philosophical lens. Together they bring new focus on pressing issues facing the rapidly-urbanizing world of today.

The contributors canvass contemporary examples and experiences, thus lending immediacy to the writing. It is to be hoped that this will appeal to a range of readers. The projects demonstrate the interconnections between local and global concerns, and this, in turn, provides a lens for considering how art events and artefacts can contribute towards a re-thinking process in order to re-imagine what urban spaces may be like in the future.

The first section, 'Art and Urban Place' groups together the work of Malcolm Miles, Tom Barker and Larissa Hjorth, to focus on different ways of positioning art as a creative and philosophical enterprise in city spaces. It starts with Malcolm Miles' 'Art and Culture: The global turn', which in some ways sets the scene for many of the chapters to follow. Miles reconsiders the relations between art and globalization through the rise of culturally-led strategies for urban renewal from the 1980s to the 2000s. He reconsiders the conditions leading to the financial-services crisis of 2008, and the interconnectedness of culturally-led urban renewal and expanding global markets, which saw a re-coding of cities as cultural destinations. Miles raises important questions to do with property and power in the rise of corporate spaces in what he calls 'the more brutal environment of urban change post-crash', and art's role in the gentrification processes. He focuses on the work of Park Fiction, an artist-squatter group in the St Pauli district of Hamburg, Germany, to ask about a new role for resistant and activist art, or at least a reclaiming of something of the spirit of a former, radical, avant-garde, but in newly-theorized and socially-grounded ways.

Tom Barker in Chapter 3, 'Catalysing our Cities: Architecture as the new alchemy for creative enterprise', considers urban design for cities arguing for the need to create the conditions for cultural meaning and value rather than trying to pre-determine those conditions. In particular he focuses on the opportunities for architecture in the creative economies of globalization to embrace innovative notions of practice and production, drawing on a concept of alchemy. He sees architectural design as a catalyst for the sustainability of future cities and, thus, in effect, he is offering architecture the opportunity to be the new alchemy of enterprise, situated between art, craft and science. Barker argues for small-scale, creative interventions that can have a significant and positive impact on urban spaces at a neighbourhood level enabling urban vibrancy through cultural production. He argues for a greater understanding of the role of architecture to leverage design for creative enterprise. This will go beyond the tradition of consultancy practice to activate an urban vibrancy in the present and future state of rapid urbanization.

This section concludes with Larissa Hjorth, Chapter 4, 'The Place of the Urban: Intersections between mobile and game cultures', which investigates the way notions of the urban are contested through the advent of cyberspace and new forms of mobility emerging through mobile media and gaming technology. Hjorth examines how mobile gaming creates the potentiality of play as an art form that transforms urban spaces into play places, while reinforcing the significance of place in cultural knowledge and production. By contextualizing the rise of urban mobile gaming in relation to urban theory and spatial experience, and a case study of second generation, or gamification, of LBS games in Shanghai, China, the chapter maps how mobile technologies re-define the ways in which urban place and locality are experienced.

The next section, 'Transforming Spaces and Experiences of the City' includes chapters by Kristen Sharp, Ashley Perry and Maggie McCormick which focus on mediating processes of art in experiencing and re-imagining the urban. The section begins with Chapter 5 by Kristen Sharp, 'Driving the Sonic City', which explores embodied experiences of the city and the multiple and complex spatial interactions that define urban spaces. These processes are mediated by technologies, such as the car. The chapter focuses on the work of Rogues' Gallery, two Japanese sound artists who create interactive performances for audiences while driving a car. The work of Rogues' Gallery amplifies the sonic, visual, and embodied experiences of urban space to create an enhanced encounter with the city. In doing so, art is revealed as a transformative practice that enables a re-imagining of the everyday spaces of the city through a locative experience of place encountered in and through the body. This provides an important way to understand how space can be produced and imaginatively re-conceived through the everyday experience of driving.

Also on a theme of understanding the city via driving in the enclosed spaces of the car, Ashley Perry's '"The Vacant Hotel": Site-specific public art and the experience of driving the semi-privatized geographies of Melbourne's EastLink Tollway', Chapter 6, examines a series of site-specific public artworks located beside a semi-privatized motorway on the south-eastern edge of metropolitan Melbourne. It explores how urban art embodies the imaginative, generic and symbolic spaces characterizing local/global relations in contemporary cities.

The aesthetic mediations are located in context of neo-liberal conditions of political and economic urbanization and globalization, and suburban commuting patterns characteristic of many contemporary cities. By mapping the dynamic relationship between artwork and motorist this chapter unlocks the complex, discursive and visual qualities of art in relation to the site of the motorway.

In Chapter 7, 'The Transient City: The city as urbaness', Maggie McCormick focuses in particular on China's rapid urbanization in the twenty-first century, configured as the first urban century. She examines urban consciousness, imagining oneself as urban, through re-interpreting Henri Lefebvre's writings on the role of rhythm in understanding the city. She argues that arrhythmia and transience are key factors in processes of re-imagining the city in terms of urban identity. To discuss this further she turns to the art practice of Ai Weiwei and curator Hou Hanru to examine their ways of reflecting, creating and clarifying a consciousness shift towards the urban. Through attention to their work and the politics surrounding it, she argues for an increasingly connected mind space, which she calls a mindscape, embracing the exacerbated difference of arrhythmia seen today as accelerated transience. There are indications here of re-imagining the city in these conditions. The study identifies challenges to paradigms, understandings and parallel backlash to processes of re-imagining the city that is currently underway in the twenty-first-century global condition.

The third section, 'Exchange and Transaction' features chapters by Pamela Zeplin, Les Morgan and Kevin Murray. This section offers different forms of exchange that are inscribing new and often unheralded cartographies of difference in discourses of art and cultural representations, technologies, labouring, identity and belonging across urban and global spaces. Chapter 8, '"The Liquid Continent": Globalization, urbanization, contemporary Pacific art and Australia' by Pamela Zeplin, considers what it means to be Pacific, and what Pacific cities are, or might be, like in the rapidly urbanizing conditions of a global world. Zeplin problematizes the prevalent habit of overlooking the South Pacific/Oceania region as a site of serious cultural research, except as evidence of a backwash of globalization. She shows how Pacific arts from across the Pacific Islands, and in New Zealand and Australian urban locations, are often presented as stereotypes. However, she argues that in fact they reveal fluid, complex and constantly-negotiated practices. Although Oceania's histories of cultural renewal may be appreciated in different ways in New Zealand and Australia, she proposes that these practices can contribute to more inclusive discourses concerning art, globalization and the urban.

This is followed by Chapter 9, Les Morgan's 'Abdul Abdullah: Art, marginality and identity'. Morgan addresses issues of 'otherness' with regard to processes of marginalization and the othering of those who are not from the historically-dominant culture of Australia. He analyses the art of Abdul-Hamid Bin Ibrahim Bin Abdullah, a young Muslim artist from West Australia, as an indicator of, and reaction to these conditions. He illustrates aptly the constructed ambivalence in the artist's work to show the wider politics of transnational relations in the context of urbanization and the dominant culture. Morgan's claim is that Abdullah negotiates his identity as a racialized and spatialized subject in the location of

Australian cities. Through the politics of representation he is able to draw attention to the social, cultural and political fragmentation characterizing urban spaces, and through engaging with discourses of Australian multiculturalism he shows how artworks can offer a critique of it.

In Chapter 10, 'The Visible Hand: An urban accord for outsourced craft', Kevin Murray discusses the increasing distance between consumers and sources of production that is occurring in a rapidly-urbanizing world. He raises questions of inequalities between what he calls the global North and global South with specific reference to the production of craft goods. He considers the global trend of outsourcing and off-shoring craft labour as a potential means of re-connecting city and village as he interrogates the exodus of manufacturing and service industries from the First to Third World. To exemplify the social relationship between craft and design, he examines three specific models of partnerships between designers and artisans, identified as developmental, romantic and dialogical. In the developmental model, the use of technology 'liberates' the producer; the romantic model positions design as a form of commodification hiding the reality of production; the dialogical contextualizes design and craft as separate but interlocking domains. Comparing the models, he offers examples of craft workers who exemplify creative approaches to the means of production bringing acknowledgement to the relations of the city and the world around it.

The fourth section, 'Interventions in Public Space' features the work of SueAnne Ware, Elizabeth Grierson and Zara Stanhope. This group brings the focus to art's capacity to intervene in known social, cultural, economic and political conditions. Through reviewing customary habits and politics these writers show the potential of renewing awareness and attitudes to do with local issues in global conditions. It starts with Chapter 11, SueAnne Ware's 'Border Memorials: When the local rejects the global'. Ware raises political issues of borders, immigration and migration and crucial questions to do with memorials to commemorate humanitarian disasters, along with public responses to such processes of memorialization. The chapter examines two anti-memorials: one concerning the fate of illegal refugees travelling to Australia, The *Siev X Memorial Project* (Canberra 2007); and the other, considering deaths of undocumented workers crossing into the United States (El Paso-Juarez 2005). Both projects reject conventional memorials as civic icons expressing national identity while questioning complacency towards the politics and policing of international borders.

Chapter 12, 'Encountering the Elephant Parade: Intersections of aesthetics, ecology, and economy' by Elizabeth Grierson, examines Singapore's Elephant Parade, a global art event that has occurred in a range of cities since its inception in 2006. The setting for the discussion is the urbanizing world of the twenty-first century in the context of the broader setting of economic globalization dominated by excessive consumption, fast economic transfers, reduced biological diversity and reductive reactions to global uncertainties. In this context, the artist or designer acts as a conduit for raising aesthetic, economic and ecological issues concerning an urbanized and globalized world. The chapter tells of encounters with 160 designed and decorated elephants placed around Singapore in 2011. It examines the

vested interests, aims and intentions of this entrepreneurial, global and urban event that has come to fruition through significant partnerships between art and business in the interests of biodiversity. The interlinking narratives of aesthetics, ecology and economy bring specific attention to the plight of the Asian elephant: its damage and destruction in the path of urbanization. Ultimately the discussion is showing how an entrepreneurial art event can act as a re-imagining process for city-dwellers.

In Chapter 13, 'Re-imagining Dutch Urban Life: *The Blue House* in Amsterdam', Zara Stanhope examines *The Blue House* (*Het Blauwe Huis*) project by the Dutch artist Jeanne van Heeswijk. This social art project is located in the new urban development of Haveneiland, Ijburg, which is part of Amsterdam's geographical expansion in response to global and local population pressures. The chapter examines *The Blue House* as a site-related art project that creates analytical and discursive relationships to urban life through a responsive and reflexive form of cultural production. It explores, and problematizes, the potential of *The Blue House* for raising awareness of the local and global significance of relationality between hosts and guests, citizens and non-citizens, self and others and the methods involved in researching the social relations of independent urban interventions.

The book concludes with Chapter 14 by Chris Hudson, reflecting upon, and engaging with the content and themes raised through the preceding chapters. Hudson emphasizes the complexities of urban spatialities through an analysis of literary representations of the urban condition, drawing on the work of Edward Soja. She comments on new forms of aestheticization discussed by the writers in the collection, and the ways they create possibilities for re-imagining the intersections of economic, social and cultural politics in urban spaces. At the same time she is offering new readings of globalization and a way forward for art and urbanization research.

Concluding Thoughts

There are many forms of re-imagining but, if people communicate these multiple ways of knowing in a kind of hermeneutical community, it may be possible to locate some common understandings about place, and the way of art within place. *Re-imagining the City* acts as such a community by bringing together the work of leading scholars in the field, and offering insightful ways to consider how art events, artefacts, design works, architectural and design projects, exhibitions and cultural interactions may contribute towards a re-imagining process in urban space. The narratives and investigations are underpinned throughout by broader issues of urbanization and politics of globalization.

The research presented here will be of interest to readers from a range of fields to do with aesthetics, cultural practices, urbanization and globalizing processes, and the book as a whole will be an important contribution to the field of art and the urban. It opens the way for a broader and deeper understanding of how the local inflects the global, and vice versa, how global actions impinge on the local with new challenges and imperatives.

But the research does not rest solely on the cultural conditions or politics of communities and groups that make up the urban. It also casts light on the role of personal meaning-making within physical, social, technological and psychological spaces as part of the urban condition.

There are also the crucial issues facing global economies and ecologies in the twenty-first century. Public discourses today turn increasingly to economic instabilities, and issues of climate change, greenhouse-gas emissions, environmental disaster, pressing issues of mobility and migration and always the reminders of post-9/11 terrorism. The writers here are not overlooking these global crises and demand for action at individual and government levels. The nature of personal responsibility is being redefined here as art, design and aesthetic processes open new and pressing questions deserving constant political vigilance. If the world is to be a sustainable place for future generations then these discussions must be considered, not in the abstract, but as concrete examples of real-life events raising crucial questions for our times.

References

Appadurai, A. (1996), *Modernity at Large: Cultural dimensions of globalization*, Minneapolis: University of Minnesota.

Baines, R., Polentis, N., and Millar, M. (2010), *Australian Jewellery Topos: Talking about place*, Melbourne: Australian Scholarly Publishing.

Boullata, K. (2008), *Belonging and Globalisation: Critical essays in contemporary art and culture*, Sharjan: Sharjan Art Foundation.

Bourriaud, N. (2002), *Relational Aesthetics,* (trans. S. Pleasance, F. Woods and M. Copeland), Paris: Les presses du reel. First published 1998.

Castells, M. (1996), *The Rise of the Network Society,* Oxford: Blackwell.

Cresswell, T. (2005), *Place: A short introduction*, Malden, MA: Blackwell.

Dovey, K. (2005), *Fluid City: Transforming Melbourne's urban waterfront*, Sydney: UNSW Press.

Elkins, J., Valiavicharska, Z., and Kim, A. (2010), *Art and Globalization*, Pennsylvania: Penn State Press.

Featherstone, M. (1995), *Undoing Culture: Globalization, postmodernism and identity*, London: Sage.

—— (1992), *Cultural Theory and Cultural Change*, London: Sage.

—— (1990), *Global Culture: Nationalism, globalization & modernity*, London: Sage.

Fry, T. (2011), *Design as Politics*, Oxford: Berg.

Giddens, A. (1999), *Globalisation*, BBC Reith Lectures, Television series, UK.

Grierson, E.M. (forthcoming), *Urban Aesthetics.*

Harris, J. (2011), *Globalization and Contemporary Art*, London: Wiley-Blackwell.

Hirst, P.Q. and Thompson, G. (1996), *Globalization in Question: The international economy and the possibilities of governance*, Cambridge, UK: Polity.

Hogg, G. and Sharp, K. (eds) (2010), *Outer Site: The intercultural projects of RMIT Art in Public Space,* Melbourne: McCulloch and McCulloch.

Hopper, P. (2007), *Understanding Cultural Globalization*, Cambridge, UK: Polity.

James, P. (2010), *Globalization and Culture, Vols.1–4*, London: Sage.

—— (2006), *Globalism, Nationalism, Tribalism: Bringing theory back in*, London: Sage.

James, P. and Nairn, T. (2005), *Global Matrix: Nationalism, globalism and state-terrorism*, London: Pluto.

Kwon, M. (2004), *One Place after Another*, Cambridge, Massachusetts: MIT Press.

Lefebvre, H. (1991), *The Production of Space*, (trans. D. Nicholson-Smith), Oxford: Blackwell Publishing.

Lippard, L. (1998), *The Lure of the Local: Senses of place in a multicentered society*, New York: I.B. Tauris.

Massey, D. (1994), *Space, Place and Gender*, Minneapolis: University of Minnesota Press.

Meskimmon, M. (2010), *Contemporary Art and the Cosmopolitan Imagination*, London: Routledge.

Miles, M. (2007), *Cities and Cultures*, London: Routledge.

—— (1997), *Art, Space and the City*, London: Routledge.

Miles, M. and Hall, T. (2005), *Interventions*, Bristol: Intellect.

Mosquero, G. and Fisher, J. (2007), *Over Here: International perspectives on art and culture*, Boston: MIT Press.

Pieterse, J.N. (2009), *Globalization and Culture: Global mélange*, 2nd rev. edn, Lanham, MD: Rowman and Littlefield.

Robertson, R. (1992), *Globalization: Social theory and global culture*, London: Sage.

Sholte, J.A. (2000), *Globalization: A critical introduction*, Exeter: Palgrave Macmillan.

Soros, G. (1998), *The Crisis of Global Capitalism: Open society endangered*, New York: Little, Brown and Company.

Steger, M. (2008), *The Rise of the Global Imaginary: Political ideologies from the French Revolution to the War on Terror*, Oxford: Oxford University Press.

—— (2002), *Globalism: The new market ideology*, Lanham, MD: Rowman and Littlefield.

Stiglitz, J. E. (2006), *Making Globalisation Work*, Victoria: Allen Lane.

—— (2002), *Globalization and its Discontents*, New York: W.W. Norton and Co.

Tomlinson, J. (1999), *Globalisation and Culture*, Cambridge: Polity Press.

Whetstone et al. (2009), *NewcastleGateshead: The making of a cultural capital*, Newcastle: ncjMedia.

Section I

Art and Urban Place

Chapter 2

Art and Culture: The global turn

Malcolm Miles
University of Plymouth

My aim in this chapter is to reconsider the relation between art and globalization through the rise of culturally-led strategies for urban renewal from the 1980s onwards. After the financial services crisis (the crash) of 2008 such strategies may have begun to decline as urban policy and urban development (like late capitalism) enter a more brutal phase. If so, then it is now an opportune time to look with the advantage of retrospect at the conditions in which these strategies arose, at how they operated, and at the extent to which the claims made for them were tested.

Looking back, it appears that culturally-led urban renewal not only coincides with the rise of globalization, but is connected to it in specific ways. Culturally-led urban renewal was used by cities seeking to gain a competitive edge in global competition for new investment (as in corporate relocation) and cultural tourism, for instance, while the kind of culture utilized in redevelopment schemes was linked to an expanding global art market and cultural infrastructure. The new art museums inserted into redundant industrial sites in many cities were, in turn, linked to a growth in cultural (and lifestyle) consumption among what became known as a creative class of young professionals. But if cities were re-coded as cultural destinations, to whom did they belong? And who was able, or not able to participate in determining the image of a city which reshaped its built and social as well as its economic environment?

I begin by setting out aspects of the conditions in which culturally-led urban renewal arose. I then discuss examples of their outcomes, and whether there was evidence for their success in regenerating cities, or whether outcomes were more a matter of property development than the regeneration of local communities or economies. The question is familiar: are artists the vanguard of gentrification? Finally, I discuss a case of art against gentrification: the work of Park Fiction, an artist-squatter group in the St Pauli district of Hamburg, Germany. Perhaps, in the more brutal environment of urban change post-crash, resistant and activist art will begin to reclaim something of the radicalism and autonomy of earlier avant-gardes, but will do so in new, more theorized as well as socially-grounded ways.

Trajectories and Conditions

The period from the 1980s to the late 2000s was characterized by several historically-specific trajectories for change in the cities of what was once called the industrialized world. One was a shift from the old manufacturing base to immaterial production in emerging sectors such as communications technologies, the media and financial services; another was the

growth of consumer culture in urban districts remodelled from working-class or semi-industrial areas; a third was the rise of global, or transnational, capital to a point at which large companies now have a higher financial profile than medium-sized countries. This was accompanied by a de-regulation by national states of the conditions in which transnational capital operated.

The rise of transnational capital was accelerated by the end of the Cold War. After the dismantling of the Berlin Wall in 1989, and the collapse of the Soviet Union in 1991, the ex-East was open to western-style consumerism. Indeed, a growing desire for consumer goods was a driving force of unrest in the Eastern bloc, alongside issues of political expression. The outcome of these events was a sweeping re-categorization of the world. Before 1989, there was a First World (the capitalist West), a Second World (the state-socialist East) and a Third World (all the rest, including the ex-colonial states of western empires, which were seen as ripe for development on the western model). Suddenly it became necessary to re-organize these categories. The outcome, still to an extent emerging, is a dualism between a global North comprising the previous West, plus industrialized countries in, for instance, Eastern Europe, and, as a foil to the North, a global South, in effect the Third world re-named. None of these terms is quite accurate: the West was essentially the industrialized world and, hence, included Japan in the geographical East, and Australia in the geographical North. Today it would include China. I use the terms only for convenience, but prefer the term majority world for the global South simply because it is not pejorative, and reflects that a majority of the world's human inhabitants live there in as much as emerging economies such as India and Brazil might be included in it. Of course, they might not, or might not be soon.

Leaving those difficulties aside for the sake of argument, in the new scenario, transnational capital has undertaken two important shifts which further redefine the global North and South: the movement of a large part of material production (manufacturing) to the global South, where regulation of trade, labour conditions and environmental protection is less effective than in the North; and, in the North, the replacement to a significant extent of material production by immaterial production – in service sectors (including the so-called cultural industries). Globalization, then, is the context in which consumer culture spreads globally. I read this as a soft enforcement of free-market economics, trading on a notion of consumer choice – I suggest as a substitute for political choice: freedom to consume in place of freedom to participate in determining social values. Consumerism and its culture, then, are the main forces by which the whole world is brought under a single regime in which the added value attached to branded goods denotes a person's social status and identity. Brands, as immaterial images rather than material things, epitomize the new, symbolic economy of immaterial production. As Melanie Klein wrote in 2000:

The astronomical growth in the wealth and cultural significance of multi-national corporations ... can arguably be traced back to a single, seemingly innocuous idea

developed by management theorists in the mid-1980s: that successful corporations must primarily produce brands as opposed to products.

(Klein 2000: 3)

Everything becomes an image in the new economy; cities, too, re-brand themselves, not least by investing in highly-visible cultural attractions and signature architecture. This is where culturally-led urban strategies for development meet globalization: in a period of de-industrialization in the North, with a proliferation of redundant industrial sites as production moves South, and with shrinking cities from Leipzig in the ex-East Germany to Detroit in the United States, culture was seen as a quasi-magic touch which could re-invent a city's image for external perception, eliminating previous signs of a downward spiral.

The rewards envisaged for cultural investment included inward private-sector investment in new enterprises and corporate re-location, and cultural tourism. Art, too, became part of the array of lifestyle marketing. In lifestyle consumption, consumers' choices identify them as members of a social category, and many of the goods and services consumed in this way are linked to aesthetic values – such as designer bars and designer clothes – while the spaces in which such consumption takes places have been increasingly linked to the insertion in the built environment of new cultural institutions. Additionally, the ways in which new cultural institutions operate are not unlike those of consumer culture's determination of style. What I have in mind here is the informal consensus among art dealers, curators, critics, collectors and well-known artists as to what constitutes contemporary art (or the Contemporary in the proliferation of Museums of Contemporary Art which is one outcome of city re-branding via culture). If another category called the art of today were to be devised, it would include a wide range of professional and amateur cultural production. But the Contemporary denotes only that category of art identified in a narrow vein by the art-world's consensus. Perhaps a further link is that both consumerism and contemporary art operate through mainstreams, which are able to incorporate almost any departure from them. For instance, after the looting that occurred in London, Manchester and other English cities in 2011, one jeans company used a photograph (taken on a mobile phone) of a looter holding a pair of its jeans in an advertisement – as if to say, buy the jeans people loot. The ad was withdrawn after objections, but it suggests that the boundary between acceptable and unacceptable images is no longer real in brand promotion. The same applies in (some) art: soon after the trashing of a Tesco store in Stokes Croft, Bristol in the early summer of 2011, the graffiti artist Banksy produced a print depicting a Tesco petrol bomb. It is hard to know how ironic this was meant to be.

In a similar way, the end of the Cold War became a source for de-contextualized marketing opportunities in 1989. Western branded goods became available, with western consultancy on setting up a market economy, and the Berlin Wall itself became an object of consumer culture when sections of it were sold at auction. One section was relocated to a small plaza in Manhattan, near the Museum of Modern Art; white garden tables and chairs stand in front of it, where commuters take coffee in polystyrene cups. The Wall could be the spoils of victory in the Cold War, but there is another twist: the West-facing

side of the Wall (painted white by the East Germans) was used for colourful graffiti. In New York, graffiti was regarded as the sign of an underclass about to destroy the city; on the Wall, as on the section transported to New York, it stood for freedom of expression against a supposed absence of such freedom on the other side (where, indeed, the Wall's surface remained blank, in a free-fire zone where those attempting to cross were regularly shot). In Berlin, and throughout the ex-East, a brisk trade developed in communist memorabilia, feeding a nostalgia for the old times (*Ostalgie* in German). Journalist Christopher Hilton records, visiting a checkpoint site:

> At Checkpoint Charlie, c. 1990, Turkish and Polish vendors sold medals, caps, insignia, Soviet general's hats and any other Eastern memorabilia they could lay hands on; sold them as vendors do, from trestle tables and car boots … A nation was for sale and they were selling it. They did brisk trade in chippings from the wall encased in polythene with an authenticity certificate for good measure, and charged more for bits which had been daubed with graffiti, especially anything multi-coloured.

> (Hilton 2001: 394)

There were, of course, buyers as well as vendors, among them western academics with a nostalgia for a system under which they never lived but which at least posed a theoretical alternative to the system of neo-liberal economics.

The example of Wall culture may seem tangential, but I cite it because it shows that global consumerism, and globalized culture, trade on de-contextualization. It is within this scenario that culture became a means to urban renewal, setting aside the aesthetic autonomy which was claimed for modern art in favour of functions – from making place-identity to reducing unemployment. The need for urban renewal followed globalization's production of empty brownfield sites, and a general worsening in residual forms of deprivation in inner-city areas while redevelopment cut through older quarters, making enclaves of new (gated) space within remaining dereliction. The result is what planning academic Peter Marcuse has described as a layered city in which divisions of class and ethnicity intersect those of wealth, power and land-use: 'a layered city, in which one line of division overlaps another, sometimes creating congruent quarters, sometimes not' (Marcuse 2002: 94). Amid such complexities, there was a tendency for redevelopment to emphasize property rather than social equity; and to insert new centres, either of commercial space or residential compounds, within an extant urban fabric which was then re-coded as a series of margins.

With complexity came a new phase of social ordering and surveillance, mediated by new technologies of communication and data collection. As sociologist Zygmunt Bauman writes, looking at the divergence of interests and opportunities between a rising global élite and various residual local or migrant publics:

> The database is an instrument of selection, separation and exclusion. It keeps the globals in the sieve and washes out the locals. Certain people it admits to the extraterritorial

cyberspace, making them feel at home wherever they go and welcome wherever they arrive; others it deprives of passports and visas and stops from roaming the places reserved for the residents of cyberspace. But the latter effect is subsidiary and complementary to the former.

<div style="text-align: right;">(Bauman 1998: 51)</div>

Bauman sees a new rich with personal mobility, and a new poor of economic migrants and asylum seekers; he also sees that transnational commerce uses transnational organizations, such as the World Trade Organization, to avoid the restrictions of national regulation. In the world of globalization, emerging élites are identified by consumption, often with cultural connotations. Bauman writes: 'The way present-day society shapes its members is dictated ... by the duty to play the role of the consumer' (1998: 80), adding, 'Everybody may be *cast* into the mode of the consumer ... may *wish* to be a consumer ... But not everybody *can* be a consumer' (1998: 85). I would suggest, similarly, not every city has the potential to be a cultural city, or node of cultural production and reception in the way that cities such as Paris, Munich or Vienna were from the 1880s to the 1930s. This is not a direct comparison with the plight of migrant publics, obviously, but the point is that globalization produces new kinds of division between groups of people in – or not in – the affluent society, and between cities, which have – or lack – an attractive cultural veneer. The next section of the chapter analyses aspects of culturally-led urban renewal, asking how the process operates and whom it benefits.

Cultural Strategies for Urban Renewal

Culturally-led urban regeneration became the norm, spurred on by a small number of cases in which an upturn in a city's image and economy was achieved. Examples such as Glasgow and Barcelona presented models which other city authorities might copy. But, inevitably, outcomes were as mixed as the conditions in which interventions were made, with differing levels of resource. Nonetheless, faced with de-industrialization from the 1980s onwards, city after city sought a place on a global culture-map. New York sociologist Sharon Zukin remarked in 1995 that 'every well-designed downtown has ... a nearby artists' quarter' (Zukin 1995: 22). It usually had a mall as well, and waterfront apartments in converted warehouses. Typically, remodelled urban centres house sites of immaterial production for the global economy – in advertising, public relations, fashion, digital communications, the media and financial services – and the gated compounds and consumption outlets where employees of the creative economy live and spend their leisure time. The young professional élite tended to identify itself with, and by, contemporary culture. Hence the designer bars and restaurants, boutiques and shops marketing things which no-one needs but many might be persuaded to want – like white-painted bird cages imported from Morocco (Raban 1974: 95) – tend to be located in

zones which have been re-coded by the insertion of a cultural institution, or designation of a cultural quarter.

For Richard Florida, young professionals constitute a *creative class* whose presence is a key factor in urban renewal (Florida 2002). Florida's definition of the creative class aligns with the use of creativity in business and financial innovation, not with cultural production. Artists are not necessarily members of it. Florida writes that, for him, creative centres are large urban centres such as San Francisco, Seattle or Boston which have 'high levels of innovation and high-tech industry and very high levels of diversity, but lower than average levels of social capital and moderate levels of political involvement'. He adds, 'These cities score high on my Creativity index and are repeatedly identified … as desirable places to live and work. That's why I see them as representing the new creative mainstream' (Florida 2002: 275).

Florida's approach is based on the presence of a consuming élite. Sociologist Graeme Evans takes a more orthodox view by defining not a creative class but a creative or cultural *sector* of employment which comprises three elements: cultural production from music to books and digital media; cultural tourism; and cultural amenities such as galleries (Evans 2001). Within the cultural sector, the borders between high and low culture, and between art and other creative fields such as fashion, design, architecture and new media, have been more or less dismantled. Franco Bianchini and Charles Landry adopt an approach between Florida's definition of a class and Evans' definitions of a sector, identifying creativity, as innovation, with the prevailing (or perceived) mind-set of the creative sector. They write of creativity as 'getting rid of rigid perceptions and of opening ourselves up to complex phenomena which cannot always be dealt with in a strictly logical manner' (Landry and Bianchini 1995: 10). This is not necessarily, however, an alignment with a mainstream but can equally indicate innovation in small enterprises or in the informal economy. The growth of new music scenes illustrates how, with modest means, by using word of mouth or social-media dissemination, informal networks operate, so to speak, under the radar of established industries. Such efforts are small-scale and localized, but this adds to their resistant character in the face of a dominant, globalized industry. In contrast, Florida sees little if any political content in the arts:

> As for the feat that mass marketing kills the artists' political message: Reports of that death have been greatly exaggerated. Few cultural products have much political content to begin with. Many cultural theorists like to see cultural forms such as graffiti art and rap as political movements expressing the voices of the oppressed. This absurd notion does a disservice to both politics and art.
>
> (Florida 2002: 201)

As a cultural theorist, but one who has no particular interest in graffiti, I would still point to the political significance as well the de-contextualization (itself a political act) of the

section of the Wall re-sited in New York. Advocates such as Florida and Landry (2000), still, have been influential in persuading city authorities to adopt cultural strategies as if they represent a non-contentious, harmonious alternative to the divisiveness of socio-political struggles and debates. Examples such as Barcelona or Seattle are seductive. Whether their success can be replicated is another matter. There are, anyway, differences between North America and Europe in the period of late capitalism. Saskia Sassen (1991) wrote of a global city, constituted by financial-services enclaves in New York, London and Tokyo, as a single, distributed city using 24-hour information super-highways to connect – but only Frankfurt in continental Europe could begin to qualify as part of this exclusive city. Hence the attraction of a cultural-city identity in Europe, formalized by the European Commission in a programme for an annual European City (or Capital) of Culture (Miles 2007: 121–42). Cultural cities, then, create another kind of mapping, not by money-power but by cultural capital. This links, in particular, to cultural tourism but has implications, too, for inward investment.

Approaches differed: in Bilbao, in the Basque region of Spain, the city's élite opted for a transnational art institution – a Guggenheim Museum designed by architect Frank Gehry – on a brownfield site at the city's ex-industrial edge. This intentionally elided Basque culture, which was linked to a violent separatist movement (Gonzalez 1993). The Guggenheim was expensive, not only in its construction but also in payment of a continuing fee to Guggenheim for their curating expertise. Whether the economic upturn initially produced by cultural tourism will persist remains a question, as tourists move from place to place and fashions change. Besides, in a recession, the weekend city break may be an unaffordable luxury for many who once saw it as a routine opportunity for acquiring cultural capital.

Barcelona, like Bilbao, the hub of an aspirant nation-state within Spain (Catalunya), with its own language and traditions, opted to develop a Catalan cultural infrastructure through public-sector investment. But this Catalan infrastructure also appealed to cultural tourists seeking out authentic cultural encounters (Dodd 1999). Claiming world status, Barcelona has a World Trade Centre designed by I.M. Pei on its new waterfront. It also has an extraordinary wealth of cultural attractions including museums for major modern artists such as Pablo Picasso and Joan Miró, and the colourful architecture of Antonio Gaudi. The city's savings banks (which work on a non-profit-distributing basis) invested in cultural projects beside the city's funding of key redevelopment schemes. Added to that is a unique political history: from the fall of the city to the Bourbons in the early eighteenth century to its fight against fascism in 1937, oppression during the Fascist period, and liberation after the death of General Franco in 1975. The key moment for the city's renewal was its hosting of the 1992 Olympic Games, in preparation for which over one hundred public spaces were created or refurbished, mainly in residential areas.

Sociologist Monica Degen writes of Barcelona as 'the most successful global model for post-industrial urban regeneration based on its urban design' (Degen 2004: 131). Perceived from outside, this success was magnetic, to be re-applied in other cities.

The difficulty is that what works in a city such as Barcelona may not work in one lacking that city's exceptional history and cultural wealth. Notwithstanding reality checks, the cultural turn was pervasive in the global North. New cultural venues transformed a city's image through a level of investment lower than that required for the renewal of a social fabric or an economic infrastructure. The shift of image was aimed in any case at external perception, not recognition by a city's diverse, competing publics. It subsumed diverse realities within a single representation of a future to which the city's governing, commercial and cultural élites aspired.

Cultural re-branding, that is, provided cities competing globally, and regardless of the nation-states in which they were situated, for investment and tourism. Culture provided the imagery – the seeming – which was required for the construction of a symbolic economy. Sociologist Sharon Zukin defines this as '[t]he look and feel of cities [which] reflect decisions about what – or who – should be visible and what should not, concepts of order and disorder, and on uses of aesthetic power' (Zukin 1995: 7). As a marketing device, a symbolic economy masks the conflicts and contested claims for space which occur in a layered built or social environment. It enhances a primacy of visuality – an emphasis on image translated into sites for the display of images, whether as art or style – as the sense offering the most mastering, as geographer Doreen Massey puts it, over space (Massey 1994: 223–24). Key to the symbolic image was, in many cases, a new, flagship cultural institution (such as Tate Modern in London and the Guggenheim in Bilbao). Other strategies included the demarcation of heritage and cultural quarters (Bell and Jayne 2004), and redevelopment of waterfronts for a mix of uses, with marinas, warehouse conversions, art galleries, designer shops and public promenades.

As said above, the context for all such initiatives was the de-industrialization produced by global shifts of production, the rise of immaterial production in the global North, and the growth of lifestyle consumption with its associations with a creative class. Perhaps there was already a synergy between the world of immaterial production and that of the expanding art world. Within the art world, the production of reputations began to replace that of art objects when artists who had rejected the tradition of the object in 1960s' conceptualism (often for socio-political reasons) were drawn back into the mainstream market through exhibitions of documentation or publication of attractive colour-plate books on their walks or twig sculptures in the woods. Sociologist Howard Becker wrote in 1982:

Art worlds … routinely make and unmake reputations – of works, artists, schools, genres, and media. They single out from the mass of more or less similar work done by more or less interchangeable people a few works and a few makers of works of special worth. They reward that special worth with esteem … [and] use reputations, once made, to organize other activities.

(Becker 1982: 352)

Image predominates over materiality in the symbolic economy. There were more definable links, too, between culture and real estate when developers found that seats on the boards of museums, for example, provided good networking opportunities. Zukin notes a conflation of cultural symbols and entrepreneurial capital in New York in corporate atriums such as Sony Plaza (Zukin 1995: 3). Zukin also sees a troubling aspect of the rise of cultural strategies, in that culture is a means of ordering a city ideologically: 'As cities and societies place greater emphasis on visualization, the Disney Company and art museums play more prominent roles in defining public culture' (Zukin 1995: 10).

A European case of culturally-led social ordering is the improvement, to use a nineteenth-century liberal term, of the old red-light district, the Bario Xino, in Barcelona. Renamed El Raval and re-coded as a cultural quarter, it became a site of social clearance. At its northern end, a new museum of contemporary art, MACBA, designed by Richard Meier, was built on the site of several nineteenth-century apartment blocks. An open plaza stands in front of it, taken over by dog walkers, cyclists, roller skaters and other distinct publics at different times of day. Further into El Raval, five blocks were cleared for a new Ramblas – a public space for walking, the character of which is between a street and a square. Street-lights in rusted steel – like late modernist sculptures – line its sides. The old Ramblas is a well-known thoroughfare between the city centre and the waterfront, with flower stalls, newspaper kiosks, cafés, street performers and the evening promenade, used by dwellers and tourists alike for an evening stroll. The new Ramblas connects two narrow streets and is little used. It has benches, but few sit on them. It has, in my experience, no flower stalls or street performers. El Raval was (and to some extent remains) an ethnically-diverse neighbourhood to which hotel concierges warned visitors not to go. This encouraged intrepid cultural tourists to seek out its back-street bars, and share narrow alleys with artists and sex workers. Today, El Raval is described as one of 'the new hip areas ... with designer shops and bars lining the streets' but is also criticized for a lack of consultation with residents in its planning, and a site of 'rebellion from [its] long-term residents ...' organized in community groups (Degen 2004: 140). Perhaps the lesson is that cultural re-coding is a reductive approach which denies the multiple actualities of street-level neighbourhoods, and a rejection of the diversity which, in fact, draws in cultural tourism. As Degen writes, tourists:

> are not only consumers of signs but active players in an overall embodied experience. The intrinsic intangibility of the tourist product – the experience of taking part in the activities of a place by eating its food, smelling and feeling the sea, the social interactions with locals ... – make the tourist experience a highly sensuous engagement.
>
> (Degen 2004: 137)

The issue is more than one of tourism, however, and a reductive city image is likely to reduce the visibility of dwellers regarded by business élites as marginal and unproductive. Life in

the outlying suburbs, peripheral social housing blocks and residual inner-city neighbourhoods is seldom seen as offering a marketable image.

Generally, the cultural turn in urbanization has produced enclaved redevelopment to house the creative class, together with a skyline of glassy towers. Art historian Jon Bird wrote in 1993:

> In London, the most public and visual expression of 1980s aggressive monetarism has been the changing skyline of East London's riverside redevelopment from the Tower of London to the Thames Barrier, spearheaded by the … Canary Wharf scheme on the Isle of Dogs.

> (Bird 1993: 121)

In opposition, artists Peter Dunn and Loraine Leeson, in the Docklands Community Poster Project, aimed to create visibility for local narratives and histories which were under threat of obliteration by the behemoth of Canary Wharf – then under construction, in the 1980s – and all it represented. They write:

> In opposition to the seemingly viral-like spread of corporate culture … the importance of local narratives has become ever more critical … Local narratives [are] not just defined by geography but as the *specificity* of what it is like to be working class in this society, to be a woman, to be black, to be gay, to be differently abled.

> (Dunn and Leeson 1993: 143)

The claim to specificity recurs in today's art-activism, as I discuss below. It is not a claim to authenticity in the mode of cultural tourism, but a demand for voice and recognition.

Questioning the Cultural Turn

I want to look briefly now at whether the cultural turn in urban policy delivered the benefits claimed for it. Investment in the arts is less costly than that required to repair urban infrastructures, or improve education, health care, social services or to offer re-skilling for the new economy. But the claims made for the benefits of culturally-led redevelopment may in retrospect seem over-optimistic. Projections of visitor numbers and job creation for new cultural institutions were, in any case, only estimates, often produced by consultants hired to write funding bids. Although figures from comparable institutions or visitor attractions can be cited, there are too many variables to allow certainty. Hence, a centre for popular music in Sheffield closed because it failed to attract predicted visitor numbers. Leaving that case aside, while the justification for public investment in new museums is that they create employment and lever private-sector investment in the environs, most of the new jobs in the museum are low-paid, in areas such as cleaning, catering and security. The curators come from elsewhere. Similarly, employment in spin-off small-scale

enterprises in the vicinity tends to be low-skilled and temporary – in bar and shop work. This was the case in Birmingham, Britain's second city, when major public investment in the 1980s and 1990s produced a city-centre cultural zone at the cost, in part, of reductions in services for outlying districts (Loftman and Nevin 1998).

If cultural redevelopment was seen as bringing a wide range of public benefits, then, the claims made for it were either too vague to be demonstrable or never tested, as Sara Selwood found in a study of public art projects in three English regions (Selwood 1995). A report for the National Endowment for the Arts, in the US, illustrates the extent of the claims:

> No longer restricted to the sanctioned arenas of culture, the arts would be literally suffused throughout the civic structure, finding a home in a variety of community service and economic development activities – from youth programs and crime prevention to job training and race relations – far afield from the traditional aesthetic functions of the arts.
>
> (cited in Yudice 2003: 11)

Well they might, but this is a case for the expansion of the art world more than an evidence-based policy statement. This is not to deny that valuable work was carried out by arts groups working with specific, often marginalized, publics (Kester 2004; 2011), but it is to say that a case as bland as that above fails to recognize that the problems faced are largely the outcomes of failures in other policy areas. Those failures are subsumed in the shiny rhetoric of culture.

The case for creativity tended, similarly, to annex social conditions. Florida uses the trope of time travel to imagine a native of the 1900s arriving in a postmodern city, seeing 'different ethnic groups … mingling in ways he [sic] found strange … mixed-race couples, and same-sex couples … women on strange new roller skates' (Florida 2002: 3). It is a de-politicized diversity, like a tourist image, in contrast to the way Leonie Sandercock (2006) writes, from radical and multi-ethnic planning, of daily negotiations over co-presence and the right to use and be seen in a city's spaces.

By the mid-2000s, a lack of evidence for the benefits of public investment in culturally-led regeneration led to a shift in British cultural policy, evident in remarks by the then Secretary of State for Culture, Media and Sport, Tessa Jowell, at a meeting of arts managers in London in 2005. Jowell, celebrating culture's civilizing role, asserted that public funding could produce 'dazzling new work, of far-reaching innovation' (Jowell 2005: 6), and continued that the arts could address a poverty not so much of money but of imagination – beyond measurement. She accepted that the arts were useful, but asserted that arts policy should focus 'on what the arts can do in themselves' (2005: 7). The phrase has a hint of modernist aestheticism, and was a defence against demands from the Treasury for data. Jowell's tactic was to turn to art's intangibles in a way not the same as but no less abstract or aspirational than Florida's tales of future wonderlands. I am not arguing, by the way, that art should be mechanistically audited – I'm an aesthete (though of a critical disposition).

31

Business as Usual

Looking back on three decades of culturally-led urban redevelopment, I wonder what else might have been achieved if the arts had not been drawn into the instrumentalism of claims to solving the problems of de-industrialization through urban re-branding. The shift from an arts policy, geared in the post-war welfare state to widening access to cultural experiences towards one of levering investment, began in the Thatcherite 1980s and has shaped cultural institutions on a corporate model. The shift was indicated by a change of terms, from arts administration (for the public good) to arts management (on a business model).

Tate Modern exemplifies the agency of new cultural institutions in changing a city's image, and has been successful in attracting visitors, including cultural tourists, but also represents the model of a corporate structure operating in, and in some ways dominating, the art-world. Tate relies on the intangible quality of style, and the consumption of a creative class in its book shops, cafés, restaurant and membership scheme. Esther Leslie, a Professor of political aesthetics in London, writes:

> Tate Modern is not just trendy, but the vanguard of a reinvention of cultural spaces worldwide. Art galleries are overhauling themselves as 'for profit' spaces where the expertise of art workers is leased out to business and education …
>
> Tate is a brand that niche-markets art experience. Its galleries are showrooms. However, this is still art and not just business. The commodity must not show too glossy a face. The reclamation of an industrial space … lends the building a fashionably squatted aspect, like Berlin water towers or crumbling arcades that serve as edgy art galleries or music venues for a while.
>
> (Leslie 2001: 3)

Leslie implies that counter-cultural activities such as squatting can be annexed. In 2009, Tate Modern's summer show, Street Art, brought graffiti artists from around the world to decorate its exterior walls. Graffiti entered New York galleries as early as the 1970s, and here finds its apotheosis, re-named Street Art, reproduced in limited edition prints and sold at international auctions. But buying graffiti prints is the kind of consumption that is easily abandoned when the money disappears.

Dark Times, Recurrence of Refusals,

At the end of *Cities of Tomorrow*, revised in the mid-1990s, Peter Hall writes of widening divisions between those who have wealth and access to the mobilities and comforts of postmodern urban lifestyles, and those who do not. Of the latter, he notes:

the less fortunate are likely to be increasingly dammed up in the cities, where they will perhaps be housed after a fashion … these groups … may find themselves in but not of the city, divorced from the new mainstream informational economy, and subsisting on a melange of odd jobs, welfare cheques and the black economy.

(Hall 1996: 422)

Hall is not a sociologist but a planner, retaining a belief in the values of planning as a means to social equity. He ends, 'as the millennium approaches, it casts a deep pre-dawn chill' (1996: 422). Eleven years after the millennium, the cultural bonanza seems over. The Niemeyer Arts Centre in Aviles, Spain is about to close due to lack of funds to run it. Construction has halted on a City of Culture complex in Santiago de Compostela. In the UK, two new art museums – the Hepworth in Wakefield and the Turner Contemporary in Margate – may be the last of a generation of lottery-funded schemes denoting culturally-led regeneration. But I wonder what social coherences or local economies were regenerated, and whether the emphasis was always on raising property values. So often, when artists arrived in a neighbourhood and took on low-rent live-in studios in redundant industrial buildings, they were followed by dealers, new media enterprises, boutiques and designer bars. So often, from SoHo in New York to Hoxton in East London, culture meant gentrification, the creative class (in Florida's terms) being its driving force (Lees, Slater and Wyly 2008: 94–98). It is interesting, then, to see how artists' groups have adopted the tactics of activism – as in anti-globalization protest – to refuse the script written by transnational capital, in anti-gentrification cultural work.

The St Pauli district of Hamburg includes a section of waterfront and the red-light district (a popular tourist destination). The area could be called an arts district, populated by artists and bohemians, many squatting in nineteenth-century apartment blocks owned by the city and vacated during a previous economic decline. St Pauli was scripted for improvement, but the process was interrupted by a decline in the property market. Many of the apartments in a new, high-rent block remain unlet. But the gentrifying script was always uncertain. St Pauli is one of most ethically- and socially-diverse neighbourhoods in Hamburg, and one of the poorest: a transitional zone of migrants and bohemians, in a way, like El Raval prior to remodelling. But, unlike El Raval, the artist-squatters are mobilized. Park Fiction emerged as a refusal of the values of the global free market of which gentrification is an outcome, and has worked with local groups to co-design a public park in a key site as a material claim to ownership of the neighbourhood's identity.

Christoph Shaefer and Cathy Stevens, participants in Park Fiction, describe it as 'a practical critique [of planning] … from the perspective of its users' (Park Fiction 2006). Shaefer and Stevens cite French sociologist Henri Lefebvre's *The Urban Revolution* (2003) which argues that the transition from an industrial to an urban society produces structural uncertainty in which new possibilities of social organization are imminent. They note Lefebvre's differentiation of urbanization from other ways of describing advanced western

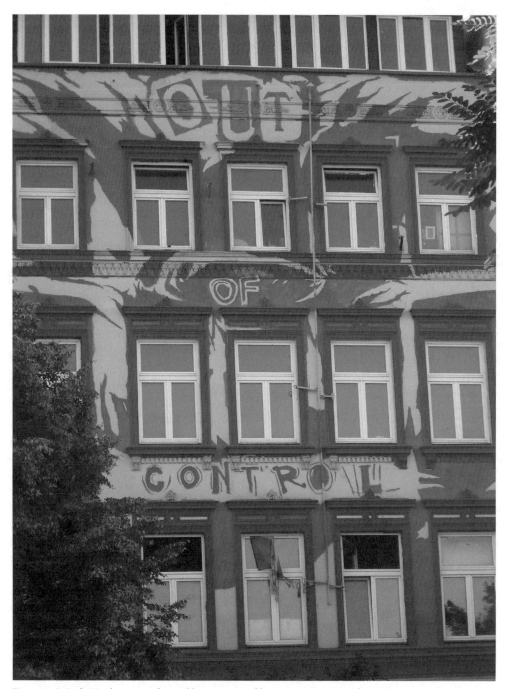

Figure 1: St Pauli, Hamburg, one of several houses squatted by artists. Image: M. Miles.

societies such as the leisure society or the information society; and agree with him that urbanization is characterized by a diversity of lifestyles, publics and cultural models. Schaefer and Stevens write: 'The decisive point for us is that the city is appropriated space, that the process of urbanization describes a process of appropriation' (Park Fiction 2006). They then adopt Lefebvre's analysis of urban power at three levels: Level G (the global) denotes institutional power, in which cities may be subjugated to the instrumentalism of the market; Level M (intermediary) denotes the streets, squares and major buildings of urban space, between institutions and living spaces; and Level P denotes a realm of dwelling where – unconventionally – trajectories for urban change begin. Revolution does not begin among sociologists, planners or architects because institutional ties prevent it. Hence, '[i]nstead the revolution of the cities will start from dwelling places. The city becomes a subject' (Park Fiction 2006). They continue:

[T]he city must turn from an object into a subject. It should no longer be the object of change effected by powers adverse to it ... but the subject of change – meaning that it should develop the direction out of itself and become the actor. How can this be conceived? The revolution begins at home.

(Park Fiction 2006)

The idea of a city as a self-empowering subject reflects feminist critiques that emphasize the personal as political; and the tactics of squatters' movements (as in Berlin in the 1970s) for a reclamation of space. I would add a third factor, also from Lefebvre: the reclamation of the idea of 'habiting' after its diminution to the quasi-biological 'habitat'; Lefebvre observes, 'Habitat, as ideology and practice ... buried habiting in the unconscious' (Lefebvre 2003: 81). By reducing dwelling to 'eating, sleeping and reproducing', Lefebvre says, urban social theory, notably among the Chicago School in the 1930s to 1960s, denied 'multifunctional and transfunctional' modes of dwelling (2003: 81). Squatting repossesses space and reinstitutes a basis of communal organization and cooperative means to meeting complex human needs. Hamburg's squatters' movement around Hafenstrasse in St Pauli came to media attention in the winter of 1987 when efforts were made to clear it: 'barricades were erected all the way into the red-light district, Radio Hafenstrasse broadcast around the clock, the city feared civil-war-like conditions were the ... buildings to be cleared' (Park Fiction 2006). This was not a strike but a movement 'driven by the desire for self-determined life and dwelling' (2006) after the legalization of squatters' settlements in Amsterdam and Utrecht, and negotiations over the free city of Christiania in Copenhagen. If the insurrection in Paris in May 1968 was cultural as well as socio-political, the defence of squats in Hamburg in 1987–88 was equally so. Bands played every night, using electricity supplied by neighbours (or simply taken from the grid). After the barricades, the city developed better negotiating skills and soft policing methods. Squatters and activists also developed new tactics, such as raves and ambient discos. In this context of persisting resistance to development, Park Fiction was formed in 1995

specifically in opposition to a proposed new residential tower facing the waterfront. Linking with a music club and an anti-fascist alliance, Park Fiction organized a parallel planning process via networks formed in past campaigns. Coalitions formed, agit-prop events took place and, as ideas for a public park took shape, the city – ignorant of this – invited Schaefer and artist Cathy Skene to deliver a public art project, which they took as an opportunity to co-design the park. While Park Fiction was organized and purposeful, with grounded community links, the politicians were unused to dealing with informal situations and networks, and tended to be characterized as having a merely negative attitude – trying to stop things, supporting the dominance of the development industry.

A collective design and planning process ensued, leading to the park that occupies the site today. But it almost failed. A developer sought to annex the site, and the city started to go back on its commitments. But, at this point and quite coincidentally, Park Fiction was invited to exhibit documentation of their work at Documenta XI, in Kassel in 2002. Representation for the city's radical artists, regardless of political positions, provided cultural capital for a city seeking cultural tourism. To show the documentation of the

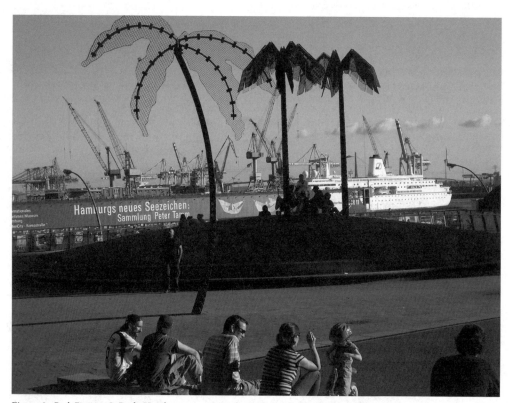

Figure 2: Park Fiction, St Pauli, Hamburg – creation of a public park resisting gentrification. Image: M. Miles.

process of co-design, contextualized by past utopian cultural projects and the failed revolts and cultural movements of the late 1960s, it put the park in St Pauli on one face of the global culture map and, at the same time, established its credentials as politicized contemporary art. There are certain ironies here but, after Documenta, opposition to the park seemed to melt away.

I went to the park in 2009. It was used mainly, but not exclusively, by young people as a place to hang-out, smoke and drink, with a hammock slung between two painted-steel palm trees. The still-squatted apartments are nearby, their colourful facades facing the river. Along the waterfront, a pseudo-beach club with straw-roofed huts and deck chairs occupies a site on the river's edge, as if the signs of Park Fiction had been appropriated by the market, except with bouncers at the gate. Yet the groundswell of refusal rises, like a living of a revolutionary life before the Revolution (which will not occur now). Perhaps that offers a more interesting scenario for artists' interventions than culturally-led redevelopment.

References

Bauman, Z. (1998), *Globalization: The human consequences*, Cambridge: Polity.

Becker, H. S. (1982), *Art Worlds*, Berkeley (CA): University of California Press.

Bell, D. and Jayne, M. (eds) (2004), *City of Quarters – Urban villages in the contemporary city*, Aldershot: Ashgate.

Bird, J. (1993), 'Dystopia on the Thames', in J. Bird et al. (eds), *Mapping the Futures: Local cultures, global change*, London: Routledge, pp. 120–35.

Degen, M.M. (2004), 'Barcelona's Games: The Olympics, urban design and global tourism', in J. Urry and M. Sheller (eds), *Tourism Mobilities: Places to play, places in play*, London: Routledge, pp. 131–42.

Dodd, D. (1999), 'Barcelona: The making of a cultural city', in D. Dodd and A. van Hemmel (eds), *Planning Cultural Tourism in Europe: A presentation of theories and cases*, Amsterdam: Boeckmann Foundation, pp. 53–64.

Dunn, P. and Leeson, L. (1993), 'The Art of Change in Docklands', in J. Bird et al. (eds), *Mapping the Futures: Local cultures, global change*, London: Routledge, pp. 136–49.

Evans, G. (2001), *Cultural Planning: An Urban Renaissance?* London: Routledge.

Florida, R. (2002), *The Rise of the Creative Class*, New York: Basic Books.

Gonzalez, J.M. (1993), 'Bilbao: Culture, citizenship and quality of life', in F. Bianchini and M. Parkinson (eds), *Cultural Policy and Urban Regeneration: The West European experience*, Manchester: Manchester University Press, pp. 73–89.

Hall. P. (1996), *Cities of Tomorrow*, updated edn, Oxford: Blackwell.

Hilton, C. (2002), *The Wall: The people's story*, London: Sutton Publishing.

Jowell, T. (2005), 'Why Should Government Support the Arts?' *Engage,* 17, pp. 5–8.

Kester, G.H. (2011), *The One and the Many: Contemporary collaborative art in a global context*, Durham, NC: Duke University Press.

——— (2004), *Conversation Pieces: Community and communication in modern art*, Berkeley (CA): University of California Press.

Klein, M. (2000), *No Logo*, London: Flamingo.

Landry, C. (2000), *The Creative City: A toolkit for urban innovators*, London: Earthscan.

Landry, C. and Bianchini, F. (1995), *The Creative City*, London: Demos.

Lees, L., Slater, T. and Wyly, E. (2008), *Gentrification*, London: Routledge.

Lefebvre, H. (2003), *The Urban Revolution*, Minneapolis, MN: University of Minnesota Press.

Leslie, E. (2001), 'Tate Modern: A year of sweet success', *Radical Philosophy*, 109, pp. 2–5.

Loftman, P. and Nevin. B. (1998), 'Pro-Growth and Local Economic Development Strategies: Civic promotion and local needs in Britain's second city', in T. Hall and P. Hubbard (eds), *The Entrepreneurial City: Geographies of politics, regime and representation*, Chichester: Wiley, pp. 129–48.

Marcuse, P. (2002), 'The Layered City', in P. Madsen and R. Plunz (eds), *The Urban Lifeworld: Formation, perception, representation*, New York: Routledge, pp. 94–114.

Massey, D. (1994), *Space, Place and Gender*, Cambridge: Polity.

Miles, M. (2007), *Cities and Cultures*, London: Routledge.

Park Fiction (2006), 'Rebellion on Level p', http://www.parkfiction.org/2006/01/112.html. Accessed 27 October 2009.

Raban, J. (1974), *Soft City*, London: Fontana.

Sandercock, L. (2006), 'Cosmopolitan Urbanism: A love song to our mongrel cities', in J. Binnie, J. Holloway, S. Millington and C. Young (eds), *Cosmoplitan Urbanism*, London: Routledge, pp. 37–52.

Sassen, S. (1991), *The Global City: New York, London, Tokyo*, Princeton (NJ): Princeton University Press.

Selwood, S. (1995), *The Benefits of Public Art*, London: Policy Studies Institute.

Yudice, G. (2003), *The Expediency of Culture*, Durham, NC: Duke University Press.

Zukin, S. (1995), *The Cultures of Cities*, Oxford: Blackwell.

Chapter 3

Catalysing our Cities: Architecture as the new alchemy for creative enterprise

Tom Barker
Ontario College of Art and Design (OCAD) University
University of Technology Sydney

Introduction

The challenge in urban design is to create the conditions under which cultural meaning and value can be seeded and then grow organically, flexibly and responsively, rather than try to prescribe all of the meaning and value at the outset. Such seed conditions are developed from the use of three capitals: social capital, cultural capital and economic capital. The author argues that when architects and urban designers work to leverage these capitals there is a greater possibility of achieving a sustainable urban renaissance.

Historically, cities were rarely designed as a whole. Cities typically evolved in a responsive and dynamic manner over years or centuries. There are some examples of successful, large-scale city renewals, including medieval Paris by Haussmann for Napoleon in the 1850s and Barcelona's Eixample egalitarian city extension in 1859 by Ildefons Cerdà. Less common are examples of *tabula rasa* design – or design from scratch – such as Le Corbusier's Chandigarh in India and Oscar Niemeyer's Brasília with Lúcio Costa, both archetypes of modernism. Chandigarh and Brasília date from the 1950s and are now World Heritage sites. The advent of the instant city is a twenty-first century phenomenon born in China, where plans to build 20 cities a year for the next 20 years have resulted in some bizarre outcomes, including 64 million empty homes and ghost towns in the desert (Mail 2011).

The gradual evolution of cities has been no bad thing because it has given us places that are about richness, diversity and vibrancy. City evolution delivers the meshing and intricacies of interaction and layered relationships. The coming together of a number of capitals over time is a key to making a city a success. Capitals have been categorized by various researchers in the field (Bourdieu 1986; Santos 2008). Pierre Bourdieu's social, cultural and economic capitals are worth considering in terms of the extent to which they can be facilitated by the built environment – even if not always guaranteed by it. Bourdieu's definitions may be summarized thus:

Social capital: the productive benefits of good, durable social relations, social obligation and cooperation;
Cultural capital: goods, peoples' disposition, or institutional such as educational;
Economic capital: endeavor that is directly convertible or realizable as money or property rights.

Architecture and urban design can attempt to consider all of the above, but social and cultural capital are highly qualitative and even the most quantifiable capital – economic capital – can

be a chimera as property and financial markets always go through boom and bust cycles. Conversion can take place between the capitals, but with inherent losses (or costs) and, at an urban design scale, conversions are likely to be politicized since they will result in significant change that will impact on a population. Conversions can take place in many ways, for example slum clearance, the establishment of an arts centre, a university or a new tourist attraction.

Urban design at its best provides a physical framework to be populated by activity and energy, as well as a fair share of chaos. Cedric Price's book, *Re: CP* (Price 1999) succinctly summarized urban design as a facilitator for delight, learning, sanctuary, friendly thresholds and urban convenience. But achieving Price's positive and desirable design outcomes within the context of city is a challenge; the multiple criteria of city design can conflict and the criteria are not always complementary. Add to this the dynamic effects of transitions over time – the evolution, revolution, regeneration and resilience that ebbs and flows through local, national and international cycles – and it is unsurprising that design outcomes are impossible to predict.

The rapid urbanization of the world's population over the last 100 years has lent some urgency to getting the architecture of cities right in a less evolutionary or leisurely manner. According to the World Resources Institute more than 50 per cent of us now live in cities (http://wri.org) and it is increasing fast; by 2030 it will be 87 per cent in the US and 60 per cent in China. In the future, it is arguable that cities rather than countries will be the powerhouses of the global economy (Florida 2008). The age of globalization has seen relentless growth of cities. Urban densification is a worldwide phenomenon and it is sustainable; according to Dodman (2009) people who live in small towns and rural areas emit 50 per cent more greenhouse gasses than city dwellers.

Architecture is both the process and product of the design and construction of cities, buildings and spaces. Architecture is also a profession which has a venerable history that predates many other professions and stretches back to the Egyptian pyramid-builder Imhotep in the twenty-seventh century BCE. And yet the architecture profession lacks the ability to predict the success of its urban work; there are many examples of successful urban designs by architects throughout the centuries and there are many examples of failures as well. As the growth of our global cities leads to new levels of complexity, architects increasingly risk being emasculated through the loss of ownership of city design to those who claim to know better: planners, politicians, transport engineers and other technocratic disciplines. But the problem of achieving good urban design is not just down to the ability of architects to predict outcomes. Alexander argued that in contemporary urban design the sense of city 'wholeness' is lost because all of the professionals involved – including architects – focus on their individual preoccupations (Alexander et al. 1986). However, it would be wrong for architects to lose ownership of city design when there is little evidence to show that other more technical disciplines can do it better and more reliably.

Against the backdrop of the known complexities of undertaking urban design for cities, there is an opportunity for architecture to embrace the notion, through design, of facilitating enterprise with the domain of the creative economy and to act as a catalyst for our future cities. In effect, offering architecture the opportunity to deliver urban transformation in terms

of social, cultural and economic capital by becoming the new alchemy for creative enterprise and catalysing our cities by creating the conditions for cultural meaning and value.

Alchemy at Work

Medieval alchemists were fixated on achieving the transformation of base metals into gold and their scholastic methods comprised dialectic reasoning and inference. Despite being practitioners of much that was pure quackery, interestingly the alchemists were also the forefathers of modern chemistry and rational materialism – a change led by Robert Boyle in the seventeenth century. In the case of alchemy, the difference between the old dialectic and the new chemistry was a shift from occasional random good fortune, such as the invention of alcohol distillation and some useful recipes for creating acid, to reliable and predictive chemical transformations. Sadly this never extended to creating gold.

In a city, alchemy also relates to transformations. There are many historical examples of unintentional urban alchemy that were the unforeseen consequences of enterprise transition. One such example revolves around the movement of goods through city docks and it is described below as a detailed example.

The Albert dock was opened by Prince Albert in Liverpool in the UK in 1846 (Figure 1). This dock was at the cutting edge of technology. Constructed from cast iron, brick and stone instead of timber, the dock offered the first fireproof buildings for the storage and transfer of goods. The Albert dock had the first hydraulic cranes for lifting goods directly on and off the ships. This dock performed admirably for a hundred years. However, the invention of the ISO shipping container by Keith Tantlinger in the US in the 1950s made the Albert dock redundant and it was closed in 1972. ISO containers were standardized boxes for the transport of goods around the world and today they transport 90 per cent of non-bulk cargo. Container terminals replaced docks across the world and they comprise vast expanses of asphalt with lifting cranes. A small number of crew can do the job that used to require hundreds of workers and, unlike traditional docks, container terminals are rarely in the centre of a city. Docks facilitated globalization of trade and the containers cemented this phenomenon.

Mirroring the decline of the dock, the city of Liverpool itself fell upon hard times with high unemployment and inner city decay. Liverpool's Toxteth riots in 1981 brought matters to a head and the British government set up the Merseyside Taskforce to help revitalize the city. Social problems continued and there were further riots in 1985. The Albert dock was reinvented and reopened in 1988 as a new multi-use attraction that has become the most visited tourist destination in the UK outside of London. The Albert dock has the UK's largest collection of grade one, listed buildings and it is part of Liverpool's designation as a UNESCO World Heritage Maritime Mercantile City (Carter 2003).

The redesigned dock has been a huge success as a cultural centre. With six million visitors a year, the Albert dock now houses the Tate Liverpool art gallery, the Merseyside Maritime museum, the International Slavery museum, a Beatles museum and numerous shops, hotels

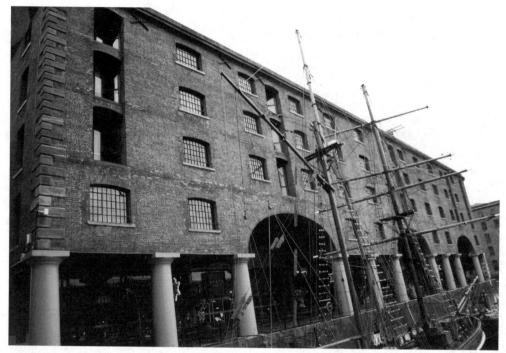

Figure 1: The Albert dock in Liverpool, UK. An example of urban regeneration in 1988. Image: Wikimedia Commons.

and restaurants. Architecture as the new alchemy for enterprise in this case was able to recover social and cultural capital from economic capital that had been destroyed by the evolution of technology for globalized trade. The necessary political condition was met by a government that desperately needed to regenerate a city that had suffered.

Enterprise and innovation had brought Liverpool's Albert dock to the point of dereliction, but a redesign has made it a success. Stories like this have played out in many of the old docks and old industrial buildings of cities all around the planet.

Where Are We Now with City Design?

The notion that rationalist planning was going to create great cities and neighbourhoods was debunked scathingly in the 1960s, notably by Jacobs (1961). Subsequently, the idea that architects – or indeed anybody – can actually create great cities from scratch has, increasingly, been challenged. Venturi (2002) argued that a vibrant city should be an eclectic, complicated and historical architectural mix. In other words, a city designed from scratch loses complexity and risks homogeneity.

The danger is that organized planning actually can make cities worse despite good intent. For example, a rational approach can highlight out the 'planning flaws' in existing cities that

contribute to the very urban richness and vibrancy of those places. Unsurprisingly counter-planning has its advocates and, for example, Koolhaas (1978) celebrated the energizing nature of unwelcome congestion in Manhattan. In a yet more extreme example, the 1969 article 'Non-plan: an experiment in freedom', by journalist Paul Barker, architect Cedric Price and urbanist Peter Hall (Banham et al. 1969) postulates that no planning at all may not make our built environment any worse. Barker revisited this theme 30 years later and drew largely the same conclusions (Barker 1999).

Deyan Sudjic places the responsibility of the modern city formation predominantly with developers and to some extent planners (Sudjic 1993). He finds vitality in multilayered complexity; as a proponent of renewal, Sudjic is also scathing about the influence of perceived rosy urban history in fetishizing the preservation of the old through unconvincing arguments about community value.

The position of Dutch architect and theorist, Rem Koolhaas (1994) is that big cities will always be complex, but he alerts us to the danger of synthesizing complexity as a 'collage', for example in his interview with John Rajchman (Koolhaas 1994):

JR: You say Bigness alone instigates a 'regime of complexity' in which 'programmatic elements react with one another to create new events.' How does this differ from the sort of complexity Robert Venturi called 'the difficult whole', or Colin Rowe the 'collage'?

RK: Collage is simulated complexity: instead of a Mondrian-esque composition of slabs, you imagine a Piranesian composition of fragments. It is composed, controlled, limited – it's a purely visual complexity.

(Koolhaas 1994)

More recently, computer aided design methods have been brought to bear on the issue of urban design. Generative digital algorithms and scripting evolve masterplans in minutes that would otherwise take centuries. However, these methods are barely tested in practice and still reside predominantly in architecture schools. An example is the Architectural Association's graduate Design Research Lab's three year investigation of Parametric Urbanism from 2006–8 (www.aaschool.ac.uk/aadrl) where the author contributed to the teaching – some project illustrations are shown in Figure 2.

Without extensive built environment examples to assess, there is little evidence as yet that computational methods for urban design have an advantage over more traditional approaches, although it is possible that the two might be leveraged most effectively in combination. Such a duality of method was used on the 180 hectare, One North Masterplan for Singapore's Jurong Town Corporation, led by Zaha Hadid Architects. Part of this work involved the creation of a Masterplanning Toolbox by the author. This was an early-stage computational tool for design-led teams to assist in the synthesis and evaluation of multimodal complexities (Barker 2011). This plan was for a phased development for the period 2001–21, so it will be some time before success can be evaluated. The plan for One North, a creative mixed-use hub in the university district of Singapore, is shown in Figure 3.

45

Figure 2: Parametric urban design methods, examples from the Architectural Association's graduate Design Research Lab's three-year investigation of Parametric Urbanism. Image: AA-DRL 2008.

If city design defies the analysis-synthesis approach of most planners, and it cannot be expected that developers or commercial interests alone will have too much interest in civic responsibility or social capital, then is it simply left to architects to create gorgeous, individual buildings as gems in an unprepossessing urban landscape? This may be the case so long as our view of a city as a design problematic is restricted to working with the stuff of building typologies, transport, infrastructure and public places.

Figure 3: City block envelope visualization and urban dependencies mapping, for 180 Hectare One North Masterplan for Singapore's Jurong Town Corporation, led by Zaha Hadid Architects. Images: Zaha Hadid Architects/Tom Barker 2003.

We need to understand the role of cities as focal points for creative enterprise and the way in which such enterprise represents and fuels the vibrancy or soul of a city. Consider the opportunity for architecture to leverage design for creative enterprise to enable urban vibrancy through cultural production and value rather than to synthesize it. In other words, how can architecture set up the meta-conditions for a blossoming city? This second-order approach is about the seeding, mediating and the mentoring of spatial configurations rather than applying the heavy hand of planning.

Does Creative Enterprise Matter?

The first comprehensive global review on the global creative economy by the United Nation's UNCTAD (Santos 2008) highlighted the importance of *creating the conditions* in which creativity can flourish by creating new capital – human, structural, social and cultural. Major cities around the globe are focal points for creative industries. According to UNCTAD:

> Creative Industries can be defined as the cycles of creation, production and distribution of goods and services that use creativity and intellectual capital as primary inputs. They comprise a set of knowledge-based activities that produce tangible goods and intangible intellectual or artistic services with creative content, economic value and market objectives.

The creative industries are categorized by UNCTAD in Figure 4.

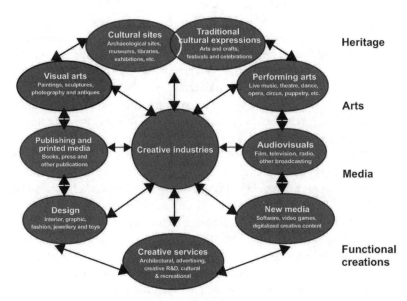

Figure 4: Classification of Creative Industries. Image: UNCTAD 2008.

In terms of economic value, the creative industries are very significant. In 2005, creative industries represented 3.4 per cent of total world trade, or $424 billion (Santos 2008). These industries are growing in developing and developed countries alike. According to official figures from the National Bureau of Statistics of China, GDP growth in China in the first six months of 2009 was 7.1 per cent, but 17 per cent for the creative industries. In London, arguably the world's creative hub, the creative industries are second only to financial services in terms of economic contribution, helping to contribute to growth of 6.2 per cent in the UK in 2007 (DCMS 2010).

Creative industries became mainstream, as a term, around a decade ago. In 2000, Business Week predicted that ideas would hold the greatest value for businesses in coming years – ahead of material assets, manufacturing capability or other resources – and noted that:

> The advanced economies have gotten so efficient at producing food and physical goods that most of the workforce has been freed up to provide services or to produce abstract goods: data, software, news, entertainment, advertising, and the like.
>
> (Coy 2000)

Most creative industries now have significant digital components in terms of process, production and distribution. This digital convergence is accelerating the move to services or abstract goods that Business Week predicted.

Opportunity through Virtual Value

The Internet has accelerated the importance of virtual value. The Internet brings ideas and value closer together than at any time in history perhaps since the golden age of philosophy with the likes of Socrates and Plato over two millennia ago. But how should architecture respond to the creative economy and the erosion of the physical manifestation of human endeavour? Earlier periods of industrial progress were physical and the industrial revolution left cities with a legacy of transport, infrastructure, factories, and also funded civic buildings and amenities. Architects and engineers were well aware of the legacy and value of the built environment and typically built accordingly. As industry left cities, empty factories and abandoned docks could form the basis of urban regeneration and the structures gained a new vitality and purpose.

For architecture, the creative economy offers new opportunities. There is some recognition emerging that architecture should have a key role to play. Hall (2000: 640) notes, 'Culture is now seen as the magic substitute for all the lost factories and warehouses, and as a device that will create a new urban image'. Howkins (2001) highlights the growth of creative industries through physical clustering in cities. Although e-commerce growth is now outpacing bricks-and-mortar retail by 2.8 per cent (US Department of Commerce 2011), the digital domain of virtual value shows few other signs of replacing the physical urban world. The popular writer Richard Florida (2008) emphasizes the increased importance of physical place, and

location-based social and business networks, as a consequence of mobility and globalization, mitigating the side effects of dispersion and alienation.

We are sold digital technology as a way of improving our lives and in many ways it has. Digital technology is making communication pervasive. But without a structure beyond the intangible and arcane 'plumbing' of the Internet's IP addresses, DNS, TCP/IP and so forth, it provides even less of a formalistic steer than a postal address – 10.1.4.6 says less about a place than 15 Paradise Plaza. Architecture has tools and techniques, and can draw on a long history. Architects have no trouble designing and there are many ways to do this. From the use of typologies to generative algorithms, the methods are now dizzying in variety – and there is no right way. What distinguishes architecture is the intellectual drive for progress, and a place in the lexicon of history. Architecture always wants to move forward. A building is usually a one-off, a prototype, and not a mundane replicated product.

The arrival of service industries showed how intellectual property could have value without a physical anchor. The internet took this to the next stage of abstraction and allows raw ideas to generate value – in some ways this is perhaps analogous to the founding years of philosophy, of Socrates and Plato. The clues to answering the question of 'where now?' for architecture, lie in this trend of value via thought.

Creating the Conditions for Creativity

Good architecture is about facilitating and catalysing the urban and spatial condition through creativity and innovation. This is the core value proposition of design in a city context. For the practice of architecture, creativity and innovation inhabit three layers, namely:

Practice: Within architectural practices through the practice of design;
Production: In the initiation and execution of specific design projects;
Alchemy: In the creation of urban conditions that foster enterprise, which may be physical constructions and urban interventions, innovative enterprise conditions, or services.

The first point is about improving practice and this comes from improvements in education, training, technology and theory. The second point is well understood in the profession. It is the third point that is a novelty, but it is the third layer of alchemy that delivers the real value in terms of capital.

UNCTAD (Santos 2008) produced an interlocking diagram in which a nexus of requirements nurtures creativity (see Figure 5). The architectural output must become an incubator for such manifestations of creativity; it does not in itself deliver them.

The ability of a city to regenerate and demonstrate *kaizen* (a Japanese term meaning change for the better) is critical to achieving and maintaining competitive and creative edge. Successful cities are dynamic, adaptive and responsive to change. Such a dynamic is catalysed by distinctive design in terms of architecture and events, along with amenities,

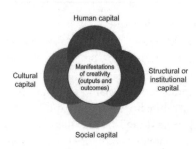

Figure 5: The capitals that are required to encourage creativity as outputs and outcomes. Image: UNCTAD 2008.

transport and services. Historically, the imprint of a city has been great civic buildings and works. The modern city is no different. However, the nature of the works now extends beyond the traditional – such as parks, fountains or plazas – into, for example, architecture as event tourism, pervasive digital media, industry-governmental joint cultural ventures and even mobile computing infrastructure.

In Singapore, a plan for a creative economy called Renaissance City 2.0 (CIDS 2003) for 2003–12 dealt with a transition from post-industrialization that has happened at breakneck speed within the city state. The plan maps out a trajectory that will take the city from a manufacturing hub to a creative economy within 40 years. In a globally-competitive market, other cities would do well to take note.

The Role of the Micro Intervention

Not everything has to be on a grand urban scale to improve a city. Every scale matters for the city experience. Cities are collections of neighbourhoods in which street, park or building scales preoccupy the inhabitants. Hence, small scale creative interventions in the existing fabric of a city can have a significant positive impact on urban spaces at a neighbourhood level. The ugly flyover, the freeway, the derelict warehouse, the grimy housing estate; all of these and many more have been brought spontaneously to life in many cities with art forms ranging from graffiti and murals, to performance and digital projection. Figures 6 and 7 show two examples of temporary interventions in the laneways of Sydney. These were created by the author, working with his UrbanAid group at the University of Technology Sydney in 2009 and 2010. Narrow laneways made these two projects possible, along with a festival and a launch party. The laneways were narrow for all sorts of reasons but the nature of the urban fabric is critical to the success of an intervention and can be planned for. Once again, even at this scale the urban task is in designing the conditions to allow creativity to happen.

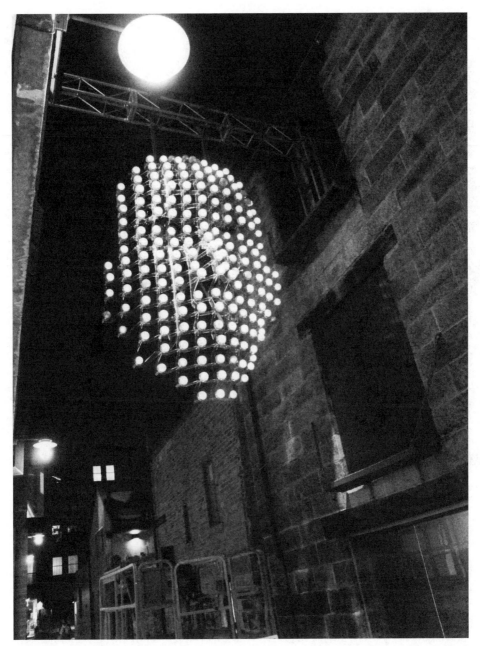

Figure 6: The *Janus* installation project in a laneway in the Rocks, Sydney, 2009. A six-metre-tall face made of solar-powered LED lights was suspended from a gantry and the expression of the face was based on self-photographs of passersby using emotion recognition software. Part of the Sydney Vivid/Smartlight festival. Image: Tom Barker.

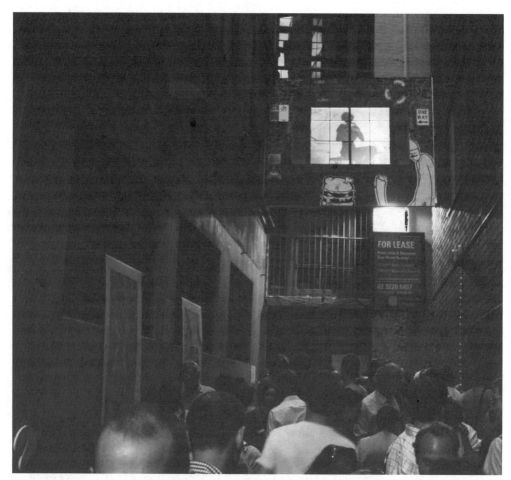

Figure 7: Rare window installation project in Temperance Lane, Sydney, 2010. A replica wall of a house with a window was constructed above a laneway. Video projection showed a couple acting out a range of domestic situations through the window. Part of the Grasshopper Bar launch. Image: Tom Barker.

Political will is usually necessary to support micro-interventions and to help overcome red tape and excessive health and safety zeal. A key challenge is how to avoid a culture of 'pop-up' spaces which can carry a similar burden of design, planning and execution as a permanent intervention. Permanence fosters a culture of contagious space activation which can be seen even with basic graffiti in cities, even if it is not always welcome. Digital technologies have great promise at this scale as prices fall and audiences become increasingly familiar with interactivity. A micro-urban renaissance in new media art could be one consequence.

Conclusion

In undertaking contemporary city design, architecture has increasingly embraced eclecticism but it is typically responsive to conditions rather than creating conditions. Such responsive urban design has emerged as a way of coping with rapid urbanization. Worryingly, at the other end of the spectrum there are many countries where a rational planning approach is resurgent as a consequence of the dash for growth, and an example is the near identical 'cookie-cutter' cities for one million-plus people that are springing up in China.

There are many factors that drive change and adaptation in cities, and these vary from place to place. Long-term trends that are influencing our cities include population growth, demographic change, transport congestion, living affordability, infrastructure development, productivity growth, climate change and ecological sustainability. These trends can place existing benefits and gains at risk and threaten to undermine the competitiveness and vibrancy of our cities. The issues are multi-nodal by nature and demand a significantly multidisciplinary research approach, offering the collective expertise as well as a broader range of research methods from across the relevant disciplines. Architecture is placed in the eye of the multidisciplinary storm.

The need now is for architecture to create context and this is a big change from responding to context. To do it effectively requires an approach that goes beyond the tradition of an architect supported by an army of consultants – an approach that has left architecture increasingly at the mercy of too many expert disciplines continuing to specialize to absurdity.

Achieving an urban renaissance is about affecting the convergence of social capital, cultural capital and economic capital. For this to be possible, the role of architecture and urban design needs to be at the nexus of art, craft and science. Now that we are entering an age of creative enterprise culture, the challenge for architecture and urban design is to embrace the complex role of urban facilitation at a deep and lasting level, catalysing our cities as the alchemy for creative enterprise.

Acknowledgements

The author wishes to thank Zaha Hadid Architects, the CRC bid team at RMIT for discussions and debate on city design, the UrbanAid team including Hank Haeusler, Carli Leimbach and Mike Prakash at the University of Technology Sydney and the Architectural Association's Design Research Laboratory.

References

Alexander, C., Neis, H. and Anninou, A. (1987), 'A New Theory of Urban Design', *STA Design Journal Analysis and Intuition*, Oxford: Oxford University Press, pp. 1–7.
Banham, R., Barker, P., Hall, P. and Price, C. (1969), 'Non-Plan: An experiment in freedom', *New Society*, 338, pp. 435–43.

Barker, P. (1999), 'Non-Plan Revisited: Or the real way cities grow', The Tenth Reyner Banham Memorial Lecture, *Journal of Design History*, 12: 2, pp. 95–110.

Barker T. (2011), 'The Masterplanning Toolbox: An early stage design tool for the synthesis and evaluation of multimodal complexities at a city scale for urban design conceptualisation', *4th World Conference on Design Research*, TuDelft, Holland, 31 October – 4 November, International Association of Societies of Design Research (IASDR).

Bourdieu, P. (1986), 'The Forms of Capital', in J. Richardson (ed.), *Handbook of Theory and Research for the Sociology of Education*, New York: Greenwood, pp. 241–258.

Carter, H. (2003), 'Glory of Greece, grandeur of Rome ... and docks of Liverpool – Buildings rated among world's treasures', *The Guardian*, Friday 7 March.

CIDS (2003), 'Renaissance City 2.0. Creative Industries Development Strategy', Ministry of Information, Communication and the Arts, Government of Singapore.

Coy, P. (2000), 'The Creative Economy', *Business Week*, 28 August, http://www.businessweek.com/2000/00_35/b3696002.htm. Accessed 12 February 2012.

DCMS (2010), 'Creative Industries Economic Estimates', Department of Culture, Media and Sport, UK Government.

Dodman, D. (2009), 'Blaming Cities for Climate Change? An analysis of urban greenhouse gas emissions inventories', International Institute for Environment and Development, *Environment and Urbanization*, 21: 185, pp. 188–90.

Florida, R. (2008), *Who's Your City?: How the creative economy is making where to live the most important decision of your life*, New York, NY: Basic Books.

Hall, P. (2000), 'Creative Cities and Economic Development', *Urban Studies*, 37: 4, p. 640.

Howkins, J. (2001), *The Creative Economy: How people make money from ideas*, London: Allen Lane.

Jacobs, J. (1961), *The Death and Life of Great American Cities*, New York: Random House.

Koolhaas, R. (1994), 'Thinking Big. Interview with Rajchman, J.', *Artforum* December, http://findarticles.com/p/articles/mi_m0268/is_n4_v33/ai_16547724/?tag=content;col1. Accessed 12 February 2012.

—— (1978), *Delirious New York: A retroactive manifesto of Manhattan*. New York, NY: Monacelli.

Mail Online (2011), 'China's Ghost Towns: New satellite pictures show massive skyscraper cities which are still completely empty', 19 June, http://www.dailymail.co.uk/news/article-2005231/Chinas-ghost-towns-New-satellite-pictures-massive-skyscraper-cities-STILL-completely-empty.html. Accessed 1 March 2012.

Price, C. (1999), *Re: CP. Birkhäuser Architecture*, Basel: Switzerland.

Santos, E. (2008), 'Creative Economy Report: The challenge of assessing the creative economy, towards informed policy making', UNHCR, Geneva: Switzerland.

Sudjic, D. (1993), *Hundred Mile City*, New York, NY: Mariner Books.

US Department of Commerce (2011), Bureau of Economic Analysis, Q1 data, http://www.bea.gov/. Accessed 1 August 2012.

Venturi, R. (2002), *Complexity and Contradiction in Architecture*, 2nd edn, New York: The Museum of Modern Art. First published 1966.

Chapter 4

The Place of the Urban: Intersections between mobile and game cultures

Larissa Hjorth
RMIT University

Introduction

The notion of mobility as a technology, cultural practice, geography and metaphor impacts on how twenty-first-century cartographies of the urban play out. Through the trope of mobility and immobility, rather than overcoming all difference and distance, the significance of local is reinforced. While nineteenth-century narrations of the urban were symbolized by the visual economics of the *flâneur*, the twenty-first-century wanderer of the informational city has been rendered by what Robert Luke calls the phoneur (2006). The conceptual distance and continuum between the *flâneur* and the phoneur is marked by the paradigmatic shift of the urban from being a geospatial image of and for the bourgeoisie; as opposed to the phoneur, which sees the city transformed into an informational circuit in which the person is just a node with little agency. Beyond dystopian narrations about the role of technology in maintaining a sense of intimacy, community and place, one can find various ways in which the tenacity of the local retains control over the technology. In particular, through the intersection between mobile media and games, it is evident that the local and the urban can be re-imagined in new ways.

A decade on from the 'mobility' turn in the humanities (Urry 2002), the conundrums facing mobility and immobility and the impact upon a sense of place and belonging persist. Far from mobile and social media eroding a sense of place and locality, the reverse has happened. The upsurge of enclaves and boundary-making has intensified (Turner 2007). New media has not afforded geography with an ability to transgress spatial and temporal boundaries globally; instead, it amplifies difference and distance. Unlike the Benedict Anderson notion of imagined communities (1983), in which the rise of print media informs the boundary of the nation-state and the decline of the local dialect, mobile and social media crave the situated and vernacular in their re-imaginings of place. Through social and mobile media 'imaging' practices, users perpetually create and redefine a sense of community and place – in short, 'imaging communities' (Hjorth 2009). In the re-imaginings of the city globally we see that place, as a notion that is geographic and physical as it is emotional and psychological, is being sketched increasingly through a diversity of ways that impact upon how art and cultural practice is conceptualized.

This chapter reflects upon the paradox of urban mobility – locating the mobile – through the role of mobile urban gaming. As a genre that has taken various forms and draws from numerous histories such as interactive fiction, hybrid reality and live action role playing

(LARP), mobile gaming creates the potentiality of play as an art form that transforms urban spaces into play places (de Souza e Silva and Hjorth 2009). By traversing online and offline spaces simultaneously through haptic screens, the possibilities for mobile gaming to inform new ways of experiencing place physically, technologically, emotionally and psychologically is endless. Mobile games reinforce the importance of place in producing particular cultural knowledge. They also highlight the significance of co-presence – online and offline, here and there, virtual and actual – in informing tacit and intimate knowledge in the overlaying of community onto place.

With the burgeoning of networked and ubiquitous technologies, there is a redefining of the ways that place and locality are experienced. Mobile, networked technologies not only transform how place in everyday life is understood, they also emphasize place as being more than just physical geographic location. More importantly, places are constructed by an ongoing accumulation of stories, memories and social practices (Massey 1993, 2005; Harvey 2001; Soja 1989). This is particularly the case within the realm of urban mobile gaming, which seeks to challenge everyday conventions and routines that shape the cityscape.

A decade on from the first generation of mobile games taking the form of high-tech, experimental performances through the likes of UK Blast Theory's collaboration with Mixed Reality Lab, smartphones are heralding a ubiquity of location-based services (LBS) and Global Positioning Systems (GPS) that effect and affect the narrations of place. These new media services are providing multiple cartographies for an experience of space in which the geographic and physical is overlaid with the electronic, emotional and social. With the pervasiveness of geomedia seeing a type of gamification through services like foursquare, which is an online mobile game where you can win prizes for visiting offline places, mobile gaming is seeing a new epoch in the ways in which it can transform the urban space. But with the democratization and gamification of geo-spatial services on mobile phones, how does this phenomenon revise the narration of place and locality? How do these types of media practice differ from the first generational experimental new media projects? This chapter contextualizes the rise of urban mobile gaming within broader conceptual approaches to the urban and to mapping a sense of place. The discussion concludes with a case study of second generation, or gamification, of LBS games in Shanghai, China to explore some of the socio-cultural factors at play.

Locating the Mobile: Conceptualizing approaches to mobile urban gaming

Once associated with casual flash-based games (2D graphics) on mobile phones or early generation mobile consoles such as Game & Watch or Game Boy, mobile games have now grown and developed into a variety of innovative game genres. These genres include urban ('big games'), location-aware (LAMG)/location-based (LBMG) and hybrid reality games. For the purposes of clarity in this chapter, 'mobile games' refers to all these different and diverse types of games and gaming practices. Moreover, while there has been development

around rural mobile games that can be viewed as extensions of live action role-playing (LARP) traditions, this discussion focuses upon the urban in keeping with the context of this book. Through advances in ubiquitous technologies, the rise of urban mobile games has been encouraged by ready access to geomobile applications that are available on most new mobile phones (third generation [3G] or 'mobile with internet'). The various types of geomobile software provide new ways of experiencing and defining the urban, thereby transforming the familiar and everyday into new and exciting possibilities of play (Jungnickel 2004; de Souza e Silva and Hjorth 2009), as well as rendering the mobile phone user into either a player or a game maker.

Apart from the obvious rapid expansion of mobile game applications for networked mobile media like the iPhone, mobile gaming has also expanded into other avenues for exploration and experimentation outside mainstream markets. In particular, location-aware mobile gaming, such as *Pac-Manhattan* (this urban game transforms the streets of New York into a retro-1980s game) or the pioneering work conducted by UK collaborative group, Blast Theory, has seen the emergence of types of games that reflect new possibilities for play between online and offline spaces. Location-aware and hybrid reality mobile games highlight that urban spaces, and movement through them, can be inherently playful (de Souza e Silva and Hjorth 2009), a feature that often has been forgotten in video games (Mäyrä 2003). This oversight has begun to be addressed through the rise of sandbox and mobile games that seek to locate the social and community through a sense of place. In particular, location-aware and hybrid reality mobile gaming has grown. This creates new possibilities for play between online and offline spaces. With the ability to negotiate simultaneously various online and offline spaces, along with senses such as the haptic (touch), mobile urban gaming is transforming how we think about gaming, play and mobility.

With this recent and quickly-changing field of research there is a need to conceptualize some of the ways in which urban mobile gaming is being discussed and contextualized in recent commentary on gaming. Some approaches have argued that play within urban spaces can be understood most clearly with reference to three historical analogies (de Souza e Silva and Hjorth 2009). Firstly, there is the transformation from the nineteenth-century formation of Charles Baudelaire's *flâneur* (the wanderer of the modern city) into what Luke (2006) calls the 'phoneur' (the user as part of the informational network flows constituting contemporary urbanity). The *flâneur*, best encapsulated by German philosopher Walter Benjamin's (1999) discussion of Baudelaire's writing, has been defined as an important symbol of Paris and modernity as it moved into nineteenth-century urbanity. Thanks to the restructuring of one-third of the small streets into boulevards by Baron Haussmann, Paris of the nineteenth century possessed a new sense of place and space.

If the *flâneur* epitomized modernism and the rise of the nineteenth-century urban, then, for Luke (2006), the phoneur is the twenty-first-century extension of this tradition as the icon of modernity. As Luke observes, in a networked city one is connected as part of circuit of information in which identity and privacy is at the mercy of the system. The picture of the urban city today painted by Luke is one in which the individuals have

minimal power in the rise of corporate surveillance. Sites such as www.pleaserobme.com, that seek to raise awareness about over-sharing of personal data, highlight not only the localized nature of privacy but also that privacy is, as Paul Dourish and Ken Anderson (2006) observe, something we do rather than something we possess. The notion of privacy and what constitutes the public online differs according to location (Goggin and Hjorth 2009). This also identifies that what constitutes 'participation' is also a localized and relative concept.

According to de Souza e Silva and Hjorth (2009), a second analogy that can be drawn on to understand gaming in urban space is to make reference to the 1960s' Situationist International (SI) subversive activity of the *dérive*. For Guy Débord (1977), *dérive* is a type of drifting through a geographic space that radically revises the usual motives and actions one generally uses while moving through urban spaces. This invention was an important strategy to challenge the increasing commercialization that Débord viewed within everyday Parisian life. By disrupting naturalized notions of place, the *dérive* rewrites the experience of the city. In an extension of the *dérive*, contemporary urban mobile games can also be viewed as converting and altering the urban and the everyday.

Finally, de Souza e Silva and Hjorth suggest that we might understand contemporary mobile urban gaming by drawing an analogy with the spirit and practice of the contemporary, French, sub-culture, called 'Parkour'. Invented by David Belle in a revision of martial art and military moves, Parkour sees the city as a series of physical obstacles to be overcome. The art of Parkour, through the act of the 'traceur' (the person doing Parkour), can be a mode for new ways of experiencing a city and its temporal spatiality. These new exercises of the urban challenge conventional notions of urban cartographies and bounded spaces. The radical re-inscription and rewriting posed by urban mobile games parallel and enact Parkour through mobile media technologies. Through contemporary examples of urban games, LBGM and hybrid reality games, much can be learnt about changing definitions and experiences of the urban, mobility and a sense of place (de Souza e Silva and Hjorth 2009).

By way of contrast with these three analogies that focus on the physical spaces of the city, other researchers have emphasized the interaction between the senses and media technologies. One way of comprehending these new economies of screen engagement is through conceptualizing the visual cultures of the twentieth century in the light of twenty-first-century haptic screen cultures. For Chris Chesher, gaming is not an engagement of the gaze, nor the glance, but rather somewhere in between: what he characterizes as the 'glaze' (2004). According to John Ellis (1982), twentieth-century media, like TV or film, were predicated on types of 'packaged media' engagement in which TV was ordered around the domestic engagement of the 'glance', whereas film deployed the gaze (Ellis 1982). While TV's small screen is ordered around the distraction of the domestic as a continuum of radio's mode of address (hence 'radio with pictures'), film – with its larger than life images – set in the context of a dark, semi-public room, is focused upon the all-consuming gaze. TV produced celebrities (branded, familiar people) while film produced the distant and aura-inspiring stars. Ellis argued that the framing of TV as film's poorer cousin did so by

privileging the visual – a comparison that is not only counterproductive but also fails to address the significance of the aural in screen cultures.

Chesher takes this paradigm further by engaging the notion of the haptic into the discussion. Chesher argues that games call upon an in-between form of sensory experience, 'the glaze' (2004). As a conflation between the gaze and the glance, games straddle and remediate older media practices through their interactive, conversational form. Identifying three types of glaze spaces – the 'glazed over' (game immersion), 'sticky' (holding the player within a visceral immersion that is hard to interrupt) and 'identity-reflective' (whereby the player can multitask, slipping between game and other worlds) – Chesher argues these three 'dimensions' of the glaze move beyond a visual orientation, also drawing on the other senses such as aural (hearing) and haptic (touch). For example, console games are sticky: they hold the player to the screen via a visual link to a virtual space, while also emphasizing that link with a haptic attachment to the hand-controller and peripherals. Casual gamers must deliberately avoid this 'stickiness' so that they are perpetually ready to resume their temporarily interrupted activities. These different modes of engagement come into further question and expansion via urban mobile games. Indeed, there is still much to be elaborated upon within this area of research (de Souza e Silva and Sutko 2009).

The sensibilities of the phoneur, of *dérive* and of Parkour, and the new media practices of the glaze, come together in innovative mobile urban games-as-art (Flanagan 2009). Much of the first generation experimentation and exploration of mobile media artwork from the late 1990s onwards has taken the form of hybrid reality and LBGM (de Souza e Silva 2006; Davis 2005) as they challenge the role of co-presence and everyday life; forging questions around the boundaries between the virtual and actual, online and offline, haptic (touch) and cerebral (mind), delay and immediacy (Hjorth 2008, 2009a). Examples include the *Pac-Manhattan* (US), Proboscis's *Urban Tapestries* (UK), *Blast Theory* (UK), *Aware* (FIN), *Mogi* game (JP) and INP's (Interactive and Practice) *Urban Vibe* (SK). In these projects we can gain insight into some of the possibilities of games: to challenge our sense of place and play. These projects also highlight the relationship between games studies and new media discourses – a synergy exemplified by work of Mexican new media artist, Rafael Lazano Hemmer. The next section briefly outlines different forms of urban mobile gaming and then turns to a case study of second generation LBS games.

The Game of Being Mobile: Types of mobile games

While the burgeoning of haptic technologies in networked mobile media such as the iPhone may seem recent, they actually have their basis in experimental urban mobile games genres such as LBMG and pervasive gaming. In this section I investigate some of the various types of urban mobile gaming. As an area often dubbed 'urban games', 'pervasive games' or 'location-aware' gaming, mobile games such as LBMG/LAMG involve the use of GPS that allows games to be played simultaneously online and offline. For expert Mäyrä (2003),

gaming has always involved place and mobility, and yet it is precisely this key feature that is missing in most current videogames, especially single player genres. Mäyrä points to the possibilities of pervasive (location-aware) gaming as not only testing our imagination and creativity but also questioning our ideas of what constitutes reality and what it means to be co-present and virtual. By using both online and offline spaces, pervasive games can offer new ways of experiencing place, play and identity. In this section, I explore the three main areas of urban mobile games through some examples. I begin with urban games (big games), then go on to consider location-based/location-aware games (LBGM, LAGM). These types of games can also be conceptualized as extensions of such genres as interactive fiction (IF) and live action role playing (LARP). For the purposes of this chapter, the focus is on the intersections between big games, hybrid reality and location-based games.

Big Games

The notion of 'big games' does not so much relate to the game pieces often being gluttonous in size but, rather, it has more to do with the role of people and the importance of place in the navigation of co-presence in urban spaces. These projects serve to remind us of the importance of locality and its relationship to practices of co-presence. Co-presence can entail people being in different spaces and states simultaneously, which is a phenomenon that ICTs help further extend. The potentiality of 'big games' to expose and comment on the practices of co-presence by traversing virtual and actual, here and there in contemporary media cultures has gained significant attention. Big games highlight some of the key forms of co-presence of everyday life that have been exemplified in mobile media projects such as location-aware gaming. The forms of co-presence include virtual and actual, online and offline, cerebral and haptic, delay and immediacy.

A New York-based game designer who has been involved in such pivotal projects as *Pac-Manhattan*, Lantz (2006) argues that location-aware mobile gaming, or 'big games', will play a pivotal role in the future of gaming. Big games are, for Lantz, 'large-scale, real-world games that occupy urban streets and other public spaces and combine the richness, complexity and procedural depth of digital media with physical activity and face-to-face social interaction' (Lantz 2006: n.p.n.). As Lantz notes, the precursors to big games were undoubtedly the art movements of the 1960s, such as Happenings (impromptu art events in public spaces) and the Situationist International (SI) tactics of the *dérive*, which served to interrupt everyday practices. He, as does Mary Flanagan (2009), signposts the significance of the US version of the SI in the form of New Games Movement. In response to the Vietnam War and the dramatic social and political changes of the 1970s (such as the energy crisis, civil rights and feminism), Stewart Brand and others established the New Games Movement. This movement, paralleled by environmental art projects such as Buckminster Fuller's *World Game* (1961, 1964, 1967), Robert Smithson's *Spiral Jetty* (1970) and Christo's *Valley Curtain* (1970), highlights the importance of role play and games in political commentary and change.

Alternatively, the development of urban mobile games can be compared to the trend in contemporary art from the 1990s that French curator and critic Nicolas Bourriaud dubbed 'relational aesthetics' (2002). As Bourriaud observed, 'relational aesthetics' dominated the international art scene from the 1990s onwards and emphasized locality, the de-institutionalization of installation and the 'international', in favour of the vernacular and local. These factors of the vernacular and local are central in the practice of urban mobile games. Urban games use the city space as the game board by offering multiplayer games that are played out in the streets and city. Three projects that exemplify big games are *B.U.G (Big Urban Game)*, *Pac-Manhattan* and *Shoot Me If You Can*. In each example, the urban space is transformed into a place for play. Play cultures are local cultures (Sutton-Smith 1997).

Location-based Mobile Games

Location-based mobile games (LBMGs) are games played with mobile phones that are equipped with location awareness (e.g. GPS) and Internet connection. Like urban games, LBMGs use the urban space as their game space. But, unlike urban games, LBMGs add the factor of location-aware interconnectivity between players, as well as the linking of information to places. Although LBMGs might have an online component, the game takes place primarily in the physical space. Players can see each other and/or virtual game elements on their mobile screen. Two examples of LBMGs are *CitiTag* and *CitySneak*.

Hybrid Reality Games

Hybrid reality games (HRGs) draw from urban games and LBMGs, transforming the city into the game canvas through player interaction in a physical space. However, the key difference is that HRGs have a 3D virtual world component that corresponds with the physical space. The shared game experience among multiple users is what creates the hybrid reality. As urban mobile gaming expert de Souza e Silva (with Daniel Sutko 2009) notes, hybrid reality games have three main characteristics: (1) they are mobile, (2) they are multi-user and (3) they create a new gaming spatial logic that circumnavigates physical and virtual spaces simultaneously. A pioneering group for HRG is Blast Theory. Key projects such as *Can You See Me Now?* and *I like Frank* were initiated at The University of Nottingham's Mixed Reality Lab in 2001, and continued to be played in different contexts. Blast Theory forged ahead with state-of-the-art new media technologies in collaboration with the Mixed Reality Lab. More recently, and no longer working with Mixed Reality Lab, Blast Theory's projects have involved less technological prowess, and have played up more of the serious dimensions of game play in terms of complicacy. In Blast Theory's recent project entitled *Ulrike and Eamon Compliant* (2009), players become involved and compliant in an event in which someone supposedly dies. In this project, there is no such

thing as an innocent bystander (or spectator). In Korea, INP took many of Blast Theory's experimentation onto the streets of Seoul through their project at new media art centre, Nabi, called *Urban Vibe* (2006).

Finally there was *Mogi*, the first commercial HRG. Released in Japan and developed by NewtGames from 2003 to 2006, *Mogi* deployed mobile phones (*keitai*) equipped with GPS or cellular positioning. Using the player's relative position in physical space to construct a game space in Tokyo, the aim of *Mogi* was to collect virtual creatures and objects, spread out in the city, with the cell phone, in order to form a collection. Players could collect these virtual objects and creatures when they were within 400 meters of them. Additionally, these collected virtual artefacts could be exchanged between players. In 2004, *Mogi* had 1,000 active users who paid just under two dollars a month to subscribe, amounting to over 70,000 objects collected and messages sent during the first year. While users could log in anytime, the 'hunt time' generally occurred during the day, from 7am to 6pm, while the mail and trade peak occurred after 8pm (Licoppe and Guillot 2006; Licoppe and Inada 2006). In *Mogi*, the phoneur gameplay tactics help to rediscover the role of community in informing a sense of place. Now, this discussion turns to an example of second-generation LBS games through a case study in Shanghai.

Games We Play: A case study of LBS game in Shanghai, China

By deploying both older gaming methods like geo-caching and drawing on established genres like Interactive Fiction (IF), Alternative Reality Games (ARG) and Live Role Playing Games (LARGs), while also utilizing new media to create hybrid realities across online and offline spaces, urban mobile gaming has been important in informing current gaming features that are mobile, social and serious. While the first generation of urban mobile games was often used for 'serious' outcomes such as education, in its current mutation there is evidence of the serious taking a back seat to the mobile and social elements; for example, in geomedia like Foursquare.

With the rise of geomedia services like Foursquare and Jie Pang (China), the parameters of urban mobile gaming, especially around the experiential and experimental types, is changing. In Jie Pang, users can 'check in' their location so others can see where they are and what they are doing. Users are encouraged to log in through prizes and awards. However, while the prize element might have first enticed them to join the LBS, often issues like socializing, *quanxi* (Chinese social capital) and documenting journeys provide key motivations for ongoing use. Given the mainstreaming of mobile games from the first generation already outlined to more recently forms of gamification, this chapter will now briefly visit one example in Shanghai, China.[1] The importance of the LBS, like all mobile games, is that location informs types of sociality and attendant game play.

China's role globally in the production and consumption of ICTs (Information and Communication Technologies) has been most evident within the twenty-first century

through the deployment of mobile phones (Robison and Goodman 1996; Wallis 2011) and the Internet as sites for contestation and technonationalism (Damm and Thomas 2006). In the case of mobile phones, they have had both material and immaterial dimensions and implications within the changing formations of Chinese technocultures. As Jack Qiu's studies (forthcoming) vividly identify, behind the role mobile phones play as commodities is another side – mobile phone production and its reflection of China's new working class in cities. In the case of the iPhone production, Qiu discusses the barbaric working conditions of Foxconn, home for much of Apple's production. The mobile phone in general has provided much fuel as a symbol for and of the growing migrant working class and, paradoxically, the new middle class. Images of the female Chinese iPhone production worker have become iconic of new aspirations within emergent digital cultures (Perlow 2011).

Within the broader Chinese mediascape, it is the *ba ling hou* generation that has dominated the usage of much of social media and geomedia. The exception is QQ, which is deployed by both young and old in rural and urban settings. The contextual background to the *ba ling hou* and their specific media practices shows that the *ba ling hou* are the first generation to grow up with China's Internet and mobile technologies. Born between 1980 and 1989, they are often from one-child families and have a distinctively close relationship with their parents. This translates into their media practices. While social media games, like Happy Farm, are played by young and old, geosocial media like Jie Pang are a distinctive practice of the *ba ling hou*.

In surveys conducted in mid 2011 with 20 Jie Pang users from the *ba ling hou* generation, what emerged was that, for many, the main motivation for Jie Pang use was to record the places they went to, for both themselves (i.e. as an *aide-mémoire*) and also in order to share this information with their friends ('networked memorialization'). According to 'Ai' (female, aged 25), Jie Pang use was in order 'to record where I go to everyday. It's like a diary with location.' The other respondents shared Ai's sentiment; with many expressing the view that recording locational information via Jie Pang was both for their own and others' benefit. According to 'Bai' (male, aged 27), he used Jie Pang primarily to 'record where I had been' and to have this information 'synchronized to social networks such as Weibo to share with my followers'. Others did not record every location they visited; rather they used Jie Pang only for those occasions when they went to new places.

One of the ways to create an intimate public, so only one's friends could view Jie Pang 'check-ins', was to check in through a Social Networking System (SNS) like Renren. This technique was deployed by most of the respondents as a way to foster some form of privacy and to make sure that the overlay between geographic and electronic co-presence was done so within the context of friends or *quanxi*. It is clear that Jie Pang brings together co-presence, place and mobility in ways that infuse them with social capital significance.

Ai observed more females than males using Jie Pang, especially in terms of everyday practices which linked this use with that of camera phone picture-taking. She put this down to the fact that, in her opinion, 'guys usually don't want to share or record this' sort of mundane, everyday information. When asked if she worried about people knowing

where she was, given that issues of surveillance are particularly important for female users, Ai responded, 'yes, to some extent. So that's why I choose [carefully] which SNS platform to synchronize with my check in.' For this respondent, like the other female respondents surveyed, she uses Jie Pang 'every new place I go to every day' and in order 'to note my footprint'. While she began using Jie Pang as a novelty to play with friends and 'to win the virtual badge', as was the case with others surveyed, her motivation soon changed to one that carried far greater significance as part of her everyday diarization and narrations of place which interwove her geographic and electronic footprints.

For Bai, Jie Pang was important in recording and archiving his activities and journey. Through the game space, Bai was reworking the urban through his own cartographies of experiences. Unlike Ai, Bai did not record each place he went to everyday, just a few highlights. Here we see the way in which gender inflects the ways in which Jie Pang relates to ongoing endeavours in narrating the everyday. Bai viewed Jie Pang as a tool for showing where he was when he wanted people to know. Sometimes the checking in on Jie Pang was accompanied by taking pictures of the place, an activity Bai definitely viewed as gendered, stating, 'usually females would spend more time on it than men, and take more photos'. Both these informants noted that recently there had been a growth in different LBS on smartphone and PC platforms and that groups of friends would use similar ones. In short, the deployment of the LBS reflected the *quanxi*.

For Baozhai (female, aged 26), as with the other respondents, Jie Pang provided an innovative way to narrate one's journey that combined a sense of place and networked sociality. She noted that surveillance was an issue and this sometimes led her to not use the service. Even so, Baozhai would use Jie Pang in a variety of locations, including 'at the airport to track my flight records', and, 'when I go to some supreme restaurants or hotels which I rarely go to'. When asked about whether she could imagine ever checking in at every place that she went to, she replied that such a feat would be 'impossible'. Moreover, 'some routine places like home or company are not worthy checking in'. Here, the choice of words 'not worthy' is important.

Jianjun (male, aged 27) used Jie Pang to 'check in at some cool places and share [these] with my friends'. This was especially so if he was to go to a 'new cool place, a meaningful place [as well as] some places with medals'. Unperturbed by worries about surveillance or privacy, Jianjun viewed Jie Pang's role as essentially a way of sharing and being co-present with friends. As Jianjun puts it, 'when I choose to use Jie Pang that means I would love to share these [places and experiences] with my friends'. Jianjun noted that most of his friends were using Jie Pang: 'In my opinion, Jie Pang is a tool for fun and interaction with friends, since you can connect your Jie Pang account with Kaixin, Renren and Sina microblog (only my friends can see my check-ins).'

Beyond the hype of Jie Pang as a first generation commercial mobile LBS game, it is apparent that respondents are using geosocial applications as a meaningful part of everyday practice. The electronic is overlaid with the socio-emotional and geographic in ways that both rehearse older practices of socio-spatial connectivity while simultaneously creating new social geographies. Particularly interesting is the way that these cartographies are often

gendered in their deployment, with males and females using Jie Pang in different ways to map their socio-emotional practices onto everyday coordinates. While being informed by factors such as gender, age and class, geomedia such as Jie Pang also signal emergent types of connected presence and ambient intimacy. By overlaying the socio-emotional with the geographic and electronic, geomedia suggests new ways in which the urban is being narrated through micronarratives of the LBS.

Conclusion: The haptically-mobile in games

This discussion has explored the various ways in which urban mobile gaming has emerged as a dominant form of practice in rewriting the intersections between gaming, new media, play, and place. As shown, urban mobile games are re-imagining how the urban is conceptualized and experienced. With three genres – urban gaming (or big games), LBGM/LAGM and hybrid realities – urban mobile gaming can help to relocate a sense of place that is missing in many video games. They offer a chance to transform an urban setting into a game space, demonstrating that urban spaces are inherently playful (de Souza e Silva and Hjorth 2009). This discussion was followed with a case study of the LBS, Jie Pang, in Shanghai to see how users are feeling about their relationship between memory, sociality and place. While in its infancy, these games will no doubt impact upon how the urban is narrated in the twenty-first century.

Far from eroding a sense of home and kinship ties, mobile technologies are reinforcing notions of locality and place. Indeed mobile, networked technologies under the rubric of mobile media not only transform how place is experienced in everyday life, they also highlight that place is more than just physical, geographic notion. In urban settings across the world, mobile technologies are reflecting local, situated and vernacular re-imaginings. Thus, despite the burgeoning of numerous forms of mobility – geographic, technological, socio-economic and physical – as part of global forces, mobile media are helping to facilitate the significance of place (Hjorth 2005). That is, place as a space that is not only geographic and physical, but evokes cartographies of the imaginary, emotional, mnemonic and psychological. As LBS and GPS become more pervasive in urban contexts, the way in which place is narrated, experienced and conceptualized will change. Through mobile games the possibilities and limits of what it means to be a phoneur can be learnt, which in turn re-imagines the place of urbanity.

References

Anderson, B. (1983), *Imagined Communities: Reflections on the origin and spread of nationalism*, London: Verso.
Benjamin, W. (1999), *The Arcades Project*, R. Tiedmann (ed.), (trans. H. Eiland and K. McLaughlin), Cambridge, Mass.: Harvard University Press. First published 1927.

Blast Theory (2005), 'Can You See Me Now?', http://www.blasttheory.co.uk/bt/work_cysmn. html. Accessed 8 November 2005.

Bourriaud, N. (2002), *Relational Aesthetics*, (trans. S. Pleasance and F. Woods), Dijon: Les Presses du Réel. First published in French 1998.

Chesher, C. (2004), 'Neither Gaze nor Glance, but Glaze: Relating to console game screens', *SCAN: Journal of Media Arts Culture*, 1: 1, http://scan,net.au/scan/journal. Accessed 10 February 2007.

Damm, J. and Thomas, S. (2006), 'Chinese Cyberspaces: Technological changes and political effects', in J. Damm and S. Thomas (eds), *Chinese Cyberspaces*, London and New York: Routledge, pp. 1–11.

Davis, A. (2005), 'Mobilising Phone Art', *RealTime*, http://www.realtimearts.net/article/issue66/7782. Accessed 20 August 2005.

Debord, G. (1977), *The Society of the Spectacle*, (trans. Fredy Permian and Jon Supak), London: Black and Red. First published 1967.

de Souza e Silva, A. (2006), 'Re-conceptualizing the mobile phone: From Telephone to collective interfaces', *Australian Journal of Emerging Technologies*, 4: 2, pp. 108–27.

de Souza e Silva, A. and Hjorth, L. (2009), 'Playful Urban Spaces: A historical approach to mobile games', *Simulation and Gaming*, 40: 5, pp. 602–25.

de Souza e Silva and Sutko, D. (eds) (2009), *Digital Cityscapes*, Berlin: Peter Lang.

Dourish, P. and Anderson, K. (2006), 'Collective Information Practice: Exploring privacy and security as social and cultural phenomena', *Human-Computer Interaction*, 21: 3, pp. 319–42.

Ellis, J. (1982), *Visible Fictions*, London: Routledge and Kegan Paul.

Flanagan, M. (2009), *Critical Play: Radical game design*, Cambridge, Mass: MIT Press.

Goggin, G. and L. Hjorth (2009), 'Waiting for Participate: An introduction', *Communication, Politics & Culture*, 42: 2, pp. 1–5.

Harvey, D. (2001), *Spaces of Capital: Towards a critical geography*, New York, NY: Routledge.

Hjorth, L. (2009), 'Imaging Communities: Gendered mobile media in the Asia-Pacific' *Japan Focus: The Asia-Pacific Journal*, http://japanfocus.org/-Larissa-Hjorth/3064. Accessed 12 January 2011.

——— (2008), 'The game of being mobile: one media history of gaming and mobile technologies in Asia-Pacific', in J. Wilson and H. Kennedy (eds), *Convergence: The international journal of research into new media technologies* Games issue, 13: 4, pp. 369–81.

——— (2005), 'Locating Mobility: Practices of co-presence and the persistence of the postal metaphor in SMS/MMS mobile phone customization in Melbourne', *Fibreculture Journal*, 6, http://journal.fibreculture.org/issue6/issue6_hjorth.html. Accessed 10 December 2006.

Jungnickel, K. (2004), *Urban Tapestries: Sensing the city and other stories*, http://proboscis.org. uk/publications/SNAPSHOTS_sensingthecity.pdf. Accessed 10 September 2009.

Lantz, F. (2006), 'Big Games and the Porous Border between the Real and the Mediated', *receiver* magazine 16, http://www.receiver.vodafone.com/16/articles/index07.html. Accessed 10 February 2007.

Licoppe, C. and Guillot, R. (2006), 'ICTs and the Engineering of Encounters: A case study of the development of a mobile game based on the geolocation of terminal', in J. Urry and M. Sheller (eds), *Mobile Technologies of the City*, London: Routledge, pp. 152–176.

Licoppe, C. and Inada, Y. (2006), 'Emergent Uses of a Location Aware Multiplayer Game: The interactional consequences of mediated encounters', *Mobilities*, 1: 1, pp. 39–61.

Luke, R. (2006), 'The Phoneur: Mobile commerce and the digital pedagogies of the wireless web', in P. Trifonas (ed.), *Communities of Difference: Culture, language, technology*, Palgrave: London, pp. 185–204.

Massey, D. (2005), *For Space*, London: Sage.

———— (1993), 'Questions of Locality', *Geography* 78, pp. 142–9.

Mäyrä, F. (2003), 'The City Shaman Dances with Virtual Wolves – Researching pervasive mobile gaming', *receiver* magazine 12, www.receiver.vodafone.com. Accessed 20 May 2005.

Perlow, S. (2011), 'On Production for Digital Culture: iPhone Girl, electronics assembly, and the material forms of aspiration', *Convergence: The International Journal of Research into New Media Technologies*, 17: 3, pp. 245–69.

Proboscis (2007), 'Public Authoring in the Wireless City', in K. Jungnickel, *Urban Tapestries*, http://urbantapestries.net/. Accessed 20 June 2008.

Qiu, J.L. (2012), 'Network Labor: Beyond the shadow of Foxconn', in L. Hjorth, J. Burgess and I. Richardson (eds), *Studying Mobile Media: Cultural technologies, mobile communication, and the iPhone*, New York: Routledge, pp. 173–189.

Robison, R. and Goodman, D.S.G. (eds) (1996), *The New Rich in Asia*, London: Routledge.

Soja, E. (1989), *Postmodern Geographies: The reassertion of space in critical social theory*, New York, NY: Verso.

Sutton-Smith, B. (1997), *The Ambiguity of Play*, London: Routledge.

Turner, B. (2007), 'The Enclave Society: Towards a sociology of immobility', *European Journal of Social Theory*, 10: 2, pp. 287–303.

Urban Vibe (2005), *Nabi Media Centre*, http://eng.nabi.or.kr/project/view.asp?prjlearn_idx=119. Accessed 28 May 2008.

Urry, J. (2002), 'Mobility and Proximity', *Sociology* 36: 2, pp. 255–74.

Wallis, C. (2011), '(Im)mobile Mobility: Marginal youth and mobile phones in Beijing', in R. Ling and S.W. Campbell (eds), *Mobile Communication: Bringing us together and tearing us apart*, New Brunswick: Transaction books, pp. 61–81.

Note

1 This case study is part of a broader three-year Australia Research Council Discovery project that explores online communities in the Asia-Pacific region from 2009–2012 (DP0986998). Through focus groups, surveys and in-depth interviews, this project seeks to investigate the role of the online in relation to offline practices of intimacy and community.

Section II

Transforming Spaces and Experiences of the City

Chapter 5

Driving the Sonic City

Kristen Sharp
RMIT University

We have had enough [of Beethoven et al.], and we delight much more in ... the noise of
trams, of automobile engines, of carriages, and brawling crowds.

Luigi Russolo, Art of Noises, 1913

W ith his manifesto, Luigi Russolo articulates a shift towards a celebration of the
sonic properties of the modern city in place of conventions of musical composition.
Russolo and the Futurists embraced the noise created by new technologies of
communication and transport: the tram, the electric light, and the motorcar. They
acknowledged the rapid transformations of urban space that were being encountered in the
early twentieth century, mediated through new technologies and triggered by industrialization.
These continual changes created significant impact on how urban space was experienced, not
the least of which was through new bodily encounters with place, machinery and new sonic
environments.

The peculiar sounds of transit are the signature tune of modern cities. These are sounds
that remind us the city is a sort of machine. The diesel stammer of London taxis, the
wheeze of its buses. The clatter of the Melbourne tram. The two-stroke sputter of Rome.
The note that sounds as the doors shut on the Paris metro, and the flick, flick, flick of the
handles. The many sirens of different cities.

(Tonkiss 2003: 306)

In the twenty-first century, a new form of globalized urbanization is occurring, creating a
different set of sonic urban conditions even though transport and communication
technologies of the early twentieth century remain present. The resulting transformations in
the contemporary city are characterized by new spaces, events, and relationships, including
encounters with different sensory environments and experience of place.

One hundred years after Russolo, two Japanese sound artists, Yasuhiko HAMACHI and
Yukihisa NAKASE (known collectively as Rogues' Gallery), continue the fascination with
the sonic experience of urban technologies and spaces. Driving a 1991 Citroën XM-X,
containing specialized audio equipment designed to amplify engine and general car noise,
Rogues' Gallery create a site-specific kinaesthetic experience of travelling in a car in their
performance work *Gasoline Music and Cruising* (1994-ongoing). Not only do they offer an
exhilarating, immersive and affective encounter with sound, machine and space but Rogues'
Gallery also create a new way to think about locative experiences of place.

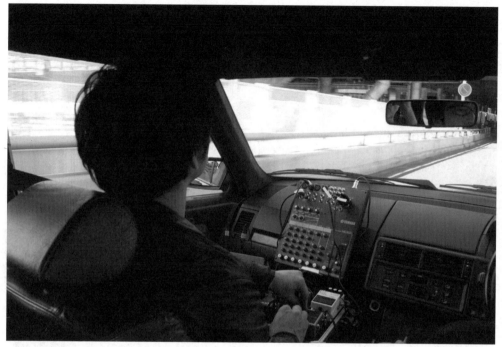

Figure 1: Rogues' Gallery performance, Osaka, October 2011. Image: Kristen Sharp.

The following chapter explores the way that Rogues' Gallery, and specifically *Gasoline Music*, construct encounters between the body, motion, speed and the sonic and visual topologies of urban space. Far from revealing driving as a homogenous, banal and featureless activity Rogues' Gallery highlight the heterogeneity and nuances of urban mobility. The work of Rogues' Gallery reveals art as a transformative practice that enables a re-imagining of the everyday spaces of the city. *Gasoline Music* draws attention to the multiple and complex spatial interactions that define urban spaces which are mediated by technologies, such as the car, and are experienced in and through the body.

The City and the Car

The car has been a critical trope of the urban cultural experience throughout the twentieth and twenty-first centuries. A condensation of speed, mobility and technology, the car has been a key mediator in the cultural, material, political and economic landscape of twentieth- and twenty-first-century cities (Urry 2004). The car has featured as both a utopic and dystopic object in discourses of urban space and modernity. As an object of pleasure, of freedom and autonomy, of speed and of technological progress, the car can be located in

sweeping visions of the urban environment, such as Le Corbusier's *L'Urbanisme* (1924). His aerial highways imagine cities defined by their smooth, speedy mobility and uninterrupted flows. Conversely, the car is simultaneously centralized as a site of environment degradation, of death and accident, of excessive use of manufacturing resources, of the banality and wasted time generated through commuting and urban sprawl.

From Jacques-Henri Lartigue's (French, 1894–1986) early photograph of the Grand Prix (1912) to J.G. Ballard's *Crash* (1974) exploring the relationship between the human body and machine, the car has been a continuous presence in representations of the urban in art and visual culture. Despite this, it has remained an unusual omission in discussions of modern and contemporary urban cultures until recently. Driving offers rich territory for the investigation of sociological patterns, subjectivities and experiences of the city.

The early-twentieth-century avant-garde, such as Russolo and the Futurists, celebrated machine and mobility. This remains the exception. More often, driving (and by association the car) is commonly dismissed as a banal, de-sensitized and de-socialized activity (Augé 1995; Sennett 1994), which is pejoratively associated with urban sprawl and commuting (Banham 1971; Relph 1976). Over the past ten years, the absence and criticism of the car has been re-addressed in urban theory (Featherstone, Thrift and Urry 2005; Miller 2001; Sheller and Urry 2000; Urry 2004), offering a counter-point to the critique of automobility. These urban geographers offer a more complex view of cars and car culture as important components of twenty-first century urban experience. Of particular note, Nigel Thrift (2004), Peter Merriman (2004) and Iain Borden (2010) allow for recognition of the embodied engagement of driving with space and place.

Yet, with a few notable exceptions (Edensor 2003; Bull 2004; Sheller 2004; Thrift 2004), the experience of driving (or being driven) is primarily discussed as a visual experience. Anne Friedberg argues that 'the automobile is a viewing machine', and links driving to other forms of spectatorship in cinema and television (2002: 184; see also Morse 1998). This myopic view echoes the dominance of visuality in urban studies and modernity (Jay 1994), and neglects the embodied practices of driving. As a social, sensory and kinaesthetic experience, driving is somatic:

> What urban driving produces, therefore, is an experience of visual signs and signals, but also of time, hearing, smelling, judging space and size, danger, impatience and frustration.
>
> (Borden 2010: 104)

Complex interactions between the senses, in this case visual and sonic, define spatial experience. More attention needs to be given to the embodied experience of the city, as an important component of the spatial experience of the urban environment, particularly through an examination of sound. Driving is one such example:

> Driving is ... a gigantic ensemble, of cars and roads, but also of all kinds of different architectures derived from driving, from petrol stations to billboards, and of people,

the thoughts we have, the actions we make, the images we consume and imagine, the meanings we make, the codes and regulations we negotiate. It is also the speeds at which we drive, the spatial conditions we encounter, the ways in which we look at and listen to the landscape, the very emotions and attitudes we have towards driving and the city.

(Borden 2010: 99–100)

The acknowledgement of the importance of embodied experienced, as urban theorist Iain Borden emphasizes above, is part of a growing field of research recognizing the sensory relations of everyday life (Classen, Howes and Synnott 1995; Drobnick 2006; Harrison 2000; Kalekin-Fishman and Low 2010; Pink 2009; Howes 2003), and particularly the urban experience (Adams and Guy 2007; Amin and Thrift 2002).

One reason for the limited, visualized approach to understanding the sensory experience of driving is the significant effort dedicated to neutralizing the sonic identity of cities throughout history. Sonic signifiers of the city, such as pedestrian footsteps, crosswalk alerts, street vendors, conversations, trams, mobile phone technologies and cars have been negated through using headphones and other portable music devices. This is not just indicative of the contemporary urbanscape. Early-twentieth-century sociologist Georg Simmel (2009) identified strategies of blasé attitudes amongst urban populations which were designed to shut out and create indifference to the noise of the modern city. Unlike eyes, the ears cannot be closed, and so a range of social and material strategies have been established to block out urban noise, particularly with personal mobile technologies such as mp3 players (Tonkiss 2003) and smartphones. The car is an important antecedent for such strategies, with radios being installed as early as the 1930s.

Such efforts to obfuscate the sounds of the city can deterritorialize sense of place as people transport themselves into a sonic bubble of music or podcasts. However, this is not straightforward. As people move through city spaces – whether on foot or in cars – they do not entirely exist in a sonic envelope. Dialogues occur between recorded music and real-time sounds, which can transform perceptions of place. This can be either an arbitrary relationship or a deliberate choice to listen to specific music for a particular space. Rogues' Gallery also provide an important conduit for understanding how space can be produced and imaginatively conceived through sonic experiences. They use noise as a signifier to create enhanced encounters with driving, the city and mobility.

Their work can be located as part of the emerging area of mobility studies (Cresswell 2011; Urry 2007) that considers how space, materiality and subjectivity are being reconfigured in everyday experiences of urban mobility. This field is situated in the context of studies in the processes of globalization which seek flexible and complex definitions on the experience of place (Massey 1994) and mobility in relation to urban spaces, particularly taking into account embodied experience. Understanding of localized place continues to be important in the global context, but how it is experienced and understood requires new frameworks for analysis that acknowledge this mobility (Cresswell and Merriman 2010). For example,

while the car is a globalized technology and common experiences can be identified, driving behaviour and experiences are diverse and localized (Miller 2001). Travelling in a car is a highly located practice (Merriman 2004; Edensor 2003), which counters ideas of the placelessness of motorways in the contemporary global environment of travel (Augé 1995; Relph 1976).

The embodied experience of driving and being in a car provides a site in which to understand the meanings of place in the contemporary city. It creates attachments to place (Bull 2004) as well as allowing detachment from the here and now through states of distracted, imaginative, wanderings (Morse 1998). This flexibility, and how it can be reconfigured constantly during a driving experience, highlights the duality of placelessness and place as experiences that define the contemporary urban environment.

Gasoline Music and Cruising

Gasoline Music and Cruising is a site-specific, performative and immersive sound work. It is a participatory work where passengers are driven on a curated route through the city. The car is driven by Hamachi and the sounds are mixed by Nakase, with additional effects added in, resulting in a form of 'composed' soundscape inside the car. The amplification of car noise changes according to the space in which the vehicle is moving – for example, driving at speed on the motorway, driving along 50 km/h streets, idling at stoplights, indicating and turning corners. The driving route is a key part of the performance and is pre-determined to provide a variegated experience of speed and sound.

The sound inside the car is overwhelming and all consuming. The intimate interior space of the car acts to contain and enhance the acoustic resonance. The sound vibrations of the actual engine mix with the composition to reinforce the volume of noise. The kinaesthetic perception of the movement and speed of the car interlinks with this amplification of sound. The overall effect is a unique, immersive experience that transforms the everyday experience of car travel into something extraordinary.

In order to create *Gasoline Music*, special contact microphones are attached to the engine and dashboard electronics such as the indicator switch. The microphones are connected to a mixing board located in the front passenger seat in which various sounds can be manipulated, amplified and distorted by Nakase using devices such as filters and guitar pedals. A series of loudspeakers are installed around the car which project the sounds of the engine and dashboard back into the space of the car. These loudspeakers include a high intensity subwoofer located behind the back passenger seats. Overlayed into this composed soundscape are the actual sounds of the engine and the sounds of driving/moving through space (the textures of the road and the sound of bodies moving on leather seats). This creates a complex cacophony of multi-sensory interactions: sound, motion, energy, vibration and vision. These orientate the participants in a new way to the environment of the city.

City Soundscapes

Formed in 1993, Rogues' Gallery are interested in the relationships between cars, driving and sound. They designed *Gasoline Music* as a participatory, site-specific and mobile experience of the city. There are a range of permutations related to *Gasoline Music*: a performance in which the Citroën is parked in a public and/or gallery space, such as *Demonstration* (1995); a series of high-definition video and sound installations in galleries, such as *Delay* (2009), *Residual Noise, cycle/second* (2001) and *Residual Noise/Car 6, 7, 8* (2002); and a series of topographical maps created from the GPS data of driving routes called *827 Drives* (2006–7).

In this range of work, Rogues' Gallery construct immersive sound spaces and use dense arrangements of noise and visual images to create experiences for audience/participants that are consciously *felt* in the body through vibration. *Gasoline Music* is unique in the way that it operates outside of traditional gallery space and becomes a mobile artwork traversing the spaces of the city. The soundscape of *Gasoline Music* can be located as part of a history of sound art and acoustic-ecology investigations of urbanism. In the early twentieth century, the Futurists were obsessed with the experiences of the modern city mediated through new machines and technologies, including the car. Luigi Russolo and others embraced rather than rejected the new sonic environments of the city that were emerging through the mechanized spaces of transport, communication and factory production. Rejecting a visually-dominated experience of the city, Russolo recommends that we traverse a modern city with 'our ears more alert than our eyes' (Russolo 1913) adhering to the complex sounds of motors, throbbing valves, pounding pistons, screeching gears, the flapping of awnings and flags, the noise of metal shutters and store windows, doors slamming, the roar of railroad stations, forges, mills, printing presses, power stations and subways. Russolo and others wanted to include incidental urban sounds in order to challenge the values of conventional music.

Walter Ruttmann offered an alternate perspective to Russolo's mimicry of the noise of the city. *Weekend* (1930) was an innovative sound recording made for radio. It captures an acoustic soundscape of Berlin over a weekend in what Ruttmann refers to as 'a cinema for the ears', a parallel to his cinematic work *Berlin, Symphony of a Great City* (1927). In order to create the composition, Ruttmann devised a mobile recording unit with hidden microphones in which to record and document the sonic environment (Figure 2). The work creates a new experience of Berlin using familiar and everyday sounds.

Pierre Schaeffer also extends Russolo's proposition for an art of noise and combines it with compositions created from fragments of found sonic materials. The pioneering musique concrète work *Etude aux chemins de fer* (1948) records the sounds of locomotives at a Paris deport. What is particularly striking about Schaeffer's work is the articulation between sound and motion, and how he captures the dynamism and energy of a modern European city, characterized through mobility and technologies of transportation.

Not everyone adopted the celebratory approach of the Futurists or Ruttmann to the incidental acoustic environment of the city. Ironically, in the late 1890s the car and the electric tram were seen as bringing about a tranquillity of 'noiselessness' in the urban

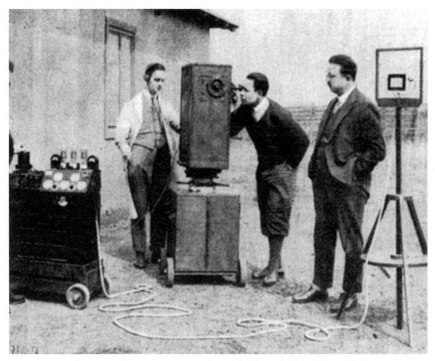

Figure 2: Walter Ruttmann, Tri-Ergon optical sound recording, 1922. Copyright: unknown. Source: Medien Kunst Netz, http://www.medienkunstnetz.de/werke/tri-ergon-lichtton-aufzeichnung/? desc=full.

environments, replacing the noise of horse and cart over cobblestone streets (Coates 2005: 641). R. Murray Schafer (1970) was particularly critical of the 'noise pollution' of contemporary urban environments. Despite his deterministic and didactic critique of urban auditory conditions, Schafer highlighted the imbalance between the sonic and visual articulations of space in developing the field of acoustic ecology (2004). His research provides important recognition of the multi-sensory experiences of urban environments.

In contrast to Schafer, the acknowledgment of all forms of sound in the urban environment, and the desire to recognize the value and meaning of noise, was very influential to later artists such as John Cage (1961) and the Fluxus movement. For instance, Yasunao Tone (part of the Japanese Fluxus movement and Group Ongaku) explored phenomenological encounters with sound and kinetic effects His 1965 work, *Volkswagen*, wired-up a VW with proximity sensors to link participants' body movements to a range of sonic and kinetic effects.

Japanese noise culture also provides an important context for Rogues' Gallery. This type of sonic exploration emphasizes a heightened visceral and aural experience as a counterpoint to the more structured everyday experiences of Japanese society. The intense noise of *Gasoline Music* creates a palpable and amplified contrast to the structured and formal scapes of the Japanese built and social environment. Other Japanese artists have been investigating the sonic

properties of transport technologies in everyday urban environments. For example, HACO and Toshiya Tsunoda's work *Tram Vibrations* (2006) uses contact microphones to create a sound installation and interaction of the motion and sonic vibrations of an Osaka city tram.

Cars have remained a persistent theme in contemporary art for artists exploring urban culture. Australian artist, Callum Morton's *Motormouth* 2002 (Figure 3) explores the sonic themes of commuting. Rather than focusing on the car, the emphasis is on the social relations of driving, particularly 'road rage'. Challenging the idea of driving as a non-social activity and dull experience, Morton's installation work emphasizes the continual series of social interactions that are enacted through driving and being in a car.

Outside of the specific context of art, other developments in electroacoustics, such as German krautrock, explore the mechanization of driving. In their famous work *Authobahn* (1974), Kraftwerk emphasizes the exhilaration and monotony of driving on Germany's autobahn. Another key krautrock group, NEU!, are well-known for their *motorik* beat in albums such as *Neu! 75* and compositions like *Negativland* (1972). Motorik is a beat that re-creates the 'feel' and rhythm of driving and moving through space.

Rogue's Gallery is clearly a part of these histories of sound culture and automobility in art and popular culture. What makes *Gasoline Music* distinct is how the work, rather than

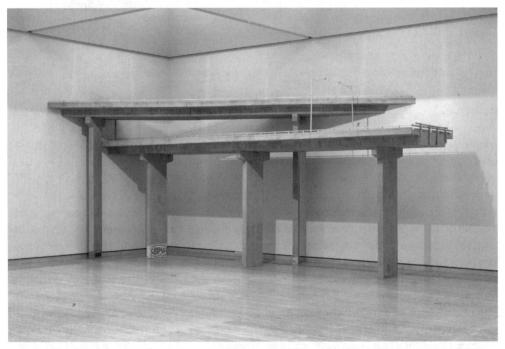

Figure 3: Callum Morton, *Motormouth* 2002, polystyrene, wood, synthetic polymer paint, impact resistant polyurethane, acrylic, sound; dimensions variable according to room size. Installation view – Art Gallery of New South Wales (Contemporary Collection Benefactors 2002). Image: Courtesy of the artist and Roslyn Oxley9 Gallery, Sydney.

creating recordings or representations of urban sonic environments, actively produces an aural and embodied experience of space at the same time as mapping that space through the bodily experiences of being driven in the car, drawing attention to the sonic and kinaesthetic pleasures of driving.

Driving: Bodies in space

Complementing the sheath of speed, the actions needed to drive a car, the slight touch on the gas pedal and the break, the flickering of the eyes to and from the rearview mirror, are micro-notions compared to the arduous physical movements involved in driving a horse-drawn coach. Navigating the geography of modern society requires very little physical effort, hence enjoyment.

(Sennett 1994: 18)

Richard Sennett argues that the desensitized act of driving creates a sense of disconnection to place. Likewise, Marc Augé (1995) critiques motorways as generic and banal 'non-places'. Speed and the monotony of the motorway are commonly cited as the key cause of detached and dull encounters: '[p]erhaps no aspect of the freeway experience is more characteristic than the sudden realization that you have no memory of the past ten minutes of your trip' (Brodsly cited in Morse 1998: 112). However, the site of the motorway itself is not featureless or 'placeless'. Peter Merriman's analysis of the M1 motorway in England reveals the experience as multifaceted and localized:

The landscapes of the M1 are placed through extraordinary and spectacular events as well as the everyday and seemingly mundane movements of individuals and groups of travellers. Landmarks visible from the motorway or individual bridges, stretches of road and service areas may assume special meanings for individuals or families, while prominent public, media events have enfolded and placed the spaces of the motorway into particular associations in the minds of the public, as well as in more durable texts.

(Merriman 2004: 161)

Geographer Tim Edensor (2003) also argues that driving produces affective and imaginative connections and pleasures. It is the routine nature of commuting that opens up the possibilities of experience to other stimuli and to sensual, imaginative, experience (2003: 166). Urban driving, including on motorways, provides a range of experiences for drivers and passengers, both banal and exhilarating:

[W]hile the urban driving sensibility is certainly dulled – given that we do it many times and often routinely – it is also hyperactive, always aware of the changing state of the city around us, always restless. It is ... an experience that represents the dual character

of the city, that which is simultaneously anonymous, repetitive and flat, and personal, rhythmical and variegated.

(Borden 2010: 104)

Further to this, while the heightened sensation (or boredom) of driving can create alertness to the spaces outside the car, it can also draw attention to the interior space of the car:

Grip, friction, sliding, undulation, curvature, inclination, acceleration, deceleration, wind, *noise*, vibration, direction, vector, ripples, proximity and distance.

(Borden 2010: 110, emphasis added)

These peculiar sensorial encounters make driving distinct from other motion experiences, such as walking or flying. For example, driving engages the body 'in and with machine' (Edensor 2003:159). There is a distinctive feel for driving that is experienced kinaesthetically, which creates an ontological intertwining between the identity of the person and the car:

[T]he driver's body is no longer theirs alone, with many drivers often commenting on how the car comes alive, merging with their own physical self to make one seamless, living whole.

(Borden 2010: 109)

In *Gasoline Music* the sounds and vibrations of acceleration, deceleration and turn signals immerse participants into the machinery of the car. Inside the car it is difficult to separate body from machine as the visceral vibrations from a high intensity subwoofer pulsate in and through the body. This is an amplified version of the ontological merging of machine/person. This sense of connection with the car is heightened through the aesthetic relationship between the slick, black leather interior of the car and the all-in-black outfits of the drivers. In fact, Rogues' Gallery refer to the car itself as a third performer (personal communication).

Being a passenger, or what Thrift refers to as 'passengering' (2004), creates a distinct form of ontology with the car machine. Albeit in a less controlled manner, because the passengers cannot manipulate the speed, acceleration, braking or direction of the vehicle. While there are overlaps between the tactile experiences of these two activities, their respective relationship to the car, speed and motion is distinct (as back-seat motion sickness attests):

The sensual vehicle of the driver's action is fundamentally different from that of the passenger's, because the driver, as part of the praxis of driving, dwells in the car, feeling the bumps on the road as contacts with his or her body not as assaults on the tires, swaying around curves as if the shifting of his or her weight will make a difference in the car's trajectory, loosening and tightening the grip on the steering wheel as a way of interacting with other cars.

(Jack Katz, cited in Thrift 2004: 47)

This effect of loss of control for the passenger is pronounced in *Gasoline Music*. Unlike conventional driving or passenger experiences, where control over the car's sonic climate can be a site of active debate, in *Gasoline Music* there is no agency given to the passengers. The route is pre-determined by the artists and the amplification of the sound is composed.

However, the body of the passenger is not just a passive recipient, it actively engages in a kinaesthetic relationship with the car, by continual adjusts of gravitational weight, form and sensory inputs/outputs (ears, eyes and mouth) to the speed and movement of the car. In *Gasoline Music* what becomes quickly apparent is the way that as a passenger there is a distinct role occupied as both participant and audience. There is no control over the driving and sonic experience, and no encouragement to interact with the artists in the front seats or with other passengers. This follows conventions of performance/audience tradition, but it is determined also by the density and volume of noise, which makes talking/listening difficult. Consequently, in the passenger role the focus shifts to subjective bodily reactions to sound, vibration and motion, which draw further attention to the act of participation in the sonic/mobile experience.

The resulting effect creates a strange duality of both privatized and collective social experience. This double identity is further split because the noise and the immersive experience can create a form of internal retreat and revelry amidst the noise and motion. This state, however, is continually interrupted by a forced recognition and interaction, through vibration and noise, with the external topography: the texture of the road, the speed of the car and the direction of travel.

Arguing that the interior space of the car is not 'hermetically sealed from the outside world', sociologist Michael Bull identifies how soundscapes of automobility connect people to the here and now of time and spaces (2004: 250). For example, singing in the car enacts a privatized bubble of experience that people construct around the act of driving. This space, however, is disrupted continually through an awareness of others looking in on this 'private' space. The space of the car is private and public, individual and social. This duality is part of a complex range of connections and disconnections between the interior and exterior spaces of the car that construct a variety of relationships to time and space, which *Gasoline Music* amplifies.

The Sonic Envelope of the Citroën XM-X

Ironically, as much as *Gasoline Music* emphasizes the kinaesthetic experience of motion and speed, this is achieved through contemporary car engineering that seeks to cushion sound, motion and vibration. Cars have become dematerialized 'sonic envelopes' (Bull 2004: 257). Self-contained, engineered and controlled, they have the ability to create a uniformly-immersive space for sound – specialized 'acoustic listening chambers' (2004: 257). Over the past 20 years there have been significant changes to the phenomenology of driving due to these technological transformations of the driving experience, particularly around the

material and physical look and feel of cars. Advanced software- and hardware technology is adopting increasingly-embodied positions, such as ergonomics, which create a new form of highly-mediated driving (Thrift 2004: 49–50). While this has the potential to create a disengaged physical experience of driving, Thrift argues that it results in a different form of hybrid ontology.

The Citroën XM-X is designed to minimize bodily interruption with its 'hydractive' suspension design. This is an electronically-controlled suspension system that delivers a so-called 'magic carpet ride', which differs from the hydropneumatic suspension systems of previous Citroën vehicles. The interior of the vehicle creates a cushioned, luxurious, bodily experience with leather seating, adjustable armrests and seat heating. The dashboard was recognized at the time for its futuristic electronic and computer look and feel. Rogues' Gallery emphasize this luxury aesthetic, and the look and feel of the shiny, black, Citroën was a critical part of the performance experience.

Rogues' Gallery subvert the muffled experience of contemporary driving, by drawing attention to the experience of motion, mobility and speed through sonic amplification. All the types of background noise normally eliminated in the sonic envelope are emphasized and heightened. The large subwoofers push against the body with soundwave vibrations from the thumping beats of the indicator switch and machinations of the engine. Ironically, Citroën already anticipated the amplification of car noise. The XM came with an FM radio that could be tuned to a certain frequency that would enable the electrovalues of the hydraulic system to be heard. The designers created a connection between the interior/exterior spaces of driving while also cushioning the interior; this creates a strange disjuncture between external (the surface of the road) and internal space.

As much as contemporary cars are designed for dematerialized encounters with sound and motion, there are limits. Car culture is reliant on levels of arousal generated by engine power, speed and motion.[1] There is a type of affect, which is an integral part of the perception of driving experience and the power of speed, that is connected to the sonic experience. The infamous film by Claude Lelouch *C'était un Rendez-vous* (1976), of an eight-minute high-speed drive through Paris in the early morning, attests to such levels of excitement connected to speed generated through sound and vision. If arousal is not stimulated through actual speed and engine noise then, often, music in the car is used to manipulate required levels of arousal. In fact, the most discussed sonic experience of cars, outside of engineering research into engine and design issues, is that of music (Bull 2004). Increasingly, driving becomes a technologically-mediated experience in which users actively create meaning for the cognitive and physical spaces they occupy using a range of sonic strategies. It is the technological advances in design which seal the interior from external and engine noise that have also facilitated these sophisticated soundtrack options.

The range of 'aural pleasure[s] and recreation' available to car users, is very much related to recorded music and not the sound of the car itself (Bull 2004: 245). For many drivers the engine noise is a thing of displeasure. It is something that disconnects, alienates and monotonizes the experience of driving. In contrast, it is the radio/stereo/music players that

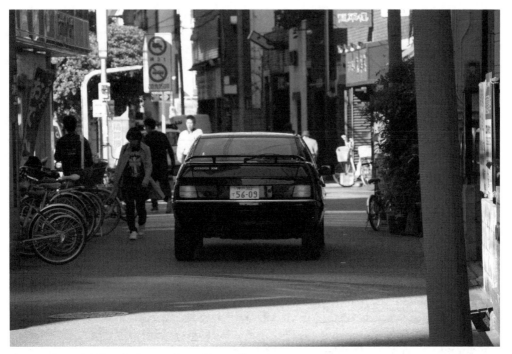

Figure 4: Rogues' Gallery, Osaka 2011. Image: Kristen Sharp.

can transform the experience of driving into a state of pleasure and/or distraction (2004: 246). Research into the use of music in cars indicates a strong relationship between volume, tempo and states of pleasure, concentration, distraction or relaxation – with accompanying impacts on driving performance (Dibben and Williamson 2007). Dibben and Williamson identify how the tempo and volume of sound (music) can alter the experience of time, speed and motion (2007: 577). The sonic space inside the car transforms the perception and experience of the visual landscape and of movement through space, making one either more or less alert to the surrounding topography. It was an accidentally-loud tuning of the FM radio in their car which originally sparked Rogues' interest in how sound effects an experience of place (Kobuki 2007).

Place and Imaginative Topography

Driving, particularly on familiar routes or when commuting on motorways (or freeways), can create a state of revelry and distraction – a drifting off into other imaginative worlds (Morse 1998: 104). By drawing on Augé's idea of non-place, Morse identifies how freeways are disengaged physically and conceptually from their surroundings: 'Freeways are displaced

in that they do not lie earthbound and contiguous to their surroundings so much as they float above or below the horizon' (Morse 1998: 104). Freeways become conducive to a dream-like state, enhanced by the perception of the road as a means of escape and liberation (1998: 105). Morse argues that driving in the nonspace of the freeway creates a type of 'fiction effect' through a cognitive state of distraction. The banal and repetitive nature of the surrounding landscape in freeway driving creates a type of 'zombie' effect. The sonic uniformity of these spaces acts in a similar way. The consistency of engine speed, the speed of other vehicles travelling in the same direction and the smooth asphalt all create monotony.

This is not at the expense of being alert to the 'here-and-now' space of the freeway through traffic, speed and movement. This engagement with presence is particularly enacted, for Morse, through the visuality enabled by the windscreen, windows and mirrors of the car. These mediate the relationship between the interior and exterior spaces of the car (1998: 111–12). To which we can now also add GPS screens. Morse draws attention to the complex range of relationships that occur between separation and connection facilitated through these screens. These objects establish separation because they provide concrete distinctions between inside and outside. They also create connections. The glass and digital screens engage the spaces outside of the car (Morse 1998: 111). This is not a simple relationship between interior and exterior or distraction and engagement. Both the 'real' space of the here-and-now and the dream-like space of distraction are encountered through the interior/exterior relationship and facilitated through screens:

A sheet of glass alone is enough to provide a degree of disengagement from the world beyond the pane. Add to this the play of light which appears to be part of the *mise-en-scene* … the world beyond the glass glows more brightly than the darker passages and seats we occupy.

(Morse 1998: 111)

The identification with place through states of presence and imagination is created through complex multi-sensory experiences. Sound is not an isolated phenomenon, it is given meaning through relationship with sight and smell; sonic experience is as much a *part of* and continuum with visuality rather than being a separate thing:

[A] visualist reading of automobile habitation assumes that drivers are continually looking out onto the world, in acts of 'objectification' rather than being preoccupied with living within the intimate space inside the automobile itself, or desiring the environment to mimic their desires. Paradoxically, visually based accounts of automobility may well mistake the mediated nature of the visual in automobility through their misunderstanding of the role of sound in transforming the visual apprehension of place. Vision is invariably audio-vision.

(Bull 2004: 248)

The sonic experience of the car can, therefore, be understood as enhancing visuality and motion (see also Edensor 2003: 161–62). *Gasoline Music* draws attention to bodily encounters, not by obfuscating the visual but amplifying (literally) the sonic, the vibratory sensations of driving and of experiencing place. It activates perceptions of the exterior landscape – particularly motion and speed – through the enhanced sonic experience inside the car. This makes passengers alert to the affective experience, to the here and now of urban space, through an embodied form of knowledge. The performance also expands the meaning of driving and its attendant spatiality beyond mobility. The sounds of acceleration, deceleration and turn signals immerse participants into the space of the car itself. A complex interplay of motion and vibration emerges through the physical movement of the car and the sound of the engine mixing with the composed or performed versions. This connects passengers both to the external and internal spaces of the car.

Gasoline Music emphasizes this audio-vision duality between presence and imagination by using the anonymous, repetitive and highly familiar space of the motorway and making it into something that is multifarious, stimulating and embodied. Being in the Rogues' Gallery Citroën creates an out-of-the-ordinary experience through the amplification of sound, the relationship to place and the framing of the experience as a discreet performance work. This creates a sense of the extraordinary – a creative and imaginative space in the city. Yet, the volume and intensity of the sound also continually re-focuses passengers into the immediate encounter with the material spaces of the car and road. The sound of the car/road, which is amplified by *Gasoline Music*, locates bodies into the spaces of the urban environment and *into* the car. This is quite different from the way music in the car can take you elsewhere, a distraction and distortion of place, as Margaret Morse and Michael Bull have identified.

Conclusion

Gasoline Music creates an experience of elsewhereness which occurs in tandem with a located sense of the here and now. Like Michel de Certeau's (1984) discussion of walking as writing urban space, participating in *Gasoline Music* re-writes the space of the city, embedding it into the body, through sound and movement, and highlighting driving as a production of space. *Gasoline Music* takes the routine activities and rhythms of the city, driving on the motorway and on urban streets, and makes them extraordinary.

Rogues' Gallery create an immersive and embodied experience of the city that not only draws attention to the multi-sensory dimensions of urban space but also how art can transform our perceptions of everyday activities such as driving. *Gasoline Music and Cruising* becomes part of the mobile flows of the contemporary city, highlighting how transport and technology can still bring excitement to urban spaces one hundred years after the Futurists celebrated such transformations. Their work builds on a history of automoblity, sound and art in the city and draws attention to the city as a space of diverse encounter, which is experienced in and through the body.

Acknowledgements

With thanks to Dr Philip Samartzis and Darrin Verhagen (RMIT University) for their enthusiastic discussions and feedback on this chapter during its development. I would also like to thank HACO (Japan) for organizing a special performance of *Gasoline Music and Cruising* in Osaka, 2011. Finally, thank you to Rogues' Gallery for providing the core inspiration for this chapter and for discussing their work with me.

References

Adams, M. and Guy, S. (2007), 'Senses and the City', *Senses & Society,* 2, pp. 133–36.
Amin, A. and Thrift, N. (2002), *Cities: Reimagining the urban,* Cambridge: Polity.
Augé, M. (1995), *Non-Places: Introduction to an anthropology of supermodernity,* London: Verso.
Banham, R. (1971), *Los Angeles: The architecture of four ecologies,* Middlesex: Allen Lane Penguin.
Borden, I. (2010), 'Driving', in M. Beaumont and G. Dart (eds), *Restless Cities,* London: Verso.
Bull, M. (2004), 'Automobility and the Power of Sound', *Theory, Culture and Society,* 21, pp. 243–58.
Cage, J. (1961), *Silence: Lectures and writing,* Middletown, CO: Wesleyan University Press.
Classen, C., Howes, D. and Synnott, A. (1995), *Aroma: The cultural history of smell,* London: Routledge.
Coates, P. (2005), 'The Strange Stillness of the Past: Toward an environmental history of sound and noise', *Environmental History,* 10, pp. 636–65.
Cresswell, T. (2011), 'Mobilities I: Catching up', *Progress in Human Geography,* 35, pp. 550–58.
Cresswell, T. and Merriman, P. (eds) (2010), *Geographies of Mobilities: Practices, spaces, subjects,* Burlington, VT: Ashgate.
de Certeau, M. (1984), *The Practice of Everyday Life,* Berkley: University of California Press.
Dibben, N. and Williamson, V. (2007), 'An Exploratory Survey of In-Vehicle Listening', *Psychology of Music,* 35, pp. 571–89.
Drobnick, J. (ed.) (2006), *Smell Culture Reader,* Oxford: Berg.
Edensor, T. (2003), 'Defamiliarizing the Mundane Roadscape', *Space and Culture,* 6, pp. 151–68.
Featherstone, M., Thrift, N. and Urry, J. (2005), *Automobilities,* Los Angeles: Sage.
Friedberg, A. (2002), 'Urban Mobility and Cinematic Visuality: The screens of Los Angeles– endless cinema or private telematics', *Journal of Visual Culture,* 1, pp. 183–204.
Harrison, P. (2000), 'Making Sense: Embodiment and the sensibilities of the everyday', *Environment and Planning D: Society and Space,* 18, pp. 497–517.
Howes, D. (2003), *Sensual Relations: Engaging the senses in culture and social theory,* Ann Arbor: University of Michigan Press.
Jay, M. (1994), *Downcast Eyes: The denigration of vision in twentieth-century French thought,* Berkeley, CA: University of California Press.
Kalekin-Fishman, D. and Low, K. (2010), *Everyday Life in Asia: Social perspectives on the senses,* Burlington, VT: Ashgate.

Kobuki, T. (2007), 'Drive x Noise – Rogues' Gallery', http://www.osaka-brand.jp/en/kaleidoscope/art/index4.html. Accessed 30 April 2011.

Massey, D. (1994), 'A Global Sense of Place', in *Space, Place and Gender,* Cambridge: Polity, pp. 146–56.

Merriman, P. (2004), 'Driving Places: Marc Augé, non-places and the geographies of England's M1 motorway', *Theory, Culture and Society,* 21, pp. 145–67.

Miller, D. (ed.) (2001), *Car Cultures,* Oxford: Berg.

Morse, M. (1998), 'An Ontology of Everyday Distraction: The freeway, the mall, and television', in *Virtualites: Television, Media Art and Cyberculture,* Bloomington, Indianapolis: Indiana University Press, pp. 99–125.

Pink, S. (2009), *Doing Sensory Ethnography,* Los Angeles: Sage.

Relph, E. C. (1976), *Place and Placelessnes,* London: Pion.

Russolo, L. (1913), 'The Art of Noise (Futurist Manifesto)', http://www.ubu.com/historical/gb/russolo_noise.pdf. Accessed 17 September 2011.

Schafer, R. M. (1970), *The Book of Noise,* Vancouver: Price Print.

——— (2004), 'The Music of the Environment ', in C. Cox and D. Warner (eds), *Audio Culture: Readings in modern music,* New York: Continuum, pp. 29–39. First published 1973.

Sennett, R. (1994), *Flesh and Stone: The body and the city in Western civilization,* New York: W.W. Norton.

Sheller, M. (2004), 'Automotive Emotions: Feeling the car', *Theory, Culture and Society,* 21, pp. 221–42.

Sheller, M. and Urry, J. (2000), 'The City and the Car', *International Journal of Urban and Regional Research,* 24, pp. 737–57.

Simmel, G. (2009), 'The Metropolis and Mental Life', in C. Harrison and P. Wood (eds), *Art in Theory, 1900–2000: An anthology of changing ideas.* rev. edn, Malden, MA: Wiley-Blackwell, pp. 132–36. First published 1902–3.

Thrift, N. (2004), 'Driving in the City', *Theory, Culture and Society,* 21, pp. 41–59.

Tonkiss, F. (2003), 'Aural Postcards: Sound, memory and the city', in M. Bull and L. Black (eds), *Auditory Cultures Reader,* New York: Berg, pp. 303–09.

Urry, J. (2007), *Mobilities,* Cambridge: Polity Press.

——— (2004), 'The 'System' of Automobility', *Theory, Culture and Society,* 21, pp. 25–39.

Note

1 I wish to acknowledge Darrin Verhagen's insightful interpretation of this aspect of car design and culture.

Chapter 6

'The Vacant Hotel': Site-specific public art and the experience of driving the semi-privatized geographies of Melbourne's EastLink Tollway

Ashley Perry
RMIT University

Introduction

This chapter explores a series of site-specific public artworks situated within the geography of a semi-privatized motorway on the southeastern edge of metropolitan Melbourne. It examines how the artworks form connections through a series of complex, compelling, affective and relational assemblages and sensibilities with motorists driving the route. The EastLink Tollway operates as a paradigmatic user-pays road that reflects the 'historic link between economic liberalism and automobility' (Davison 2004: 243) embedded in the city's urban consciousness. It represents neo-liberal conditions of privacy, individuality and flexibility associated with political, economic and cultural characteristics of urbanization and globalization consistent with the spatial, temporal and material qualities of outer suburban Melbourne, which are also emblematic of many

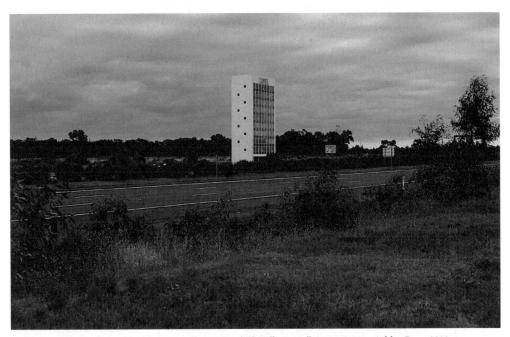

Figure 1: Callum Morton, *Hotel* 2008, installation, Eastlink Tollway Melbourne. Image: Ashley Perry 2012.

contemporary cities. It also represents a significant urban development project designed to re-activate a dormant stretch of semi-industrial/rural land providing the opportunity for an expansion in the commercial interests and individual lifestyle, consumption practices of outer-suburban residents.

Sited in a prominent position along the Tollway roadside is Callum Morton's evocative artwork, *Hotel* (2008). A scaled model of a multi-story hotel, it simultaneously embodies imaginative, generic and symbolic notions of both the local and global characteristics of contemporary cities, while producing a compelling relationship between the passing motorist and the material, temporal and spatial geographies of the route. By mapping the dynamic relationship between the artwork and motorist, this chapter unlocks the complex, discursive and visual qualities of *Hotel*, and its site-orientated identity within the roadscape of the EastLink Tollway, while seeking to demonstrate how site-specific public art can allow for a re-imagining and re-configuring of the urban environment.

Mobility and Automobility

In recent times social scientists have sought to account for the diverse, complex and interdependent nature of movement and flow within globalization processes by investigating a range of physical, informational, visual, imaginative and virtual movements that define contemporary social life. Writing in *Sociology Beyond Societies*, John Urry argues that the movement of 'peoples, objects, images, [capital] and information travel … produce and reproduce social life and cultural forms' (2000: 49) through modalities that relate to the contemporary experience of time, space, dwelling and citizenship. Additionally, Urry investigates these corporeal, informational, imaginative and virtual mobilities through concepts of 'metaphor and process' (2000: 49). He also suggests that

> some of the material transformations that are remaking the 'social', especially those diverse mobilities that, through multiple senses, imaginative travel, movements of images and information, virtuality and physical movement, are materially constructing the 'social as society' into the 'social as mobility'.
>
> (Urry 2000: 2)

At the centre of thinking about the processes and qualities of mobility is a collection of metaphors, which include the nomad, the vagabond, the tourist, the ship, the hotel, the motel and the transit lounge. For Urry, these 'embody alternative presumptions of homogenization/heterogenization, of simplicity/complexity, of movement/stasis, of inclusion/exclusion' (Urry 2000: 26). This collection maintains discursive weight and aligns comfortably with other familiar mobility metaphors of regions, networks and fluids that define contemporary global studies.

In recent years a 'new mobilities paradigm' or 'mobility turn' has emerged (Hannam, et al. 2006; Sheller and Urry 2006; Cresswell 2010), gaining considerable theoretical traction

within the social sciences. This nascent field of mobilities research explores increased levels and new forms of mobility, and considers ways of thinking and theorizing that foreground the mobility of people, ideas and things as a geographical fact that lies at the centre of constellations of power, the creation of identities and the microgeographies of everyday life (Cresswell 2010).

Emanating from these considerations there have been varying approaches to the consideration of spatialities, materialities and subjectivities that underpin daily mobility, movement and travel; particularly, in relation to the automobile. Due to the spectacular and omnipresent nature and practice of urban driving, the exploration and interrogation of car travel has become a trope in understanding ideas of automobility.

Considered an important social and technical institution through which contemporary social life is shaped and organized, research into automobility has been engaged with accounting for the multiple interlocking dimensions of the car and the broader machinic complex it constitutes (Urry 2000; Böhm et al. 2006). In attempting to account for the complexities of the 'car-system' and the hybrid figure of the 'car-driver' (Sheller and Urry 2000), an important focus of automobility studies has been devoted to socio-spatial and material investigations of motorways. For example, urban geographer, Peter Merriman examines the critical sociologies and geographies of driving in terms of site-specific encounters:

the ways in which subjectivities, materialities and spatialities associated with driving emerge through the folding and placing of the spaces and materialities of cars, bodies, roads and surroundings (with a variety of thoughts, atmospheres, senses and presences) into dynamic, contingent topological assemblages.

(Merriman 2004: 146)

Additional studies within the automobilities' field have included the multi-faceted exploration of driving within motorway landscapes, *Defamiliarizing the Mundane Roadscape* (2003) by Tim Edensor, and more recently, *Driving* (2010) by Iain Borden. Both Edensor and Borden critique the notion that the spaces of the car are dystopian, featureless and desensitized environments and that driving is a purely automatic behavior. A typical example of this characterization is located in Marc Augé's (1995) concept of 'non-place'.

This chapter will reveal the complex relationships to place that can be encountered through driving. It does this by mapping the spaces beyond the car in order to conceptualize the EastLink Tollway as a material, social and imagined site that is central to the formation of identities and the production of meaningful attachments for motorists. In particular the discussion focuses on the 'affective and imaginative connections' (Edensor 2003: 152) established between the presence of public artworks and motorists experiencing an array of embodied and engaging sensations within the 'complex topographies of apprehension and association' (Edensor 2003: 152) that can be attributed to the road. The proposition is that the artworks located along the Tollway assist in re-configuring ideas

of urban space and re-asserting concepts of place. An underlying theme running through this investigation relates to centrality of car-led mobility in the urban life of Melbourne, something that is common to many cities. The characteristically animated and embodied experience of driving requires that consideration is given to the 'specific feelings which arise from momentary associations and attachments that are integral to the ongoing [and] performative constructions of places' (Merriman 2006: 77) and, in this instance, as they apply to motorists travelling along EastLink Tollway and their encounters with public art.

Tollway Driving

A significant amount of research has examined the role and powerful effects of the car-system in relation to contemporary urban life (Sheller and Urry 2000, 2006; Merriman 2007). Recently, this research has been supplemented with consideration given to the conditions, experiences and pleasures of driving within cities. Iain Borden suggests:

> Through driving – a continual and restless mobile interaction with cities, architecture and landscape – the human subject emerges as someone who has experienced one of the most distinctive and ubiquitous conditions of the modern world, and who has become, as a result, a different kind of person.
>
> (Borden 2010: 120)

In relation to the urban environment, Borden's research has examined the affective qualities of driving in terms of sensory, cognitive and embodied experiences while questioning 'the various pleasures involved in different kinds of driving, at different speeds and in different kinds of spatial landscapes' (Borden 2010: 100).

Borden attempts to reappraise the relationship between driving and the urban environment. He suggests that the material conditions of urban architecture when experienced through the mobile and animated activity of driving are responsible for unlocking a range of social and cultural meanings as well as powerful emotions from the motorist. The material conditions and physical sensations related to the practice and experience of Tollway driving maybe characterized as non-sterile, embodied and pleasurable. Motorists ensconced within a 'mobile semi-privatized capsule' (Urry 2000: 190) engage in a series of physical and mental skills that are reinforced by an implicit connectedness to the passing spatial landscape.

At the commencement of their investigation into automobility, Sheller and Urry described the motorway as a site of 'pure mobility within which car-drivers are insulated' (2000: 746). This negative connotation ascribed to the spaces of the motorway as solitary and alienated environments with motorists enveloped in high-speed travel are located in the theories of Paul Virilio and Jean Baudrillard. Sean Cubitt suggests that for Virilio the motorway remains 'the scene of picnolepsia, the suspended consciousness of auto-pilot driving' (1999: 140), where the

car becomes 'a device which isolates the driver from the world' (1999: 139), and 'a device for immobilization and subjection' (1999: 140), encompassing a roadscape effectively 'smeared across the windscreen, devoid of detail, no longer a world of objects but a landscape flattened into a perpetual and undifferentiated present' (Cubitt 2001: 62). Baudrillard writes that driving at high speeds reduces 'the world to two-dimensionality, to an image, stripping away its relief and its historicity' (1996: 70). Definitively labelled as 'non-places', a term instigated by Augé, and reinforced in the familiar trope of the single-occupant driver speeding programmatically to and from work along 'unstimulating and desocialised' (Edensor 2003: 152) auto-routes/ passages; these spatial conditions of the motorway are alternatively characterized as 'abstract' (Lefebvre 1991) and 'placeless' (Relph 1976; Casey 1993).

An alternate argument in relation to motorway driving is located in Peter Merriman's cultural-historical investigation of the landscape of England's M1 Motorway, *Driving Spaces* (2007), wherein he counters the malign position of travelling by car on the motorway by arguing for the potential of these types of urban typologies to afford a wider spectrum of experience. As Merriman suggests:

> The practice of driving or being a passenger in particular cars, travelling to and from particular places, along particular stretches of motorway, provokes a range of emotions, thoughts and sensations: from feelings of anxiety or excitement about being in motorway traffic, to emotions surrounding one's departure and arrival at another place.
>
> (Merriman 2007: 218)

His less cynical examination of the car and the experience, practice and performance of driving, located within 'the diverse "scapes" associated with car travel' (Merriman 2006: 75), resonate with journeying by car along the EastLink Tollway.

A car trip along the EastLink Tollway exposes motorists to fleeting and/or sustained moments of stimulation and reverie where imaginative, visually-diverting and existential thoughts – including daydreams, musings and opinions as well as physical sensations and feelings derived from the high-speed encounter between the route the motorist and the roadside environment – amplify the driving experience. Additionally, a series of 'topologies and multiple, heterogeneous "placings"' (Merriman 2004: 154) are uncovered along the elaborately-conceived, designed and engineered motorway. The 'multiple sensualities, materialities, topographies and psychogeographies' (Edensor 2003: 152) encountered on the Tollway are augmented by the strategically-positioned, site-specific public art.

Tollway Geographies

A month after its official opening in 2008, the EastLink Tollway became fully operational. The dual six-lane carriageway opened up a new arterial passage linking inner-city Melbourne to its outer eastern and southeastern suburbs. Characteristic of neo-liberal forces of

privatization that consider the city 'a decentralized metropolis where relatively few journeys [are] capable of being made by public transport' (Davison 2004: 252), the Tollway seeks to 'meet the transportation needs of the new world of electronic communication, information-based industries and just-in-time-technology, and of a workforce increasingly geared to part-time, casual and mobile employment' (Davison 2004: 252), as its route extends across an interstitial space that slices through established suburbs, passes by new outer-urban housing developments and across a collection of other sites including golf courses, scrap and timber yards, electrical substations, water treatment facilities, market gardens, wetlands and grasslands and commercial and industrial parks. As with all of the city's major roads, the EastLink Tollway is aligned to a major watercourse reflecting the common arterial '[nature] of the transport networks developed in Melbourne in the past 120 years' (Presland 2008: 220), with many of the city's major roads and freeways situated adjacent to the flow of rivers and creeks.

The EastLink Tollway was initially conceived during a period of urban expansion that was marked by freeway building in the early 1960s. For the duration of its construction period (commencing in March 2005), the Tollway represented Australia's largest and one of the most expensive infrastructure projects. Since its inception the Tollway has underperformed financially yet, in many ways, from its complex architectural design, engineering characteristics and timely construction, it has been lauded. An example of its positive local reception is located in an initial review of the Tollway by architectural critic Dimity Reed, who observed that

> [t]o drive along EastLink is to experience the city as through a film clip. You move from dense residential areas to open landscapes and big skies, on through industrial landscapes, back to parklands and outer-suburban developments, and then on through market gardens beneath more big skies.
>
> (Reed 2008: 70)

Reed's impression of the road as it passes along an unerring trajectory through 13 outer-metropolitan suburbs equally reflects and invokes the kinaesthetic nature and experience of high-speed car travel along the Tollway. Her comments are also suggestive of the possibility for 'sight, senses, intellect, landscape, meaning, artistic creativity and the human body' to be 'potentially reconfigured' (Borden 2010: 109) for motorists journeying along the route.

These transformative notions also allude to the multi-dimensionality of the landscape. The Tollway encompasses a terrain of vibrant and diverse geographies and possesses the ability to facilitate a sense of 'strangeness, newness and disconnectedness' (Borden 2010: 108) at various times of the day and night. These relational assemblages and sensibilities can encompass both fleeting moments or sustained periods of thought and embodied sensation that lead to the onset of 'immanence, nostalgia and anticipation'

(Edensor 2003: 154) for motorists. This assessment extends towards Edensor's belief that

> the linearity of the road … dissolves as monuments, signs, and surprises form a skein of overlapping features, enveloping the motorway in a web of associations. This is a topography of possible sights and destinations that reference other spaces and times because motorways are spaces of material, imaginative, and social flows.
>
> (Edensor 2003: 156)

When travelling by car along the EastLink Tollway motorists encounter a collection of ideas, feelings and sensations present in the material conditions on and off the road. These tactile non-human objects, signs, surfaces and textures are embedded within the varying natural and built forms of the roadscape. The spectacular design features are essential components in the capacity of the Tollway to forge a dynamic and engaging sense of place for motorists.

Travelling by car along the route offers the potential for drivers and passengers to 'become enfolded within [the] externalities' (Thrift 1999: 296) of the roadscape. This process of integration with the route is hard to dismiss when passing along the 45 kilometres of motorway-standard road, through the twin 1.6 kilometre, three-lane tunnels, or beneath the 90 bridges and three rail crossings (Reed 2008). It remains difficult to escape the omnipresence of the Tollway's operations centre, sited in a dominating position above the northern end of the road and clad in various shades of green, or neglect the extensive plantings, kilometres of bicycle and walking tracks and the positioning of ten slightly more concealed minor-scale artworks that aid in placing the motorist within the geography of the road. A car trip along the Tollway may trigger in the motorist any number of 'memories, sensations, desires, fantasies, interpretations, stories and bits of knowledge' (Edensor 2003: 166).

The programme of roadside artworks represents a tangible link to the 'visual regime of the motorway', where the 'constant oscillation from the detail to the territorial, from the local to the global' (Borden 2010: 114) exists. The presence of *Hotel* amplifies this juxtaposition as the passing landscape is experienced both individually and collectively, offering multiple opportunities for motorists to apprehend and consider 'a host of intertextual and interpractical spaces, places, eras and occasions' (Edensor 2003: 153), while encompassing a landscape imbued with 'many stories [from] pre-settlement through to the making of orchards, market gardens, industry and new housing' (Reed 2008: 70).

Positioned at various points and in the line of sight of motorists travelling in either direction along both the inbound and outbound trajectories of the road, the EastLink Tollway's public artworks are configured in diverse and spectacular forms that engage an array of audiences in ways that are suggestive of a desire to offer a more expansive,

intensive and non-standard engagement with art objects beyond the institutional spaces of the art gallery (Kwon 2004).

Site-specific Public Artworks

It is the large artworks that command the greatest attention of motorists due to their prominent positioning on the Tollway roadside. When travelling south along the route the first visible sculpture adjacent to the northbound carriageway is James Angus' (Australia), *Ellipsoidal Freeway Sculpture* (2008). Formed by a painted fiberglass and steel framework, with 24 white, green and blue modular ellipsoids, from one to three metres in diameter, the work is 36 metres long, five metres high and six metres wide. Its abstract formal qualities constantly modulate depending upon the direction and speed of encounter with the artwork. From the perspective of a moving car the colours of *Ellipsoidal Freeway Structure* slightly blur and its form warps, establishing an affective albeit brief moment of visual spectacle for the passing motorist. Further south along the Tollway adjacent to the southbound carriageway is another sculpture, Emily Floyd's (Australia), *Public Art Strategy* (2008). This is a 13-metre-high, painted steel blackbird, with a seven-and-a-half-metre wingspan featuring a wormlike object at its base. It is a giant mix of pre-existing and familiar public art forms from across Melbourne resonating with the iconography and history of these well-known pieces. The southernmost sculpture adjacent to the northbound carriageway is Simeon Nelson's (United Kingdom), *Desiring Machine* (2008). Resembling a fallen tree or electrical tower, the metal structure is made from galvanized steel plate, 36 metres long, nine metres high and eight metres wide. It is suggestive of a future calamity and resonates with themes of decay, equally abstract and ornamental, and exhibits a structural logic that is not easy to identify from a passing car. Placed between *Public Art Strategy* and *Desiring Machine* is Callum Morton's *Hotel*, arguably the most visible and iconic artwork, given its size, scale and position along the route as well as the international status of its creator. In relation to the artwork, Dimity Reed writes:

> In concrete, it stands to the west of the road on a site that hints at dereliction. Hotel is writ large across the upper façade, above rows of windows and a doorway. It is quite extraordinary in the way it ambiguously invites you in, while somehow hinting that there is no in. This is Hitchcock on the film clip.
>
> (Reed 2008: 70)

Within the landscape of the Tollway all of the artworks produce for the passing motorist the possibility for conscious and imaginative interpretation whereby they may engage, feel, concoct, reflect upon and/or dismiss the relationship between the artwork and the geography. They can be considered affective markers of place that assist in the re-imagining of the Tollway as a road space containing dynamic, contingent and topological assemblages of cars, bodies and varied surroundings embedded with thoughts, atmospheres, senses,

presences and feelings (Merriman 2004), distinctly non-utilitarian or banal. Amplifying Reed's observation is the notion that the components of the Tollway, including, the public artworks, are experienced in cinematic terms,

> notably those of framing, sequencing, editing, unusual juxtapositions and montage, changing pace, unexplained events and sights and so on, all of which is induced by the speeding kinematic nature of driving.
>
> (Borden 2010: 108–9)

Additionally, travel on the road does not preclude other multi-sensory and embodied conditions such as the affective qualities of speed/motion and sound both within and beyond the interior of the car. It also includes the sensual transference of feeling between the control of the car and physical texture of the road surface. The built environment of the Tollway, comprising multi-level interchanges, bridges and flyovers, tolling gantries and electronic signs, footbridges and roadside protective barriers where light reflects upon and refracts across the artificial surfaces as well the multiple moments afforded by on and off ramps to enter and exit the route, all feed into 'a complex series of flows and matrices that connect spaces, times, representation and sensations' (Edensor 2003: 154). For Reed, the variance in the EastLink Tollway's material conditions is 'dramatized by a curve of the road, by the slope or detail of a wall, by a swathe of mass plantings, a bridge, a tunnel or a sculpture' (2008: 70). This theatricality is also present when passing *Hotel* with its uncanny ability to momentarily suggest it is something more than an elaborate artwork.

Typical perceptions by motorists encountering the Tollway's artworks for the first time encapsulate notions of novelty, while regular road users passing the forms on a regular basis are able to identify with them as familiar and arguably reassuring components of the journey. In many ways they offer motorists 'points of orientation ... to which the ... imagination may extend as a sort of virtual travel' (Edensor 2003: 159), functioning as entities that 'can be apprehended through an imaginative engagement' (Edensor 2003: 159), while leaving traces of their aesthetic qualities with the motorist. All of the public artworks located throughout the landscape of the EastLink Tollway assist in establishing the conditions for a 'complex, associational, and folded geography' (Edensor 2003: 156), as they have been interwoven into the fabric of the roadside environment. They elicit the traces of ideas, memories and events along with the other permanent and semi-permanent surroundings of the Tollway such as petrol stations, advertising billboards or broken-down motorists.

Within the Tollway's semi-privatized geographies the presence of site-specific public artworks helps to transform the motorist's journey along the route. As David Harvey notes:

> The elaboration of place-bound identities has become more rather than less important in a world of diminishing spatial barriers to exchange, movement and communication.
>
> (Harvey, cited in Hayden 1995: 43)

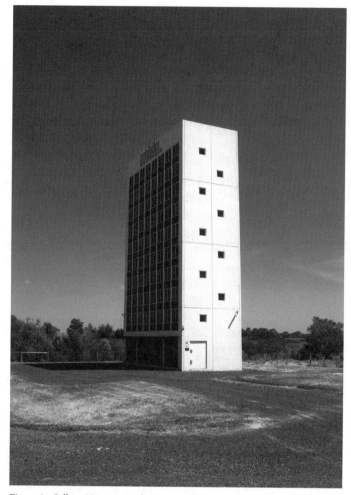

Figure 2: Callum Morton, *Hotel* 2008, installation, Eastlink Tollway Melbourne. Image: Ashley Perry 2012.

The experience of these artworks is most commonly witnessed and produced from within the car and this perspective accounts for the bold, imaginative and playful geometries that are encapsulated in their design.

The Vacant Hotel

In her recent survey of Callum Morton's career, *Call Me Mr. In-Between*, Linda Michael suggests that his 'highly ambivalent objects … animate the tensions between art and life, history and the present, and make us look again at the ubiquitous structures we see but

rarely notice' (2011: 3). Situated in an unlikely context and exhibiting a slightly altered and unfamiliar architectural quality, *Hotel* (see Figures 1 and 2), represents a particularly good example of Morton's ambivalence. His site-orientated or, arguably, context-specific public artwork invites motorists to gaze upon its deliberately-odd scale, and its slightly unconvincing prefabricated quality, as Michael notes:

> Fakery, mimicry and automation are used to comic effect, deflecting our anxiety about the life they hint at behind his walls and surfaces. Through his mastery of inference and implication, dumb staring turns into imagining and wondering. Everything is not alright in Morton's world, *our* world, and the viewer is asked to take the uncertainty on.
>
> (Michael 2011: 3)

Morton reinforces the strangeness of his work when he writes:

> 'Hotel' continues the development of what amounts to a parallel built universe that I have been constructing alongside the real world for a number of years. In this world things appear in unlikely contexts in oddly de-scaled and altered form, as if they have been pushed down a portal from the recent past and popped out mistakenly in this time and place. 'Hotel' appears as a piece of roadside architecture, only there are no other buildings for miles and you can't get in.
>
> (Morton 2007)

The unique qualities of *Hotel* coupled with the site-specific conditions attributed to its roadside position assist in problematizing the status/position of Morton as its creator. For although the artwork contains 'traditional aesthetic values such as originality, authenticity, and uniqueness' (Kwon 2004: 31), motorists encountering the artwork have no ability to identify its author, as the ability to stop and park in front of the artwork is strictly prohibited. In this instance, Morton, an internationally-recognized artist, is recast not as author but as 'a silent manager/director' (Kwon 2004: 31); yet this process does not impact upon the site-specificity of the public artwork, or on its boundedness with the Tollway landscape.

In relation to the position of *Hotel* within the geography of the Tollway, regardless of the ability of motorists to accurately identify the author of the public artwork, Callum Morton remains central to its creation and the 'progenitor of meaning' (Kwon 2004: 51). As Kwon suggests:

> What is prized most of all in site-specific art is still the singularity and authenticity that the presence of the artist seems to guarantee, not only in terms of the presumed unrepeatability of the work but ... the presence of the artist also endows places with a 'unique' distinction.
>
> (Kwon 2004: 53)

Morton articulates the distinctive qualities of his artwork in these terms:

> Hotel acts as a type of monument or mirror to the effect produced by both the car and the space of the tollway itself. It is strangely disconnected from the landscape it is in, and its form is distilled and generic rather than specific. It looks like a number of places simultaneously, as if its identity is unstable and still moving, but it is never quite of this world. In a sense the mirror effect it produces is simply a question about how our worlds are constructed, not an alternate vision but the same or slightly out of focus.
>
> (Morton 2007)

The importance of Morton's *Hotel* within the geography of the EastLink Tollway is ultimately linked to its association with motorists and to the 'flow of experience that moves inward and outward folding together places, people, stories, performances, and sensations over time' (Edensor 2003: 167).

Conclusion

As a transdisciplinary investigation into site-specific public art, drawing upon concepts and research from mobilities studies, this chapter argues that mobile practices and experiences are central to the co-production, animation, performance and control of urban spaces, places and landscapes. Although based upon the logic of contemporary neo-liberalism, the semi-privatized geographies of the EastLink Tollway offer complex, relational assemblages and sensibilities between site-specific public artworks and passing motorists that assist in re-configuring journeys along the route. These dynamic public artworks scattered along the edges of the Tollway assist in the production of place. Further to this they allude to an imaginative driving experience that significantly counters popular negative assumptions and characterizations related to the banal affects and mundane spaces of motorway driving.

References

Augé, M. (1995), *Non-Places: Introduction to an anthropology of supermodernity*, London: Verso.

Baudrillard, J. (1996), *The System of Objects*, London: Verso.

Böhm, S., Jones, C., Land, C., and Paterson, M. (eds) (2006), 'Introduction: Impossibilities of automobility', in S. Böhm, C. Jones, C. Land and M. Paterson (eds), *Against Automobility*, Oxford: Blackwell, pp. 3–16.

Borden, I. (2010), 'Driving', in M. Beaumont and G. Dart (eds), *Restless Cities*, London: Verso, pp. 99–121.

Casey, E.S. (1993), *Getting Back into Place: Towards a renewed understanding of the place-world*, Bloomington: Indiana University Press.

Cresswell, T. (2010), 'Mobilities I: Catching up', *Progress in Human Geography*, 35, pp. 550–58.

Cubitt, S. (2001), *Simulation and Social Theory*, London: Sage.

—— (1999), 'Virilio and New Media', *Theory, Culture & Society*, 16, pp. 127–42.

Davison, G. (2004), *Car Wars*, Sydney: Allen & Unwin.

Edensor, T. (2003), 'Defamiliarizing the Mundane Roadspace', *Space & Culture*, 6, pp. 151–68.

Hannam. K., Sheller, M. and Urry, J. (2006), 'Mobilities, Immobilities and Moorings', *Mobilities*, 1, pp. 1–22.

Hayden, D. (1995), *The Power of Place: Urban landscapes as public history*, Cambridge, Massachusetts: MIT Press.

Kwon, M. (2004), *One Place after Another*, Cambridge, Massachusetts: MIT Press.

Lefebvre, H. (1991), *The Production of Space*, (trans. D. Nicholson-Smith), Oxford: Blackwell.

Merriman, P. (2007), *Driving Spaces*, Oxford: Blackwell.

—— (2006), ' "Mirror, Signal, Manoeuvre": Assembling and governing the motorway driver in late 1950s Britain', in S. Böhm, C. Jones, C. Land and M. Paterson (eds), *Against Automobility*, Oxford: Blackwell, pp. 75–92.

—— (2004), 'Driving Places: Marc Augé, non-places, and the geographies of England's M1 motorway', *Theory, Culture, Society*, 21, pp. 145–67.

Michael, L. (ed.) (2011), 'Call Me Mr. In-Between', in L. Michael (ed.), *Callum Morton: In memoriam*, Melbourne: Heide Museum of Modern Art, pp. 2–51.

Morton, C. (2007), *Hotel*, Melbourne: ConnectEast Group.

Presland, G. (2008), *The Place for a Village*, Melbourne: Museum Victoria.

Reed, D. (2008), 'EastLink Motorway', *Landscape Architecture Australia*, 120, pp. 68–74.

Relph, E. (1976), *Place and Placelessness*, London: Pion.

Sheller, M. and Urry, J. (2006), 'The New Mobilities Paradigm', *Environment & Planning A*, 38, pp. 207–26.

—— (2000), 'The City and the Car', *International Journal of Urban and Regional Research*, 24, pp. 737–57.

Thrift, N. (1999), 'Steps to an Ecology of Place', in R.J. Johnston, P.J. Taylor and M.J. Watts (eds), *Human Geography Today*, Cambridge, UK: Polity, pp. 295–322.

Urry, J. (2000), *Sociology Beyond Societies*, London: Routledge.

Chapter 7

The Transient City: The city as urbaness

Maggie McCormick
RMIT University

Introduction

'The Transient City: the city as urbaness' looks to China's rapid urbanization and consciousness change in the twenty-first century to seek greater understanding of re-imagining of the city and self in the twenty-first urban century. The discussion applies a re-interpretation of Henri Lefebvre's 'Rhythmanalysis' (1985, with Régulier, and 2004) to a study of art practice emerging out of the contemporary Chinese experience. It can be observed that urban consciousness, that is the understanding of oneself as urban, is defined increasingly by what Lefebvre called arrhythmia or collision between or amongst two or more rhythms. What has changed is that this now takes place within accelerated transience. In addition, a growing love of transience or what is described here as transphilia (McCormick 2009), as well as a re-assessment of exacerbated difference (Koolhaas 2001) can be observed. The Chinese urban experience has led to an art practice that constructs spaces for possibilities to facilitate understanding of shifts in urban consciousness. The artistic practice of Ai Weiwei and the curatorial practice of Hou Hanru will be discussed for their ways of reflecting, creating and clarifying a consciousness shift that is moving towards urbaness as an understanding of the city as an increasingly connected urban mind space. Although their methodologies differ, the observation and analysis of Hou's and Ai's modes of practice provide signposts that assist in understanding urbaness as a category of thought not experienced in earlier urban scenarios. Signposts, while not definitive in their value, have the capacity to reveal challenges to current paradigms or modes of accepted ways of thinking or being, parallel understandings, moments of backlash and possible future directions. Henri Lefebvre observed the beginnings of change in urban consciousness in the twentieth century. Later, Hou Hanru (1991, 2002) coined the term 'mid-ground' to describe the twenty-first-century transitionary urban phase. The term still holds true today as the shift towards an urban world continues. The chapter begins by considering an earlier conceptualization of the urban, in the city of Beijing during the Ming Dynasty, and finishes by drawing a reinterpretation of Lefebvre's arrythmia together with the practice of Ai Weiwei and Hou Hanru to decipher aspects of the contemporary re-imagining of the city as urbaness.

The City and China: Ideas in flux

One wonders what the Ming Dynasty Yongle Emperor would have thought of the twenty-first-century urban world. In the fifteenth century the Emperor moved China's capital to Beijing and built the Forbidden City as its centrepiece, reflecting the meaning of the word 'China' or *zhongguo* as 'Empire of the Centre'. Although the emperor had sent out flotillas of ships to explore the world outside this perceived centre, could he have imagined how the city would be re-imagined through the ubiquitous contact of thousands of 'foreigners' crossing the Forbidden City's borders? Fast forwarding to the twenty-first century, could he have imagined how China's boundaries would become increasingly porous in an urban world with a Chinese population of some 1.3 billion and a Bejing city of more than 30 million? One wonders too what twentieth-century Mao Zedong might have thought about a shift in urban consciousness that now displays very different 'Shades of Mao' (Barmé 1996) as urbanites walk the streets of cities across the world in designer Mao jackets sporting Mao watches bought on the Shanghai Bund. Then there are Internet and mobile users who slip past the Golden Shield that is the great firewall of China. Mao's emperor-like portrait still hangs above the Gate of Heavenly Peace in Tiananmen Square but, nearby the square today, one can also see the floating titanium and glass egg-like shape of the National Theatre by French architect, Paul Andreu. A myriad of such buildings by inter-global architects define the new urban China over which Premier Wen Jiabao presided. The city of Beijing was evidence of Yongle's and China's centrality and power that was also true in many ways for 'Rural Mao' (Wasserstrom 2006: 19) as he re-imagined Beijing in his own image. The notion of the city and self are constantly in flux and both are once more in the midst of being re-imagined in ways not formerly experienced within China and beyond. In ways that are very different from both the Yongle Emperor's and Mao Zedong's urban imaginations, China remains central to understanding the re-imagining of the twenty-first-century concept of city and its role in reviewing understanding of the self as an urban entity.

Western media discussions of China revolve around criticisms of perceived political shortcomings, the impact of economic influences and, when addressing artistic practice, the focus is almost entirely on the commercialization of Chinese contemporary art. The public debate underestimates the contribution the Chinese experience makes to a broader reading of the re-imagining of the city and self in the first urban century. Not so academic and architect Rem Koolhaas, who has added another element by making urban China a focus of much of his writing and practice. Amongst other projects, he undertook the Harvard School of Design's *Great Leap Forward: Project on the City* in 2001 and worked with Hou Hanru on several occasions on China-focused projects such as *Beyond: An Extraordinary Space for Experimentation for Modernization* in 2005. Koolhaas recognizes China's 'great leap forward' as essentially an urban leap of accelerated encounter within the population of China as well as between East and West (Koolhaas 2001).

It is estimated that some 300 million people in China will be relocated to urban centres between 2000 and 2020 (UN Habitat n.d.). Urbanization of China is a 'leap within an

ancient tradition of cities' (Friedmann 2005: 1). 'Of all historical civilisations, it is China that has been characterised most by great cities' as until the Industrial Revolution in the West 'Chinese cities were ranked amongst the world's top three cities by population in every century over a millennium' (Taylor and Hoyer 2008: 23). Taylor and Hoyer list Kaifeng in 1100, Hangzhou in 1200, Najing in 1400 and Beijing in 1500 and again in 1800 ahead of London. Post-1900, China's urbanization slowed compared to the West but now China has over 120 cities with populations of over one million people (Johnson 2008: 13).

Because of China's growing worldwide influence, change within China has implications outside of its geographical borders. After many years of being a society predominantly closed to and from the West, today China's doors are ajar. Shanghai was one of the few exceptions to China's earlier exclusion of foreigners, with the 1842 Treaty of Nanjing opening up Shanghai to international trade and by 1854 to international concessions within the city. In the 1920s and 1930s Shanghai became a favourite destination for western élites and celebrities. Their perceived ideas of an exotic China were reflected in the concept of Shanghai as the 'Paris of the East'. The term metaphorically transposed the West onto the East and was materialized in the western-style buildings that border the Shanghai Bund. Although many of these buildings remain, they are now accompanied by contemporary skyscrapers such as those in the Pudong. This new part of Shanghai occupies the east bank of the Huangpo River, assertively facing the Bund and signifying a very different relationship between East and West today. While western architects have played a big role in China's contemporary architecture, such architecture now speaks of China's power, rather than that of the West.

Friedmann reminds us that both physical and consciousness changes taking place within China grow as much from internal catalysts as they do from external pressures (Friedmann: 2005). A slow transformation within internal introspection can be seen in the growing influence of what China observer John Garnaut calls the 'princelings' (Garnaut 2011b), the now-adult children of former Cultural Revolution leaders. Although their beliefs may differ they are beginning to have a say in China's future. 'The irony is that it is in China, not mainstream Western historiography, where the process of admitting other voices has begun' (Garnaut 2011a). These other voices find their roots in Deng Xiaoping's Open Door Policy of 1978, which marked a shift in attitude from the political orientation of Mao Zedong's policies to a predominantly economic perspective. Such change in perspective interwove with shifts in consciousness. Special Economic Zones were set up and opened to foreign investment and trade. Seemingly-instant cities emerged such as Shenzhen that grew from a small fishing village in 1980 to the bustling city of today of some nine million people. The impact of such a rapid rate of urban density has extended well beyond economics to open new political as well as cultural questions for consideration. Among these are questions of who really played the key roles in China's move to urbanization in contrast to what Garnaut describes as 'a time honoured tradition that each new Chinese dynasty gets to rewrite the history of its predecessor to legitimise its own rise to power' (Garnaut 2011a). For example, some historians are now challenging Deng's writing out of the role of Chairman Hua Guofeng,

among others (Teiwes and Sun 2011). However history views Deng, without 'Urban Deng' (Hu 2008: 147) and his imagining of an urban China, today's China would be very different. Perhaps what Hua Guofeng's re-inclusion tells us is that Deng was not alone in re-imagining China within an equally re-imagined urban world. In this process of re-accessing history within China the nature of the city itself has also come under review.

The physical incarnations of an urban century can be problematic. While social inequality, environmental pollution and political free speech continue to be issues raised about China, one can observe that there is an underlying recognition within China that 'China must change' (Charlton 2011: 22). The most recent 12th Five Year Plan delivered by past-Premier Wen Jiabao to the National People's Congress in March 2011 is a case in point (The Wall Street Journal 2011: n.p.n.). The plan, while attempting to address urban problems in practical ways by economic reforms such as lifting wages in the manufacturing sector, shifting workers to higher paid service industries and refocusing the economy on domestic rather than export markets, acknowledges also that there is a change in understanding of urban consciousness. China is not new to mind-shifts moving from dynastic to republican to communist states and now moving to what the past-Premier Wen Jiabao described as 'socialism with Chinese characteristics' (Wen 2011) or, as it is often referred to, as capitalism with Chinese characteristics.

The Mid-Ground: A process in progress

Contemporary China sits on the brink of another change of mind-set, shaped in part by a global re-imagining of the urban self 'on the mid-ground' (Hou 2002), as we move 'beyond the old order of nation states and the separation between the East and the West' (Hou 1991: 191). Hou Hanru says of himself 'I am not a Chinese curator' (Hou 2007: 85) despite the fact that he was born in China. In saying this he reflects his own position on the urban 'mid-ground', moving first to Europe and then to the United States of America as well as curating exhibitions across the world. This experience of transient urban encounter frames his consciousness and sense of identity that is in transition within a steadily-increasing urban process. The 'UN Habitat State of the World Cities' report (UN Habitat n.d.) has identified that a century ago only 10 per cent of the world's population lived in cities. By 2030 it is predicted that some five billion of the estimated eight billion worldwide will be urban dwellers. 2008 was a tipping point when the world's urban population moved to over 50 per cent. A 'space of flows' (Castells 1996) across urban space has been identified as 'ethnoscapes', technoscapes', 'mediascapes', 'finanscapes' and 'ideascapes' (Appadurai 1996). Many of these social-, economic- and political-flow communities serve to solidify national, ethnic or religious identity manifesting itself at the worst end of the spectrum as extremism and terrorism. On the other hand, many paradigms founded on concepts of belonging to one city, nation or ethnicity, are being eroded by cities themselves. New concepts of the urban that can be described as a 'mindscape' connect cities more strongly to each other than

to the physical territories they inhabit. In these 'liquid times' (Bauman 2007) a sense of disorder may be a destabilizing process that creates 'an ideological vacuum' in the short term. It is also recognized that what has been called the 'Urban Revolution' (Brugmann 2009), that is the process of 'organization of the planet itself into a City: into a single, complex, connected, and still very unstable urban system' (Brugmann 2009: ix), is a time 'rich with possibilities for creating new human values' (Wu 1999: 128). This is a revolution of thought and of how we conceptualize the city and self.

Physical changes on the 'mid-ground' can be quantified to a large degree, but moves in consciousness require different observational tools. It is argued here that one such tool is a study of art practice emerging from within China itself, not so much through an analysis of production or modes of commerce as through an understanding of practice and modes of intellect and imagination. Within this sphere are the curatorial practices of Hou Hanru and the artistic practice of Ai Weiwei. Both have emerged out of the Chinese experience while now operating globally. It is argued that a reinterpretation of Henri Lefebvre's Rhythmanalysis applied to the practice of Hou and Ai can reveal clues as to the nature of contemporary re-imagining of city and self. Even though Lefebvre's ideas evolved out of a twentieth-century European urban scenario, it is argued that his notion of arrhythmia is now in tune with the transience of this urban century. To begin we need to consider the concept of Rhythmanalysis and its role in understanding how the city has been imagined and is being re-imagined.

Arrhythmia: An idea born posthumously

At the end of Lefebvre's life that spanned almost the entire twentieth century and played out far from China, his thoughts returned to the idea of the city as rhythm. Lefebvre can be thought of as an urban theorist, philosopher and creative observer. It is difficult to categorize such a thinker. Perhaps it is this difficulty in categorization that makes Lefebvre's observations so pertinent to an analysis of today's urban world in which departmentalization of ideas is increasingly blurred. As Lefebvre looked out of his apartment window on Rue Rambuteau across the quintessential city of twentieth-century imagination, Paris, he observed the beginnings of a re-imagining of the idea of the city not formerly experienced. He was not alone in his observations. Gaston Bachelard for one had also pondered on the city and its rhythms in his publication *Poétique de l'espace/Poetics of Space* (1994) but it was Lefebvre who developed the idea into a methodology, a mode of analysis to understand the changing nature of urban space. Lefebvre's last thoughts in *Eléments de Rythmanalyse: Introduction à la connaissance des rhythmes* (1992)/*Rhythmanalysis: Space, time and everyday life* (2004) were ideas destined to be 'born posthumously' (Elden 2006: 185). Even after Lefebvre's ideas on Rhythmanalysis were translated into English from the original French publication, most urban theorists did not regard the ideas as highly as those in his better-known publications in the English-speaking world, such as *La production de l'espace*

(1974)/*The Production of Space* (1991). The city as lived social space has framed much contemporary thinking on cities, but it was not until more recently that concepts inherent in Rhythmanalysis have coincided with the lived experience of the twenty-first century and led to the re-thinking of how Lefebvre's ideas might be applied to today's urban condition (Highmore 2005; Meyer 2008). Lefebvre endeavoured to understand the city through the analytical tool of rhythm that he defined as polyrhythmia or co-existence of two or more diverse rhythms, eurhythmia or association between different rhythms and isorhythmia or equality between rhythms, implying equivalence of repetition, measure and frequency. His final work built on earlier explorations by others, including his collaboration with Katherine Régulier (Lefebvre and Régulier 1985, 1986). Their work investigated the role of rhythm in relation to individual and groups of cities already recognizing urban groupings and networks that would later expand into far more complex networked relationships. When he wrote *The Urban Revolution* in 1970, Lefebvre recognized that a revolution was in progress, that society had become urbanized and that it was the urban that shaped society (Lefebrve 2003), but it was not until later applications of his ideas that the significance of urban consciousness has come to the forefront.

Ben Highmore (2005) recognized the role that Rhythmanalysis could play in understanding cityscapes by taking movement and mobility as crucial points of perspective. Highmore draws from twentieth-century experience of the material and symbolic forms of urbanism and applies this to largely European and American cities. In many ways the attempt here is to add another chapter that applies Lefebvre's analysis and extends Highmore's observations to the contemporary experience of the city as a connected urban mind space with the emphasis on the role China plays in this re-imagining of the city. As Highmore notes, '[t]here is a good reason for assuming that 'rhythm' is going to be a vital aspect of all cities and all texts concerned with figuring the city' as rhythm is a dynamic interplay of forces and the city the most complex exemplar (Highmore 2005: 141). Even though many urban thinkers have now embraced rhythm within space and time as a tool of urban investigation, and while the world's population has never before been so influenced by urban activity and experience, 'the urban seems to be least understood at the very moment of its apotheosis' (Koolhaas 2001: 27). It is argued here that it is Lefebvre's observation of arrhythmia within his observations of city rhythms that holds clues to understanding how the city is being re-imagined in the first urban century. In a relatively recent publication on reading Henri Lefebvre (Goonewardena et al. 2008), I could find only one reference to Lefebvre's ideas on arrhythmia in the use of the word arrhythmic (Meyer 2008: 154). Lefebvre identified arrhythmia as conflict between or among two or more rhythms and likened this scenario to what might biologically occur in an ill person. In this sense arrhythmia can be seen as a negative that he described as 'fatal disorder' (Lefebvre 2004: 16), but also a positive in that he also observed that rhythms become clearer at the point at which they break down. Conceptually this relates to Lefebvre's ideas of moments when change takes place.

Some two decades after his death, Lefebvre's concept of arrthymia is now in an accelerated transient context and re-shaped by the ubiquitous experience of collision as an integral part

of the collective urban experience. This has physical implications but, more importantly, it frames a different kind of mind space than that explored by Lefebvre. Just as the material city has long and complex histories so too 'the immaterial city has its own histories' (Donald 2000: 4). Material cities are physically expanding, shrinking and merging. The immaterial city, that is urban mind space or consciousness, is also in a process of change. It is clearest at the arrhythmic points, indicating that the understanding of the city has now become predominantly a 'category of thought and experience' that has produced 'a unique way of seeing and being' (Donald 1999: 121). This is in contrast to the physical commercial networks that dominated city re-imaginings in the 1980s and 1990s (Friedmann 1986; Sassen 1991). Today 'World = City' (Koolhaas 2001) as a mindscape is at the centre of twenty-first-century re-imagining. Central to this mindscape is transience.

Transience: Acceleration, movement and density

Increasingly one is 'born urban, born transient' (McCormick 2009: 17) within a conceptual framework that aligns perceptions of world with the idea of city. Understandings of 'what used to be the city' (Koolhaas 2001: 19) are challenged, as are perceptions of self. Transience re-conceptualizes the city from an understanding of separate city connections or even networked connections, to an awareness of collective urban consciousness that grows out of all urban experience defined here as 'urbaness' (McCormick 2009: 30). As the urban world is rapidly compressed, movement as both physical and virtual mobility and density is an everyday experience and, as such, has become as significant as space and time in reconfiguring the notion of city and belonging. The experience of compression brought about by the first trains in the nineteenth century and the first planes in the early twentieth century drew cities closer together while also expanding the individual's sense of connection, not only physically but also mentally. Today, the experience of instantaneous satellite connection means that connectivity is created through the click of a computer or the ring of a mobile phone, as Google, Skype, Twitter, Tumblr crisscross a virtually-borderless planet. While recognizing that not all of the earth's population can necessarily move with physical or virtual ease and for some mobility is a necessity, it is the understanding of the impact of increased mind mobility that is at issue here. Such a constantly emergent state, moving from one temporary configuration to another, may be considered as a product of an urban world and impacts on all its inhabitants. Images and sounds connect in a dense multiplicity of layered transient alignments, more often than not arrhythmic in character. World = City can be re-imagined again as 'World = The Transient City' (McCormick 2009: 20).

It is important here to note that transience is an integral part of the urban condition. In today's context, what differs is its acceleration. Looking back, one has only to think of the nineteenth-century poet Charles Baudelaire's understanding of urban modernity within the context of the city as transient, fleeting and contingent in his influential 1863 essay, *Le peintre de la vie moderne/The Painter of Modern Life* (1964). Baudelaire says that one should

not despise this transitory fleeting element and indeed my argument builds on this idea. The uniqueness of today's transience is that it now has a global context that is embedded in urbaness to the point that it can be argued that there is a love of transitory elements that I have defined elsewhere as 'transphilia' (McCormick 2009: 19). Like Baudelaire, Walter Benjamin understood that transience was central to understanding modernity in the twentieth century as he observed urban life and art in the era of mechanical reproduction in such influential essays as *Das Kunstwerk im Zeitalter seiner Technischen Reproduzierbarkeit/ The Work of Art in the Age of Mechanical Reproduction* (2008). The idea of the *flâneur* runs through both Baudelaire's and Benjamin's analysis of the city. Later Guy Debord and others associated with the Situationists transformed the practice of the *flâneur* into the unintentional chance encounters of the *dérive*. Debord and Lefebvre knew each other well and, despite some disagreements, both had deciphered the constructed and unintentional arrhythmia of the city. In the twenty-first-century urban world the strolling movement of *flânerie* and the drift of the *dérive* are accelerated by instantaneous mobility within dense urban space in an endless arrhythmic pattern. Suggestions of urban disorder evident in the *dérive* are now central as a means of understanding the city. Rem Koolhaas describes it in today's terms as 'exacerbated difference' (Koolhaas 2001: 21). He developed this idea through observation of places such as the Pearl River Delta in China as a new form of urban co-existence. Koolhaas defines this new condition as based on the greatest possible difference between its parts, in opposition to the traditional city values of striving for individual identity. His interest lies in the conceptualization of city as flukes, accidents and imperfections and the opportunistic exploitation of these. The model easily transfers to a global urban co-existence made possible because of, and in spite of, apparent disorder of compatibility that can be seen as an extension of Lefebvre's concept of arrythmia.

Baudelaire, Benjamin and the Situationists looked to new art practices as a way of interpreting transience within the context of their times, as does Koolhaas in his architectural work and Wu Hung in his cultural commentary. Wu has observed that transience is one of the themes critical to an understanding of the immaterial within Chinese contemporary art (Wu 1999). He applies this thinking to his assessment of contemporary China in 'Remaking Beijing: Tiananmen Square and the Creation of a Political Space' (Wu 2005) by viewing through the lens of contemporary art practice. In this way he deciphers the inherent urban meanings and overlays now associated with Tiananmen Square, post the 1989 shooting of demonstrators by the Chinese Government, that otherwise might pass by unnoticed. Artistic thinking today operates in a dense and mobile arena in which concepts of time, space and human interaction are in a state of flux. Arguably, one could say that visual culture has been central to understanding the urban world (Highmore 2005) as well as central to the West's understanding of Asia, albeit at times through interpretations coloured by a perceived exoticism of the East by the West. Such perceptions have given way in the cold hard light of global urban flow. At the end of 1999, the artist Cai Guo Qiang instigated a gunpowder explosion that created the outline of a dragon in the sky over the European city of Vienna, titled *Dragon Sight Sees Vienna*. The concept is a powerful symbol of what is

being recognized increasingly as not only an urban century but also an Asian-dominated century and more precisely, a Chinese century.

China on the Move: Art in transit

Chinese art and artists increasingly transit the urban world through exhibitions and collections. One such collection is *White Rabbit* (co-curators Judith and Paris Neilson, curatorial consultant Wang Zhiyuan). This collection and regularly-changing displays of Chinese art from 2000 was launched in Sydney in 2008. Located in a renovated warehouse, it is estimated to have cost some ten million AUS dollars. Collections and major survey exhibitions of contemporary Chinese art in galleries outside of China followed China's own recognition of the potential of the *avant-garde* with the staging of the 1989 exhibition, *China/Avant-Garde* (National Art Gallery, Beijing, curator Gao Minglu). The 1979 Stars and the more radical *85 Art New Wave* played a significant role leading up to the China/Avant-Garde exhibition and the Chinese Government's softening of its tolerance of contemporary art. This hardened again in the Chinese Government's heavy handed response to the 1989 Tiananmen Square protests, but as a 'No U-Turn' traffic sign placed outside the China/Avant-Garde exhibition flagged, there is no turning back. Following soon after the Beijing exhibition and spreading its influence internationally was *Les magiciens de la terre* 1989 (Georges Pompidou Centre and the Grande Halle at the Parc de la Villette, Paris, curated by Jean-Hubert Martin). In 1986, curator Fei Dawei took a collection of 1,200 slides of contemporary Chinese art to Paris instigating this exhibition that featured 50 Asian, African, Oceanic artists with 50 western artists. This Paris exhibition was the first time that Chinese contemporary art had been shown in a western public gallery. Many others followed including *China's New Art, Post-1989* (Hanart T Z Gallery, Hong Kong, curator Chang Tsongzung) that travelled to Australia and the USA in 1993. Others include *Inside Out: New Chinese Art* 1998 (Asia Society Galleries and P.S.1 Contemporary Art Centre, New York and the San Francisco Museum of Modern Art and other galleries in the USA, Mexico and the Asian region, curated by Gao Minglu); *Transience: Chinese Experimental Art at the End of the Twentieth Century* 1999 (The David and Alfred Smart Museum of Art, University of Chicago, curated by Wu Hung); *Alors la Chine* 2003 (Georges Pompidou Centre, Paris, curated by Fan Di'an); *China Now* 2006 (Sammlung Essl, Vienna, curated by Feng Boyi); *China Power Station* 2006 to 2008 (Serpentine Gallery and Battersea Power Station, London and Astrup Fearnley Museum of Modern Art, Oslo and Beijing, curator Hans Ulrich Obrist); *The Real Thing* 2007 (Tate Liverpool UK, curated by Simon Groom and Karen Smith.); and *Body Language* 2008 (NGV International, Melbourne, curated by Dr Isabel Crombie).

The 1993 Venice Biennale was the first to include Chinese artists. The number of artists participating in biennales has continued to increase and their impact has grown. Chinese artist Cai Guo Qiang for example has exhibited in more biennales than any other artist from the East or the West. Many galleries from other parts of Asia and from the West have moved

to China, in particular to Beijing and Shanghai. In 1991, Australian-born Brian Wallace set up Red Gate Gallery in Beijing and Swiss born, Lorenz Helbling set up ShanghART in 1996 in Shanghai. These are both now well-established China-based galleries. The establishment of the Ullens Center for Contemporary Art in 2007 in the 798 Art District in Beijing by Belgian collectors Guy and Myriam Ullens, with its emphasis on archiving and research, marks a significant point in the internal and interurban recognition of Chinese contemporary art. The opening exhibition of UCCA was titled *85 New Wave Art: The Birth of Chinese Contemporary Art*, curated by Fei Dawei.

The China Phenomenon: More than commerce

This explosion of contemporary art within China and from China has been referred to as 'The China Phenomenon' (Britton and Huangfu 2003). Much of the interest hinges on investment possibilities of contemporary art production seen first through the rise of the European market for Chinese contemporary art and more recently the rise of a domestic market as China's middle class grows wealthier. Although some claim that generally the 'China Fever' (Maerkle 2008: 22) apparent in the West has been overplayed, it is becoming increasingly evident that China and the growing urban world are economically intertwined. Independent of these commercial considerations, it is argued here that this entwinement extends to urban consciousness and that perhaps this is the most significant aspect of the 'China Phenomenon'. Artistic and philosophical thinking together with political awareness play a critical part in understanding the re-imagining of city and self. Henri Lefebvre's urban analysis and thinking 'was always philosophically informed and politically aware' (Lefebvre 2004: xv) framed by the context that 'he thought like an artist' (Castells, cited in Merrifield 2006: xxii). Lefebvre counted many artists amongst his closest friends, perhaps indicating his high regard for their mode of thinking. Two key creative thinkers who engage the artistic, the philosophical and the political to varying degrees in their urban analysis though practice are artist Ai Weiwei and curator Hou Hanru. Both are part of the China Phenomenon.

Born in 1957, Ai Weiwei's life experience was impacted by the Cultural Revolution through the denouncement of his poet father, Ai Qing, in 1958 when the family was sent to a labour camp, where they remained until 1975. Later Ai Weiwei left China, as did many others, to live for the most part in New York. Again like others, he moved back to work as a professional artist in China. Hou was born in 1953 and left China in 1990 to live in Paris and more recently in San Francisco. He remains living outside of China while at the same time engaging in cultural commentary on art production and practice emerging out of contemporary China. There are differences between Hou and Ai in both practice and intention. Observation of their individual practice reveals constructed as well as unanticipated arrhythms growing out of their urban analyses through art practice. This creates not a condition of either/or but something altogether new to reveal shifts in urban consciousness and perceptions of self that

reflect a process evident in China itself of 'reinventing of its own culture' (Fei 2007: 1). Such a reinvention takes place within 'circular movements of ideas' (Huangfu 2001: 200) and an increasing experience of transience across the urban world.

Culture in Transit: A new East/West

The rise of what might be viewed as unauthorized 'special cultural zones', such as the 798 Art District, facilitates the circular movement of ideas. This is moving East/West relations towards a practice 'created jointly by China and the West' through 'the interaction of inseparable societies caught up in the process of globalization' (Leng 2000: 62–66). A seminal work by artist Huang Yong Ping, in 1987, heralded this future scenario. The artist put two books – 'The History of Chinese Art' and 'A Concise History of Modern (Western) Art' – into a washing machine. The result was something entirely new, a pile of pulp that symbolically was neither the East nor the West. The East/West discourse can be read as both an encounter and a collision of opposites. As such it can be considered an arrhythm, however 'these dualities are not polarised but combined' (Fuchs, cited in Zhaohui 2005: 32). Exchange between cultures is always a two-way process. The balance and form of that flow is changing as half of the world's population now live in Asia, and the capacity to transit borders is steadily increasing. Equally, art practice in both the East and the West has taken a relational turn that embraces transience as a key element in the creation of art. The 798 Art District is like a microcosm of this relational turn and the changes it has wrought in China's urban consciousness, from identification with a particular city to identity though urbaness, and from art as cultural object to art as 'relational aesthetic' (Bourriaud 2002) that asserts the role of art practice over art production.

The 798 Art District is a kilometre square area in the Dashanzi district, northeast of central Beijing. In 1957 the district opened as a showcase factory area of the recently-formed People's Republic of China. Later the area was divided into units, the largest of which was *sub factory 798*. Today, this 1200-metre-square factory space is the 798 Art Factory, a contemporary art gallery set up by artists Huang Rui and Xu Yong. As a state-owned factory site it declined during Deng Xiaoping's 1980s' economic reforms. Sixty per cent of the workers were laid off by the end of the 1990s. This economic change coincided with the emergence of an avant-garde in China, and growing international awareness of the Chinese contemporary art movement. In 1995, Beijing's Central Academy of Fine Arts moved into the vacant factories and, by the start of 2000, Chinese and non-Chinese alike were setting up galleries. The 798 Art District even has its own biennale, the Dashanzi International Arts Festival, which began in 2004. The changing attitude of the Chinese Government towards the 798 Art District is symptomatic of shifts more generally. The area is managed by the Seven Stars group, who originally saw an economic advantage in renting out the vacant factories to artists. Later, they made moves to demolish the factories and build a new electronics centre. In 2006 an eviction notice was served. This was put on hold by the Central Government, and Beijing's mayor, Wang Qishan, put a preservation order on the site. In the run up to the Beijing Olympics, the government

injected some fourteen million US dollars to give the site a makeover. The potential as a tourist destination is well recognized. The site has shifted its identity from model-factory site in a bordered China to model-art site in a global transient world. Art and politics are coinciding again as they did during the Cultural Revolution, albeit in a different way. The symbolism of the recent announcement that the new National Art Museum of China is to be constructed next to the Olympic Stadium marks the movement of contemporary art to centre stage, but this move has also brought its backlash.

Backlash on the Mid-ground: The arrhythm of Ai Weiwei

Another 'art district', FAKE Design, established by Ai Weiwei in Beijing in 2003 reflects change, but also backlash as art, philosophy and politics clash. Ai's commentary through exhibitions, publications and online Blogs has become increasingly verbose and difficult to disengage from his political activity. This can be seen in his strong criticism of the Chinese Government over its handling of the Beijing Olympics despite the fact that he had been part of the design team for the Olympic Stadium. In 2009 Ai posted on his studio walls the names of over 5,000 children killed in the 2008 Sichuan earthquake while concurrently publishing the list on his Blog. In Ai's practice generally any perceived boundary line between art, philosophy and politics is blurred. Art and activism are intertwined in all his practice, from his gallery work to his public installations, architecture and Blogs, web sites and Twitter zones. His work has become more and more extreme to the point of him becoming 'a no holds-barred dissident on a collision course with the government' (Johnson 2011). Just prior to his arrest he published an almost-nude picture of himself on the Internet. The caption characters have a double meaning in Chinese, so millions of Internet users have interpreted the characters as 'F...k your mother, the party central committee' (Sheridan 2011). Much of Ai's virtual presence has disappeared due to intervention by the Chinese Government. His Internet pronouncements now take new forms such as the book publication, *Ai Weiwei's Blog: Writings, interviews and digital rants 2006 – 2009* (Ai and Ambrozy 2011). The closing down of Ai's Internet presence in China, the bulldozing of his studio in Shanghai and his arrest at Beijing's airport in April 2011 can all be seen as aspects of backlash within a period of political, social and economic transition. After his arrest it was not clear what had happened to Ai and his secret detention had all the hallmark signs of China's past. In time, a reported visit by Ai's wife, Lu Qing, confirmed that he appeared to be unharmed (Sheridan 2011). In June 2011, Ai was released from what was reported as 'residential surveillance' (Wong 2011) at the same time as Hu Jia, a prominent prisoner of conscience, was also reported released (Martin 2011) among a series of high profile releases around the time of celebrations of the sixtieth anniversary of Communist Party rule and the ninetieth anniversary of the founding the Chinese Communist Party. The releases and the timing of them could be interpreted as symptomatic of shifts on the mid-ground. Ai has been accused of tax evasion and only time will tell if this was indeed the cause of his arrest or if in fact his

arrest was a means of trying to silence this outspoken artist. Whatever the outcome, his arrest indicates that the arrhythm created through Ai's persistent irreverence still has consequences in China. Ironically, it could be said that China itself created the possibility of Ai's outspokenness by opening its intellectual borders at a time when 'postmodernist pastiche, sensationalism and performance art were reaching their ascendency in the West' (Smith 2011: 58). By moving to New York, Ai's artistic thinking was grounded in this ascendency and is now being played out in China. Arrhythm is the cental characteristic of Ai Weiwei's methodological processes. Arrhythm and backlash are integral parts of the mid-ground between urban past and future.

Ai himself can be seen as on the mid-ground through his art production that often reflects the fact that he 'remains a profound nationalist' (Smith 2011: 59) while his practice can be seen to be an expression of an erosion of nationally-perceived culture. His practice demonstrates a positioning within the mind space of urbaness as he both destroys (*Dropping a Han Dynasty Urn,* 1995) and reassembles chairs, tables and vases into new configurations (*Table with Two Legs,* 2004). The content, though, is drawn from a past, less dense, urban consciousness, full of culturally-bound Neolithic vases and Ming chairs and tables, as in the case of the two examples cited here. Nationalism and urbaness create an arrhythm within Ai's practice, a discord that offers something quite different, not necessarily intended by the artist. As he reassembles, re-paints, rearranges, the underlying questions are embedded in his Chinese experience sitting side by side with his status as 'global man' (Johnson 2011). It must be said that Ai appreciates arrhythmia, displaying a sense of transphilia or love of transience, symptomatic of contemporary times. This was most evident when *Template,* his 1997 Documenta 12 artwork consisting of wooden doors and windows from Ming and Qing Dynasty houses (1368–1911) collapsed. He declared that he liked it much better. His attitude reflects the playfulness of his early Dada-influenced works, but it is also recognition that the collapse transformed the work from a static object into an idea in motion.

Ai Weiwei: Methodology for possibilities

Ai's practice sets up structures that 'make room for possibilities' (Ai cited in Bingham 2010: 11) rather than definitive statements and creates what Lefebvre called 'moments' of change, Debord called chance and Koolhaas calls exacerbated difference. Within this practice Ai creates moments of connection between disparate and unexpected actions and objects that disturb and transform the status quo. Ai's *Sunflower Seeds* at the TATE Modern, London, UK 2010 and his *Fairytale* at Documenta 12, Kassel, Germany 2007 both demonstrate this practice. As in Lefebvre's theoretical inquiry, Ai's practice in both *Sunflower Seeds* and *Fairytale* reveals multiple philosophical layers of intention combined with political overlays that reflect his consciousness on a shifting mid-ground. At one level both art works address issues of Chinese culture and politics; at another level the works are symbolic of a worldwide shift in consciousness that could only have been imagined and undertaken in an

urban century. Within this context Ai's practice is enigmatic and contradictory in that it is part of an unfinished process. *Sunflower Seeds* consists of one hundred million porcelain seeds, hand painted by 16,000 artisans from Jingdezhen city where Imperial porcelain was produced. The devaluation of the individual within the mass is central to Ai's intention, as is the reference to Mao's countless portraits that incorporate sunflowers. At the same time the number of seeds in the Turbine Hall in London perhaps inadvertently connects the viewer's mind to contemporary 'revolutions' in the Middle East and the implications these may have for China. *Fairytale* is also a multi-layered work. By transporting 1,001 people from various backgrounds from cities across China to Kassel, the German Documenta city, Ai again highlights questions of individual and mass within the Chinese context while almost inadvertently employing a transient practice seeped in arrhythmia. This was most evident in the continuous movement and re-assemblage of the 1,001 chairs by visitors to Documenta 12 and in the random movement of Chinese people across the city of Kassel.

Hou Hanru: Constructed shifts

Although less provocative on the surface, it is in Hou Hanru's curatorial practice that the seeds of change can be identified most clearly. Hou's methodology can be seen as an arrhythmanalytical tool as he curatorally constructs a set of arrhythms that become the basis of inquiry though practice. Lefebvre is written all over it, though not acknowledged as such by Hou. His approach is not so much to respond to or reflect artists' new ways of making art as to create a dense interrelationship between curator, artist and audience through movement as an integral part of the exhibition model. *Cities on the Move* (1997–2000) was jointly curated with European-born Hans Ulrich Obrist. It began in Vienna as the Secession celebrated its centenary of the break away of a group of avant-garde artists from the more traditional Vienna Künstlerhaus artists at the turn of the twentieth century. Above the entrance of the Secession building in Vienna a sign reads in German *Der Zeit ihre Kunst. Der Kunst ihre Freiheit*/To the Age Its Art. To Art Its Freedom. Like the Secessionists, Hou is seeking the art of his age. The model developed for Cities on the Move was pivotal in changing many modes of curatorial practice. The title itself flags its intensions. Central to the new practice was movement or transience but also a changing relationship between East and West. Concepts of joint transformation have replaced concepts of exoticism of the other. Such a mind space could only be shaped by urbaness. Hou constructed an inter-disciplinary, inter-cultural, inter-urban mapping that embraced multiple cities over its timeframe, each time reinventing itself. Each component was connected to the other through arrhythm and transience. This is even more evident in the curatorial model for the second Guangzhou Triennial in 2005 titled *Beyond: An Extraordinary Space for Experimentation for Modernization*. It did indeed go beyond conventional curatorial models. Again Hou worked with Obrist as well as Guo Xiaoyan and Wang Huangsheng, curator and director of the Guangdong Museum. The intention was to interrogate the Pearl River Delta as an urban performative mind space,

rather than set out to represent the changes taking place through artistic interpretation. The key word is performative. It is a word that embraces cultural collision as a 'reciprocal contact zone' (Obrist 2005) within which new values and understandings of city and self are shaped by urbaness. Hou has turned the exhibition model into an act that is a 'process of de-identification, re-identification and re-invention of the self' (Munroe 2008: 79). Rem Koolhaas is a favourite of Hou and one can see why by observing how Hou's curatorial strategies are played out by Koolhaas. Koolhaas's *Hyper Building* in Cities on the Move created 'spontaneous diversity' (Koolhaas, cited in Hou and Obrist 1997: 35) by creating a vertical population density comparable with the density, complexity and diversity of thirty-six square kilometres of horizontal central Bangkok. In *Beyond: An Extraordinary Space for Experimentation for Modernization* he randomly inserted a library across an existing residential building. As with Hou, he constructs a space within which transience, arrhythmia and exacerbated difference are the key performative elements.

The Transient City: The city as urbaness

In this chapter it has been argued that the city in the twenty-first urban century is in the process of being re-imagined as urbaness. China's rapid urbanization and its associated changes in consciousness along with the art practice emerging out of this experience has provided a platform from which to investigate urbaness. Within that platform the practice of Ai Weiwei and Hou Hanru suggest clues as to changes taking place in the urban consciousness of the first urban century. Through applying a re-interpretation of Henri Lefebvre's Rhythmanalysis to Ai and Hou's practice it has been shown that both reinforce observations of China more broadly. The indications are that the city is in the process of being re-imagined as a mindscape that embraces accelerated transience and arrhythmia as increasingly natural states of thought and being.

References

Ai, W. and Ambrozy, L. (ed.) (2011), *Ai Weiwei's Blog: Writings, interviews and digital rants 2006–2009*, Cambridge, Massachusetts: The MIT Press.

Appadurai, A. (1996), *Modernity at Large: Cultural dimensions of globalization*, Minneapolis, Minnesota: University of Minnesota Press.

Bachelard, G., (1994), *The Poetics of Space*, (trans. M. Jolas), Boston, Massachusetts: Beacon Press. First published in French 1958. First English edition 1964.

Barmé, G. (1996), *Shades of Mao: The posthumous cult of the great leader*, Armonk, New York: M.E. Sharpe.

Baudelaire, C. (1964), *The Painter of Modern Life: And other essays*, (trans. J. Mayne), London: Phaidon. First published in French 1863.

Bauman, Z. (2007), *Liquid Times: Living in an age of uncertainty*, Cambridge, UK: Polity.

Benjamin, W. (2008), *The Work of Art in the Age of Mechanical Reproduction*, (trans. J.A. Underwood), London: Penguin. First published in French 1936, in German 1955.

Bingham, J. (ed.) (2010), *Ai Weiwei Sunflower Seeds*, London: TATE Publishing.

Bourriaud, N. (2002), *Relational Aesthetics*, (trans. S. Pleasance, F. Woods and M. Copeland), France: les presses du reel. First published in French 1998.

Britton, S. and Huangfu, B. (eds) (2003), 'The China Phenomenon', *Artlink*, 23: 4.

Brugmann, J. (2009), *Welcome to the Urban Revolution: How cities are changing the world*, Australia: University of Queensland Press.

Castells, M. (1996), *The Rise of the Network Society*, Cambridge, Massachusetts: Blackwell Publishers.

Charlton, A. (2011), 'Bitter Fruits: China's twelfth five-year plan', in B. Naparstek (ed.), *The Monthly: Australian politics, society & culture*, June, pp. 20 –26.

Donald, J. (2000), 'The Immaterial City: Representation, imagination and media technologies', in G. Bridge and S. Watson (eds), *A Companion to the City*, Malden, Massachusetts: Blackwell Publishers.

—— (1999), *Imagining the Modern City*, London: Athlone.

Elden, S. (2006), 'Some are Born Posthumously: The French afterlife of Henri Lefebvre', in *Historical Materialism*, 14: 4, pp. 185–202.

Fei, D. (2007), curatorial essay, in *'85 New Wave Art: The Birth of Chinese Contemporary Art* catalogue, Beijing: Ullens Centre of Contemporary Art.

Friedmann, J. (2005), *China's Urban Transition*, Minneapolis: University of Minnesota press.

—— (1986), 'The World City Hypothesis', in *Development and Change*, 17, The Hague: International Institute of Social Studies, pp. 69–83.

Garnaut, J. (2011a), 'Revising the Great Revisionist's Work', *The Age*, 7 June, pp. 8–9.

—— (2011b), 'China's Princelings Break their Silence', *The Sydney Morning Herald*, 7 October.

Goonewardena, K., Kipfer, S., Milgrom, R., Schmid, C. (2008), *Space, Difference, Everyday Life: Reading Henri Lefebvre*, Hoboken: Taylor and Francis.

Highmore, B. (2005), *Cityscapes: Cultural readings in the material and symbolic city*, Houndmills, Basingstoke, Hampshire and New York: Palgrave Macmillan.

Hou, H. (2007), *Trans(ient) City: Luxembourg cultural capital of Europe*, catalogue, Barcelona: Bom Publishers.

—— (2002), *On the Mid-Ground*, Hong Kong: Timezone 8 Ltd.

—— (1991), 'On the Mid-Ground: Chinese artists, diaspora and global art', in *Beyond the Future*, Third Asia-Pacific Triennial exhibition catalogue, Brisbane: Queensland Art Gallery, pp. 34–51.

Hou, H. and Obrist, H.U. (2007), *Cities on the Move*, catalogue, Ostfildern-Ruit: Gerd Hatje Verlag.

Hu, R. (2008), 'China's Urban Age', in C. Johnson, R. Hu and S. Adedin (eds), *Connecting Cities: China - a research publication for the 9th World Congress of Metropolis*, Sydney: Metropolis Congress, p. 147.

Huangfu, B. (2001), 'In and Out', in H. Wu (ed.), *Chinese Art at the Crossroads: Between past and future, between East and West*, London: New Art Media Ltd. and Institute of International Visual Arts, pp. 200–209.

Johnson, C. (2008), 'Introduction', in C. Johnson, R. Hu and S. Adedin (eds), *Connecting Cities: China - a research publication for the 9th World Congress of Metropolis*, Sydney: Metropolis Congress, pp. 10–15.

Johnson. I. (2011), 'China Misunderstood: Did we contribute to Ai Weiwei's arrest?', *New York Review of Books*, NYR Blog, 22 April, http://www.nybooks.com/blogs/nyrblog/2011/apr/22/ai-weiwei-arrest-china/. Accessed 7 June 2011.

Koolhaas, R. (2001), *Mutations: Harvard project on the city*, Bordeaux and Barcelona: Arc en réve centre d'architecture and ACTAR.

Lefebvre, H. (2004), *Rhythmanalysis: Space, time and everyday life*, (trans. S. Stuart Elden and G. Moore), London and New York: Continuum. First published in French 1992.

—— (2003), *The Urban Revolution*, (trans. Robert Bononno), Minneapolis: University of Minnesota Press. First published in French 1970.

—— (1991), *The Production of Space*, (trans. D. Nicholson-Smith), Malden, Massachusetts: Blackwell Publishing. First published in French 1974.

Lefebvre, H. and Régulier, K. (1986), 'Attempt at the Rhythmanalysis of Mediterranean Cities', *Peuples Méditerranéens*, 37.

—— (1985), 'The Rhythmanalytical Project', *Communications*, 41, pp. 191–99.

Leng, L. (2000) 'Nine Chinese Artists', in J. Clark (ed.), *Chinese Art at the End of the Millennium*, Hong Kong: New Art Media Ltd, p. 63.

McCormick, M. (2009), 'The Transient City: Mapping urban consciousness through contemporary art practice', PhD Thesis, The University of Melbourne, Melbourne.

Maerkle, A. (March 2008), *Ctrl+Pdf Journal of Contemporary Art*, 11, p. 22.

Martin, D. (2011), 'Chinese Dissident Released as Premier visits Europe', *The Age*, 27 June, http://www.theage.com.au/world/chinese-dissident-released-as-premier-visits-europe-201106. Accessed 7 July 2011.

Merrifield, A. (2006), *Henri Lefebvre: A critical introduction*, New York: Routledge.

Meyer, K. (2008), 'Rhythms, Streets, Cities', in K. Goonewardena, S. Kipfer, R. Milgrom and C. Schmid, *Space, Difference, Everyday Life: Reading Henri Lefebvre*, Hoboken: Taylor and Francis, pp. 147–75.

Munroe, A. (2008), 'Guggenheim Museum's Asian Art Council Symposium Part 3: Exhibiting Asian Art – Alternative Models and Non-Western Paradigms', *Yishu*, 7: 5, pp. 76–98.

Obrist, H.U. (2005), 'Canton Calling: Metabolism and beyond', in *Beyond: An extraordinary space of experimentation for modernization*, exhibition catalogue, Guangdong, China: Guangdong Museum of Art, pp. 22–62.

Sassen, S. (1991), *The Global City: New York, London, Tokyo*, Princeton, New Jersey: Princeton University Press.

Sheridan, M. (2011), 'Ai Weiwei Held for 'Obscene' Political Art', *The Sunday Times* published in *The Australian* online, 11 April, http://www.theaustralian.com.au/news/world/ai-weiwei-held-for-obscene-political-art/story-e6frg6so-1226036859366. Accessed 7 June, 2011.

Smith, T. (June, 2011), 'Art of Dissent', in B. Naparstek (ed.), *The Monthly: Australian politics, society and culture*, 69, pp. 58–9.

Taylor, P. and Hoyer, M. (eds) (2008), 'Chinese Cities in Contemporary Globalisation', in C. Johnson, R. Hu and S. Adedin (eds) *Connecting Cities: China - a research publication for the 9th World Congress of Metropolis*, Sydney: Metropolis Congress, pp. 21–43.

Teiwes, F. and Sun, W. (2011), 'China's New Economic Policy under Hua Guofeng: Party Consensus and Party Myths', quoted in J. Garnaut (2011), 'Revising the Great Revisionist's Work', *The Age*, 7 June, pp. 8–9.

The Wall Street Journal (2011), 'China NPC 2011: The Reports', in 'China Real Time Report', in *The Wall Street Journal*, 5 March, http://blogs.wsj.com/chinarealtime/2011/03/05/china-npc-2011-reports-full-text/. Accessed 30 October 2011.

UN Habitat (n.d.), 'UN Habitat State of the World Cities 2008/9', in *UN Habitat: for a better urban future*, www.unhabitat.org. Accessed 10 June, 2011.

Wasserstrom, J. (2006), *China's Brave New World: And other tales for global times*, Bloomington, Indianapolis: Indiana University Press.

Wen, J. (2011), 'China is Building a Better Future for All', edited version of speech to the Royal Society London after receiving the King Charles 11 medal, *The Daily Telegraph*, 28 June.

Wong, E. (2011), 'China Frees Rebel Artist after Tax "Confession"', *The Age*, 24 June.

Wu, H. (2005), *Remaking Beijing: Tiananmen Square and the creation of a political space*, Chicago and London: The University of Chicago Press and Reaktion Books.

——— (1999), *Transience: Chinese experimental art at the end of the twentieth century*, Chicago: The David and Alfred Smart Museum of Art and The University of Chicago.

Zhaohui, Z. (2005), *Where Heaven and Earth Meet: Xu Bing and Gai Guo Qiang*, Hong Kong: Timezone 8 Ltd.

Section III

Exchange and Transaction

Chapter 8

'The Liquid Continent': Globalization, urbanization, contemporary
Pacific art and Australia

Pamela Zeplin
University of South Australia

Introduction: Which Pacific?

For my part, anyone who has lived in our region and is committed to Oceania, is an Oceanian.

<div align="right">(Teresia Teaiwa 2010)</div>

Within contemporary discourses of globalization the 'Pacific' region looms increasingly large. Indeed, the twenty-first century has been proclaimed as the 'Pacific century' (White, cited in Mane-Wheoki 1996: 28). It is seen also as the Asian Century, acknowledging not only this expanse of ocean comprising a third of the world's surface area and the diverse cultures along its shores but also the intense economic and political developments taking place in the region since the 1980s. So how do we begin to make sense of such a vast region with 'periphery indeterminable and a centre that may be anywhere'? Of '*whose* Pacific do we speak... and *when?*' (Dirlik 1992: 55).

In fact, the Pacific that has been spoken and written about via debates on globalization and urbanization in the Asia-Pacific is an amorphous, catch-all concept, understood principally in economic and trade terms to signify the northern Pacific, and encompassing the populous and industrializing regions of eastern and northern Asia. Not surprisingly, these geo-politics have flowed into the cultural sphere during the last decade, creating a powerful Asia-Pacific presence on the international art scene throughout the northern hemisphere and beyond (Wang n.d.). However, art from Pacific Oceania, at the other end of the hyphen, is yet to create even a minor splash.

Without attempting a comprehensive analysis of Pacific visual cultures and their labyrinthine identity politics, the following discussion examines aspects of urbanization and globalization as experienced by contemporary artists in and of Anglophone Pacific/Oceania (these terms are subject to changing interpretations and are used interchangeably when referring to the southern Pacific region). In particular, the study seeks to interrogate the continuing marginalization of contemporary Pacific cultures beleaguered by Eurocentric stereotyping, which has defined cultural production of this region as nature rather than culture, as immobilizing history rather than engaging contemporary currency, and privileging ethnographic artefact rather than art. A visual void also remains evident within global art events, such as the Venice or Gwangju Biennales and the quinquennial Documenta held in

Kassel, Germany. Closer to home, and apart from efforts by Queensland Art Gallery/Gallery of Modern Art (QAG/GOMA) to embrace Oceania, contemporary Australian Pacific art is virtually invisible in major Australian exhibitions and state collections, yet its inclusion can contribute to the re-imagining of place for Australia as part of a Pacific region.

While alert to the dangers of cultural genericization, the discussion acknowledges the insistence by many Pacific artists on commonalities and connections throughout a 'sea of islands' (Hau'ofa 1994: 152). This is not to deny complex identity formations flowing in and between islands and urban centres, and constant negotiation occurring across mixed cultures and ethnicities, the customary and the contemporary and the individual and the social, but to acknowledge Pacific peoples' familiarity with movement, migration and fluidity. Such cultural buoyancy endures, even in the face of literal and figurative swamping by the rest of the world. The diverse circumstances of Oceanic people across scattered places, surviving successive tidal waves of colonization, missionization and globalization, indicates this region may yet offer alternative and sustainable exemplars for vocabularies of the urban, the global and the cosmopolitan that are currently dominated by northern hemisphere discourses.

Australia and its Neighbours: Pacific globalization and urbanization

Strong attachments to place and journeying habitually inform Oceanic peoples' fluid identities and identifications, allowing cities of the Pacific to be re-imagined as culturally multi-layered within this region's vastness and diversity. Across twenty million square kilometres of sea and twenty to thirty thousand islands (excluding Australia and New Zealand) 2,000 known languages are spoken amongst eight million people. Unlike Australia, (Aotearoa)[1] New Zealand has been identified over the past three decades as a 'Pacific nation' with Auckland as the world's largest Polynesian city, notwithstanding political tensions surrounding understandings of 'Polynesia' by first nation Māori, and immigrant and New Zealand-born Pacific Islanders (Hill 2010). Government promotion of Pacific and Indigenous arts has assured a strong national profile for many artists who have contributed to the changing identity of New Zealand regional centres and cities. Australia's Pacific experience has been more aligned with Melanesia but, with Australia's global economic sights set on Asia-Pacific horizons, governments and cultural institutions have rarely embraced their eastern geographical reality, despite 400,000 Australians (approximately two per cent of the population) identifying with Pacific Island heritage. Although not apparent in art and academic institutions in southern capitals, contemporary Pacific artists 'present a vibrant but consistently untapped and overlooked dimension of the Australian art scene' (O'Riordan 2009). Confounding curatorial definitions of Asia-Pacific, New Zealand-Pacific, International and Indigenous art, the impact of Pacific cultures is strongly recognizable in Australian cities such as Brisbane and Darwin and the smaller regional cities of Cairns, Townsville and Bundaberg, as well as Sydney's western suburbs.

The status of Pacific artists in Australia and internationally is not surprising. Only in recent times has the Pacific Ocean been acknowledged as a globally-significant indicator of future climate, health and food security (Hales et al. 1999). Notwithstanding scientific discoveries, the default image of Pacific Island countries, beyond their attraction as tourist destinations, remains principally negative. Typically, the region is represented as a global backwash where economic and climatic catastrophes are evidenced by rising sea levels, nuclear testing, violence, poverty and corrupt governmentality.

If Oceania is characterized as an under-developed victim of economic globalization, subject to escalating emigration, there is good reason for attracting the concern of many artists of Pacific heritage residing in foreign metropoles and/or throughout smaller islands. With embedded geo-social histories different from northern hemisphere experience, urban-based artists of Pacific ancestry can offer broader interpretations of what urbanization, globalization, nomadism and 'flow' may signify – and how such significations may be evidenced in the varied characters of Pacific cities, their festivals and their art institutions, from Apia to Auckland and Cairns to Port Vila. Thus, within the all-encompassing might of 'turbo capitalism' (Flanagan 2011), geography and place can still matter.

Images of static indigeneity (and by implication, vulnerability) have been imposed upon Oceania by successive waves of colonialism (Thomas 2011) and are challenged by Pacific artists, writers, poets, performing artists and cultural historians through processes of re-claiming agency and relevance across wider global communities. Indeed, the myriad cultures, languages and histories of this region have witnessed extensive movements of peoples, trade and cultural interchanges across vast distances over millennia. With Pacific roots stretching back at least to ancient Austronesian voyages from Taiwan (5,000BC to 2,500BC) (Bellwood 2007), Oceanians have long identified with global journeying, of 'enlarging their world' (Armstrong 2003). 'Not only was the Pacific a place rather than a space', explains Edmond (n.d.), 'it was a cosmopolitan world in which islanders, Europeans, East Asians, black Americans and others met and mixed, entered and left'. In this way, migration to populous Australian and New Zealand centres is just another means of maintaining Pacific ways.

Pacific/Oceanic movements, currents and cultures have, ineluctably, shaped all aspects of life, including 'fluid' art forms of lived, embodied experience, imbued with a sense of community that is integral to all forms of cultural enterprise. This shared regional understanding has seen the burgeoning swell of a renewed *Pasifika* arts movement across Oceania since the 1970s through poetry, writings and oratory by many Oceanians, including Samoan-New Zealand writer, Albert Wendt, Kanak political leader, Jean-Marie Tjibaou, and most influentially for the arts, Tongan anthropologist and poet, Epeli Hau'ofa (1994) who honoured the Ocean as a symbol of Pacific belonging.

Unlike conventional western art, Pacific arts are inclusive of people, performance and material production, embracing craft and everyday life practices as integral to creativity. Ironically, these values were espoused before the rise, and subsequent demise, of western styled 'relational aesthetics' (Bishop 2004). Hau'ofa (2008) identified the unique contribution of these wide-ranging practices in establishing the meagrely resourced but vibrant Centre for

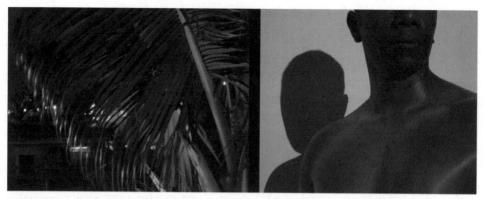

Figure 1: Torika Bolatagici, Vaniqa (the sound of someone treading on leaves), 2007, from the series Security/ Threat. Digital Print on 100% cotton rag, 153 × 61 cm × 61 cm. Image courtesy of the artist.

Oceanic Arts and Culture (COAC) at Fiji's University of the South Pacific. There he advocated for all those 'trying to create artforms – visual, dance, music – that transcend our individual culture'. In school curricula and academic Pacific Studies courses from Suva to Auckland, and in exhibitions (predominantly initiated from urban New Zealand) artists, curators and writers continue to draw inspiration from Hau'ofa's metaphoric sources in navigating cross-cultural urban realities of colonial legacies, religion and Islander versus New Zealand heritage. Since the 1990s foundational exhibitions include *Bottled Ocean* (touring New Zealand cities,1994–5), *Island Crossings* (Ipswich, Queensland, 2000), and more recently, *Pacific Storms* (Bundaberg and Brisbane, 2009) and *Austronesian Art in the Contemporary Pacific* exchange projects in Kaohsiung Museum of Fine Arts (KMFA, Taiwan), *Across Oceans and Time* (2007). *Le Foulaga: The Past Coming Forward* (2008) and *The Great Journey* (2009).

If dominant definitions of urbanization include 'liv[ing] in permanent processes of transition, hybridisation and nomadisation' and dwelling 'simultaneously in different time zones' (Braidotti, cited in McCormick 2007: 3), then life in villages, towns and cities throughout the Pacific may expand future understandings of what it means to be urban. These patterns differ from European, urban concentrations, which 'steadily evolve[ed] over centuries in response to the art, religion or high culture of the indigenous peoples' (Puamanu and Teasdale 2007: 265). On the other hand, Pacific towns and cities occurred relatively suddenly as a result of European colonial enterprises. With different colonization experiences and 'piecemeal development [as] the norm' (Bryant-Tokelau 1997), diverse political, social and cultural narratives emerge in urban, peri-urban and town centres across Oceania; from poverty and rural migration in Port Moresby to Vanuatu's situation as the happiest and most economically sustainable country in the world (Simms 2009). While recognizing 'traditional' art forms may be contemporaneous, opportunities for overtly contemporary artists are 'very limited and ad hoc' across Oceania (Regenvanu 2000: 28). Vanuatu Cultural Centre in Port Vila, for example, privileges sustainable heritage, and with PNG's National Museum and Art Gallery activities suspended (Zhang 2012), art is sold

outside Port Moresby tourist hotels. Apart from Hawai'ian institutions, COAC in Suva and Noumea's architectural gem, the Jean-Marie Tjibaou Cultural Centre, the region offers little support for contemporary art. Samoa's situation is different again, with an economy dependent on urban-derived foreign remittances from diasporic communities, mainly in South Auckland. In 2006 Samoans represented New Zealand's largest Pacific ethnic group, constituting 49 percent of its 265,974 Pacific, and 6.7 per cent of total population (Statistics New Zealand 2011; Schwartz and Crothers 2011: 4).[2] In this way 'Polynesians are more highly urbanized than other Pacific islanders if their concentrations in Auckland, Honolulu, Sydney and the west coast of the United States are included' (Bryant-Tokelau 1997: 287).

Notwithstanding the scale of Pacific immigration, Liliomaiava-Doktor (2009: 59) notes, '[a]s important as those who move are, those who "stay put" have just as much influence on diasporic processes and the two populations cannot be separated'. Thus a strongly heterogeneous *Pasifika* has infused the fabric of Auckland's environment, not only through continuing social and religious ties, but in markets and popular cultural celebrations such as Polyfest, Pasifika Festival and the Auckland Arts Festival. This presence has reached into central cultural precincts including Karangahape ('K') Road, known for its galleries, cafés and clubs. These influences have directly affected the status of and support for contemporary art which is reinforced through school syllabuses and university courses, while emerging artists are nurtured in urban contemporary art spaces, state and private galleries (Stevenson 2008), and through specific funding mechanism such as the Tautai Contemporary Pacific Arts Trust.

Picturing the Pacific

How has the Pacific been pictured over the centuries of colonial expansions into the region? Centuries of negative colonial perceptions of Oceanian art-forms as frozen in time have the effect of uniting Pacific peoples. Since French explorer Dumont d'Urville problematically divided Oceania into three ethno-geographical zones of 'Polynesia' (many islands), 'Micronesia' (small islands) and 'Melanesia' (black islands), the categories have been contested as arbitrary and racially-based by scholars such as Thomas and Losche (1999) and Jolly (2007, 2008). Micronesia's tiny, northern islands became prominent in the Pacific War and recently through rising sea levels, but the Pacific dominating European imaginaries was a volatile form of contradiction, situated symbolically between Polynesia and Melanesia. Polynesia has long been represented in pictorial documentation and popular media as a paradisiacal playground of palm-fringed beaches and 'dusky maidens' (Vercoe 2004), while a different Pacific has been painted of Melanesia by colonial Europe's missionizing and demon-fixated consciousness. Consequently, Pacific visual culture has been understood largely as 'traditional' objects of brooding desire or unspeakable barbarity, 'collected by conquest, swindle, and purchase during the colonial era' (Lebovics 2007).

Euramerican-dominated interest in Oceanic art as ethnographic connoisseurship continues unabated, in Pacific arts scholarship and conferences (Ireland 2010), which

privilege art 'out there and back then' (Clifford, cited in Jolly 2001: 456) rather than contemporary art, here and now. While contemporary art forms are alive and thriving throughout Oceania, they continue to be regarded widely by élite European institutions, as 'primitive' (McLean December 2011 personal discussion), 'folk' or 'naïve' (Raabe 1995, cited in Cochrane 2007b: 17) and relegated to natural history museums as 'inauthentic' and non-collectible (Martin 2008). With few exceptions, contemporary Pacific art is absent from the compulsive and convulsive flows of global, including Asia-Pacific, biennale culture with their nomadic 'tribes' of artists, curators and audiences purportedly creating more inclusive understandings of connection, mobility and belonging (Chiu n.d.; Wang n.d.).

From northerly perspectives, the antipodean Pacific remains a remote elsewhere, even if art from this region is institutionally 'badged' with a certain 'Biennale Club Class' look (Fuller, cited in Murray 2007). So pervasive is this new form of aesthetic colonialism that non-academically-trained Oceanic artists, particularly those of Melanesian heritage (read 'primitive'), have found less acceptance in global art environments attuned to conceptual art installations and screen-based media (Searle 2008). Visibility for Melanesian artists in Australia is nevertheless pertinent, considering the country's proximity and intertwined histories with peoples of this region. Myriad connections include immigration, Queensland's history of indentured labour (Moore 2001), World War Two operations (1942–45), Australian administration of Papua New Guinea (1945–72), foreign aid and tourism.

While New Zealand *Pasifika* artists, of predominantly Polynesian ancestry, are acclaimed at home in state and private galleries and enjoy moderate exposure at regional biennials and triennials,[3] as well as Taiwan's Art in the Contemporary Pacific projects at KMFA, these artists remain internationally under-exposed as evidenced in a number of targeted international group exhibitions, usually shown in natural history venues such as the University of Cambridge Museum (UK) or the Asia Society Museum (New York) (Tautai Contemporary Pacific Arts Trust 2011). As a minor part of its 'Asia-Pacific' enterprise, QAG/GoMA's Asia-Pacific Triennial of Contemporary Art (APT) has exhibited a limited range of contemporary Oceanic art (mostly New Zealand-based) Pacific and Māori work (averaging between 12 and 25 per cent of total artists and/or exhibits)[4] to global audiences and has acquired many works. Regionally, this neighbourly exposure has encouraged New Zealand and Island-based artists, but not wider international markets, for their work, which may be partly due to APT's declining influence and it emphasis upon the performativity of Polynesian *Pasifika*. Australian Pacific art, however, remains a notable omission.

At a regional level, performance dominates pan-Pacific Melanesian Arts Festivals and peripatetic quadrennial Festivals of Pacific Arts (FPA), reinforcing the fluidity of Oceanic aesthetics and extending inter-island and global connections. Celebratory in nature, these events interlink individuals with communities in multi-sensorial and collaborative spectacles involving visuality, dance, song, oratory, story-telling and feasting, with a focus on sociality and conviviality. Here, despite increasing commercialization (Stevenson 2002), the contemporary jostles – and clashes – with ancient values, allowing renewal and reinvigoration (or rejection) of traditions. Pacific towns and cities are

transformed temporarily through the influx of Oceanic communities and thousands of other international visitors experiencing alternative forms of 'cosmopolitanism' in the South Seas. Significantly, 'long term benefits' can accrue for FPA host centres as in Apia, (Western) Samoa, where the 1996 festival inaugurated the *First Pacific Festival Contemporary Arts Exhibition* and 'ensured continuation and strengthening of the Arts in Samoa for generations to come' (Leahy et al. 2010: 27).

Australian museum collections of Oceanic art and local community programmes increasingly emphasize continuity between the 'customary' and 'contemporary' but the latter enjoys minimal exposure in public art galleries outside Queensland and Victoria. It took four decades for the National Gallery of Australia (NGA) to seriously implement one of its foundational policies prioritizing art from 'Southern and Eastern Asia and the Pacific Islands' (National Art Gallery Committee of Inquiry 1966), announcing in 2008 'the full revival' of its large Pacific collection (Radford, cited in Howarth 2008: 3), albeit with few contemporary exhibits. Meanwhile, among Australian state galleries, only QAG/GoMA has appointed a Contemporary Pacific Art curator and recently increased through donation and acquisition its collection of Pacific textiles and Melanesian art. Pacific classification is complicated by curatorial 'silos' where a dedicated New Zealand/Pacific Island focus 'out there' excludes the Australian and/or Australian Indigenous Pacific. This was evident in QAG/GoMA's otherwise collaborative exhibition *Land, Sea and Sky: Contemporary art of the Torres Strait Islands* (Queensland Art Gallery 2011) where there was no Contemporary Pacific Art perspective alongside contributions from Australian Indigenous Art and Australian Art staff, and external writers. As in New Zealand, institutional sensitivities may require separate Indigenous and Pacific categorization but many artists work between and against these constrictive boundaries.

In 2006 over twenty local Indigenous and Pacific Australian artists protested against such APT representation in an exhibition titled *The Other APT*, a multi-artform exhibition encouraging fluid, 'alterNative' collaborations between artists from Pacific, Indigenous and Asian heritage. Curated by Murri artist, Jenny Fraser, in 2008 it toured to Noumea's Tjibaou Cultural Centre in 2008 and the (online) Biennale of Sydney; it continues online at cyberTribe. Here Fraser (2006: n.p.n.) discussed crossovers between islander and Australian indigenous cultures:

> [T]hroughout the Asia-Pacific Region Aboriginal people are known, respected and still referred to as the Old People of the Pacific ... [and] [i]t's not as if Aboriginal people and neighbouring groups haven't shared an Ocean or had contact with each other that could provide the basis of an art dialogue.
>
> (Fraser 2006)

Indigenous curator, Djon Mundine affirmed this exhibition's role in 'finding a space for the Asian and Pacific within us; those local Australian societies of Asian and Pacific heritage who have had a long and deep relationship with our national identity; though often folded/

secreted within' (2007: n.p.n.). Meanwhile, QAG/GoMA's Pacific homepage declares its 'particular focus on contemporary works from New Zealand ... by significant Māori and Pacific Islander artists' (Page 2011: n.p.n.). With 14 of 17 image links to this collection by New Zealand artists of Polynesian Māori and Pākehā extraction, and most other Pacific images 'not available', only an 'exotic' Polynesian New Zealand is visible.

The Contemporary Pacific

In her landmark study *Art and Life in Melanesia* Susan Cochrane (2007b: 15) explains that Oceanic practices, whether created in Pacific homelands or diasporic urban centres, remain contemporaneous in their openness to constant change and innovation, having long incorporated new conceptual and material forms of expression within customary heritage practices, widely known as *kastom*. Thus the contemporary may coalesce within an artwork, an *oeuvre* or a movement and as Cochrane (2007a: 57) asserts: '[a]rt is constantly reinventing itself, throughout the islands of Oceania, as elsewhere'. The multiplicity of Pacific art and identities may be seen across Melanesia, Micronesia and Polynesia, Australia, New Zealand (and beyond) in, for example, Kaipel Ka's war shields decorated with PNG beer labels, experimental fashion in Cathy Kata's PNG *bilum*-wear, funky performances by Auckland-based Pacific Sisters, and in Sydney artist, Latai Taumoepeau's re-interpretation of her Tongan ancestry at art events, clubs and concerts using contemporary dance, fashion and popular music.

Increasingly, across antipodean cities, Pacific-identified artists are interrogating issues of gender, race and colonialism, often using multidisciplinary forms of installation and/ or performance in community centres, high profile galleries and events such as Auckland Triennials and APTs. Fabricated from Samoa's ubiquitous corned-beef cans, Michel Tuffery's animated bulls critique westernized nutrition in the islands while ni-Vanuatu artist, Eric Natuoivi's pig tusk and ceramic sculptures honour indigenous tradition through abstract form. In both countries, Auckland-based Michael Parekowhai's sophisticated installations wittily and audaciously stake a claim for 'brownie' identity (Parekowhai, cited in Genoux 2000). Australian practices range from Ken Thaiday's Torres Strait dance machines and Torika Bolatagici's photographs critiquing Fijian militarism and forms of masculinity (see Figure 1) to Sam Tupou's perspex prints of questionable Pacific paradises and Keren Ruki's dingo skin cloaks (Figure 2). Whatever the form or subject, a bewilderingly diverse array of visual culture confronts stereotypes of Pacific people as macho sportsmen-cum-security 'bouncers', south seas sirens or dysfunctional high school students (Teaiwa 2007).

One of the most influential figures contributing to debates on Pacific identity, globalization and urbanization is PNG artist and scholar Michael Mel at the University of Goroka in PNG's Eastern Highlands, where national art education is now centred. Mel (2007: 3) explains that 'art in Melanesia today builds on the same principles of making art in the past' and celebrates the 'productive tension' surrounding contemporary/customary practices. His lectures, writings and socially-engaged performances draw attention to the erosive effects

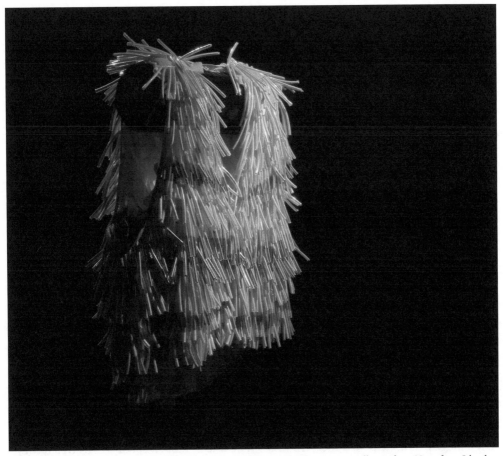

Figure 2: Ruki's vest, News from Islands, 2007. Keren Ruki, Cultural Safety Vest, installation from News from Islands, Campbelltown, Australia, 2007, mixed materials, including plastic tubing.

of globalization on village communities, particularly on young people with limited options. An international spokesperson, the tribal aesthetics of Mel's interactive performances do not always sit comfortably with cosmopolitan trends in Pacific art, notwithstanding the recent popularity of (western derived) relational aesthetics. However, his strong avowal of community-based ethics and sustainability as models for future societies has much to offer 'a world where "... the hedonistic palpitations of uniformity, containment and consumption ..." can swamp indigeneity' (Mel, cited in Neale 2003: n.p.n.).

Since the late 1960s, a surge of enthusiasm for modernity swept across newly-independent Pacific nations and the term Melanesian was re-appropriated as a unifying force in 'assert[ing] cultural identity' throughout the western Pacific (Searle 2008: 29). Modern art, typically understood as multidisciplinary in Pacific communities, and modern architecture were

widely embraced throughout newly-invigorated urban centres, often catalysed by expatriate artists, such as Georgina and Ulli Beier in informal Port Moresby workshops. These new forms of arts activity in 1970s' PNG eventuated in a National Art School and public art commissions for government buildings.

Later, Pacific residency programmes developed at COAC in Suva (Higgins 2009), Noumea's splendid Tjibaou Cultural Centre, Taiwan's KMFA and now predominantly, throughout New Zealand cities. Increasingly, island-based artists have taken advantage of travel, cosmopolitan training and exposure to urban audiences in New Zealand, Australia and beyond. Certainly, apart from few residency opportunities, a major factor inhibiting contemporary visual production outside Tasman metropoles is a lack of local resources. Puamanu and Teasdale note that, throughout this region, 'Western artefacts like museums and art galleries, where they exist are not particularly popular with the local indigenous population, although a major attraction for tourists' (2007: 265). Tjibaou Cultural Centre, designed by architect Renzo Piano, however, provides significant support for artists throughout New Caledonia and Oceania while re-fashioning Noumea as a sophisticated cultural city.

Without ongoing institutional support for marketing, advocacy and administration, Island-based artists adopt a daunting range of entrepreneurial and artistic skills. Many, with or without the aid of digital technologies, now work from rural or peri-urban bases in Honiara, Noumea, Suva, Port Vila and Port Moresby. These new forms of urbanization in contested zones between rural villages and urban outskirts often lack municipal regulation and services so that '[t]o some extent, in the Pacific, it is problematic to define what, or where, a city lies ... [and] in less than two generations more Pacific Islanders will live in or near cities than in rural environments' (Storey 2005: 3).

These changes in urbanization patterns demand innovative responses and, through the transformational possibilities of digitization, issues and images of *kastom* are no longer relegated to villages by emigré artists, who now strengthen kinship and cultural ties to geographically remote areas, and vice versa. As Duncan (2008: 11) observes: '[r]eform in the mobile telecommunications sector is one of the best stories to come out of the Pacific in the past decade', with these networking potentials between urban, peri-urban, suburban and rural situations further expanding possibilities for Pacific identities as twenty-first-century peoples. In this way, new technology is akin to Oceanic journeying across oceans and space in previous centuries.

The Urban Pacific and Australia

Despite apparent historical and cultural similarities, Australia and New Zealand have demonstrated radically-different attitudes towards their neighbouring 'sea of islands' and their Indigenous populations. While New Zealand's rich spectrum of Pacific cultures has been well documented and lies outside this discussion's focus, brief comparisons with Australia's situation as regards indigenous relations, demography, immigration and different

developments of cities allow some insight into these attitudes. Foremost are colonial settlement practices which set up completely different relationships with and legal obligations to Indigenous peoples; Australia's 1770 foundational declaration of *'Terra Nullius'* (empty land) contrasts with New Zealand's 1840 Treaty of Waitangi, which, for all its shortcomings (McGinty 1992), established legal acknowledgement of Indigenous Māori: Indigenous Australians were not enfranchised until 1967 (Council for Aboriginal Reconcilliation n.d.). Notwithstanding racist policies and practices prevalent in both countries, New Zealand's bi-cultural/bi-lingual policies recognize its almost fifteen per cent Māori and approximately seven per cent Pacific Islander populations. Australian indigenous populations have decreased to approximately two and a half per cent of total population, similar in size to the percentage of Australians claiming Pacific/Māori heritage (Australian Bureau of Statistics 2012). Unlike Australia's large and geographically-dispersed metropoles, New Zealand's smaller, more rural settlement history has created moderately-sized cities where Māori and Pacific Islanders have gained strong urban visibility.

Re-invigoration of Māori culture, increased Pacific immigration and changing demographic patterns in this rapidly-urbanizing society have not been achieved without social, economic and cultural cost. Many Indigenous and Islander people have suffered conditions of dislocation, unemployment and disproportionate incarceration, in addition to racial discrimination and diminished identity along the way (Webb 2009). An influx of cheap Pacific Island labour in the 1970s accompanied by exploitation, brutal raids and summary deportation also underlies the glitz and glamour of *Pasifika* New Zealand. One of the few artists to tackle this ugly period of Pacific history, and to openly criticize Samoan social and religious excesses, was 'Kamoan' (Kiwi-born-Samoan) artist Andy Leleisi'uao, whose early work gained slow acceptance within the shiny new constellation of *Pasifika* arts (Higgins and Leleisi'uao 2009).

Notwithstanding continuing tensions arising from Indigenous, and non-indigenous Pacific relations in the 'navel of the Pacific' (Lilo, cited in Bolatagici 2008: 13), a growing urban youth culture has mainstreamed the fluidity of *Pasifika* style on the streets, in clubs and catwalks, through community projects and reggae, hip hop and rap music, as well as other performative and exhibition events. As waves of cultural renewal in both Australian and New Zealand urban and suburban contexts inject urban visual arts with youthful dynamism, inevitable generational tensions arise for Pacific-identified artists around questions of identity, belonging, place, colonialism and 'tradition'. In New Zealand such questions invite a range of artistic responses within a veritable Pacific 'industry' of art production, critique and theory in and beyond specialist university departments. Nevertheless, eminent Pacific art historian, Karen Stevenson (2009) suggests that intellectualization of Pacific heritage does not inhibit artists, who often respond, '[w]e're islanders, but we live in urban situations. We're artists and we'll take any sort of medium and do what we like with it and just keep pushing it.' While inhabiting the local, these artists seamlessly engage with the global.

This kind of spirit is shared by Australian artists, of Pacific heritage. Although their work may be virtually invisible in state and other mainstream Australian galleries, many alternative if modest opportunities are opening up. New Zealand-born, Samoan-Australian

artist Chantal Fraser (cited in Bolatagici 2008: 16) explains that 'being a Pacific Islander is so hot right now'. However, Fijian-Anglo-Australian artist and academic Torika Bolatagici (2008: 6) notes that in 2008 '[c]ontemporary art by Pacific Islanders is still quite marginal in Australia and certainly doesn't have the profile that it has in New Zealand', while, according to Chantal Fraser, 'a verbal database of Islanders who are artists living in Australia' was only just being created among this group (cited in Bolatagici 2008: 16). This is not confined to the arts, as Katerina Teaiwa (2007) explained in commenting on the large numbers and significant achievements of Pacific Australians:

> So numbers grow, Fijians and Tongans are scoring the Australian tries, Australian museums and galleries are hankering for Pacific art and artefacts, and there is a strange and simultaneous increasing gap in understanding the islands in the streets, classrooms, sports fields, media and halls of government.
>
> (Katerina Teaiwa 2007: n.p.n.)

While many urban art and academic institutions are yet to begin closing these gaps, important outer suburban initiatives are happening, including Campbelltown Art Centre/Gallery 4A's *News from Islands* (2007) and *Edge of Elsewhere* (2011–12) highlighting Australia's contemporary Pacific. Another active western suburbs art/community centre, Casula Powerhouse hosted *Pacific Wave* festivals (1996 to1998) and recently combined with the National Rugby League and Australian National University's Pacific Studies Programme to provide cultural awareness training for players as part of two major exhibitions, *Body Pacifica* (2010) and *Nui Warrior* (2011). Represented as traditional 'cultural warriors', the players aimed to 'mentor our kids, to show them ... culture reconnection (Paligaru 2010: n.p.n.); 18,000 people attended the events (Tanoi 2012 personal correspondence). In 2012 the Pacific Studies Programme will also launch a Pacific Studies Artist in Residence Programme (ANU 2012) .

Elsewhere, a lack of cultural consciousness about Pacific cultures seems surprising, given regular and intensive activities by some of Australia's 400,000 Pacific immigrants, South Seas Islanders and Indigenous Torres Strait Islander populations. Inevitably, growing Pacific visibility in high density areas will assist in countering stereotypes through public exposure to increasing individual and community achievements, and encouraging the emergence of new and stronger cultural configurations.

Similar to New Zealand's *Pasifika* 'scene', these cultural, social and religious connections to Australian Oceanic heritage are diverse, often with mixed ethnicities within a rapidly-growing urban youth culture (Gough 2009; Friend November 2009 personal discussion). As in Auckland, street and club culture represent 'cool' sites where a cultural, non-violent Pacific presence is emerging. Here rap and hip-hop protagonists frequently embed ubiquitous US 'guns and gangstas' style into local Pacific meanings and situations (Stevenson 2008; Gough 2009: 213). These dynamic characteristics are vital for the re-imagining of urban spaces, although sites of Australian Pacific activity are dispersed and most active in suburban and regional centres such as western Sydney, Darwin, greater Brisbane and the Sunshine Coast, Cairns, Townsville and

Bundaberg, as well as a few contemporary art spaces in CBDs. Although fewer Pacific festivals occur in Australia compared to New Zealand, Oceanic and Torres Strait Islander visibility has increased through Indigenous/folk/Pacific events, especially Queensland's *QPAKifika* (2005), Pacific Vibe Festival, *Floating Land* and Woodford Folk Festival. The combined effect of these and other activities throughout the country is contributing to broader and more vibrant revitalization of notions of 'the urban' in the twenty-first century, with its increasing mobilities and hybridities of not only cultural but also economic formations.

In northern Queensland, Perc Tucker Regional Gallery, Cairns Regional Art Gallery, Tanks Art Centre, KickArts Contemporary Arts, private galleries and island art centres have raised the profile of contemporary Indigenous Torres Strait Islander and other Pacific artists, and this in turn has added to the renewal of Pacific identities in Australian regional communities. Particularly notable has been printmaking, a 'phenomenon' catalysed by Anna Eglitis and Theo Tremblay when Eglitis initiated the Aboriginal and Torres Strait Islander Visual Arts Course at Cairns Institute of TAFE (Technical and Further Education) in 1984. Ironically, only after achieving international fame have Indigenous artists from this region (such as Dennis Nona, Alick Tipoti, David Bosun and Billy Missi) enjoyed national acclaim (Eglitis and Tremblay May 2008 interview with author). Torres Strait Islanders' identification with Pacific as well as Indigenous heritage goes largely unacknowledged in urban art institutions, evoking the later 1980s when global recognition of Aboriginal art preceded mainstream Australian acknowledgement.

In 2009 an artist-curated exhibition *Pacific Storms* swept into Bundaberg Regional Art Gallery and throughout local communities, later travelling to Brisbane's Waterfront Place and, re-configured as *Lusim Land,* to Logan City in 2011 accompanied by a Pacific textiles exhibition *Talking Tapa.* For large urban audiences these endeavours laid waste to any claims of stereotypical Pacific art. Declared by curators, Joycelin Kauc Leahy and Bianca Acimovic (2009: 8–9) as 'a platform of contemporary creativity which integrates and addresses the real issues of the modern Pacific society', the project foregrounded Indigenous/Pacific issues including environmental concerns and local histories of indentured labour ('blackbirding' of 50,000 South Sea Islanders formerly known as 'Kanakas')[5] (Moore 2001), some of whose descendants exhibited in *Pacific Storms.* This project not only featured a wide range of contemporary work made locally, across Australia and in the Islands by 27 artists, but its collaborative nature and fluid connections between local communities and conventional art world protocols created a dynamic and convivial, if complex, model for curating the Pacific in Australia (Ahrens 2010).

Apparent institutional indifference to these Pacific populations and programmes becomes even more puzzling considering Australia's broad and long history of engagement with Oceania, particularly in Melanesia. Furthermore, there has been a great deal of scholarship by the 'Canberra School of Pacific historians' (Hau'ofa 2000: 455), and longstanding independent advocacy for contemporary Pacific art by researchers, educators and curators (such as, Susan Cochrane, Hugh Stevenson, Ross Searle, Uli and Georgina Beier, Michael Mel, Margaret Jolly and Jacqueline Lewis-Harris). Even the Australian Association for the Advancement of Pacific Studies, a national, multidisciplinary education and advocacy organization inaugurated in 2006, is just beginning to embrace contemporary Pacific, but not Indigenous,

visual art. Prior to *Art Monthly Australia's* 2010 edition of 'Bountiful OzPacifica', writings on contemporary Australian/Pacific art have been dispersed across catalogue essays, occasional articles in industry or, rarely, scholarly journals. While New Zealand-based, Pacific material is abundant, Australian authored books are few and include benchmark studies by Cochrane, notably, *Contemporary Art from Papua New Guinea* (1997), *Beretara: Contemporary Pacific Art* (2001) and *Art and Life in Melanesia* (2007b).

A Conclusion and a Beginning

The questions of this chapter have revolved around issues of identity and how Pacific identities can be articulated and recognized in urban locations. Participants of an animated gathering of a 2009 national workshop at Wollongong, Australia, raised issues pertinent to Pacific artists in Australia.[6] They wrestled with questions similar to those of a 2008 email 'roundtable' conducted by workshop participant, Torika Bolatagici (2009: 20), namely: '[W]hat is Pacific art? Is it art that draws from and has references to Pacific Island culture? Is it art made from artists who have Pacific blood? Is it art that is made in the Pacific Islands?' These questions have been crucial for the discussion in this chapter as a way of investigating the identities and identifications of Pacific art and the urban.

This chapter has canvassed the issues relating to identity, the contemporary and the customary, institutional practices, audiences and Pacific futures in a globalizing world, and also problematized the vexed matter of promotion and support within an apparently indifferent sector in the arts. At the national workshop noted above, there was evidence that art practitioners are negotiating official boundaries and institutional gate-keeping practices by doing it for themselves. Participants explained that they work in wider 'Pacific ways' via extensive local, regional and global networks, created by digital technologies. Indeed, many artists working in visual media throughout Oceania are exhibiting, promoting, curating, archiving and critiquing, using new global communication systems of social networking sites such as Facebook, Twitter and Bebo, websites, online exhibitions and blogs such as Pacific Arts Alliance, CyberTribe, Masalai Blog, Urban Viti, iCi, Beyond Pacific Art, Colour me Fiji and paradiseishell. This evidences renewed Pacific identity formations, working with urban and global practices to re-imagine what 'being Pacific' might be like in the twenty-first century.

As in ancient Pacific voyager economies, mobility, migration and sociality have created previously unimaginable communities, alliances and artforms whereby Australian-Fijian artist, Salote Tawale (cited in Bolatagici 2008: 15), and other artists of 'in-between pacificness' can say 'I feel I sit on the edge of all worlds ...'. Ironically, these alliances have connected Australian artists, not only with their originating communities but also with established New Zealand, *Pasifika* networks. These endeavours in the hands of artists themselves are creating regional and international exhibiting and publishing opportunities, such as the landmark edition of *Art Monthly Australia* in 2010, with exciting potential for a Pacific Australia.

In spite of conflicting discourses of the Oceanic Pacific, as discussed in this chapter, artists, writers, scholars and others of Pacific origin are asserting confidently and effectively, 'what it means to be here now … and of course, before' (Fraser 2006). In an increasingly connective (art) world seeking sustainable solutions to questions of Pacific identities, the Oceanic region may yet offer new alternatives beyond being a space of global effects and a repository of redundant histories.

Geographical and ecological predictions for this region may be grim in current narratives of globalization and urbanization but people of the region are acutely attuned to unexpected change, resilience, mobility and innovation. As University of Hawai'i Press noted (cited in *Solomon Times* 14 January 2009), 'According to Hau'ofa, only through creative originality in all fields of endeavor can the people of Oceania hope to strengthen their capacity to engage the forces of globalization'. This discussion has shown the complexity of issues at stake in understanding and engaging these forces, and the crucial role of the arts and people of Oceania in this venture. Beyond any notions of a backwash, this, the most expansive region in the world, is undergoing a transformation via new forms of mobility and reconfiguration. The discourses canvassed in this chapter are making sense of a changing Pacific by launching new narratives and fluid ways of re-imagining being Pacific and being urban at one and the same time.

References

Ahrens, P. (2010),'Pacific Storms; A contemporary Pacific art exhibition', *Intersections* 1: 2 and 2: 1, http://intersections.anu.edu.au/pacificurrents/ahrens_review.htm. Accessed 23 October 2011.

ANU, (2012), 'Pacific Studies Artist in Residence Program', *ANU Website*, http://asiapacific.anu.edu.au/research/pacific-visiting-fellowships/pacific-studies-artist-in-residence-program. Accessed 15 April 2012.

Armstrong, P. (2003), 'Ocean-going Craft: The writing of contemporary Polynesia', *New Zealand electronic poetry centre*, http://www.nzepc.auckland.ac.nz/features/whetu_moana/armstrong.asp. Accessed 15 September 2011.

Australian Bureau of Statistics (2012), 'Experimental Estimates of Aboriginal and Torres Strait Islander Australians, June 2006, http://www.abs.gov.au/ausstats/abs@.nsf/mf/3238.0.55.001. Accessed 14 October 2011.

Bellwood, P. (2007), 'Tracing Ancestral Connections across the Pacific', in J. Lee and S. Cochrane (eds), *Across Oceans and Time: Art in the contemporary Pacific*, Kaohsiung: Kaohsiung Museum of Fine Arts, pp. 38–40.

Bishop, C. (2004), 'Antagonism and Relational Aesthetics', *October*, 110, pp. 51–79.

Bolatagici, T. (2009),'The Big Island: Promoting contemporary art and craft in Australia: A development workshop', 23–24 November, University of Wollongong.

—— (2008), 'Identity and Authenticity in the Pacific Diaspora: Conversations on art', unpublished manuscript, discussed at *The Big Island: Promoting contemporary Pacific art and craft in Australia: A development workshop*, University of Wollongong, November 23–24, 2009, pp. 1–24.

Bryant-Tokelau, J. (1997), 'Review of John Connell and John P Lea Pacific 2010: Urbanisation in Polynesia, Pacific Policy Paper 14, Canberra National Centre for Development Studies, 1995', *The Contemporary Pacific*, Spring, pp. 286–88.

Chiu, M. (n.d.), 'Asian Contemporary Art: An introduction', *Oxford Art Online*, http://www.oxfordartonline.com/public/page/asiancontintro. Accessed 31 October 2011.

Cochrane, S. (2007a), 'Art and Artists in the Contemporary Pacific', in J. Lee and S. Cochrane (eds), *Across Oceans and Time: Art in the contemporary Pacific*. Kaohsiung: Kaohsiung Museum of Fine Arts, pp. 57–63.

——— (2007b), *Art and Life in Melanesia*, Newcastle: Cambridge Scholars Press.

——— (2000), *Beretara: Contemporary Pacific art*, Sydney: Halstead Press.

——— (1997), *Contemporary Art in Papua New Guinea*, Sydney: Craftsman House Press.

Council for Aboriginal Reconcilliation (n.d.), http://www.austlii.edu.au/au/orgs/car/docrec/policy/brief/terran.htm. Accessed 4 April 2012.

Dirlik, A. (1992), 'The Asia-Pacific Idea: Reality and representation in the invention of a regional structure', *Journal of World History*, 3: 1, pp. 55–79.

Duncan, R. (2008), 'Solomon Islands and Vanuatu: An economic survey', *Pacific Economic Bulletin*, 23: 3, pp. 1–17.

Edmond, R. (n.d.), 'Islanders: The Pacific in the Age of Empire', *Historyextra.com*, http://www.historyextra.com/book-review/islanders-pacific-age-empire. Accessed 4 April 2012.

Flanagan, R. (2011), 'Richard Flanagan on the Decline of Love and Freedom', *The Book Show*, Radio National, 15 September 2011.

Fraser, J. (2006), 'The Other APT', *NAICA*, http://thenaica.org/wordpress/2008/06/03/the-other-apt-curator-jenny-fraser. Accessed June 12 2010.

Genoux, I. (2000), 'Ten Guitars: Interview with Michael Parekowhai', *Artok: Pacific Arts Online*, http://www.abc.net.au/arts/artok/visual/s209772.htm. Accessed 23 October 2011.

Gough, D. (2009), 'Cultural Transformation and Modernity: A Samoan case study', PhD Thesis, Centre for Asia Pacific Social Transformation Studies and School of Social Sciences, Media and Communication, Faculty of Arts, University of Wollongong.

Hales, S., Weinstein, P. and Alistair Woodward, A. (1999), 'Ciguatera (Fish Poisoning), El Niño, and Pacific Sea Surface Temperatures', *Ecosystem Health*, 5, pp. 20–25.

Hau'ofa E. (2008), *We are the Ocean: Selected works.* Honolulu: University of Hawai'i Press.

——— (2000), 'Epilogue: Pasts to Remember', in R. Borofsky (ed.), Remembrance *of Pacific Pasts: An invitation to remake history*, Honolulu: University of Hawai'i Press, pp. 453–71.

——— (1994), 'Our Sea of Islands', *The Contemporary Pacific* 6: 1, pp. 148–61.

Higgins, K. (2009), 'The Red Wave Collective: The process of creating art at the Oceania Centre for Arts and Culture', *The Contemporary Pacific*, 21: 1, pp. 35–70.

Higgins, K. and Leleisi'uao, A. (2009), 'Kamoan Mine', in A.M. Tamaira (ed.), *The Space Between: Negotiating culture, place, and identity in the Pacific*, pp. 37–53. Occasional Paper Series, 44, Honolulu, Hawai'i: Center for Pacific Islands Studies, School of Pacific and Asian Studies, University of Hawai'i at Mānoa.

Hill, R. (2010), 'Fitting Multiculturalism into Biculturalism: Maori–Pasifika relations in New Zealand from the 1960s', *Ethnohistory* 57: 2, pp. 291–319.

Howarth, C. (2008), *Gods Ghosts and Men: Pacific arts from the National Gallery of Australia*, National Gallery of Australia, http://nga.gov.au/GODSGHOSTSMEN/article.cfm. Accessed 16 October 2011.

Ireland, J. (2010), 'For the Love of Art', *Cook Islands Herald,* 524: 11, August, http://www.ciherald.co.ck/articles/h524m.htm. Accessed 23 November 2010.

Jolly, M. (2001), 'On the Edge? Deserts, oceans, islands', *The Contemporary Pacific,* 13: 2, pp. 417–66.

—— (2008), 'The South in *Southern Theory*: Antipodean reflections on the Pacific', *Australian Humanities Review*, March, n.p.n., http://www.australianhumanitiesreview.org/archive/Issue-March-2008/jolly.html. Accessed 25 September 2011.

—— (2007), 'Imagining Oceania: Indigenous and foreign representations of a Sea of Islands', *The Contemporary Pacific*, 19: 2, pp. 508–45.

Leahy, J.K. and Acimovic, B. (2009), 'Curatorial statement', in C. Moore (ed.), *Pacific Storms: Beyond Pacific art*, pp. 8–9.

Leahy, J.K., J. Yeap-Holliday and B. Pennington (2010), *Evaluation of the Festival of Pacific Arts*, Noumea (New Caledonia): Secretariat of the Pacific Community.

Lebovics, H. (2007), 'Echoes of the "Primitive" in France's Move to Postcoloniality: The Musée du Quai Branly', *Globality Studies Journal,* 4, 5 February, http://globality.cc.stonybrook.edu/?p=50#6. Accessed 23 August 2010.

Liliomaiava-Doktor, S, (2009), 'Samoan Transnationalism: Cultivating "home" and "away"', in S.T. Francis, *Migration and Transnationalism: Pacific perspectives*, Canberra: ANU ePress, pp. 57–90.

McCormick, M. (2007), 'Suitcases, Maps, Wolves and Glass Walls: Mapping urban consciousness and reflecting on gender asymmetry in contemporary art', *UNESCO Observatory, Faculty of Architecture, Building and Planning, the University of Melbourne Refereed e-Journal*, 1, pp. 1–19, http://www.abp.unimelb.edu.au/unesco/ejournal/pdf/suitcases.pdf. Accessed 21 October 2011.

McGinty, J. (1992), 'New Zealand's Forgotten Promises: the Treaty of Waitangi', *Vanderbilt Journal of Transnational Law,* 25, pp. 681–722.

Mane-Wheoki, J. (1996), 'A Recentred World: Post-European/pro-indigenous art from Aotearoa/New Zealand and Te Moananui-a-Kiwa/the South Pacific', in C. Turner and R. Devenport (eds), *The Second Asia-Pacific Triennial of Contemporary Art, Brisbane, Australia*, Queensland Art Gallery, Brisbane, pp. 28–29.

Martin, S. (2008), 'The Approach of the Quai Branly Museum to the Art in Oceania and its Relationships with Museums in the Pacific and the Source Communities', keynote address, *Oceanic Art Symposium*, 6–8 May 2008, Port Vila, Vanuatu, organized by the Pacific Islands Museums Association (PIMA) and the Vanuatu Cultural Centre, 7 May.

Mel, M. (2007), 'Introduction', in S. Cochrane, *Art and Life in Melanesia*, Newcastle: Cambridge Scholars Press, pp. 1–9.

Moore, C. (2001), 'The South Sea Islanders of Mackay, Queensland, Australia', in J.M. Fitzpatrick (ed.), *Endangered Peoples of Oceania: Struggles to survive and thrive*, Westport, CT: Greenwood Press, pp. 167–81.

Mundine, D. (2007), 'The Other APT', *Cybertribe*, http://www.cybertribe.culture2.org/. Accessed 21 October 2011.

Murray, K. (2007), *Undercurrents: News related to the South Project*, 6 July, n.p.n., southproject.org/blog/2006/07/build-on-it-and-they-will-come.htm. Accessed 21 October 2008.

National Art Gallery Committee of Inquiry (1966), *National Art Gallery Committee of Inquiry Report*, Canberra, 1966.

Neale, M. (2003), 'Touch a Native', in C. Turner and N. Sever (eds), *Witnessing to Silence, Art and Human Rights*, Canberra: Humanities Research Centre, http://www.anu.edu.au/hrc/research/WtoS/Neale.pdf. Accessed 4 April 2012.

New Zealand Government Ministry for Culture and Heritage (2011), http://newzealand.govt.nz/browse/history-heritage/. Accessed 14 October 2011.

O'Riordan, M. (2009), 'Big Ideas for a Big Island: Critical workshop in Wollongong tests the waters on future directions for Pacific arts', Press Release, 26 November, *AAAPS Australian Association for the Advancement of Pacific Studies*, http://www.aaaps.edu.au/?q=node/300. Accessed 28 November 2009.

Page, M. (2011), 'Contemporary Pacific Art', *Queensland Art Gallery/Gallery of Modern Art*, http://qag.qld.gov.au/collection/pacific_art. Accessed 31 October 2011.

Paligaru, C. (2010), 'NRL players' Pacific Heritage', *Australia Network*, November 25, http://australianetwork.com/pacificpulse/stories/3076206.htm. Accessed 15 April 2012.

Puamanu, P.Q. and Teasdale, G.R. (2007), 'The Urban and the Peripheral: New challenges for education in the Pacific', in W.T. Pink and G.W. Noblit (eds), *International Handbook of Urban Education*, 19: 2, pp. 265–84.

Queensland Art Gallery, Queensland Art Gallery Staff (2011), *The Torres Strait Islands*, Brisbane: Queensland Art Gallery/Gallery of Modern Art.

Regenvanu, R. (2000), 'Transforming Representations: A sketch of the contemporary art scene in Vanuatu', in *New traditions: Contemporary art of Vanuatu*, Port Vila: Vanuatu Cultural Centre, pp. 25–28.

Schwartz, D. and Crothers, C. (2011), *Macro Auckland: Informing and inspiring generosity: Summary report 2011*, Auckland: Auckland Communities Foundation.

Searle, R. (2008), 'Parallel Traditions: Contemporary art in Melanesia', in *New traditions: Contemporary art of Vanuatu*, Port Vila: Vanuatu Cultural Centre, pp. 29–30.

Simms, A. (2009), 'Happy like Vanuatu', *New Economic Foundation*, 14 April, http://www.neweconomics.org/blog/2009/04/14/happy-like-vanuatu. Accessed 25 September 2011.

Solomon Times (2009), 'USP Professor and Oceania Centre Founder Passes Away', Wednesday, 14 January, http://www.solomontimes.com/news.aspx?nwID=338. Accessed 1 May 2012.

Statistics New Zealand Tatauranga Aotearoa (2011), New Zealand Government, http://www.stats.govt.nz/tools_and_services/tools/population_clock.aspx. Accessed 15 December 2011.

Stevenson, K. (2009), 'Author's Detailed Exploration of Pacific Art', 'Recreation-Literature', *Christchurch City Libraries*, http://christchurchcitylibraries.com/Literature/People/S/StevensonKaren/. Accessed 23 October 2011.

——— (2008), *The Frangipani is Dead: Contemporary Pacific Art in New Zealand, 1985–2000*, Wellington: Huia Publishers.

——— (2002), 'The Festival of Pacific Arts: Its past, its future', *Pacific Arts*, 25, pp. 31–40.

Storey, D. (2005), 'Urban Governance in Pacific Island Countries: Advancing an overdue agenda', *State, society and governance in Melanesia*, discussion paper 2005/7, http://www.unescap.org/epoc/documents/R3.11_Study_1.pdf . Accessed 4 April 2012.

Tautai Contemporary Pacific Arts Trust (2011), 'An Interview with Niki Hastings-McFall', http://www.tautai.org/. Accessed 28 December 2011.

Teaiwa, K. (2007), 'Ignorance Rife about Islander Australians', *Canberra Times*, 29 October, http://www.canberratimes.com.au/news/opinion/editorial/general/ignorance-rife-about-islander-australians/132817.aspx?storypage=3. Accessed 4 April 2012.

Teaiwa, T. (2010), 'We sweat and cry salt water, so we know that the ocean is really in our blood', *Oceania*, 26 April, http://paradiseishell.wordpress.com/2010/04/26/we-sweat-and-cry-salt-water-so-we-know-that-the-ocean-is-really-in-our-blood-teresia-teaiwa/. Accessed 26 September 2011.

Thomas, N. (2011), *Islanders: The Pacific in the Age of Empire*, Newhaven (CT): Yale University Press.

Thomas, N. and Losche, D. (eds) (1999), *Double Vision: Art histories and colonial histories in the Pacific*, Cambridge: Cambridge University Press.

Vercoe, C. (2004), 'Many Faces of Paradise', in C. Vercoe, and M. Chiu (eds), *Paradise Now? Contemporary art from the Pacific*, New York: Asia Society Museum.

Wang, M. (n.d.), 'Reflecting on International Biennials and Triennials in Asia', *Asiart Archive: Perspectives*, http://www.aaa.org.hk/newsletter_detail.aspx?newsletter_id=562. Accessed 15 September 2011.

Webb, R. (2009), 'Māori, Pacific Peoples and the Social Construction of Crime Statistics', *MAI Review*, 3, Peer Commentary 2, pp. 1–4, http://review.mai.ac.nz/index.php/MR/article/viewFile/277/291. Accessed 4 April 2012.

Zhang, K. (2012), 'Countries: Papua New Guinea', *ArtAsiaPacific Almanac*, http://artasiapacific.com/Magazine/Almanac2012/PapuaNewGuinea. Accessed 2 March 2012.

Notes

1 Aotearoa New Zealand (or New Zealand Aotearoa) is an increasingly-used, if contested, term referring to the country's indigenous heritage and bi-cultural policy. The New Zealand Government Ministry for Culture and Heritage (2011) website notes: 'Aotearoa is the Maori name for New Zealand, though it seems at first to have been used for the North Island only. Many meanings have been given for the name ...'.

2 In addition to Māori populations, the highest Pacific concentrations reside in Auckland's southern suburbs, comprising 14 per cent of that city's population, of which 57 per cent were born outside New Zealand.

3 Regional biennials/triennials featuring Pacific artists have included: the Biennale d'art contemporain de Nouméa, The Auckland Triennial, Brisbane's Asia-Pacific Triennial of Contemporary Art and to a lesser extent, The Biennale of Sydney. These examples do not include numerous international touring exhibitions of Māori and/or Pacific art initiated from New Zealand.

4 These figures do not include individual artists within collectives; for example, APT6 (2009–10) featured 17 per cent of artists from Oceania, notably Vanuatu, Fiji, New Zealand and Hawai'i, or 36 per cent if individual artists within collectives and the Pacific Reggae Project are included.

5 South Sea Islander people constitute a recognized ethnic group of Australians descended from indentured labourers brought to Queensland from Pacific Islands in the late nineteenth and early twentieth centuries.

6 'The Big Island: Promoting contemporary art and craft in Australia: A development workshop', 23–24 November 2009, University of Wollongong. Participants included Dr Karen Stevenson; Torika Bolatagici; David Broker, Gary Lee, Maurice O'Riordan; Dr. Susan Cochrane, Ross Searle, Joycelin Leahy; Jenny Fraser; Lisa Havilah; Dr Jacquelyn Lewis-Harris; Keren Ruki; Annalise Friend; Dr Peter Eklund, Auntie Barbara Nicholson, and convenors, Dr Pamela Zeplin and Associate Professor Paul Sharrad.

Chapter 9

Abdul Abdullah: Art, marginality and identity

Leslie Morgan
La Trobe University

uslims, and other transnationals including migrants, international students, refugees and temporary workers, are part of the global flows of people across borders whose new homes are the urban spaces of globalized cities. Their marginalization by the host communities in cities in Australia and Europe is a feature of these globalized cities; hence their cultural production is an expression of this condition. While global cities are celebrated for their cosmopolitan mix of diverse transnationals engaged in a range of intercultural transactions, this chapter explores how the city shapes the bodies, experiences, identity and art of those at the 'dark end of the city street' who are subject to the forces of social and economic marginalization. It addresses the art of Abdul–Hamid Bin Ibrahim Bin Abdullah (hereafter called Abdullah) a young Muslim artist from West Australia, as an indicator of these conditions.

While dualistic notions of the city as divided along black/white, wealthy/poor, straight/gay lines are insufficient to explain their complex intersectionality, it is also true that 'cities today [can] seem fragmented, partitioned – at the extreme, almost drawn and quartered, painfully pulled apart' (Marcuse 2008: 270). As such, race, migration and ethnicity emerge as important factors in the urban spaces of the city since people are pulled apart in terms of poverty and wealth, ethnicity and power. This discussion considers how urban city spaces impact upon the artists who have moved countries, either by force or voluntarily, into a new urban space. They are often out of place and out of language and are connected to other spaces, sometimes also globalized and urban. Hence the creative works produced by these artists are an expression of their condition of making art outside the imagined, white community of Australia. Here, the focus is on how one such artist negotiates his belonging in Australia through his art as a form of protest against being racially marked in globalized and urban spaces. In so doing, he engages with the discourse of Australian multiculturalism in order to offer a critique of it.

Those living outside the host communities of globalized cities of Australia, Europe and North America include Muslims, Indigenous people, refugees, immigrants and so-called 'ethnics'. As Abdullah is a Muslim, a brief aside is necessary to outline some relevant information concerning Muslims in Australia in order to contextualize his work. As a group, Muslims constitute 1.7 per cent of the Australian population (DIAC 2006). Almost a third of Muslims are second generation Australians and young Muslims aged 15–24 years are almost twice as likely to be unemployed compared to their non-Muslim counterparts which, according to a significant study, has implications for their sense of belonging to

their own and the wider community (Hassan 2009: 9). Muslims in Australia have a similar educational profile of attainment to non-Muslims (ABS 2009); however, their achievement does not translate into increased financial, social or cultural capital for young Muslims as it does for non-Muslims (Hassan 2009: 6). The reasons for their economic marginality include geographic location, the non-recognition of qualifications gained overseas, racial prejudice and systemic discrimination (Hassan 2009:11). Claims of discrimination are based on the findings of a report from a small sample that found what most migrants know too well – that a foreign name is less likely to land the applicant a job (Martin 2009).

In addition to the racial and religious discrimination Muslims face in Australia, they have also been subject to a torrent of negative media reporting that 'emphasize[s] cultural explanations for individual behaviour' (Humphrey 2007). They face a relentless questioning and scrutiny of their identity as a result of recent events including the global terrorism of 9/11, the Bali bombing in 2002, the Cronulla riots[1] and the Danish cartoon controversy of 2005, the comments of Mufti Al-Hilaly on women in 2007,[2] the banning of the head scarf in France, and opposition to the building of Mosques in cities across North America, Europe and Australia.[3] These events and others have led to social and economic marginalization of Muslims where stereotypes abound – that they cannot or will not integrate, they want Islamic law, support terrorism and actively oppress women, despite the fact that all of these assumptions have been refuted by a recent study that explores '[w]hat Australian Muslims really think' (Rane et al. 2010). While there is a view that Islamic theology is responsible for religious radicalism with the fear that 'they may turn to more radical sects of Islam' (Issues Deliberation 2007), the alienation of Muslims is more likely to be a product of social and economic exclusion that denies them the opportunity to belong to the wider community (Hassan 2009: 11). This disadvantage is compounded by the view that Muslim youth is alienated from so-called mainstream values and therefore more open to the dangers of radicalization. The resulting alienation makes Muslims more 'vulnerable to such adaptations as innovation, retreatism and radicalism' (Hassan 2009: 10).

In this context, I describe how Abdullah negotiates his identity in an embodied way in the globalized city as a member of a 'partitioned' minority. I will look at how the city impacts upon his body, and at his response, as resistance, to the marginalization forced upon him by the dominant discourse that renders him 'other', disenfranchises him, makes him invisible, and silences his dissenting voice. Thus, I will argue, he engages with the discourse of multiculturalism and plays with it on his own terms. Rather than dress his work up in 'multicultural drag' (Cohen 2008: 318) he employs a range of strategies that introduce ambivalence and uncertainty concerning his positionality, and in relation to his own work. In so doing, his work challenges the viewer to reconsider their relationship and attachments to a cultural and religious difference. Thus, this chapter addresses how a young Muslim artist negotiates his identity in relation to the discourse of multiculturalism in urban city spaces.

I will examine three key artworks from Abdullah's June 2011 exhibition at Kings Artist Run Initiative, an established and high-profile artist-run space in Melbourne, and will draw

out themes in his work that voice a resistance to his marginalization. For this exhibition, Abdullah was sponsored by the City of Melbourne's Next Wave Festival. This discussion proposes that Abdullah's art constitutes a form of identity construction, protest and resistance to his experience of racism in Perth and Melbourne – cities in Australia where the artist has lived and worked.

The discourses of whiteness as outlined by Richard Dyer (1997) and Ghassan Hage (2009; 1998) provide suitable models in which to contextualize Abdullah's work. Dyer views whiteness as normative and universal (1997: 45) and as an ideal (1997: 71); it is associated with of enterprise and striving (1997: 80), heterosexuality (1997: 39), 'a corporeal cosmology that values transcendence' (1997: 39), and its invisibility and neutrality is manifest as a 'control over the body and the world' (1997: 44). On the other hand, Hage's significant contribution to whiteness studies describes the white fantasy of white Australian subjectivity concerning their paranoia, which he sees as a wish to control the racial mix of the nation.

I will elucidate the strategies in which Abdullah negotiates his positionality as a citizen and artist and constructs a sense of belonging in multicultural city spaces. This will demonstrate how Abdullah's work utilizes the discourses of diversity, multiculturalism and cosmopolitanism, not by celebrating his relationship to his social space as a 'a site of exotic liminality' (Cohen 2008: 318) but, rather, to reveal the ugly racism and anxieties that reside in the 'shadows' of a white city. In this protest and resistance inherent in Abdullah's work there is a culturally-productive site for inter-cultural dialogue rather than a form of retreatism (Hassan 2009: 10) that strengthens in-group solidarity while fostering out-group distrust (Putnam 2007). Influential American writer on Social Capital Robert D. Putnam's thesis concerning the initial impact of ethnic diversity and immigration found a decline in active citizenship, social networks and trust among all races. However, he maintained this condition could be changed through the building of community by individuals joining clubs, volunteering and engaging in inter-cultural dialogue across communities. In the context of the globalization of urban spaces and its impact on those marginalized, Abdullah's participation contributes to such dialogue.

While I make no claims that Abdullah's work is in any way representative of other Muslim artists in Australia, this discussion will perhaps shed light on many issues that may be apply to Muslims in Australia, Europe and in North America, and other migrants and minority groups that are denied a substantive sense of belonging to their new home through exclusion from the imagined community of the globalized city and nation.

Abdullah

Abdullah is a young Muslim artist from Perth, West Australia. He studied in his home city before living in Melbourne and returning to Perth where he shares a house and studio with his brother, a sculptor. He grew up in Victoria Park and East Cannington, both low

socio-economic areas with other second-generation migrants from Malaysian, Turkish and Indigenous backgrounds. He experienced racism as a form of inter-ethnic tribalism in his early school years before gaining an art scholarship to Applecross High School in year eight where the student population comprised 70 per cent Asians from mainland China and Indonesia (Abdullah 3 June 2011 interview with author).

Abdullah explains that while he was growing up he encountered racism in the nationalism of Australia Day, a day also considered 'invasion day' by some sections of the community. After the events of 9/11 the local Mosque in Canning Perth was the subject of racist graffiti and vandalism (Abdullah 3 June 2011 interview). Abdullah's mother was one of many Muslim women who were assaulted in public on the pretence that they were somehow responsible, as Muslims, for this act of terrorism: while on a shopping trip in the Hay Street Mall in Perth, she had her scarf pulled from her head and was chased into a shop and sought refuge.

The recent anti-Muslim sentiment can be traced back to the 1990s in Australia when attacks on political correctness became routine and multiculturalism was beginning to be rolled back (Poynting 2008). The language and discourse of multiculturalism became haram (forbidden) for the then Prime Minister, John Howard. Racism and resentment was made acceptable, particularly so in some quarters of the city, especially in the outer suburbs of some major cities where cars and utility trucks sported bumper stickers that raged, 'Fuck off we're full', 'Love it or leave it' and 'Bugger multiculturalism, support an Australian identity', suggesting Australian identity cannot claim diversity.

The outburst of bigotry and a feeling of grievance from some quarters in the country was aided and encouraged, by 'religious fundamentalism and right wing minority parties' (Jupp 2002: 134). More recently, the threat of terrorism and those seeking asylum has contributed to a certain undertow of resentment.

'Fuck Off We're Full'

Abdullah's exhibition titled *Them and Us* 2011, characterizes the impasse between the so-called entities of the 'Muslim world' and 'the West' as they exist in the public imaginary, yet the complexity begins to unravel since white Australia's imaginary is constructed under the normative discourse of whiteness, so 'us' means white Australia and 'them' refers to 'others'. While the dominant group claims legitimacy through the coercion of the now-stabilized category 'us', this has been ambushed by Abdullah, renovated and shifted to a space of ambivalence and uncertainty that questions the ground on which these questions are asked: who does 'them' and 'us' refer to?

The bumper sticker's ignoble language appealed to the imagined (white) community of far-right politician Pauline Hanson's 'forgotten people' (Stratton 1998: 31). The fears and anxieties of this constituency have not gone away with the demise of far-right political parties, but remain a festering sore in white Australia's psyche.

Figure 1: Abdul Abdullah, *Fuck off we're full* 2011, lightbox 120 × 155 cm. Image courtesy of the artist.

The bumper sticker image (Figure 2) is seen in various forms across Australia; however, it is perhaps more evident in the more decentralized states of West Australia and Queensland. They were prominent during the rise of the far-right political party, One Nation in the 1990s, and remain a feature of the racist terrain.

Figure 1, *Fuck off we're full* is an artwork that consists of a light box with a vinyl front. It takes the message of the bumper sticker and subverts its anger in a manoeuvre that is both seductive and strategic. In terms of design, there is a similarity of size, though the area of text in the sticker is larger than in the artwork: the font is larger and more aggressive and it has a stencilled look that is fractured, but tough, symbolic of the pioneering spirit, identified with 'enterprise' (Dyer 1997: 80) of white Australia. Its barely-contained rage connotes that Australia is under threat but nevertheless is fighting back, against Asians, boat people, Muslims and any who do not share 'our' values. They or 'Them' are excluded from white Australia's constructed 'imagined community' (Anderson 1983).

Figure 2: Abdul Abdullah, *Fuck off we're full,* bumper sticker. Image courtesy of the artist.

Abdullah deliberately converts the hard edges of the text in the sticker into soft focus in a distancing effect, so the text that was once hard, sharp, forceful-masculine becomes soft to produce an image where the font is smaller, wider and feminized,[4] so that its meaning is altogether less threatening than the sticker. However, there is much ambiguity in this act of appropriation.

Abdullah's intervention works to slow down the viewer's recognition and reading of this confrontational image to address the shock or surprise factor (the image does not appear on the promotional material for this reason). It provides a 'hiccup' or 'thinking space' that 'allows the viewer to think about it just a little bit more than if the image was clear' explains Abdullah (3 June 2011 interview). Thus, the softening of the whole image is a strategic move thwarting early recognition and dismissal. Abdullah said he 'wanted people to walk in and be confronted by it'; however, the audience reception prompts further questions.

In a 'partitioned city' (Marcuse 2008) where disadvantaged groups and the inner-city crowd rarely engage in any form of intercultural connection or dialogue, an art gallery setting might not appear to provide this opportunity; in this case it is an exception. From the author's perspective, the art cognoscenti gathered at the opening night were not at all shocked by what they saw; the cluster of artists and exhibition opening night attendees would most likely 'get' the concept, even though they might not be reading it in its 'fullest' context. I would argue this group of inner city art-goers, who, like Australian writer Sophie Cunningham, inhabit city spaces 'not far from a latte' (Holden 2011), might not even have seen the bumper sticker, since they are spatially sectioned off in the city (despite its mobility on a car bumper) and sheltered from its jingoism and political belief system.

Figures 1 and 2 both omit the Torres Strait Islands (situated north of the Queensland coast) but include the island of Tasmania in a parody of the racist sticker as depicted in Figure 1. While Figures 1 and 2 paint the Australian continent as black and the text white, perhaps an inadvertent reference to its black history and white colonization. White Australia's denial of its black history highlights the relationship between migrants 'perpetual foreigners within' and white Australians 'that produce the onto-pathology of white Australian subjectivity' since 'white Australia is unwilling to recognise its occupier status' (Nicolacopoulos and Vassilacopoulos 2005: 32–33).

The hard brittle edges surrounding the Australian coastline of the sticker image speak to a hard and stubborn approach epitomized by then Prime Minister, John Howard's chilling response to 'boat people' when he declared 'we will decide who comes to this country and the manner in which they come' (Howard 2001). It is an approach reiterated ten years later by the current Labour government concerning its offshore processing of Asylum Seekers. These sharp and abrasive edges serve to pronounce the image of 'fortress' Australia as an outpost of Britain in Asia.

The image of the Australian continent used in all representations is symbolic of a 'unique' Australian environment that has produced a nation of people who are prepared to give others a 'fair go' (Stratton 1998: 31). Another layer of irony inadvertently enhances the tenor of the sticker in Figure 1 and resonates in Abdullah's appropriation since the country of the 'fair go' is revealed to be the exclusive right of white Australians. The granting of rights to minorities threatened what far-right politician Pauline Hanson saw as the true Australian values of 'egalitarianism, a fair go, admiration of the battler, and a belief in the individual' (Leach 2000: 48). According to Dyer, this Anglo-Celtic sense of striving and enterprise is a feature of whiteness that thereby casts non-whites with significantly less 'resolve and determination' (1997: 80).

If use of the vernacular is a signifer of marginalization harnessed by those whose access to mainstream pathways is denied 'due to the insufficiency of existing ideological frameworks' (Farred 2003: 17) then its use as a bumper sticker is telling. The sticker speaks for one particular 'quarter' of the population, a section of old Australia that sees itself as forgotten in the globalized cities of temporary migrant workers, international students and the inner city professionals. This latter group of white multiculturalists also exhibits a collective silence on race, preferring instead to emphasize cultural difference, a kind of a soothing balm applied to the skin of the 'other' to avoid recognition of the ugly scab of racism and marginalization suffered by those 'othered'. The political liberalism of cultural difference fails to recognize and calculate the impact of racism, poverty and other structural factors by focusing on culture. In so doing, it provides an escape route from reality and facilitates an analysis of the other's culture, which is deemed to lack the values of liberal western democracies.

Hage (1998) apportions the blame squarely on 'white multiculturalists' who suppressed, in their own minds, the impact of a new reality where white Australian 'control' is diminished. The anger and resentment felt by white Australians against migrants and Indigenous people who they felt were getting 'something for nothing' inevitably emerged. In 1990s' Queensland,

the 'return of the repressed' was manifest in the bigotry of Hansonism and the sticker is evidence of such home-grown 'neo-fascism'. As Hage states:

> White multiculturalism cannot admit to itself that migrants and Aboriginal people are actually eroding the centrality of white people in Australia. This is because the very viability of White multiculturalism as a government ideology resides entirely in its capacity to suppress such a reality. As a result of this suppression, however, White multiculturalism leaves those White people who experience the loss with no mainstream political language with which to express it. This is why, like a return of the repressed, the discourse of White decline was bound to express itself in the pathological political language of a home grown Australian neo-fascism.

> (Hage 1998: 22)

Thus, I argue that those 'ordinary Australians' who identify with the sticker feel they have the monopoly of 'worrying' about the racial mix (Hage 1998: 10) of Anglo-Celtic Australia. Perhaps Abdullah's image acts as an anxiety-relieving mechanism for art-goers as it serves to reassure them that they indeed are really not racist. In summary, the jingoistic message and hostile register of the banner 'Fuck off we're full' appeals to the fantasy of white Australians (Hage 1998), and the Australian government's obsession and paranoia concerning border control exhibits racial and spatial anxieties (Ang 1999).

Assimilate

The emphasis on the culture of 'others' and cultural difference, as mentioned earlier, fed into the so-called 'clash of civilisations' debate (Huntington 1997). It constructs Muslims as a 'backward other' compared to the secular modernity and postmodernity of western democracies. This view seeks to essentialize Islam as discrete, monolithic, unmoveable and 'as being essentially barbaric and sexist' (Afshar 2008: 413) and unwilling to conform to western values. It is argued by Afshar (2008: 414) that while terrorist acts, such as 9/11, were not wholly responsible for this racism, they nevertheless acted as 'the catalyst', providing free-rein for the 'play' of Islamophobia in the public imagination. Thus 'othered' groups were required to assimilate into the dominant culture of white Australia. Following Kristeva, Humphrey (2007) discusses the abjection of Islam in a similar way. He argues that the abjection of Islam from the imagined communities of Britain and Australia position it as 'an enemy within' or 'a fifth column' (Afshar 2008: 415).

Assimilate (Figure 3) is a large photographic portrait of the artist's father. A white Australian with links to a convict past, he married an Indonesian woman in 1971, converted to Islam, and changed his surname to Abdullah in 1972 (Beard 2011). Abdullah plays with the positioning of the viewer concerning her/his own positionality within the social discourse of personal history and belonging to Australia, imagined or otherwise, since the process of

ASSIMILATE

Figure 3: Abdul Abdullah, *Assimilate* 2011, digital print 146 × 110 cm. Image courtesy of the artist.

assimilation is associated in Australian history as Indigenous and migrant assimilation to white Australia. In this context, however, Abdullah's father had to assimilate into the Muslim world also subject to globalization, and this process was largely successful. He was active in the Muslim community and was secretary of the Australian Islamic Council in the 1980s (Abdullah 3 June 2011 interview).

The artist's father is represented in Muslim attire: a turban-style headdress and a kaffiyeh, an Arab scarf that is now considered 'hip' among young Australians. While Abdullah claims in an interview (3 June 2011) that his intentions excluded parody, since the costume belonged to his father, he nonetheless has set the stage for an entry into the debate concerning the politics of representation – that is, who can speak for whom. He is looking to the left and sports a long white beard and a halo of white light around his head. His blue eyes are an intense blue, a deeper blue than the background blue hue. The sharpness within his eyes contrasts with the softer edges in the image and expresses the clarity of his intent and vision. As the light radiates outwards from Abdullah's father's head to the frame's edges, it changes from a very light white through gradations of white/pink indeterminate tints and gradually

into a more saturated blue. The heavenly glow, like a halo associated with western Judeo-Christian art, expresses pureness and spirituality. Religion and whiteness are concomitant, where white and light represent civilization, reason, western enlightenment and modernity. Black and dark are cast as barbaric, unenlightened, primitive or backward.

While there is much diversity of opinion among Muslims concerning what is haram or forbidden, in particular the representation of the figure, Abdullah maintains that for him there can be no 'intifada of the mind' or limits on the imagination. *Assimilate* playfully evokes Christian art, perhaps a reference to his father's religious conversion and to his past life that goes well beyond his outer exterior of his Islamic dress.

Towards the bottom of the image the blue becomes more intense and the word ASSIMILATE underlines the image printed in bold Helvetica – used because of its global usage and neutral Swiss origin (Abdullah 3 June 2011 interview). This representation of a Muslim with a 'PLO scarf' speaks of the experiences of a Muslim in Australia. What is tellingly hidden is the personal narrative of Abdullah's father. Thus, there is something of the trickster at play as the viewer's positionality is situated as 'other', i.e. non-Muslim, so that the 'backward' Muslim is enunciated. The clear gaze of the father is achieved by blurring around the edges of his face to create a clear sharp image that has the clarity and purposefulness of the text below. The suggestion of a horizon at the meeting of the bluest blue and the text arguably confirms the dominant position of the monotheistic nature of western and Islamic belief (Aly 2007). This is underpinned by the dominant way of viewing the land in western perspectival systems of art-making and viewing, which is prevalent in Australian art education. This clearly positions the history of western art as the normalized perspective by assimilating diversity into a unified western paradigm. Perhaps as a student Abdullah might well have come across this effect that controls and excludes via its normative representational system.

In a racialized milieu, skin colour has high symbolic value (Dyer 1997: 50). That Abdullah's father is white introduces ambivalence, although his Muslim attire overrides the dominance of white skin, as whiteness is perceived in terms of universalized whiteness as an ideological normativity. In an ambivalent turn Abdullah's father is rendered black, since white Australians who convert to Islam are considered a threat to the boundaries of whiteness.

In contrast to this image, there is more to be uncomfortable about concerning the word 'assimilate'. 'To tell someone to assimilate is to tell them to forget who they were, forcing them to deny their identity, demanding that they become something else – assimilate to whom' (Abdullah 3 June 2011 interview). Assimilation in Australian history is based on a myth of racial, religious and cultural homogeneity which is historically erroneous (Jones 2011).

Them and Us

Figure 4, *Them and Us*, depicts Abdullah and his older brother, Abdul-Rahman Abdullah. There are differences between the jpeg image on my computer screen, the printed image on the A4 flyer, the exhibition brochure and the large photograph exhibited. While this is

due to the technical limitations of digital resolution and printing, its ambiguity speaks to the ways in which these representations play with the visibility of these racialized bodies. The large print emphasizes Abdullah's body and, less so, his brother, whereas in the jpeg version Abdul-Rahman is more prominent. Thus another layer of meaning concerning the visibility and invisibility of 'othered' bodies is explored in reproductions of the 'original' image.

Abdullah knows it is haram for males to show their body below the navel and above the knee and he is also aware that tattoos are not allowed, since it is seen as a violation of the body. While it is decidedly fashionable for young men and women to get tattoos, this one was specifically commissioned for this photograph. The tattoo on Abdullah's ribs brings together the crescent moon, a symbol of Islam and introduces it as an anchor to the Southern Cross, a symbol represented on the Australian flag and associated with belonging to Australia. Thus, Abdullah is contesting white Australia's exclusive rights to this star configuration in a disruptive and embodied way. A tattoo is a mark that is not only on the skin but in it, and as such, it speaks from the boundaries of the artist's body, between self and other. In this case it is a statement of his complex multi-layered identity as a Muslim and as a young Australian.

There is a mirror image or *doppelgänger* effect here, as Abdullah's look-alike, Abdul-Rahman is not a literal doubling but the artist's brother; yet both share the same first name. The doubling effect of this photograph is uncanny, as the image of the two brothers resonates in terms of a shadow, alternative persona and of a double consciousness associated with the migrant or outsider (Gilroy 1993).

Two brothers, both named Abdul, are represented, both engraved with tattooed images. Abdullah's brother, therefore, acts as a literal and metaphorical shadow, attracting and reflecting light in a fragmentary way. The image is one of shared and split subjectivity. The text in English and Arabic is another doubling, of language, where the latter is seen as a primitive expression of a backward culture (Aly 2007: 23-24). The view that 'othered' groups are incomplete and unformed was a product of western enlightenment thinking and, remarkably, reiterated by Raymond Williams (Gilroy 1987), despite the achievements of Islamic civilizations, and so *Them and Us* is a play on the view of Islamic culture as 'medieval'.

The mirror-like quality is also apparent as the brothers look different ways, negotiating identity in and out of subjectivity and of the frame called Australia, as sons of a father who converted to Islam from Christianity. The tonal contrast of this screen image of the photograph emphasizes the dark/light progression as it leads the viewer's eye back into the image according to the laws of western perspective, emerging out of the darkness; in this way Abdullah is playing with the viewer's own perception. The Abdullah brothers emerge from the 'shadows' of darkness, but not into the light of Christianity, which has symbolic connotations concerning spirituality, morality and beauty (Dyer 1997: 57–60).

While Abdul's gaze is firm, he covers his mouth with his hand. As the prophet Mohammad said, 'He who is silent is saved' (Aly 2007: xx), so perhaps this signals the desired silence of

Figure 4: Abdul Abdullah, *Them and Us,* digital print 164 × 110 cm.
Image: David C. Collins.

spirituality, a form of passive resistance. This action also mimics pornographic representations
on the one hand while, on the other, it emphasizes an intense expression, especially of the
artist's eyes. More significantly, the mouth covering expresses a silencing, a voicelessness, of
not being able to speak or be heard. Muslims as a subaltern group are spoken about, but do
not always get the chance to be heard.

The politics of representation, looking and being looked at, are significant aspects of the
gaze, particularly the white gaze where 'looking and being looked at reproduce racial power
relations' (Dyer 1997: 45). Abdullah's gaze stares intently back at the viewer with his brother
in the background. The brothers' lithe half-naked bodies, with their underwear showing,
common for young males, has the pornographic quality of Calvin Klein advertisements

that is countered by the hard gaze of Abdullah. The representation of two Muslim brothers trades on a new confidence of an ethnicized masculinity and belonging, a new form of respect. Abdullah works in a boxing gym and both brothers have boxed competitively so this might partly explain the narcissistic quality of two young males showing off their bodies and their tattoos. The gym is a safe space away from the white gaze where bodies are the subject of work, or striving for control over the body, just like identity and belonging. In light of this, *Them and Us* can be viewed in terms of a new confidence concerning Muslim men and masculinity.

This doubling of the image of the body is a form of repetition that involves repetition and difference: the representation of bodies is repeated; however, they occupy different positions in the frame. Abdul-Rahman is older and his body is bigger, stronger and protective of his younger sibling. His tattoo reads *jihad al-nafs* or the struggle against oneself. According to Aly (2007), Jihad is derived from the Arabic *juhd*, meaning 'effort', the exerting of effort to achieve a goal, thus not associated with violence or terrorism (2007: 150), and the tool of jihad is the Qur'an (2007: 151). The other form of jihad is jihad al-nafs, the jihad against the defects of one's own soul (2007: 152), and this is considered the 'greater jihad' (2007: 153). Thus, while the conceptual breadth of jihad is accepted by theologians, 'the word's primary meaning was reserved for armed struggle' (2007: 155), but rooted in 'notions of justice' (2007: 162). This is significant for all those who want to understand the meaning of Jihad.

Thus *Them and Us* does not represent some cheerful assimilatory image of a reconciled Muslim Australian identity since the presence of Abdul-Rahman in the background with the tattoo of jihad al-nafs is a swift rejoinder to such an easily-claimed resolution. Yet another layer of ambiguity is the reflective nature of a framed photograph that acts as a mask or a distancing layer that demands the viewer to look and think again. If *Them and Us* is concerned with expressing the voice of a marginalized artist, it is a vision literally and metaphorically from the dark end of a partitioned city. Its multiple layers of ambivalence contest a celebration of Australian multiculturalism as it speaks to a complex hybrid identity and a sense of belonging to Australia that requires much *juhd*.

Conclusion

This discussion has shown the ways that Abdullah, as a member of a targeted minority in Australia, negotiates his identity as a racialized and spatialized subject in Australian cities. Abdullah strategically uses the tropes of representation, which are framed in terms of whiteness, and subverts them. In so doing, he uses the Muslim male body – himself, his father and his brother – to comment upon the power relations of looking, being looked at and being represented. His work also demonstrates how identity is constructed in racialized city spaces. As mentioned earlier, my study of one artist is limited so I do not claim to speak generally about Muslim artists in Australia, given their diversity. However, this study can

highlight some issues and concerns that suggest that further in-depth empirical research is required. The politics of representation are at stake here: about who can speak for whom; in what gallery is this work presented and how it is received; and on what terms can work from the margins be incorporated into the mainstream.

This discussion has offered ways in which Abdullah uses various strategies to seduce the viewer and slow down the viewer's process of cognition in order that the artwork may not be easily dismissed. The chapter draws attention to the impact of the urban spaces on the 'othered' Muslim body – ways it can shape the experiences and identity of a young artist from a cultural group subject to social and economic marginalization in a globalized and partitioned city. The layers of ambiguity that are woven throughout the artwork position the non-Muslim viewer in a way that demands further questions rather than easy answers. Significantly, Abdullah's work is one example of protest and resistance to the white Australian imagination and, as such, acts as a counter-discourse to a cheery and exoticized Australian multiculturalism. The smooth approach Abdullah employs is a strategy to protest in a non-confrontational way. As Nigerian and British artist Yinka Shonibare states, '[y]ou are not going to even realise that I am protesting' (Gellatly 2006).

References

ABS (2009), *A Picture of the Nation: the Statistician's Report on the 2006 Census*.

Afshar, H. (2008), '"Can I see your hair?" Choice, agency and attitudes: the dilemma of faith and feminism for Muslim women who cover', *Ethnic and Racial Studies*, 31: 2, pp. 411–27.

Aly, W. (2007), *People like Us*, NSW: Picador.

Anderson, B. (1983), *Imagined Communities: Reflections on the origin and spread of nationalism*, London: Verso.

Ang, I. (1999), 'Racial/Spatial Anxiety: "Asia" in the psycho-geography of Australian Whiteness', in G. Hage and R. Couch (eds), *The Future of Australian Multiculturalism*, Sydney: The Research Institute for Humanities and Social Sciences Sydney University, pp. 189–204.

Beard, N. (2011), *Them and Us*, essay in exhibition catalogue, June, Melbourne: King's ARI.

Cohen, P. (2008), 'From the Other Side of The Tracks: Dual cities, third spaces, and the urban uncanny in contemporary discourses of "race" and class', in G. Bridge and S. Watson (eds), *A Companion to the City*, London: Wiley-Blackwell, pp. 316–330.

DIAC Department of Immigration and Citizenship (2006), 'Muslims in Australia – A snap shot', http://www.immi.gov.au/media/.../Muslims_in_Australia_snapshot.pdf. Accessed 9 November 2009.

Dunn, K. (2003), *Representations of Islam in the Politics of Mosque Development*, http://onlinelibrary.wiley.com/doi/10.1111/1467–9663.00158. Accessed 18 December 2012.

Dyer, R. (1997), *White*, London: Routledge.

Farred, G. (2003), *What's my Name?*, Minneapolis: University of Minnesota Press.

Gellatly, K. (2006), 'Yinka Shonibare', in *Contemporary Commonwealth*, Melbourne: National Gallery of Victoria.

Gilroy, P. (1993), *The Black Atlantic: Modernity and double consciousness*, London: Verso.

—— (1987), *There Ain't No Black in the Union Jack*, London: Routledge.

Hage, G. (2009), *Speech, Racism in Australia*, Melbourne: Latrobe University.

—— (1998), *White Nation: Fantasies of white supremacy in a multicultural society*, Sydney: Pluto Press.

Hassan, R. (2009), 'Social and Economic Conditions of Australian Muslims: Implications for social inclusion', *National Centre of Excellence for Islamic Studies*, 2: 4, http://www.nceis.unimelb.edu.au/sites/nceis.unimelb.edu.au/files/NCEIS_Research_Paper_Vol2No4_Hassan.pdf, pp. 1–13. Accessed 11 November 2009.

Holden, K. (2011), '"Streets of our town", book review of Melbourne by Sophie Cunningham', *The Age*, 6 August.

Howard, J. (2001), Election campaign policy launch speech, 28 October 2001, http://museumvictoria.com.au/immigrationmuseum/discoverycentre/identity/videos/politics-videos/john-howards-2001-election-campaign-policy-launch-speech/. Accessed 20 December 2012.

Humphrey, M. (2007), 'Culturalising the Abject: Islam, law and moral panic in the West', *Australian Journal of Social Issues*, 42: 1, Autumn, pp. 9–25.

Huntington, S. (1997), *The Clash of Civilisations and the Remaking of World Order*, NY: Touchstone.

Issues Deliberation (2007), 'Australia Deliberates: Muslims and non-Muslims in Australia', *Canberra, Issues Deliberation Australia*.

Jones, B. (2011), 'Getting under the Skin of Immigration', *Alfred Deakin Lecture*, State Library of Victoria, 3 August.

Jupp, J. (2002), *From White Australia to Woomera*, NSW: Cambridge University Press.

Leach, M. (2000), 'Hansonism, Political Discourse and Australian Identity', in M. Leach, G. Stokes and I. Ward (eds), *The Rise and Fall of One Nation*, St Lucia, Qld: University of Queensland Press.

Marcuse, P. (2008), 'Cities in Quarters', in G. Bridge and S. Watson (eds), *A Companion to the City*, London: Wiley-Blackwell, pp. 270–81.

Martin, P. (2009), 'Australian bosses are racist when it's time to hire', *The Age*, 18 June.

Nicolacopoulos, T. and Vassilacopoulos, G. (2005), 'Racism, Foreigner Communities and the Onto-pathology of White Australian Subjectivity', in A. Moreton-Robinson (ed.), *Whitening Race: Essays in social and cultural criticism*, ACT: Aboriginal Studies Press, pp. 32–33.

Poynting, S. (2002), 'Bin Laden in the Suburbs: Attacks on Arab and Muslim Australians before and after 11 September', *Current Issues in Criminal Justice*, 14: 1, pp. 43–64.

Putnam, R. (2007), 'E. Pluribus Unum: Diversity and community in the twenty-first century', *Scandinavian Political Studies*, 30: 2, pp. 137–174.

Rane, H., Nathie, M. Isakhan, B. and Abdalla, M. (2010), 'Towards Understanding What Australia's Muslims Really Think', *Journal of Sociology*, http://jos.sagepub.com/content/early/2011/03/09/1440783310386829, pp. 1–25. Accessed 5 August 2011.

Stratton, J. (1998), *Race Daze*, Sydney: Pluto.

Re-imagining the City

Notes

1 The use of social space by young Muslims was tested at Cronulla beach, Sutherland Shire, a white area of south Sydney during the summer of 2005 where white youths attacked anyone of Middle-Eastern appearance in a turf war over space and white women.

2 In 2006 the then Imam of the Lakemba Mosque in Sydney, Mufti Al-Hilaly, controversially stated that women who dressed or behaved in a certain way were themselves to blame for being raped, rather than men who were the perpetrators of the crime.

3 This trend has been highlighted recently in the case of the proposed 'Mosque' in the vicinity of Ground Zero (2010) and in opposition to Mosque building particularly in Sydney in the 1980s and 1990s based on traffic concerns and it being out 'of character' in the urban setting (Dunn 2003).

4 While the construction of gendered categories concerning the visual representation of text is problematic, in the context of the power relationships concerning those 'othered' and their male perpetrators, gendered representations are appropriate here.

Chapter 10

The Visible Hand: An urban accord for outsourced craft

Kevin Murray
RMIT University

One of the conditions of recent urbanization in a globalized world is an increasing distance of consumers from sources of material production. Compared to traditional village lifestyles, where production such as agriculture and craft is embedded in everyday life, the goods used in cities are derived from supply chains that span many different countries (Jayne 2006). By way of example, Snyder (2007) documents the production of denim from cotton-growing in Azerbaijan to garment assembly in Cambodia. In broad terms, manufacture has been 'offshored' from West to East.[1] This global distribution of production often entails a distance from the origins of consumer goods, particularly for those who live in western cities. Dependence on the lower standards of workers is less obvious when they live on the other side of the world. While this removal of the industrial scene has previously occurred at the level of mass manufacture, with factories moving from global West to East, it is now beginning to affect handmade craft production, previously a quintessentially local activity. Craft practice thus expands beyond the production of traditional objects sold for local use or to tourists as souvenirs. It now involves bespoke handmade production such as one-off commissions and customization. This chapter considers craft in this broader sense of the application of skill in the making of decorative objects by hand.

Should this distance from production be viewed as a natural evolution or a convenient distantiation of economic inequity? On the one hand, this specialization is celebrated in the concept of a 'smart nation' whose fortune is based increasingly on an information economy. Concepts such as Richard Florida's (2005) 'creative class' identify sources of growth in design rather than manufacture, thus modes and methods of production are somewhat overlooked in the interests of fostering 'smart' creative economies. The idea is that while western cities may have lost their factories to offshore production, they can retain their economic advantage through innovation, gaining income through licensing of designs and receiving royalties.

On the other hand, the practice of offshoring can be critiqued as exploiting the labour of the global South, which in the sense of this analysis takes on the factory routine work necessary to maintain urban lifestyles. Offshoring is sometimes the source of scandal casting a shadow over leading brands. For example, in the 1970s Nike sports shoes suffered a blow to their brand identity when it was revealed they were produced in sweatshops. More recently, it was discovered that the Foxconn factory in southern China producing Apple iPhones had systematically violated worker rights, leading to employee suicides (Branigan 2011). Given the more traditional context for craft production, it would seem that the same

concerns would not be as relevant to the handmade. But as the handmade begins to be outsourced, and artisan workshops depend increasingly on foreign commissions, there is potential for craft production to follow the 'race to the bottom' of mass manufacture. [2] This would include not only lower wages but also lower health and safety standards, such as exposure to dangerous chemicals in ceramic glazes. Can an outsourced craft avoid these disadvantages and dangers?

Discourse about this dimension of globalization often focuses on the flows of capital and labour (Sassen 1998). This chapter considers the creative dimension of this issue in the social relations that are at play in the interaction of craft and design. The handmade contains a symbolic meaning, particularly in the form of objects with artistic value found in galleries or craft boutiques. Here the means of production can be more relevant than it is, for example, with industrially-produced goods sold in supermarkets. The design process for handmade goods may entail not only the form and function of the product but also its 'back-story' in how it was made. Craft represents a village lifestyle that draws on resources at hand and is characterized by rhythmical activities such as weaving that involves repetition. On the other hand, design is a more urban phenomenon that draws on external resources and involves a greater proportion of singular actions such as drawing. The creative difference within North-South relations provides a stage for examining alternative models of how design and production, thinking and making, city and village, interrelate. In recognizing the value of skill, for example, one promotes a more even North-South relationship. While there is the potential to reproduce global inequity in the offshoring of craft, there is the possibility of a more transparent relationship in which it is possible to recognize mutual interests. In this way, the occlusion of inequality behind brand identity is less likely than when this relationship is taken for granted. This offers incentive to ensure fair conditions of production as an ethical practice in global consumerism. Outsourcing the handmade has the promise of re-imagining the city as an agent in partnership with the village on which it depends.

Labour Arbitrage

Craft outsourcing is considered here in the broad context of the global distribution of labour. Labour arbitrage operates on the principle that whereas the price of goods can remain relatively fixed the cost of labour differs according to place. Using this logic, many global corporations engage in a 'race to the bottom' to find manufacturers offering lowest wages and minimum environmental standards (Berle and Means 1967). This has led to the exodus of manufacturing from the First to the Third World, where wages are lower. According to a 2007 Parliamentary inquiry into manufacturing in Australia, the proportion of the workforce in manufacturing has halved since 1950, particularly in textile and metal products (House Standing Committee on Economics, Finance and Public Administration 2007). Figures such as this show the effects of global outsourcing on local or national workforces.

Today the exodus of labour is extending beyond manufacture. The wave of offshoring has more recently affected the business sector, with 'back office' services moving in particular to India. There is even the report of Chinese prisoners involved in 'gold farming', building up credits on online games such as World of Warcraft through the monotonous repetition of basic tasks (Vincent 2011). While providing employment in poorer countries, offshoring has also coincided today with increasing gaps between rich and poor to the point where the overall consumption of the richest 20 per cent of the world's people is 16 times that of the poorest 20 per cent (United Nations Development Programme 2000). The global distribution of labour can be seen to have benefitted the global North in many ways. Lower prices on consumer goods imported from China have kept inflation down in the First World. The air is also cleaner now that many polluting factories have closed in the manufacturing regions of North America, Europe and Australia. And internalized class conflict between managers and workers has diminished, reflected in declining trade union membership across the developed world (Australian Labour Market Statistics 2004). But these benefits are based on the lower wages and environmental standards of the global South, to where the factories have moved.

Some questions arise for consideration. Is craft outsourcing to be seen in the same way as offshore manufacture? Does it represent the export of a drudgery that is no longer tolerable in the global North? Are different factors at play when an object is produced in a workshop by hand rather than by machine in a factory? As a form of production involving traditional skill, the crafting process has greater potential for visibility than does anonymous factory labour. Various recent initiatives have sought to inform urban consumers about the origins of products. As an autonomous platform for exchange of ethical goods, Fair Trade provides certification for agricultural cooperatives that comply with set labour standards (Murray 2010). The rise of 'ethical chic' in fashion has stimulated interest in the conditions of production (Cameron and Haanstra 2008). Platforms such as ebay's 'World of Good' now seek to add symbolic value to the craft products on sale through a 'trustology' that guarantees specific ethical benefits, such as gender equity and poverty alleviation (World of Good 2011). By contrast with mass-manufactured products such as iPhones, there is a market for commodities and handmade goods that promises to engage the consumer more directly with the scene of production.

The history of craft since industrialization is associated with campaigns against poor labour conditions. In late-nineteenth-century England, the Arts & Crafts movement emerged to champion local craft practices that were endangered by industrialization. Writers such as William Morris (1884) defended traditional handcrafts against the factories that had mechanized production. In the twentieth century, the studio crafts movement emerged as a paradigm for crafts based on the visual arts, involving the production of largely original works (Adamson 2007). In almost all cases, the personal experience of the artists working with materials such as clay and wood was an essential part of the production process. In the case of ceramics, there was a strong influence of oriental traditions, particularly from China and Japan (Leach 1978).

However, until the late twentieth century, there was rarely any indication that production could be outsourced to these countries. Making it oneself was an essential commitment.

As the leader of this movement, Bernard Leach wrote: 'Laborious hand-methods have almost been abandoned in the western world, but a craftsman is not worth his salt if he makes no effort to preserve this natural joy in labour' (Leach 1978: 187). It is thus worthy of note to see a trend towards the outsourcing of handmade craft, following the exodus of mass manufacture. This kind of globalization is occurring not at the level of factory production, but more along the lines of 'bespoke' workshop production.

Artisan workshops are now setting themselves up to take commissions from overseas urban designers.[3] Given the trend towards transparency in ethical consumerism, this craft outsourcing has the potential to engage urban dwellers with issues of production. To understand this better, it is important to map forms of collaboration between designers and craftspersons in terms of transparency and equality. By this means, it is possible to see how outsourced handmade production might avoid the 'race to the bottom' of labour arbitrage.

Three Models

Three models are constructed as a means of exemplifying and understanding the social relationship of craft and design.[4] These models concern situations where individuals from wealthier countries seek to have their work hand-produced by artisans using craft skills found in non-western countries. The models are characterized as 'developmental', 'romantic', and 'dialogical'. The developmental model figures production as a secondary and increasingly-insignificant part of the process. According to this model, technological progress liberates the producer from drudgery, allowing for increased creative freedom. The romantic model positions design as a form of commodification that hides the reality of production. This is expounded, in recent times by Richard Sennett as a personal moral issue, echoing the Arts & Crafts movement of Victorian England. Finally, the dialogical model contextualizes design and craft as separate but interlocking domains of ideation and realization.

These identified models are compared here through three examples. The first is the practice of Danish ceramicist Anne Black who has her work manufactured by Vietnamese workshops. The second is Kandahar Treasures, an NGO which attempts to rescue Afghan craft through product development for export. And the third is Punkasila, a project involving Australian artist Danius Kesminas and Indonesian collaborators. Rather than singling out one model as superior to the others, consideration is given to the contexts of each.

Developmentalist

The first model follows the implicit logic of offshoring. The developmentalist model assumes a hierarchy of work in which the abstract is more important and deemed to be more satisfying than the concrete. In the implicit deal struck by such arrangements, the designer is free from

the drudgery of production, leaving the labour to be done by those who, it is presumed, are grateful for the income. Within this model, craft skills are considered a vestige of feudal society. Following this premise, the benefit of technology is to free others from menial chores so that a more creative engagement with the world may be possible.

Anne Black

The atelier model features a master designer whose concepts are realized by skilled artisans. Relatively high wages combined with decline in craft skills has seen some studios outsource their production to cheaper labour in the global South. An example of this can be found in the work of Danish ceramicist Anne Black, who has offshored her production to the Vietnamese village of Bat Trang.

Bat Trang was established in the middle of the fourteenth century, close to kaolin reserves. Its ceramics has been widely praised for the freedom and individuality of its designs. According to a local saying, 'Chinese pottery is good for the eyes; Vietnamese pottery is good for the heart' (Ngoc 2010). Today there are more than thirty ceramics businesses eager for work from foreign companies.

Anne Black is a successful ceramic designer whose work can be found in fashionable outlets throughout the West. She produces not only vessels but also jewellery and home decor. Her work can be characterized as light, clean and quirky.

In the various presentations of her work, she does acknowledge the skill of Vietnamese ceramicists, particularly in hand-painting designs. But in using these skills, she does not seem obliged to grant them creative input. In fact, the few images of the factory feature a visit from the Danish Queen Margrethe and the Crown Princess Mary (Figure 1). While the Danish royalty are clearly enjoying their opportunity for creative expression, there is no evidence or recognition of those who actually make the work. No ceramicist is mentioned by name, nor are there any photos of the artisans at work.

Though their labour is anonymous, there is no obvious reason to suspect that the workers are exploited. Black works in partnership with DANIDA, the Danish International Development Agency, to ensure that her production complies with fair trade agreements. But the agency in this operation rests with her creativity. According to a company spokesperson, Bat Trang is important for Anne Black both as a source of inspiration for her and that 'it makes it possible for her to continue and make a living based on a traditional crafting techniques [sic]' (2011 personal communication). It seems no longer possible for such traditional crafts as ceramics to survive in the global North, so designers must seek out opportunities like Bat Trang where wages are lower.

This global contract of labour arbitrage has been questioned recently with the imbalance of trade between consumer and producer nations. The offshoring of manufacturing to China has seen the US eventually lose its economic power. US strength is redefined in terms of its people skills, rather than manufacturing capacity (Steingart 2008).

As with other forms of labour arbitrage, this arrangement is easily characterized as exploitative. The nameless toil of potters in Vietnam increases the profit margin of a privileged First World designer. However, the developmentalist model can seem liberating from one perspective. In presuming purely abstract relations with the worker, it does not lay claim to any interest in their cultural or personal identity, presuming they have time left for such things.[5] The advantage of anonymous toil is that one can be left to oneself. There is no obligation to please patrons with signs of appreciation. No calls to smile for the camera. Capital provides a means of engagement with no strings attached. There is another side to this relationship. It is not only the workers who can be seen to be exploited in this context. In divesting oneself of the productive capacity, it can be argued that one is also denying oneself particular psychological benefits.

The information society poses particular challenges for well-being. Rather than tangible outcomes in one's daily work, there is an endless horizon of activities. In terms of one's relationship with others, greater distance from the life of things can have an impact on one's

Figure 1: Screenshot, *elevate sydney*, Australian supplier of Anne Black Ceramics, http://www.elevatedesign.com.au/pressandnews.html. Accessed 3 January 2012. Web caption: The Danish Queen Margrethe and the Crown Princess Mary visit the Anne Black porcelain factory in Hanoi Vietnam. They were both very delighted with the factory visit and Anne's fresh designs. Both the Queen and Princess hand painted on black is blue and hay-black designs.

emotional literacy. The argument of writers like Richard Sennett is that the care and patience demanded to make things well exercises qualities that are conducive to good social relations. He argues that an information society is disposed to managerialism. As Sennett writes:

> Material challenges like working with resistance or managing ambiguity are instructive in understanding the resistances people harbor to one another or the uncertain boundaries between people.
>
> (Sennett 2008: 289)

The loss of tangible products of one's labour can be seen to lead to the kind of depression and anxiety that characterizes consumer nations.

The developmentalist model follows the logic of outsourcing of mass manufacture. It is seen to both liberate those in the global North from drudgery of craft labour while providing work for those in the global South. While this can reproduce the existing global hierarchy, it does offer the freedom of a wage that demands nothing else from the worker beyond their labour. But in extending the export of labour from the global North, it raises concerns about the emotional impact of the loss of productive capacity in countries that outsource their manufacture.

Romantic

The antithesis of the developmentalist model is the romantic, which privileges the lifestyle of the traditional craftsperson above that of modern urban worker. The romantic model usually focuses on a dying craft tradition, which can be rescued through the intervention of foreign consumers.

After World War Two, a movement developed to protect cultural heritage from the forces of modernity. Predominantly led by UNESCO, organizations like the World Craft Council were established to promote the work of traditional craftspersons. While drawing on the spirit of the Arts & Crafts movement, its broader reach was articulated by writers such as Octavio Paz, who privileged the authenticity of craft above the power of modernity: 'Between the timeless time of the museum and the speeded-up time of technology, craftsmanship is the heartbeat of human time' (Paz 1974: 24).

The concept of world craft reflects the emergence of other 'world' media like 'world music' and 'world literature'. With a fear that westernization entails cultural homogenization, festivals and museums overtly celebrate the survival of cultural diversity by packaging exotic traditions that can be categorized as representative of their culture.

World craft is supported by collectors, travellers and artists, who often establish a bond with a particular community whose craft they celebrate. Though they would not normally identify as such, this group shares a structural similarity with the tourist. Its mobility is defined by the fixity of the other. The attraction of world craft collectors in

visiting traditional communities is to find a way that is more at home with its world (Canclini 1993).

One of the assumptions behind world craft is that, given the choice, communities prefer to preserve their traditions. Their distinctiveness is a matter of pride rather than shame. This is not a reciprocal relationship, as the collector is not explicitly driven by a love of his or her own culture. Often they are more conscious of the emptiness of western capitalist culture and are drawn to the more organic lifestyles of traditional peoples. The exchange is often a matter of providing those capacities that sit outside tradition, such as the contemporary systems of finance and marketing.

Kandahar Treasure

The Afghan NGO Kandahar Treasure is dedicated to sustaining the embroidery skill of Khamak (Figure 2). The goal of this enterprise extends beyond the survival of a craft to the empowerment of women. Their mission is 'reviving the rare and unique embroidery of

Figure 2: Screenshot, *Kandahar Treasures*, http://www.kandahartreasure.com/. Accessed 3 January 2012. Image: Paula Lerner, www.lernerphoto.com.

Kandahar and empowering women in the process' (Kandahar Treasure 2011). Its founder is an Indian ex-pat, Rangina Hamidi now living in the US. Hamidi sees herself as providing these Afghan women a 'profit platform' that grants them greater financial independence than they might otherwise find under traditional patriarchy.

By contrast with Anne Black ceramics, the Kandahar Treasure's website profiles and names individual women artisans who produce their goods. While their skills were traditionally applied to traditional coverings, such as shawls, this project involves products for the western market, including table linen and bags.

Kandahar Treasure has recently been profiled in the US magazine *Hand/Eye*, which is dedicated to promoting such initiatives. According to the article supplied by Kandahar:

During the days of the Taliban, Khamak embroidery was on the brink of extinction. Women were forced to stay at home and prosecuted for taking part in the economy. Raw materials and stitching needles were difficult to come by, electricity was scarce, and creative expression was repressed. Kandahar Treasure creates economic independence for these women, exposing this art to the outside world. This enterprise is reviving traditional art as well as giving voice to the world through these beautiful pieces.

(Waterman 2011)

In league with the consumer, Kandahar Treasure positions itself as a saviour for traditional artisans, enabling them to return to their previous ways of life while conforming to the tastes of the foreign consumer.

The romantic model is readily critiqued. It conforms to Slavoj Zizek's characterization of a liberal sensibility that cannot own its own interests: 'Enjoyment is good, on condition that it not be too close to us, on condition that it remain the other's enjoyment' (Zizek 1993: 212). Critics of ethical consumerism argue that the main motivation of such projects is the internalized moral dramas of the consumers, rather than any sense of real interest from producers (Black 2009). Such enterprises can then be characterized as 'feel good' exercises serving the interests of the global North rather than genuine partnership between the worlds of producers and consumers.

An open process of transaction between artist and collaborators can alleviate such criticisms. It need not be presumed that the symbolic work which arises from this collaboration is meaningful to the producers. Rather than a selfless missionary, it can be argued that is more honest that the artist identifies his or her own interests, such as the growth of his or her cultural capital.

What is most often missing from these projects is any identification of the interests involved. It is usually subsumed by the logic of spectacle, where a complex story is represented by an easily-digested image. What do the producers gain from such a project? What is the nature of the consumers' pleasure in seeing the results? A flaw in the romantic model is the absence of space for critical review. There is no mention of any potential compromise of interests as products are developed to meet the needs of First World consumers.

Dialogical

While the developmental model increases design capacity, it does not recognize the creative capacity of the producer. And though the romantic model privileges the creative energy of the producer, it elides the agency of the designer. In the tradition of speculative philosophy, this antithesis prompts the expectation of a synthesis. From the opposition of developmental and romantic models, it may be possible to imagine a collaboration that produces mutual recognition.

In such a scheme the ideal collaboration between global North and South is that of equal partners. This would be a context beyond exploitation, where designers take advantage of low expectations of artisans, and its redress in cases where the designer is seen merely to serve the interests of artisans. The dialogical model is one where both parties form a partnership as equals. In this way, both parties might acknowledge a reciprocity between the distinct capacities that the producer and consumer worlds can offer.

Danius Kesminas

Danius Kesminas is a Melbourne artist with a long engagement in popular culture. While he seeks community participation, this is more often about the release of creative energy than building moral structures. One long-term project is a documentation of the way communities in Lithuania are linked by a vodka pipeline.

His Australia work combines the energy of rock music with high art references. In this way, he seeks to attack art's elitism by popularizing its most privileged secrets. His rock band Histrionics perform songs about revered contemporary artists, like the Thai relational artist Rirkrit Tiravanija who transforms galleries into restaurants. The lyrics follow a familiar tune: 'I don't like Rirkrit, no, no/I love him, yeah/I don't like your bean curd/Don't mean no disrespect/I don't like your tofu/If this dish is an art object.' His work reflects a carnivalesque popularization of elite art, while at the same time confirming shared references within the art world.

At the end of 2005, Kesminas arrived in Jogjakarta for a three month Asialink residency (2009 interview with author). His only preparation for the new culture was reading a book, *The Politics of Indonesia*, by Damien Kingsbury. It was a dense read, filled with acronyms. Despite their inscrutability, these acronyms would later end up being an important creative resource.

Soon after he arrived in Jogjakarta, Kesminas started spending time at a local art school. There he found a familiar scene of young rebels playing aggressive rock music. So he decided to form a band of his own and went about recruiting musicians, with immediate success. As Kesminas did not speak any Indonesian, they created lyrics together that were inspired by the acronyms he had read. Fortuitously, this method corresponded with a local word game, plesatan, which satirizes the official language of the Indonesian state. For example, the song TNI is based on the acronym that stands for Tentara Nasional Indonesia (Indonesian National Military) but which is sung as Tikyan Ning Idab-Idabi

Figure 3: Danius Kesminas, PUNKASILA chicks at the Sultan's Palace, Yogyakarta, Indonesia, 2009. Image: Edwin 'Dolly' Roseno.

(Poor but Adorable). In a similar vein, the band adopted the title Punkasila, which is drawn from the concept pancasila, the official five ideological tenets of Indonesian nationalism (Figure 3).

Local involvement in Punkasila expanded rapidly. A batik textile printer produced the band uniform in military camouflage; a wood artisan carved elaborate machine-gun electric guitars from mahogany; and others produced t-shirts, stickers, videos, etc. Much of this creative craft activity was well beyond Kesminas' control, but this was exactly as he wanted it – 'you're a catalyst lighting this wick'.

Like many foreign artists, Kesminas enjoyed the freedom to make art in Indonesia. He contrasted this with the situation in a country like Australia where everything has to be paid for – 'over there it's different. You just do things because you do them.'

Given the role of the military in Indonesian life, Kesminas was afraid their provocative repertoire would endanger his collaborators. He claimed that he 'always had to defer to them for limits. We never did anything they didn't want to do' (2009 interview). Yet, at the same time, he recognized that his role as an outsider was critical: 'There was a nice unspoken agreement. I gave them a kind of cover, as a naïve Westerner' (2009 interview). It is hard

to tell who is using whom in this situation. Even though punk is an identifiably-western popular movement, Kesminas associates it more broadly with a DIY principle of cultural independence. Like the paraphernalia that was locally made for Punkasila, it represents self-sufficiency in culture and defies a reliance on imported readymade products.

For Kesminas, the most significant complaint against Punkasila came from 'NGO do-gooder missionary types' who thought he was showing disrespect for Indonesian culture. Kesminas claims that he was actually more respectful by following the authentically carnivalesque nature of Indonesian street culture. According to this line, what we normally associate with Indonesian traditions, such as Wayang, is just a cultural commodity sustained for western tourists. For Kesminas, the real life is on the street.

Kesminas is still open to criticism. While he celebrates the DIY free spirit of his collaborators, it is Kesminas who gains the local cultural capital in his artistic profile, gaining opportunities to exhibit the work in major galleries. But it could equally be argued that his Indonesian participants gain their own version of cultural capital. Kesminas raised money for his fellow band members to participate in the Havana Biennale, which profiled them on an international stage. In terms of immediate material interests, sales for work based on Punkasila are minimal and limited to merchandise sales.

What is less avowed is the pleasure gained from an Australian audience in seeing its populous Muslim neighbour to the immediate north embrace western culture. It featured as a story in the ABC television programme *Foreign Correspondent* as young Indonesians exercising their fun-loving self-expression above adherence to patriarchal authority. Punkasila represents a popular revolt against traditional authority in the spirit of rock and roll. Thus it can be seen as a form of cultural imperialism, even if antithetical in values to its missionary forebears. However, the opposite response of the romantic to save a culture from westernization can be seen as equally culturally intrusive. The level of participation in Punkasila seems more spontaneous than in the standard developmental or romantic model. A recognition of mutual interest is in evidence.

It should be noted that, like the other collaborations, Kesminas is a westerner seeking to have work produced by artisans from poorer countries. The outcomes are less predictable than others and extend to music as well as craft, but nevertheless it does share similar structural factors with the other two, particularly in the division between intellectual and physical labour. While seeming to attract spontaneous forms of collaboration, Punkasila can become a stereotype if it remains fixed in any one particular form of relationship between artist and maker. Such partnerships have relational value as creative products in themselves, so they need to be open to innovation and self-reflexivity.

Conclusion

The three models of collaboration reflect alternative relations between the First and Third World, city and village. According to the developmental model, the outsourcing of craft

production can be seen as an extension of labour arbitrage. It takes advantage of global inequality to divide labour so that the drudgery of handmade tasks can be performed in poorer countries of the global South. The freedom of creative expression by the designer of the global North is purchased with wages for workers in the global South. While this does little to question the global divide, it can be seen to provide some tangible material benefits for the workers involved. By contrast, the romantic model is based primarily on the interests of village artisans from the global South, whose lifestyle reflects a valued alternative to the consumerism associated with modernity. Though contesting the hierarchy of global North and South, this can still be seen as serving the interests of western consumers, eliding potential artisan aspirations for the very consumerism against which they are defined. Finally, the dialogical model aims to represent a reciprocal relationship where there is creative agency on both sides. The example of Punkasila creates a shared identity involving carnivalesque satire that ridicules conventional authority. There is potential for other forms of solidarity, such as protection of the environment. Such a model is more likely to succeed in an urban setting where there is literacy and familiarity with cultural exchange.

While the dialogical model formally involves a more equal relationship, it is possible to see contexts where the developmental and romantic are more appropriate. The reduction of participation to a conventional labour contract in the developmental model can preserve a buffer between local culture of the workers and a foreign consumer market. Where communities seek to preserve their traditions in a globalized context, the romantic model can serve to replace a lost local market. What potentially counteracts the exploitative nature of labour arbitrage in craft outsourcing is a critical evaluation of its benefits and losses on both sides. A Code of Practice that involved protocols for the development of such partnerships would help ensure that such critical evaluation was part of the collaborative process.

Cities, particularly in the West, are increasingly removed from the means of production upon which urban lifestyles depend. Products of mass manufacture appear as branded commodities with little reference to their origins. The trend to offshoring craft work offers a more transparent relation between city and village where the 'back-story' of how an object is produced contributes to its final value. It is a creative challenge for designers and artisans to keep alive the dialogue between city and village.

Acknowledgements

This chapter is based on a keynote lecture 'A Race to the Top: Transnational Collaborations in Craft and Design' presented at Collaboration in Experimental Design Research conference COFA August (2010) and is closely based on Murray (2010). Thanks to Elizabeth Grierson for valuable comments.

References

Adamson, G. (2007), *Thinking Through Craft,* Oxford: Berg.

d'Anjou, P (2011), 'The Ethics of Authenticity in the Client-Designer Relationship', *The Design Journal,* 14: 1, pp 28–44.

Australian Labour Market Statistics (2004), http://www.abs.gov.au/ausstats/abs@.nsf/7d12b0f67 63c78caca257061001cc588/592d2f759d9d38a9ca256ec1000766f7!OpenDocument. Accessed 10 November 2011.

Berle, A.A. and Means, G.C. (1967), *The Modern Corporation and Private Property,* New York: Harcourt, Brace and World.

Black, S. (2009), 'Microloans and Micronarratives: Sentiment for a small world', *Public Culture,* 21: 2, pp. 266–92.

Branigan, T. (2011), 'Misery in the Making', *The Age,* http://www.theage.com.au/technology/ technology-news/misery-in-the-making-20110802-1i8yg.html. Accessed 2 August 2011.

Cameron, J. and Haanstra, A. (2008), 'Development Made Sexy: How it happened and what it means', *Third World Quarterly,* 29: 8, pp. 1475–89.

Canclini, N.G. (1993), *Transforming Modernity: Popular culture in Mexico*, (trans. L. Lozano), Austin: University of Texas Press, p. 40.

Florida, R. (2005), *Cities and the Creative Class,* New York: Routledge.

House Standing Committee on Economics, Finance and Public Administration (2007), 'Australian manufacturing: today and tomorrow' Parliamentary Report, http://www.aph.gov.au/house/ committee/efpa/manufacturing/report/chapter2.htm#fn7. Accessed 1 August 2011.

Jayne, M. (2006), *Cities and Consumption*, Abingdon, Oxon; New York: Routledge.

Kandahar Treasure (2011), http://www.kandahartreasure.com. Accessed 10 July 2011.

Leach, B. (1978), *Beyond East and West,* New York: Watson-Guptill Publications.

Morris, W. (1884), 'A Factory as it Might be', *Informal Education Archives,* www.infed.org/ archives/e-texts/william_morris_a_factory_as_it_might_be.htm. Accessed 8 August 2011. First published in *Justice,* April-May 1884.

Murray, K. (2010), 'Fair Trade and Creative Practice: A participatory framework for the globalised world', *ACCESS: Critical Perspectives on Communication, Cultural & Policy Studies* 29: 1, pp. 41–54.

Ngoc, L.B. (2010), *Earth and Fire – Tradition and Passion: The art of ceramics in Vietnam,* unpublished.

Paz, O. (1974), *In Praise of Hands: Contemporary crafts of the world*, Toronto: World Crafts Council.

Pelugada (2011), http://www.palugadaglobal.com. Accessed 1 July 2011.

Ross, R.J.S. and Chan, A. (2002), 'From North-South to South-South', *Foreign Affairs,* 81: 5, pp. 8–13.

Sassen, S. (1998), *Globalization and its Discontents: Essays on the new mobility of people and money,* New York: New Press.

Sennett, R. (2008), *The Craftsman,* New Haven: Yale University Press.

Snyder, R.L. (2007), *Fugitive Denim: A moving story of people and pants in the borderless world of global trade,* New York: W.W. Norton.

Steingart, G. (2008), *The War for Wealth: The true story of globalization, or why the flat world is broken,* New York: McGraw-Hill.

United Nations Development Programme (2000), *Human Development Report 2000,* New York: Oxford University Press.

Vincent, D. (2011), 'China used prisoners in lucrative internet gaming work', *Guardian Online,* http://www.guardian.co.uk/world/2011/may/25/china-prisoners-internet-gaming-scam. Accessed 29 May 2011.

Waterman, A. (2011), 'Kandahar Treasure', http://handeyemagazine.com/content/kandahar-treasure. Accessed 9 July 2011.

World of Good (2011), http://worldofgood.ebay.com. Accessed 21 May 2011.

Zizek, S. (1993), *Tarrying the Negative: Kant, Hegel and the critique of ideology,* Durham: Duke University Press.

Notes

1 This chapter employs a variety of terms to describe two halves of the world. West is the agent of colonization that occurred from the fifteenth century. East is the region where much mass-manufacture now occurs as part of global trade. First and Third Worlds are conventional terms for regions based on industrial or traditional economies, though this can be replaced by more neutral terms global North and South. The relation between city and village parallels this difference, though village here is understood broadly as a place where products emanate. This certainly includes much craftwork and agriculture, though many villagers now work in factories particularly in southern China.

2 The phrase 'race to the bottom' is used to describe situations where competition between labour markets leads each to undercut their standards. For example, 'The examples of China and Mexico show just how much the international competition among nations of the South influences their workers' well-being. And this race to the bottom affects people elsewhere in the developing world who hold jobs in those sectors.' (Ross and Chan 2002: 12).

3 For example, an Indonesian company Pelugada has been established with artisans to take commissions from foreign artists and designers (Pelugada 2011).

4 Murray (2010) involves a parallel assessment of three examples in creative collaboration, which points to a need for critique. This chapter develops that further by constructing models for examining different paradigms of craft outsourcing.

5 There are some cases where developmentalist models are disguised as something else. The New York fashion house Suno celebrates Kenyan culture in its garments made from kanga. But the only direct Kenyan involvement in this product is the garment assembly. The clothes are designed and cut in New York, and their materials sourced from vintage kangas already in circulation.

Section IV

Interventions in Public Space

Chapter 11

Border Memorials: When the local rejects the global

SueAnne Ware
RMIT University

Introduction

Centuries of immigration and migration of various 'peoples' have created incremental and dramatic shifts towards notions of globalism and the formation of pluralist societies. Forced migration practices and refugee situations are included in the diaspora of people, language and culture (Sandercock 2003: 21). Our cities are often celebrated as multi-cultural, pluralist societies. Contemporary cities and in particular those in western democracies crave the richness of cultural diversity and celebrate particular ethnic enclaves, but they rarely acknowledge those who 'do not belong' and more specifically, supposedly-unwanted refugees.

In the built environment, where national identity and history are often spatialized and reinforced through the production of memorial spaces, how are recent plights of 'illegal' refugees considered? In postcolonial nations, whose fundamental histories rely on truths and mythologies of immigrant populations, the contemporary refugee crisis is incredibly paradoxical. In particular in Australia and America, memorials seldom interrogate the politically-contested aspirations of refugees with relation to those who are already in situ. Recent public memorials tend to acknowledge heroes and victims, not queue jumpers and illegals. Andreas Huyssen calls attention to the contradictory nature of public memorial landscapes when he writes:

> A society's memory is negotiated in the social body's beliefs and values, rituals and institutions, and in the case of modern societies in particular, it is shaped by such public sites of memory as the museum, the memorial, and the monument. Yet the promise of permanence a monument in stone will suggest is always built on quicksand. Some monuments are joyously toppled at times of social upheaval; others preserve memory in its most ossified form, either as myth or as cliché. Yet others stand simply as figures of forgetting, their meaning and original purpose eroded by the passage of time.
>
> (Huyssen 2003: 114)

This chapter examines two anti-memorial projects, one concerning the fate of illegal refugees travelling to Australia, The *Siev X Memorial Project* (Canberra, 2007) and the other speculative design work, *Inundating The Border: Migratory Spaces Within The Seam*, from a university postgraduate studio considering the deaths of undocumented workers crossing

into the United States (El Paso-Juarez 2005). Each project grapples with complexities of forced migration, definitions of place and meaning in global cities, and how the urban environment might begin to accommodate public memorials that acknowledge contemporary debates. These projects are by their nature global, but have very specific local, political implications. Both projects reject conventional notions of memorials in the public realm as icons or celebrations of civic and national identity and question our complacency with regards to the politics and policing of international borders. Further, the project work intervenes politically in public space as deliberate acts of activism and questions the role of design as a physical agent of social change. They call into question the very role of civic space and position it perhaps more appropriately as democratic space. While Hajer's and Reijndorp's theoretical definitions of public realm as well as Chantal Mouffe's philosophical writing about democratic space looms large,[1] I draw here mainly from geographer Don Mitchell and landscape architect Beth Diamond for the definition of democratic space. Mitchell writes: 'What makes a space public ... is not its preordained "publicness." Rather, it is when to fulfill a pressing need, some group or another takes space and through its action and makes it public' (Mitchell 2003: 35). Further, Diamond writes:

> Democracy is about constant negotiation with multiple and conflicting groups and individuals working to create a contingent co-existence, which, by its very nature, will never be stable. Public space, in this context, is not the territory of shared values and beliefs, but the arena where differences and conflict can be revealed.
>
> (Diamond 2004: 24)

So, in further consideration of civic space, or democratic space as I more precisely term it, these works begin to allow a political agency that, similar to notions of place, is neither fixed nor static but, rather, emergent and complex. Through the specific reflections about each project and discussions in the conclusion, the chapter considers larger themes in this book around impacts on concepts of civic and democratic space, the politics of participation and interaction and, how contemporary design work can reflect the transforming experiences of place and identity in a global urban context.

The Pacific Solution and the *SIEV X Memorial*

In September 2001 the Migration Amendment (Excision from Migration Zone) Bill 2001 amended the *Migration Act 1958* to excise Christmas, Ashmore, Cartier and Cocos (Keeling) Islands from the Australian migration zone (DIMIA 2004a). As a result, any unlawful non-citizen attempting to enter Australia via one of these islands is now prevented from making an application for a protection visa or refugee status unless the Minister for Immigration determines that it is in the public interest for such a person to do so (DIMIA 2004b). Towed back out of Australian waters, the asylum seekers face deportation from Indonesia, a country

which has not ratified the 1951 Refugee Convention. This is known currently and colloquially in Australia as, 'The Pacific Solution'. These measures arose as a direct response to the controversial *Tampa* incident in August 2001 when 433 asylum seekers en route to Australia were rescued by a Norwegian freighter, the *Tampa*. These asylum seekers were refused entry to Australia, transferred to HMAS *Manoora* and (along with later arrivals) sent to a mandatory detention centre on the Pacific island of Nauru.

Meanwhile in Darwin, Australian government negotiators were stretching the border to a point hundreds of kilometres off the northern coast in negotiations over a new maritime boundary with East Timor. Under the waters of the Timor Sea between Australia and the East Timor lie vast reserves of oil and natural gas. There are tens of billions of dollars worth of oil and gas from an area of the Timor Sea that is currently subject to overlapping maritime boundary claims by the two countries (Ensor 2003). The long-standing tradition of setting Australia's national boundaries according to international law was abandoned in favour of a new 'elastic band' approach to fencing the borders. This new policy approach involves the Australian government simultaneously shrinking or stretching its borders according to principles of self-interest, which could be construed from an ethical perspective as greed.

In October 2001 a small fishing boat sank just inside of the excised area waters north of Australia, killing 353 people. Of the approximately 160 women, 170 children and about 70 men, only 40 survived (Greenlees 2001). The passengers were refugees from Iraq and Afghanistan, mainly women and children coming to join their spouses already in Australia. The unidentified 19.5 metre-long boat was titled the SIEV X from the Australian naval term SIEV for Suspect Illegal Entry Vessel number 10 (SIEV X 2006). Australian newspapers carried news of the event several days later, but in the midst of the national election campaign, the story vanished until the memorial event in 2002.

The *SIEV X Memorial Project* was founded in 2002 by psychologist Steve Biddulph, author and Uniting Church Minister Rob Horsfeld, artist and project manager Beth Gibbings and myself, a landscape architect. The intention of the memorial project is to recognize both personal and political issues that surrounded the event and to work positively toward a better understanding of problems that could avoid any similar future disasters. It is also an exploration of how the Australian public might be able to assist and share in the grief of the victims, something which memorials have always sought to do but which becomes more difficult when trying to reach across the divide of countries, cultures and even the dividing lines of the law. It is also something that becomes more urgent in the struggle to find useful ways to assist in helping refugees of global crises that are currently involving the largest mass movements of people in human history.

A major focus of the memorial was to be the education of future generations. This is in part an acknowledgement that Australians had a responsibility for such tragedies. Every secondary school in Australia received a letter inviting their participation in a collaborative effort to suggest design ideas for construction of a memorial place. As most Australians and every school child in the country, at some stage, visit the national capital during their schooling to learn about their country's history and identity, the proposed

memorial's location is Canberra. Over ten per cent of the country's schools responded to request a teaching kit, and of these about two hundred actual entries were received.

We prepared a travelling exhibition of the collected works that toured throughout major Australian cities in 2003 and 2004. It was through these exhibitions that the public became more aware of the SIEV X tragedy. The momentum to build a physical memorial increased and we finally selected the proposal of a year eleven Brisbane student, Mitchell Donaldson. His design consisted of 353 poles that sweep through a gently undulating landscape, divide to form the abstract outline of a small boat, and then trail off into the water. Individual poles represented lost children (three feet high) and adults (five feet high). The arrangement of the poles included the shape of a boat to the exact dimensions of the SIEV X, allowing visitors to walk amongst them, experiencing the small, confined space, which held so many people.

The memorial group again turned to the broader community to adorn the poles, inviting grieving family members, community and arts groups, schools at all levels from primary through to university, and church groups, to decorate a pole. A diverse range of communities participated in the memorial-making, as both an educative experience and a collective act of remorse. In October 2006 each pole travelled across the continent to a Weston Lake Park, Canberra. Weston Park was selected because of its location next to Lake Burley Griffith and the newly-declared memorial precinct for non-war memorials. The National Capital Authority and the Australian Capital Territory government bodies both have jurisdiction over this site. This meant negotiating a controversial memorial between a conservative government body at the national level and a liberal government body at the state level.

Initially we petitioned the National Capital Authority (NCA) for a temporary memorial artwork to be installed for six weeks marking the five-year anniversary of the sinking. The NCA's policy on memorials required that in order for a memorial to be commissioned there must be a minimum of ten years following the event it commemorates (NCA 2002). A controversial decision was made to hold a memorial event where the poles would be displayed and erected in a short, one-day ceremony. It is common for government policy and statutes like those of the National Capital Authority in Canberra, to insist that memorials only be erected years after the events they memorialize. This has several effects which are both intended and unintended. There is firstly an assumption that the longevity of any concern for issues surrounding the event or people involved is a measure of their importance and universal value. There is also an assumption that time will render historical remembrance more accurate or, perhaps, if inaccurate, less important for its facts than for an abstract or universalizing ideal. Most importantly, however, it denies the public a means by which to grieve and to explore the issues and emotions raised by tragic events at the very time such assistance is needed. It fails to recognize the central role that memorials can play in providing powerful and searching catalysts for shared examination of current and ongoing issues.

The press coverage which followed the decision to hold a one-day ceremony ensured that the memorial event would be well attended and debated. It evolved into a form of public

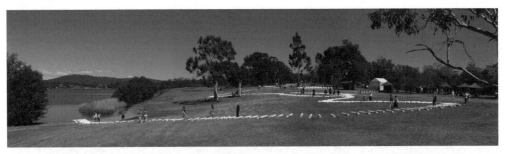

Figure 1: The pole raising during the October 2006 SIEV X Memorial Ceremony. Image: Brett Milligan.

protest and grieving. On 15 October 2006 in Canberra's Weston Park almost 300 poles arrived and were lifted up by 600 volunteers, and over 1400 others were in the audience. Before and after the ceremony crowds wandered amongst the poles, which lay in situ on the ground, inspecting and touching their surfaces. During the ceremony (Figure 1) the poles were slowly erected for a brief moment of silence.

In 2007 the poles were installed for a longer time period as a semi-permanent public art project. We gained a six-week permit in spite of the NCA's guidelines. This is primarily because of two recent and notable exceptions to the ten-year rule: The Bali bombing Memorial and a recently-commissioned Steve Irwin Memorial. We also deliberately timed the installation of this work with the federal election. The federal government changed over from a fairly conservative, John Howard-led Liberal Party, to Kevin Rudd's more moderate Labour Party. The shift in government also led to downsizing the NCA, and the *SIEV X Memorial's* permit was extended indefinitely and it currently stands in situ (Figure 2).

The debate about the *SIEV X Memorial* continues to bring to bear the nature of contemporary memorials and political polemics. In October 2007 in *The Canberra Times*, then Prime Minister John Howard's Government Territories Minister, Jim Lloyd described the memorial as 'protest art' criticizing the way it 'trivialises existing memorials commemorating those who gave their lives for our country' (Lloyd 2007). Others responded positively to Lloyd's condemnation in the letters pages of the newspaper. Dr Tom Ruut, a Canberra citizen, applauded Jim Lloyd's call for the demolition of the memorial and described it as a haphazard collection of poles that posed a 'hazard to joggers' (Ruut 2007). Retired Australian Defence Force Officer Warren Feakes wrote that the memorial offended him because it shoved unwarranted political statements upon him in a public recreational space. 'A Stanhope-run, bleeding heart capital territory is the only place such a ridiculous erection would be tolerated', he raged.[2] Feakes wanted the supporters of the memorial to 'swipe their credit cards and pay the rent for the space' (Feakes 2007). These responses tap into a perception generated by controversial Australian writer and historian Keith Windshuttle, and reproduced in *Quadrant Magazine* in January 2007, that the story of the sinking of the SIEV X is the kind of atrocity story that has 'been critical to the success of the propaganda campaign that has infected the writing of history for the past thirty years'.

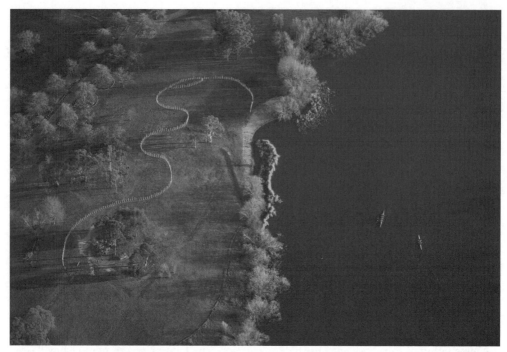

Figure 2a: The SIEV X Memorial as it currently stands in situ. Image: Brett Milligan.

Windshuttle accuses the 'tertiary-educated, middle-class Left' of promoting interest in the fate of SIEV X and of becoming 'morally unhinged' by their efforts to undermine the Howard government (Windshuttle 2007: 23). Defenders of the memorial also surfaced in the public debate. Many charged Jim Lloyd with trivializing the value of life and the preventable deaths of 353 asylum-seekers. David Perking, another Defence Force retiree, described how members of his family had served in two world wars. He had wept at only three memorials in his life. The first time was at the Belgium war cemetery where his uncle fell in 1917, then at Dachau and the third time at 'the SIEV X memorial down by the lake' (Perking 2007).

The fervour of the public contestation highlights the accomplishments of this memorial. Complex political stakes and meanings are bound up with what a culture remembers and forgets. Content, sources and experiences that are recalled, forgotten or suppressed are always intricately bound up with issues of power and hegemony. The discussion that the work raises is just as pertinent to the memorial as the physical interventions themselves. The discussion and debate *is* the memorial. The influential life of a memorial project is also far more than any particular moment of its built expression or discussion raised about that arbitrary moment.

The *SIEV X Memorial* also raises questions around participation, activism and design. Harrison Fraker writes:

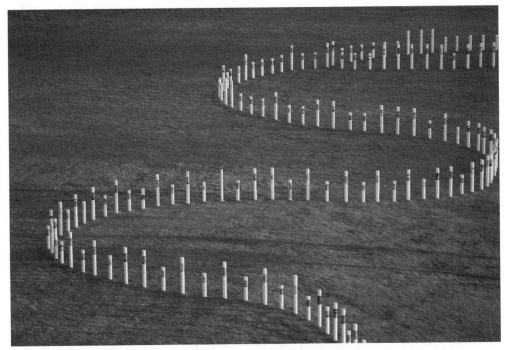

Figure 2b: The SIEV X Memorial as it currently stands in situ. Image: Brett Milligan.

Design Activism is problem seeking, it is proactive; it chooses an issue (or set of issues) and explores it (or them) from a critical, sometimes ideological perspective. It uses design to recognize latent potential and make it visible. It explores 'absences' in everyday life and gives them a 'presence.' It reveals new ways of seeing the world and challenges existing paradigms.

(Fraker 2005: 3)

It explores a physical catalyst for social and political change. Inevitably, the design work is a part of a larger activist movement. It highlights global issues of refugee crises and how societies are ill equipped to debate and construct new paradigms for global dislocation. The interest in political agency through design and collective action demands that others are also thinking through and acting out various political and social agendas in the built environment. The *SIEV X* was quite consciously located in the public realm as a way of intervening with the status quo.

This memorial not only calls into question who we memorialize in the public realm, it questions the role of memorials within our cities. One of the *SIEV X Memorial's* roles is to provoke responses and incite debate. Canberra is Australia's national capital city; its physical fabric is embedded with iconic representations of Australian national identity. Memorials

in Canberra are meant to highlight our collective pasts, define what has made Australia, inform notions of who we are, and importantly, demonstrate what we stand for. The *SIEV X Memorial* questions all of these ideals in a very public way. It stands in physical juxtaposition to Parliament House, and forces visitors to question values that other Canberra memorials celebrate. This memorial poses that a public memorial is not a passive receptacle for mythologies and demonstrations of heroics but a vehicle for questioning Australia's current geo-political situation. The procurement processes for public memorials are often overly concerned with minimizing political risks, mitigating public contention and ameliorating debates. In Australia's rapidly-changing urban environments where communities are indeed diverse and disparate; public memorials can celebrate conflicting values and needs, rather than placating the public.

La Linea - El Paso/Juarez and Operation Hold the Line

The United States, in similar strategies to Australia but a decade earlier, also attempted to limit illegal passage across its borders. In 1994, President Bill Clinton began a new border strategy, strangely enough corresponding with The North American Free Trade Agreement (NAFTA), which sought to remove barriers between the US, Mexico and Canada. 'Operation Hold the Line' in El Paso, 'Operation Safeguard' in Arizona and 'Operation Gatekeeper' in the San Diego area sought effectively and physically to block any possibility of immigrants crossing into the US in urban areas (Clayton 1995). The US Border Patrol's blockade of the US-Mexico border in El Paso, 'Operation Hold the Line', was extended ten miles west along the border into southern New Mexico in 1999. The extension of the blockade increased it to 30 miles long and the US Immigration and Naturalization Service (INS) agents currently are stationed every quarter mile along the El Paso, Texas-Ciudad Juarez border (Palafox 2006). In 2006 the INS proudly announced that there had been a drastic reduction in illegal crossings since the security was increased (Palafox 2006). This is very much disputed by academics, other US government bodies including the Department of Agriculture, Homeland Security, the State Department and California's, Arizona's and Texas's State Agricultural labour surveys (Palafox 2006). All in all it is estimated that between three and four thousand *migra*, (Immigration Agents) patrol the Jaurez-El Paso border at any one time. These include, the Immigration and Naturalization Service (INS), the National Guard (introduced in June 2006) and law enforcement officers from both nations in both state and federal capacities (US 2006).

The city of Juarez is located on the Mexican side of the border just across from El Paso, Texas, and roughly fifteen miles from the state of New Mexico's border with Texas. Juarez-El Paso is an interesting example of how NAFTA provided economic incentives for location of assembly factories just across the US border. Relatively inexpensive labour and a high demand for consumer goods meant that numerous twin border cities became home to the likes of Volkswagon, Sony and Foxconn formerly ACER (Industry Week 2011). Ciudad Juárez's population exceeded 1.2 million in 2000, up from 800,000 in 1990. The average

annual growth over this ten-year period was 5.3 per cent. Juarez, the fifth largest city in Mexico, currently has over two million permanent residents and an estimated half a million temporary residents (Federal Reserve Bank of Dallas 2011). There is widespread unemployment, poverty and homelessness in Juarez. The city's infrastructures simply cannot compete with the population influxes. The population increase is partially due to the increasing number of migrants from central Mexico who come to work at the border factories (*maquiladoras*) as well as others who come to the border city to cross illegally into the US. There are in fact thousands of immigrants who are willing to risk their lives daily to work in America (Humane Borders n.d.). One of the main consequences of 'Operation Hold the Line' is that it forces immigrants to cross the border in the mountains and deserts where the conditions are harsher and more dangerous. It is estimated that over one million people per year cross illegally into the United States from Canada and Mexico mainly for the purpose of employment (Stop Operation Gatekeeper 2006). A University of Houston study estimated that over three thousand people have died crossing the El Paso border between 1993 and 1999. According to records kept by the Mexican Consulate in Houston for 1998, 520 border crossers died in Texas and New Mexico since Hold the Line began (Eschbach et al. 1999: 437). Other sources estimate that over three thousand undocumented workers die annually crossing this particular part of the border (Humane Borders n.d.).

There has been a continual re-configuration of the border area between El Paso and Juarez since the Mexican Cession of 1848, The Treaty of Guadalupe-Hidalgo and the Gadsden Purchase in 1853 established the borders' inception over 150 years ago (Castillo 1992: 57). Historically and legally, the border is marked by the Rio Grande/Rio Bravo del Norte River. As it is a meandering river, the international border migrated for a number of years within the ebb and flow of the water and its riparian ecosystem. The Chamizal Dispute, an over-one hundred-year border dispute between the United States and Mexico was caused by the natural change of course of the river between the cities of El Paso and Juárez. A national memorial was established on part of the disputed land that was assigned to the United States according to the Chamizal Treaty of 1963; a corresponding Parque Público Federal 'El Chamizal' was created on the now-Mexican portion of the land. The river was stabilized within a concrete channel. This change left a void in the urban fabric, the empty parkland, between Juárez and El Paso that still exists today (Castillo 1992: 112).

Postgraduate student Brett Milligan's University of New Mexico design studio proposal, 'Inundating the Border: Migratory Spaces Within the Seam', examines this physical space of the border (Figure 3). Brett's project speculates about what could occur if the river was de-channelized and allowed to inundate and fluctuate once again. The physical border becomes blurred through various entopic landscape processes. In a practical sense, the site can now accommodate surface water run-off and mitigate flash flooding that has resulted from the rapid urbanization of Juárez-El Paso. Further, Brett writes:

> The Rio Grande/Rio Bravo is a polluted and dying river. Regulated flows and concrete channels engineered in the 1960s have eliminated much of the riparian habitat along

Re-imagining the City

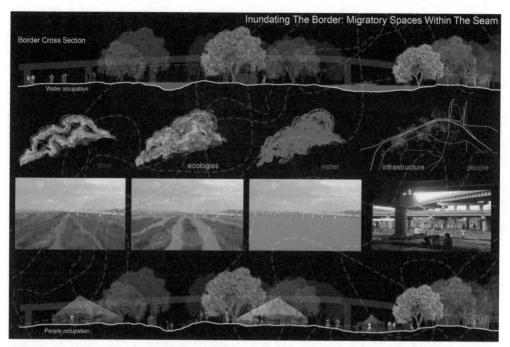

Figure 3a: Brett Milligan, 'Inundating the Border: Migratory Spaces within the Seam', postgraduate student proposal. Image: Brett Milligan.

its banks. Industries on both sides of the border dump heavy metals, and runoff from irrigated fields increases the alkalinity of the water. If the Rio Grande is released from the concrete channel, it will once again penetrate into the ground, and create a diversity of habitats, such as bosques, meadows and wetlands that will begin to reclaim the river through regenerative natural processes. These environments will emerge and migrate with the fluctuations of the river, creating places that are never the same. An abandoned braid of the river becomes a tall grass meadow ... the next day the river floods and the meadow lies beneath the swiftly moving current. Years later riparian trees have matured and the place becomes a shady bosque. During a particularly dry year, the space becomes part of the border patrol surveillance pathway.

(Milligan 2005)

Milligan's design work speculates with fluctuation and emergence beyond the landscape's ecological systems through a series of proposed public occupations. He sites temporary festivals and events carnivals during drier months, provides for temporary shelters for homeless or migrant workers passing through, and areas for conventional riverside activities such as fishing, walking and sitting. He does not deny that the political border exists, as he provides various access points and roads for the border patrol, but they constantly shift with

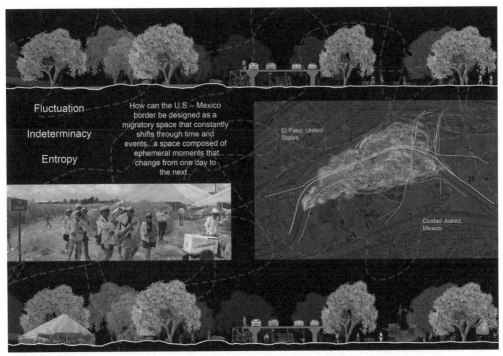

Figure 3b: Brett Milligan, 'Inundating the Border: Migratory Spaces within the Seam', postgraduate student proposal. Image: Brett Milligan.

the changes in the landscape. There is both a convergence of site, politics and landscape ephemera and a divergence in the strict delineation of the border. The border is recognized as a thickness that recedes and expands because of a variety of forces. It is celebrated as indeterminate and its own potential space.

This project encourages us to see that the border is not merely a line on a map or a political boundary. It is a unique, spatial entity. Brett uses a somewhat conventional approach or perhaps better stated he presents a very landscape-architectural exploration of the possibilities of border spaces. His work is situated well within contemporary design examinations of open systems and dynamic processes. And while it may be reminiscent of James Corner's and Field Operation's proposals for the Fresh Kills Landfill site just outside New York City or Downsview Park in Toronto, Canada, he positions the political border as paramount not subservient to the landscape operations. It is an intertwining of systems, a palimpsest which engages the physical landscape context and the economic phenomena of border cities. There is a dense weaving of ecological programmes, public events culture, urban and environmental infrastructure, public space, border security and surveillance coming together and converging here. His work invests in and celebrates the possibilities of a border condition.

Conclusion

Doreen Massey in *A Global Sense of Place* writes:

> One of the results of globalisation is an increasing uncertainty about what we mean by 'places', and how we relate to them. How, in the face of all this movement and intermixing, can we retain any sense of a local place and its particularity? An *idealized* notion of an era when places were inhabited *supposedly* by coherent and homogenous communities is set against the current fragmentation and disruption. The counter position is anyway dubious, of course; 'place' and 'community' have only rarely been coterminous. But the occasional longing for such coherence is none-the-less a sign of the geographic fragmentation, the spatial disruptions, of our times. And occasionally, too, it has been part of what has given rise to defensive and reactionary responses – certain forms of nationalism, sentimentalizd recovering of sanitized 'heritages' and outright antagonism to newcomers and 'outsiders.' One of the effects of such responses is that place itself, the seeking after a sense of place, has come to be seen by some as necessarily reactionary.
>
> (Massey 1991: 24)

Massey then calls for a sense of place to be progressive, not self-closing and defensive but outward looking. It is in this spirit that the two memorial works have been presented. The *SIEV X* and *La Linea* projects grapple with the complex qualities of memory and remembrance practices in relation to contemporary social and political issues that can affect urbanizing cultures. Ultimately, the project work queries whom we as a society select as worthy of memorials as well as the forms assumed by contemporary memorials. Massey calls for the possibility of developing a 'politics of mobility and access'. These memorials highlight in an activist manner what currently occurs without such politics (Massey 1991: 28). In Juárez, where the underlying urban condition results from encouraged economic mobility and access to *free* trade, it is paradoxical that the border is a place entirely defined by control and lack of flexibility. Brett's proposition calls for an outward-looking acknowledgement that borders are spaces that should accommodate flux and that cities that straddle border conditions should celebrate their inherent character as places of transience, mobility and access. In Canberra, where the fundamental premises of national identity are imbued in the city's urban morphology, and monuments attest to our nation-state's ability to offer a 'fair go' to all Australians, memorial landscapes are not accommodating the evolving sense of who we are: a diverse and complex society without a collective, shared past. Fixed notions of history and collective identity prevent our monumental and iconic spaces in Canberra from changing with our society's values, conflicts and constructs.

Massey also refutes conventional notions of a sense of place and rootedness as a form of evasion from the actually-unavoidable dynamic change of real life, when she writes, 'place and locality are a form of romanticised escapism' (Massey 1991: 29). The work presented here speculates beyond comment or concerns about challenging ideas regarding international

borders and their static nature. The urban public landscape is vital in this sense in that it is both an emergent and complex political entity. It offers ideas about democratic space and a public realm that embody certain types of social, environmental and cultural responsibilities as well as recognizing that places are processes.

These places do not have boundaries, they transcend them. This transcendence is both literal and figurative in these works in that they are linked to things/events outside of their geographical contexts and they call for visitors to do the same. The globalization of social relations does not deny place or the importance of the uniqueness of place. It is a sense of place that can only be constructed by linking that place to places and beyond (Sandercock 2003: 136). Places and indeed democratic spaces do not have single unique identities; they are full of internal conflicts. The debates about, within, and through these memorial works are as much a part of the work as their physical manifestations. Kirk Savage, Professor of Art and Architectural History at the University of Pittsburgh, speculates that once a memorial is built, society and the public at large seem to feel at ease with forgetting (Savage 2009: 21). It is as if, by building or making a memorial, there is a conscious placating of those affected, but also collective minds are put at rest as guilt is eased. So, memory must undergo continual renewal in order for the subject of remembrance – in this instance the deaths of undocumented workers travelling into the US and Australia illegally – to stay vivid in our collective conscious (Young 1993: 39). The memory work, as presented in this chapter hopes to illicit discussion and renewal of this ongoing debate as well as interrogating place, space and identity through memorial design.

In the case of the SIEV X, as I write this chapter, I am conflicted with the news that the 'Malaysian Solution', the current plan of Australian Prime Minister Julia Gillard's government, to place illegal refugees into detention centres in Malaysia, has been found unconstitutional by the Australian High Court. Ten years on from the SIEV X tragedy, numerous other boatloads of hopeful refugees have been either refused entry or tragically lost, as is the case with last year's horrific events near Christmas Island. I cannot help feeling that the *SIEV X Memorial* failed. The debate looms on, yet we are no closer to a humanitarian approach for our borders. The *SIEV X Memorial* placated and pacified and lulled us into thinking that Prime Minister Kevin Rudd's decision at the time to ban mandatory detention for women and children would see an eventual end to how Australia currently negates refugees' status and rights. When memorials are built, in many instances the affected communities move on. Memorials offer some sort of closure in that they recognize and identify various aspects of our history and in some cases they offer an educational stance on how we need to learn from the past to ensure our future. They pay tribute to those who have come before us. The *SIEV X* may have eased certain consciousnesses at the time and won political brownie points for supportive politicians, but it did not necessarily affect the lives of subsequent refugees. The memorial in this case allows us to forget and continue on without shifting our practices.

Additionally, the border memorial work and humanitarian efforts in the US and Mexico are also abject failures. Agencies including Humane Borders, Borderlinks, Coalición de Derechos Humanos/Alianza Indígena Sin Fronteras (Human Rights Coalition/Indigenous

Alliance Without Borders), Healing Our Borders, Border Action Network (BAN), Border Solutions, Coalition to Bring Down the Walls and The coalition: No More Deaths (NMD), work tirelessly to rescue imperilled undocumented workers, only to have President Obama in October 2010 order yet another 10,000 national guard members and border patrol agents to defend America's front line (Jeffrey 2010).

This chapter, much like the project work it explores, is not about finding definitive solutions but perhaps more about opening up possibilities between global, political discourses, temporal-spatial practices and roles that the design of the built environment can play in urbanizing conditions. Within the specifics of commemoration design projects, there is a common practice that is bound with issues of national identity and hegemony. Through re-examining and offering alternative modes of engagement, these projects offer fertile ground for re-considering place, civic and democratic space and global issues with local consequences. They enable alternative imaginings of the city and reveal how global forces shape the urban; additionally the projects provide comment and critique and in some cases altogether reject the social and political consequences of these forces.

References

Castillo, R. (1992), *The Treaty of Guadalupe Hidalgo: A legacy of conflict*, Oklahoma City: University of Oklahoma Press.

Clayton, W. Jr. (1995), 'Our Border can be Controlled', *The Houston Chronicle*, 1 June.

Department of Immigration and Multicultural and Indigenous Affairs (DIMIA) (2004a), *Fact Sheet 71 – New Measures to Strengthen Border Control*, produced by DIMIA 8 August 2002, updated by DIMIA 11 March 2004.

Department of Immigration and Multicultural and Indigenous Affairs (DIMIA) (2004b), *Fact Sheet 76 off-shore Processing Arrangements*, revised by DIMIA 29 September 2004, updated by DIMIA 7 October 2004.

Diamond, B. (2004), 'Awakening the Public Realm: Instigating democratic space', *Landscape Journal*, 23: 1, pp. 21–29.

Ensor, J. (2003), 'Australia: Land of sweeping plain and flexible borders needing protection', *The Sydney Morning Herald*, 27 November.

Eschbach, K., Hagan, J.M., Rodríguez, N.P., Hernández-León, R. and Bailey, S. (1999), 'Death at the Border', *International Migration Review*, 33: 2, pp. 430–40.

Feaks, W. (2007), 'Letters to the Editor', *The Canberra Times*, 18 October.

Federal Reserve Bank of Dallas (n.d.), http://dallasfed.org/research/busfront/bus0102.html. Accessed 15 September 2011.

Fraker, H. (2005), 'Dean's Notes: The College of Environmental Design at the University of California at Berkeley', *Frameworks*, 4: 1, p. 3.

Greenlees, D. (2001), 'I have lost everything', *The Australian,* 23 October.

Hajer, Maarten and Reijndorp, Arnold (2001), *In Search of the New Public Domain*, Rotterdam: NA Publishers.

Humane Borders (n.d.), http://humaneborders.org/. Accessed 15 September 2011.

Huyssen, A. (2003), *Present Pasts: Urban palimpsests and the politics of memory*, Palo Alto, CA: Stanford University Press.

Industry Week (n.d.), http://www.industryweek.com/articles/manufacturing_in_the_el_paso/juarez_region_20097.aspx. Accessed 1 September 2011.

Jeffrey, T. (2010), 'Congressman Introduces Bill to Force Obama to Deploy at Least 10,000 National Guardsmen at Mexican Border' *USA World Report and News*, 4 October.

Lloyd, J. (2007), 'Letters to the Editor', *The Canberra Times*, 15 October.

Massey, D. (1991), 'A Global Sense of Place', *Marxism Today*, pp. 24–29.

Milligan, B. (2005), 'Inundating the Border: Migratory spaces within the seam', unpublished, *American Society of Landscape Architecture competition submission*.

Mitchell, D. (2003), *The Right to the City: Social justice and the fight for public space*, New York: Guilford Press.

National Capital Authority (NCA) (2002), *Guidelines for Commemorative Works in the National Capital*, Canberra: NCA.

Palafox, J. (2006), 'Militarizing the Border', *Covert Action Quarterly*, http://mediafilter.org/CAQ/CAQ56border.html. Accessed 12 September 2011.

Perking, D. (2007), 'Letters to the Editor', *The Canberra Times*, 18 October.

Ruut, T. (2007), 'Letters to the Editor', *The Canberra Times*, 18 October.

Sandercock, L. (2003), *Cosmopolis II: Mongrel cities in the 21st century*, London: Continuum.

Savage, K. (2009), *Monument Wars: Washington, D.C. the National Mall, and the transformation of the memorial landscape*, Berkeley: University of California Press.

Stop Operation Gate Keeper (n.d.), http://www.stopgatekeeper.org. Accessed 7 May 2006.

The SIEV X Memorial Project (2001), http://www.SIEVXmemorial.com/about.html. Accessed 18 December 2006.

US Customs and Border Protection (n.d.), http://www.cbp.gov/xp/cgov/home.xml. Accessed 10 June 2006.

Windshuttle, K. (2007), 'Interview', *Quadrant Magazine*, 51: 2, pp. 20–23.

Young, J.E. (1993), *The Texture of Memory: Holocaust memorials and meaning*, New Haven: Yale University Press.

Notes

1 See Hajer, Maarten and Reijndorp, Arnold (2001), *In Search of the New Public Domain*, Rotterdam: NA Publishers, or Chantal Mouffe's collective website *The Space for Democracy/The Democracy of Space*, http://www.spaceofdemocracy.org/.

2 John Stanhope was at the time the Chief Minister for the Australian Capital Territory (ACT) government. The ACT Government has similar powers to state governments when it comes to planning and policy with regards to the built environment. At the time of the *SIEV X Memorial*, the ACT planning authority was often at odds with the NCA over projects in the public realm.

Chapter 12

Encountering the Elephant Parade: Intersections of aesthetics, ecology and economy

Elizabeth Grierson
RMIT University

Introduction: Encountering the elephants

It was a warm, wet, December day in 2011 as I walked along Singapore's Orchard Road seeking to identify art's presence in this highly commercialized, public setting. It was the time of the Elephant Parade Singapore, when 160 life-sized, designed, cast and decorated baby elephants were to be seen around Singapore. They were occupying street-sides and spaces outside Singapore's mega department stores and malls, such as Paragon, C.K. Tang and Ion. A taste for luxury goods characterizes this area of Singapore's central shopping mecca, with Prada, Hugo Boss, Louis Vuiton, Dior, Gucci and other élite, global, brands dominating the multi-level, consumer centres with their cathedral-like pillars, and vast, enticing, marbled foyers. At this time of year strings of twinkling blue lights activate Orchard Road at night lending a kind of eerie magic to the economic realities of the festive season. By day a tropical sun beats down on endless gatherings of hustling consumers and, in their midst, these aesthetic productions of a particular kind were making their presence felt. Along with other shoppers and tourists I encountered *Free Spirit* designed by Leona Lewis, *E Happy* by Ratchakirt Wichalyo, *Starbust* by Paul Smith, *Raoul* by Odile and Douglas Benjamin, and many other life-sized, fiberglass, baby elephants, variously designed and decorated. They were stationed at intervals along Orchard Road and elsewhere in Singapore, holding the attention of shoppers, workers and tourists, who would gather, photograph and disperse.

There was something captivating going on here. This chapter investigates what this something was. It brings together narratives of aesthetics with ecological and economic interests of globalized and urbanized culture. It examines the intentions of an entrepreneurial, city-based event that has come to fruition through significant partnerships between art and business, and the effects of such a partnership as a process of re-imagining place for city-dwellers. The setting for the subsequent discussion is twenty-first-century urbanization in context of the broader setting of economic globalization, in a world dominated by excessive consumption, fast economic transfers, reduced biological diversity and global uncertainties.

Artworks: Encountering the Elephant Parade Singapore

In the midst of the deepening, globalized, economic crisis of 2011, Singapore shoppers were out in force in November and December 2011. On 10 November 2011, a media conference at The Fullerton Bay Hotel launched the Elephant Parade Singapore, with

speakers from each of the participating partners.[1] The Elephant Parade co-founder Mike Spits and other speakers drew attention to the plight of the Asian elephants, the inception and mission of the Elephant Parade and Singapore's dedication, as a global city, to global concerns of ecology and environment. With a range of original and colourful designs, baby elephants were stationed in Singapore's Orchard Road, Marina Bay, VivoCity,[2] museums, Botanic Gardens and Singapore Zoo. This delightful introduction into city spaces brought together aesthetic, business and ecological interests to become the world's largest, open-air, art exhibition dedicated to the preservation of the Asian elephant. A significant percentage of proceeds from a grand auction of the painted elephants at Sotheby's Auction House in January 2012,[3] plus elephant merchandise, contributed to the Asian Elephant Foundation. Within three years since its inception, the Elephant Parade auctions had raised over seven million euros to benefit the cause of protecting the Asian elephant.

Here in Singapore, the artwork designs reflect the multi-cultural approaches of the 160 artists with some using traditional, applied arts techniques, and others a more contemporary approach. *E Happy* by Ratchakirt Wichalyo with its brightly-painted red and purple decorations sat well amongst ornamental plants and city pavements, reminding younger consumers and passers-by of the appeal of twenty-first-century popular culture and easy attachment to endearing artefacts. *Lotus Sutra* by Nandita Chaudhuri (Figure 1) carries on its back a utopian world of harmony, peace and beauty.

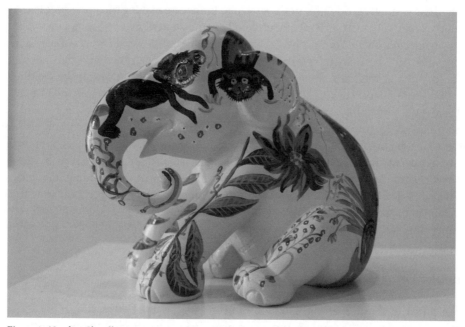

Figure 1: Nandita Chaudhuri, *Lotus Sutra*, adopted by ABN AMRO Banking. The Elephant Parade, Singapore 2011, merchandise. Image: Nicholas Gresson.

A stately baby elephant, *Kirimek*, from the Jim Thompson Design Studio with artist, Mongkol Ueareeporn (Figure 2), is decorated with the ancient Thai technique of 'Lai Rod Nam' applying gold leaf over black lacquer, and deriving designs from the Ramakian story in which Rama the hero vanquishes evil powers (Elephant Parade Singapore 2011: 30-32). Others attracted attention including Dipo Andy's *Ai Buin*, whose name derives from the artist's native language, Sumbawa, *ai* meaning 'water', and *buin* 'a bathing place on the riverbanks'; *Worth to be Dutch* by Hollandsche Waaren, displaying the characteristic blue and white Dutch colours, symbols and heritage patterns to reference a continuing need for cultural preservation; and *Nong Mai* (new kid) by Attasit Aniwatchon (Figure 3), with its pastiche of vegetation and flowers bringing attention to the tropical setting and ecological purpose of the Parade.

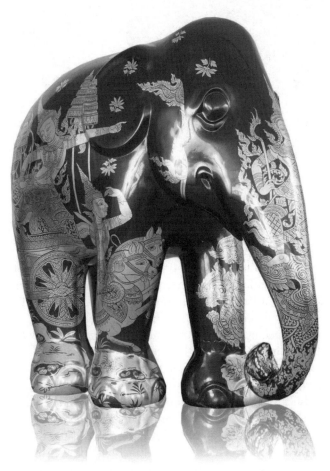

Figure 2: Jim Thompson Design Studio with artist Mongkol Ueareeporn, *Kirimek*, adopted by ABN AMRO Banking. The Elephant Parade, Singapore 2011. Image: elephantparade.com/elephants/Singapore-2011. Accessed 12 December 2012.

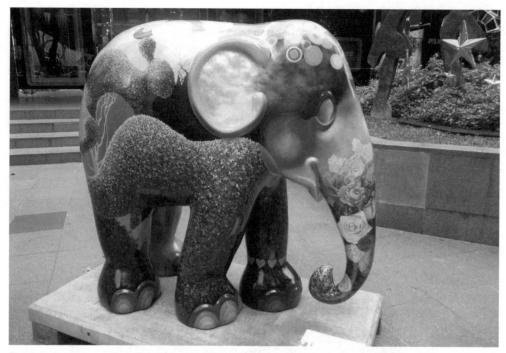

Figure 3: Attasit Aniwatchon, *Nong Mai*, adopted by ABN AMRO Banking. The Elephant Parade, Singapore 2011. Image: Elizabeth Grierson.

But perhaps the most crucial contribution to the exhibition is Mosha, the little grey elephant with a white, prosthetic leg decorated with signatures of the cities that have featured the Elephant Parade – London, Milano, Amsterdam, Copenhagen, Singapore, et al. *We Love Mosha*, designed by Diana Francis (Figure 4), is described as 'the source of our commitment'. Featuring in every such parade, Mosha is the inspiration for the global series of baby elephant artwork exhibits (Elephant Parade Singapore 2011: 26) and as Diana Francis says, Mosha represents the city commitment to The Asian Elephant Foundation.

Such stories are compelling for the human heart, but one might ask how effective, really, such a staged art event is in terms of activating a re-imagining process for city-dwellers in such a commercialized and hyper-urbanized place as Singapore. In this global, business hub and melting-pot of cultures, there is an overt emphasis on innovative production and economic commodification of culture as a materialist, consumer site. Cultural theorist Chris Hudson writes about the aestheticization of Singapore's urban landscape, in which there is a proliferation of local and international cultural events 'located in a constellation of overlapping and multilayered discourses which incorporate, amongst others: the construction of the nation's global brand image; the culture of consumption that drives the economy; and the manipulation of individual consumer desires' (Hudson 2010: 1). Do the elephants as cultural productions attract the attention of those consumers to turn individual desires towards

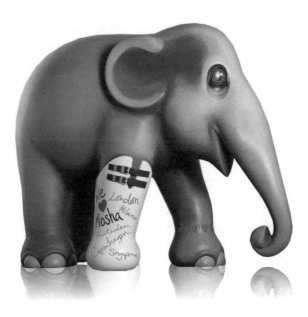

Figure 4: Diana Francis, *We Love Mosha*, adopted by ABN AMRO Banking. The Elephant Parade, Singapore 2011. Image: elephantparade. com/elephants/we-love-mosha. Accessed 12 December 2012.

concern for the planet's ecological crises or are they merely a momentary intervention into the consumer mind-set?

To consider these questions theoretically, it could be said that the designed elephants act as a *punctum*, Roland Barthes' (1993) term for the point in a photograph that activates the rest, known as the *studium*. The semiotics, of the visual field, are drawn together into readable form via the *punctum* and, thus, the symbolic language of art finds a meaning-making process. Could this be applied to the urban spaces of Singapore and the baby elephants of The Elephant Parade? Locals and visitors stop, notice, photograph, read the signage, admire the elephants, respond to the unique designs and expressions, and perhaps note the way they relate to the city spaces. By stopping to admire, talk, gather in groups, they may notice the situated environment of the elephants, read about the event, sit on the broad steps outside shopping complexes, photograph features of street gardens or trees, leaving their children to pat the elephants and run around them.

Globalization: Encountering Foucault, 'the play of signs' and the eurozone

Reflecting a personal point of view within the theme of re-imagining place, though not deriving in any specific way from the relational aesthetics of Nicholas Bourriaud (2002), '[r]elational arts produce encounters that are based in inter-relations or inter-subjectivity

and meanings become apparent through the community encounters. This takes the experience of the arts to an alternative space from that of individual consumption' (Grierson and Gibbs 2008: 16). Taking these concepts further to a globalized setting, Michel Foucault wrote:

[B]ehind the great abstraction of exchange, there continues the meticulous, concrete training of useful forces; the circuits of communication are the supports of an accumulation and a centralization of knowledge; *the play of signs* defines the anchorages of power.

(Foucault 1991: 217, emphasis added)

In Singapore during that week of December 2011, dominating the media were reports of how the global economy affects our lives. It was exactly the time of the eurozone sovereign debt crisis, and the *International Herald Tribunal*, the *Straits Times*, CNN and BBC news spoke of little else. These economic realities were in defiant contrast to the charm, and optimism, of the 160 life-sized baby elephants occupying the public spaces of Singapore. But on further investigation it soon became apparent that there were links between the economic realities of the eurozone and the art event, in that both were relevant to the apparatus and forces of globalization. It was becoming startlingly clear that globalization – economic, cultural and ecological – is the interdependent system in which everyone is implicated and ultimately affected. To think that the eurozone crisis was an economic situation exclusive to Europe would be as foolhardy as thinking that deforestation would affect only those local areas where forests had once stood. One of the characteristics of globalization is that what happens in one part of the world is more than likely to have global impacts.

Hard on the heels of the 9–10 December, 2011, European Union (EU) Summit, the local and global media reports were predicting that once-booming economies would soon be feeling the effects of the eurozone crisis, that fiscal austerity would put nations and banks in jeopardy, and that the global, economic outlook for 2012 was grim indeed. Reports were predicting an economic recession as government leaders and policy-makers ran out of options, and this account by Nouriel Roubini drew attention to the global, domino effects:[4]

The outlook for the global economy in 2012 is clear, but it isn't pretty: recession in Europe, anaemic growth at best in the United States, and a sharp slowdown in China and in most emerging-market economies. Asian economies are exposed to China. Latin America is exposed to lower commodity prices (as both China and the advanced economies slow). Central and Eastern Europe are exposed to the euro zone. And turmoil in the Middle East is causing serious economic risks – both there and elsewhere – as geopolitical risk remains high and thus high oil prices will constrain global growth. At this point, a euro zone recession is certain.

(Roubini 2011)

Here, Foucault's 'play of signs' (1991: 217) is quite explicit, presenting evidence of globally-interconnected systems with one nation highly dependent on another for fiscal stability. The global times have changed since the 1990s. Then, globalization was heralded by the orthodoxy as a kind of free-market nirvana, a new, heady and inevitable force, holding promises of new and better times for the networked cultures of the world. The neo-conservative views of Francis Fukuyama, for example, predicted the end of divisive ideologies with the universalism of western, liberal, humanist democracies as a final form of global, human governance. This, he called the end of history as an evolutionary process (Fukuyama 1992). However, looking beyond such idealized, neo-liberal, promises of progress, these past decades give evidence of globalization as a space of forced mobility producing economic exiles: increasing numbers of people rendered homeless, jobless, voiceless and powerless in the global flows of conglomerate power bases. In a range of ways in this globalized world a fast rate of urbanization is having negative effects on the environment.

Today, in the second decade of the twenty-first century, Foucault's 'play of signs' presents a globalized world characterized by the ubiquitous spread of the English language, fast-growing cities particularly in Asia, fluid capital and instantaneous transactions in a hyper-information world of digital transfer and knowledge exchange, with interconnected capital and communication systems governed by a non-territorial centre that financier, philanthropist and writer, George Soros (1998) had called 'an abstract Empire'.[5] In 2009 Soros advocated reform of this global empire, which he predicted was inherently unstable, into an economic system based on multilateral agreements. Warning that the global economy will crash under the present 'lottery of unregulated markets' (Grierson 2006: 71), Soros organized a Bretton Woods-style conference in 2011 to bring together policy makers, academics and business leaders.[6] Leading economists were invited to speak on the global economic system, including Nobel laureate, economist, Joseph Stiglitz.[7]

Stiglitz, amongst others, is highly critical of the management of the eurozone. In 2006, Stiglitz argued that the abject poverty and human terror in much of the world should not be seen as an inevitable consequence of globalization and that economic globalization could work better. To reinforce this proposition, he pointed out that 'the advanced industrial countries actually created a global trade that helped their special corporate and financial interests, and hurt the poorest countries of the world' (Stiglitz 2006, cited in Grierson 2006: 69). Five years later, Stiglitz writes:

Even if those from Europe's northern countries are right in claiming that the euro would work if effective discipline could be imposed on others (I think they are wrong), they are deluding themselves with a morality play. It is fine to blame their southern compatriots for fiscal profligacy, or, in the case of Spain and Ireland, for letting free markets have free reign, without seeing where that would lead. But that doesn't address today's problem: huge debts, whether a result of private or public miscalculations, must be managed *within the euro framework*. Public-sector cutbacks today do not solve the

problem of yesterday's profligacy; they simply push economies into deeper recessions. Europe's leaders know this.

(Stiglitz 2011, emphasis in original)

Such critique frames the economic consequences of globalized, unregulated markets and the eurozone crisis. Soros had pointed out that although the global empire has no formal structure, 'it has a centre and a periphery just like an empire and the centre benefits at the expense of the periphery', and the subjects of this empire are in peril as they 'do not even know they are subjected to it or, more correct, they recognize that they are subjected to impersonal and sometimes disruptive forces but they do not understand what those forces are' (Soros 1998, cited in Grierson 2006: 71).

The 'great abstraction of exchange' of Foucault's (1991) descriptive analysis, and Soros's (1998) 'abstract empire' opens to a highly volatile set of non-abstract conditions with forces and shifts of power producing radically-contingent, global effects. This is a complex scenario. As globalization scholar Tomlinson predicted in 2000, 'globalizing phenomena are … complex and multidimensional, putting pressure on the conceptual frameworks by which we have traditionally grasped the social world' (Tomlinson 2000: 14). In a technologically-connected world wherein modernity's spatial and cultural concepts of locality and place are open to question, the analysis of globalization as a non-material, non-physical, un-bounded, cultural, communicative network is as disruptive of connections as it is inter-connective. The local human subject, bound into these complexities with perhaps little comprehension or control of this economic environment, appears to be open 'to suffer the slings and arrows of outrageous fortune' to use Shakespeare's famous phrase.[8]

Urbanization and Biodiversity: Encountering damage and disadvantage

The major concerns of economists, like Soros and Stiglitz, turn towards the uneven distribution of power, and the inevitable damage to disadvantaged nations and people. Damage and disadvantage also inform the need to protect global environments, with understanding and protection of biological diversity, and survival of the world's forests and critically endangered species. One such species is the genus *elephas*, elephant. This species, particularly in Asia, is the subject of major concern of the Elephant Parade.

The fast pace of urbanization and population growth in the Asian region presents particular threats and dangers to the natural habitat of the Asian elephant. Today there are 25,000 to 35,000 Asian elephants existing in the wild compared to around 200,000 elephants a century ago. But the last 25 years has seen a loss of about 150,000 of these animals, with severe incursions into their natural habitat. Current predictions show that, if present trends continue, within 30 years the Asian elephant will be extinct in the wild. Claire Chiang, the Chairman of Wildlife Resources Singapore, and Ambassador of

Elephant Parade Singapore, cites such contributing factors as economic growth, increased commercial logging and encroachment into the elephants' natural habitat, with competition for natural resources between human beings and the elephant population. She states, '[e]xpansion of farmlands bringing farmers into conflict with elephants, bad management practices contaminating fresh water supplies and overall urbanization without considered planning all present growing strains upon elephant populations' (Chiang 2011). She calls for more awareness and sustainable practices, globally.

These moves and thinking are in line with what is known as the Rio Accord. At Rio de Janeiro, Brazil, in 1992, the United Nations (UN) held a major global summit, the United Nations Conference on Environment and Development (UNCED), called the Earth Summit.[9] The aim of the Summit was for participating countries to pay urgent attention to the protection of the planet and its resources for future generations, to ensure governments rethink their approaches to economic development, and to implement effective ways to halt the destruction of natural resources and environmental pollution. The resulting document was a comprehensive plan of action known as Agenda 21, comprising the adoption of the Rio Declaration on Environment and Development, the Statement of Forest Principles, the United Nations Framework Convention on Climate Change and the United Nations Convention on Biological Diversity. Unprecedented in terms of United Nations conferences for its size and scope, the 1992 Earth Summit had grappled with crucial environmental issues facing the world. A decade later in 2002, in Johannesburg, South Africa, the United Nations World Summit on Sustainable Development reaffirmed the 1992 adoption of Agenda 21, followed by Rio+20 held in Rio de Janeiro in June 2012. This major event saw the establishment of an implementation and accountability framework for sustainable development goals to 2020. Member states engage in local policy-making practices, plans of action, implementation processes and review cycles to ensure that the political commitments to the Rio Accord and Rio+20 are manifested as practical action.[10]

The founding of a major series of art events known as the Elephant Parade was consistent with these global moves and affirmations. However, this set of events, based in the power of art and culture to change public attitudes, did not comprise a grand government scheme. Interestingly enough, this global art event was founded by two entrepreneurial individuals whose personal encounters inspired a desire to implement something structural that would make a difference for the Asian elephant. In 2006, father and son Marc and Mike Spits met a baby elephant, who had lost a leg after stepping on a landmine. The elephant, Mosha, was being cared for in the Friends of the Asian Elephant Hospital, the first elephant hospital in the world, in Lampang near Chiang Mai, Thailand. Spits tells his story:

I was on holiday in Chiang Mai and I went to visit an elephant hospital. In came an injured baby elephant called Mosha, who was in a horrible state. I became very interested in the animals and decided that I would use my background in copyrighting to launch a campaign.

(Marc Spits, cited in Krieger 2009)

A year later, in 2007, the first Elephant Parade took place in Rotterdam. Since then the Elephant Parade has been seen in Antwerp 2008, Amsterdam in 2009, Bergen, London and Emmen in 2010, and in 2011 in Heerlen, Copenhagen, Milan and Singapore.

Is something important happening here as far as a re-imagining process is concerned? Neo-classical economic theory posits that, as knowledge is technologized, transferred and circulated, the human subject undergoes transformations of identity formation as *Homo economicus*. There is a corresponding eviction from the coordinates of physical space, and loss of the potential of *Homo sapiens* to feel, and make real through re-imagining, and perceiving aesthetically, as a way of sustaining subjective connection to place. *Homo economicus*, as used by economists in accounts of human agency, positions the human being as a self-interested, rational agent, characterized in terms of a capacity for maximization and optimization in economic decision-making. This 'privileges efficiency in what Cento Veljanovski calls the "market paradigm" of objective "market settings" with the individual as the unit of analysis, the objectified and rational actor' (Grierson 2011).

According to this account, global consumers are not open to the coordinates of space and ethical implications of the environment, other than in economic terms. It follows, in such an approach, that the possibilities of re-imagining space as place would need to be addressed so that city inhabitants, as economic actors, could recognize the responsibilities for place, the correlations between urban and natural habitats and the destruction of biodiversity in the face of so-called, economic advancement. In considering acts of survival, such a necessity would not have a timeframe attached to it but would be apparent in what curator Charles Merewether described as 'the fault-lines of the present in which the past persists and the future is uncertain' (2006: 045).

Marc and Mike Spits give evidence of how, in this rapidly urbanizing world of global uncertainties, the imagination of individual actors can spark a re-imagining process that brings together people, place, care for the environment and protection of species diversity, but not denying economic interests, through entrepreneurial acts with global potential. The Elephant Parade shows the value of bringing art and business together in a global cause, by partnering with leading commercial enterprises, to achieve the aim of raising significant funds in aid of Asian elephants and their protection in the wild. Sotheby's Auction House and ABN AMRO Private Banking, the presenting sponsor of Elephant Parade Singapore, feature strongly as business partners working for the end-goal of biodiversity protection and enhancement through this project.[11]

Conclusion: Encountering interlinked narratives

In *Designing Place*, Lucy Lippard pondered, 'I wonder what will make it possible for artists to "give" places back to people who can no longer see them, and be given places in turn, by those who are still looking around' (Lippard, cited in Byrne et al., 2010: 12). Might this be what the elephant artworks are performing – a giving back process, eliciting

personal responses from those whose lives, particularly prior to Christmas, focus almost exclusively on consumer transactions? The busy Singapore streets may have the potential to arrest the attention, make people stop and stare, re-imagining as they encounter place in new ways. Can we claim that these cultural conduits do have a place is such fast market economies?

Foucault talked about the 'circuits of communication' and 'play of signs' defining 'the anchorages of power' (1991: 217). The Elephant Parade reminds us that this is what it is all about. There is a communicating process of interlinked narratives at work here, with the 'play of signs' rippling through the consumer life of the city in such a way that place is being re-imagined and re-invigorated.

Foucault had talked also about 'the great abstraction of exchange' (1991: 271). That day in Singapore, in December 2011, while seeking to identify art's presence in Orchard Road, with the world media featuring the eurozone economic crisis as a stark reminder that the potent forces of economic globalization are inescapable, 'the great abstraction of exchange' was in action.

If those designed and decorated elephants could inspire just some of the people living in and visiting Singapore and other Elephant Parade locations, to see the immediacy of their presence as global inhabitants of urban environments, and to imagine what excessive rates of urbanization might mean for themselves and the planet, then perhaps something has been achieved beyond a passing aesthetic experience. If they can recognize the play of signs that activate the consumer terrain, and take the mind beyond the immediate and into the space of the Asian elephant and global responsibility, they may go from there to play some small part in activating the Rio Accord. Then the Elephant Parade might be one of the twenty-first century's most significant, global, art events contributing to a re-imagining process that has every chance of leading to effective, global action.

References

Barthes, R. (1993), *Camera Lucida: Reflections on photography,* London: Vintage.

Bourriaud, N. (2002), *Relational Aesthetics,* (trans. S. Pleasance and F. Woods), Dijon, France: Les Presse du Reel. First published in French 1998.

Byrne, L., Edquist, H. and Vaughan, L. (2010), *Designing Place: An archaeology of the Western District,* Melbourne: Melbourne Books.

Cheong, C.Y. (2011), 'VivoCity Grand Patron', in *Elephant Parade Singapore,* Singapore: ABN-AMRO Private Banking, p. 24.

Chiang, C. (2011), 'Ambassador of Elephant Parade Singapore', in *Elephant Parade Singapore.* Singapore: ABN-AMRO Private Banking, p. 17, http://elephantparade.com/cities/singapore-2011/ambassador-elephant-parade-singapore. Accessed 3 March 2012.

Elephant Parade, 'How it all began', http://elephantparade.com/about-elephant-parade/how-it-all-began. Accessed 27 December 2011.

Elephant Parade Singapore (2011), Singapore: ABN AMRO Private Banking.

Elephant Parade Singapore News (2011), Media Conference of Elephant Parade Singapore, 14 November, http://elephantparade.com/news/media-conference-elephant-parade-singapore. Accessed 27 December 2011.

Foucault, M. (1991), *Discipline and Punish: The birth of the prison*, (trans. A. Sheridan Smith), London: Penguin. First published in French 1975.

Fukuyama, Y.F. (1992), *The End of History and the Last Man*, New York: Free Press.

Grierson, E. (2011), 'Freedom, Individualism and Law of Contract: Future proofing education', paper presented at *Educational Futures*, 41st Annual Conference of Philosophy of Education Society of Australasia, 1–4 December, AUT University: Auckland.

—— (2006), 'Between Empires: Globalisation and Knowledge', *ACCESS: Critical Perspectives on Communication, Cultural & Policy Studies*, 25: 2, pp. 66–78.

Grierson, E. and Gibbs, C. (2008), 'Aesthetic Education through the Arts', in A. St. George, S. Brown and J. O'Neill, *Facing the Big Questions in Teaching: Purpose, power and learning*, South Melbourne: Cengage Learning, pp. 14–21.

Hudson, C. (2010), 'The Singapore Arts Festival and the Aestheticisation of the Urban Landscape', *ACCESS: Critical Perspectives on Communication, Cultural & Policy Studies*, 29: 1, pp. 1–10.

Krieger, C. (2009), 'Mike and Marc Spits create a heavyweight art display in London', *The Jewish Chronicle Online*, 29 May, http://www.thejc.com/news/people/mike-and-marc-spits-create-a-heavyweight-art-display-london. Accessed 27 December 2011.

Merewether, C. (2006), 'Taking Place: Acts of survival for a time to come', in *2006 Biennale of Sydney: Zones of Contact*, Sydney: Biennale of Sydney, pp. 045–060.

Open Society Foundations, About Staff (n.d.), 'George Soros', http://www.soros.org/about/bios/staff/george-soros. Accessed 26 December 2011.

Roubini, N. (2011), 'Nouriel Roubini: Fragile and unbalanced in 2012', *Straits Times*, Global Perspectives, 17 December, http://www.straitstimes.com/Project_Syndicate/Story/STIStory_745999.html. Accessed 24 December 2011.

Soros, G. (1998), *The Crisis of Global Capitalism: Open society endangered*, London: Little, Brown and Company.

Stiglitz, J.E. (2011), 'What Can Save the Euro?', *Project Syndicate, A World of Ideas*, http://www.project-syndicate.org/commentary/stiglitz146/English. Accessed 26 December 2011.

—— (2006), *Making Globalisation Work*, Victoria: Allen Lane.

Tomlinson, J. (2000), *Globalisation and Culture*, Cambridge: Polity Press.

United Nations (n.d. a), Department of Economic and Social Affairs, Division for Sustainable Development, sustainabledevelopment.un.org. Accessed 11 March 2013.

United Nations (n.d. b), System follow-up to Rio+20, sustainabledevelopment.un.org/unsystem.html. Accessed 11 March 2013.

Notes

1 The opening event featured co-founder, Mike Spits; Marieke de Zeeuw, Project Manager, Elephant Parade Singapore; Hugues Delcourt, Country Executive, ABN AMRO Singapore and CEO, Private Banking Asia; Claire Chiang, Ambassador of Elephant Parade and Chairman of

Wildlife Reserves Singapore; Bjarne Clausen, First Member of Board of Trustees of The Asian Elephant Foundation; Ben Cabrera, International Artist from The Philippines; and Foo Tiang Sooi, CEO of C.K. Tang Limited, Singapore. See Media Conference of Elephant Parade Singapore, http://elephantparade.com/news/media-conference-elephant-parade-singapore. Accessed 27 December 2011.

2 VivoCity is termed a 'grand patron' of the Elephant Parade Singapore. It is Singapore's largest retail and lifestyle centre opened officially in December 2006 and located at the Harbour Front. It was designed by Japanese architect, Toyo Ito (Cheong 2011).

3 ABN AMRO Private Banking and Elephant Parade with Sotheby's Auction Houses presented the Elephant Parade Singapore Auction in three auctioning sessions at St Regis Hotel and Fullerton Hotel, Singapore, January 2012. The total raised was S$1,781,000. The highest price was S$62,000 for *Elephantasm* by Filipino artist, Ronald Ventura. Reproduced replicas (hand painted, numbered limited edition) are offered for sale at the Elephant Parade shop at Singapore Zoo and web-shop elephantparade.com/shop.

4 Nouriel Roubini is professor at the Stern School of Business, New York University and Chairman of Roubinni Global Economics.

5 George Soros, economist, philanthropist and author, is founding chairman of the Open Society Foundation, supporting democracy and human rights in over seventy countries.

6 The United Nations Monetary and Financial Conference at Bretton Woods conference, 1944, was informed by the economic theories of British economist John Maynard Keynes to regulate the international, economic order, post-World War Two. It led to the establishment of the World Bank, the International Bank for Reconstruction and Development (IBRD), the International Monetary Fund (IMF) and the General Agreement on Tariffs and Trade (GATT). In 1995 the World Trade Organization (WTO) replaced GATT.

7 Joseph E. Stiglitz was awarded a Nobel Memorial Prize in Economic Sciences in 2001 for his analysis of markets with asymmetric information, and is a former Chief Economist and Senior Vice-President of the World Bank. He is arguably one of the most frequently cited economists today.

8 William Shakespeare: 'To be, or not to be, that is the question:/Whether 'tis nobler in the mind to suffer/The slings and arrows of outrageous fortune,/Or to take arms against a sea of troubles/And by opposing end them'. *Hamlet*, Act 3, Scene 1.

9 172 participating government representatives attended, 108 at level of heads of state and 2,400 representatives of non-governmental organizations (NGOs) with 17,000 people attending the NGO Forum.

10 'The organizations of the UN system play a critical role in implementing the Rio+20 outcome and advancing sustainable development goals' (United Nations n.d. b).

11 ABN AMRO Private Banking specializes in wealth management and dealing with investment assets for clients with excess of one million euros to invest.

Chapter 13

Re-imagining Dutch Urban Life: *The Blue House* in Amsterdam

Zara Stanhope
Australian National University

The geographical expansion of Amsterdam in response to global and local population pressures provides the site for Dutch artist Jeanne van Heeswijk to research social life and space in the new edge suburb of IJburg. She uses 'social art' as a means to re-imagine how life could be more publically minded within state-controlled urban design. In 2005 van Heeswijk negotiated the use of *The Blue House (Het Blauwe Huis)*, an exceptionally large Dutch home with a blue exterior on the new island of Haveneiland, IJburg.[1] IJburg's streets, waterways, architecture, public space, nature reserves, marina, public tram, shops and community centre were pre-planned by the Amsterdam Projectburo in pursuit of a holistic but diverse social environment. This level of bureaucratic spatial control is what David Harvey (2000) characterizes as a form of neo-liberalized urban authoritarianism.

This chapter explores *The Blue House* as a site-related project (Kwon 2004), which creates an analytical and discursive relationship to urban life through a responsive and reflexive form of cultural production. As a social art project, *The Blue House* research project employs many processes and methods that borrow from the techniques of the participant-observer of anthropology, which assisted the engagement of artists with residents and their mutual participation in temporary and permanent projects. While the social processes and relations support artists to reside independently and research or undertake fieldwork at IJburg, the relations created by *The Blue House* also partly undermined van Heeswijk's intention of independence while indicating its success. This chapter also critically interrogates the potential of *The Blue House* for raising awareness of the local and global significance of relationality between hosts and guests, citizens and non-citizens and self and others.

Comprising a long term social intervention involving artists and communities in public space, *The Blue House* on IJburg was typical of van Heeswijk's art practice. Previous projects by van Heeswijk, such as De Strip in Vlaardingen in 2004, where artists, designers and inhabitants reactivated a disused retail strip with entrepreneurial and other activities, brought together artists and non-artists with a public in the interrogation of civic space and opportunities for cultural life. *The Blue House* builds on social art precedents in post-1970s' art practice, which focused on social interactions and adopting non-conventional forms, often ephemeral and undocumented. Social art takes multiple purposes and forms, from the delivery of social goods or amelioration of social issues key to the 'socially-engaged' art defined by American artist, Suzanne Lacy (1995) or the embedded and dialogical

relationships with communities that circumscribe the art as an ethical 'social service' provider (Kester 2004: 138), to more politically activist practices. Nicholas Bourriaud (2002) coined the term 'relational aesthetics' to embrace forms of art that replaced economic relations with socialization (particularly with an audience). Other art writers such as Claire Bishop have criticized relational aesthetics for its evacuation of politics and reinserted ethics and dissensus in discussions of 'relational antagonism' (Bishop 2006). By engaging a small local population in situ rather than addressing an audience in institutional spheres, such as art galleries or museums, van Heeswijk's practice is more accurately termed social art. With the sole purpose of *The Blue House* being to situate artists and others at IJburg for the purpose of autonomous research, *The Blue House* ignored conventional forms and media of art, and disrupted the perception of social art as community activism or social reform, consequently challenging the role of the artist and urban space in the global city of Amsterdam.

Planning in the Global City of Amsterdam

Amsterdam's global status today is associated with its centrality in international financial services and trade (Sassen 1994: 90). Additionally, this identity is also ascribed to several cultural attributes including the city's civic society, arts and drug culture (Keane 2003: 25; Yeoh 2005: 948; Castells 2010: 2743). Such contradictory characteristics assist in the contestation of theoretical definitions of neo-liberal globalization (Flew 2009; Kalb, Pansters and Siebers 2004: 31; Leorke 2009; Robertson 2004).

First posited in the 1980s, globalization predicted an inexorable movement toward a borderless cosmopolitan epoch controlled by supra-national corporations and a unilateral economic order of free trade, and unimpeded movements of capital and labour. The establishment of globalization in the form of worldwide neo-liberal economic corporatism and free movement of people (Kalb, Pansters and Siebers 2004: 13) has also been impeded by the intrusions of imperial and state powers, closed borders, trade barriers, international organizations and private property interests (Harvey 2006). Yet these forms have also enabled the single market and economic and social cooperation of the European Union (EU) of which the Netherlands is a part. The Netherlands offers an interesting case study for the relationship between open global trade and immigration and state controls. The Netherland's service-orientated economy, which operates at a global level and in compliance with supranational finance and legal regimes, is moderated by state protection of social rights and services that aim to protect civil society from the inequities of economic or financial neoliberalism. This welfare state was adopted philosophy after World War Two to replace the Dutch 'pillarized' social structure – the coexisting Protestant, Catholic and socialist sections of society that privately provided social and cultural institutional services (Ministry of Education, Culture and Science

2006). For the Netherlands, the consequence of distorting economic globalization with state social and immigration policies has been described as the experience of 'soft' globalism or a 'localized globalism' (Santos 2006: 394, 396).

IJburg is one response to this localized globalism and Dutch open borders. Urban geographers have described the Netherlands as a 'laboratory' for urban development (Duyvendak, Hendriks and van Niekerk 2009: 10) based on the enormous economic and demographic transformations resulting from the combination of contemporary globalization, urbanization and welfare platforms operating in recent decades.

Recent Dutch urban planning priorities have been directed toward generating attractive compact cities: dense environs incorporating predetermined socio-economic strata to encourage social integration and reduce racial tension. Within the country's small area of 41,528 square kilometres, up to 82 per cent of the population of 16.6 million have deliberately been concentrated in four major cities (Amsterdam, Rotterdam, The Hague and Utrecht) and 27 larger towns (Duyvendak, Hendriks and van Niekerk 2009: 12).

IJburg arose from the prioritization in 1993 of the creation of 750,000 new affordable, suburban housing units by the Dutch Ministry of Housing, Spatial Planning and the National Environment to address projected housing demands. IJburg is the latest in a long history of reclamation projects in the Netherlands and comprises an archipelago of eight man-made islands northeast of central Amsterdam on the IJmeer lake. However, it is unique in being designed for a metropolitan residential milieu living on island environments (de Lange and Milanovic 2009: 28).

With the first two islands due for completion in 2015, the city planning authority and administrative body of IJburg, the Amsterdam Projectburo, predicts that the islands will accommodate over 100 nationalities in 70,000 homes by 2030 (de Rooy, Val and Vierboom 2002: 23–4). The initial islands are intended to comprise 18,000 homes with 45,000 residents at a typical average housing density for large European cities of 71 dwellings per hectare (Living 2006). The ratio of 80 per cent social to 20 per cent private housing (de Lange and Milanovic 2009: 27–28) complies with policies for low private house ownership and a high proportion of middle class residents in social housing (Duyvendak, Hendriks and Niekerk 2009: 11).

Strict Dutch urban design control and instrumentalization of culture, with the aim of creating cultural capital, is based on research that global cities benefit from governance of the urban environment (Johnson 2009: 73). A high level of urban governance is undertaken by both municipal councils and non-government organizations (Duyvendak, Hendriks and Niekerk 2009: 12), including inviting participation in neighbourhood councils, citizen initiatives and other networks to increase community cohesion (Dekker, Torenvlied, Völker and Lelieveldt 2009: 223–25).

The control of state planning authorities over the development of IJburg's physical and social urban space was diluted in 2001 during the initial phase when construction was contracted to private companies in order to minimize financial risk. Significant consequences

of this decision included the Projectburo's loss of influence over the development, the delay of numerous cultural and service facilities, the consequent loss of half of the expected 12,000 jobs on IJburg, and the deferral of the development of other islands (Roovers 21 May 2010 interview with author). In this environment Jeanne van Heeswijk established *The Blue House* to intervene into this designed response to localized globalism and to interrogate how it failed to incorporate private and public needs.

IJburg and *The Blue House*

The Blue House was the physical base for van Heeswijk's five-year investigation into the predetermined urbanism of its neighbourhood (van Heeswijk 19 May 2010 interview with author). Positioned in the centre of buildings that faced four streets in Block 35, the house was surrounded by a mix of habitation: multi-storey private residences, social housing, rental units and accommodation for a religious community. Occupancy fulfilled the Projectburo's diversity guidelines (de Lange and Milanovic 2009: 28). According to one resident, the block included 'poor people, rich people, families, singles and couples, white people, black people all together' across a 50-metre span, and 'houses [are] worth 700,000 euros and those people rent for 400 euros a month' (Knulst 2008: 2). At its commencement, *The Blue House* provided a significant social space on the island when the only other civic amenity was a 'supermarket' located in a tent open for a few hours each day. It was noted by a member of *The Blue House* that residents did not know each other and were not very socially minded (Leão 2005) due to the lack of infrastructure or community organization.

Establishing a foundation to govern *The Blue House*, van Heeswijk described her role as a 'participating embedded observer' (O'Neill and Doherty 2011: 30) in the task of 'making a hole' for things to emerge in the top down urban design and social engineering of IJburg (Dobricic 2008: 5). In its initial years, *The Blue House* acted as an information centre and a meeting point but was carefully organized by van Heeswijk to avoid supplementing state or municipal objectives. She invited artists and others with interests in urbanism to join as members in *The Blue House* 'Housing Association for the Mind', a decision-making body for the project. Members comprised local and international artists, art theorists, architects, curators, students, IJburg residents, a philosopher, a writer, a sociologist and a key funder, the European Cultural Foundation – at least half of whom were Dutch.[2] Membership provided a residency in the House for a period of up to six months on the condition research was shared with the other members.

Although van Heeswijk described the membership as a self-organized network (van Heeswijk 19 May 2010 interview) she retained final control of the operations and membership (Maasland 2008: 5). She defined her research as including the responsibility for fund raising of the members' remuneration (6,000 euros or 1,200 euros per month of residency) and the operational costs, including the mortgage. Intending to avoid the risks of the project or practitioners being subsumed into the interests of urban developers,

institutional value adding or social engineering (Johnson 2009: 251) van Heeswijk rejected state support including the City of Amsterdam and the IJburg Projectburo, and cultural funding that demanded predetermined outcomes.[3]

The Blue House research projects identified gaps in planning, offered alternatives entrepreneurial and social activities, and replaced market exchanges or non-existent state services in response to desires expressed by IJburg residents. However, in mirroring the high-imagination-enabling and do-it-yourself attitudes valued in creative industries or the citizen initiatives encouraged by levels of Dutch government, these research outcomes and cultural productions risked being instrumentalized by local authorities. While *The Blue House* responded to gaps in the urban plan of IJburg and improved the quality of local life, it also drew significant media attention and was useful to city authorities and businesses in attracting interest. Igor Roovers, Director of Projectburo IJburg, engaged with *The Blue House* throughout its five-year duration, attending multiple activities including the municipal Alderman's 'Consultation Hour' (2007). He concluded that *The Blue House* created a civic space (Roovers 2007: 7) and suggested he would employ ideas it generated to create more organic and responsive city planning in the second phase of IJburg, and possibly other future projects (Roovers 21 May 2010 interview). By default *The Blue House* also contributed to delivering the Netherland's policy of involving young people and immigrants in cultural expression (Ministry of Education, Culture and Science 2006: 12).

Researching the Unplanned in Amsterdam

The pursuit of researching 'the unknown' or unplanned in IJburg and potentially stimulating 'fields of interaction' (van Heeswijk 19 May 2010 interview) with neighbours resulted in many members enacting problem-solving or heuristic methodologies. In addition, whilst not being trained in anthropological research methods, or necessarily interested in applying its frameworks for designing research methodologies, *Blue House* members took the role of embedded observer-participants conducting pre-visit research and fieldwork that investigated the forms, behaviour and conditions of everyday life and culture at IJburg.

Initial promotion of *The Blue House* by van Heeswijk and the live-in manager aimed to connect with the population of Block 35 and invite IJburg residents to utilize its resources (van Heeswijk 2008: 35). However, individual members residing in *The Blue House* keenly felt the challenge of how to engage IJburg residents in their daily lives (Leão 22 May 2010 interview with author), a sentiment that is noted by anthropologists in the field (Jongmans and Gutkind 1967). Members succeeded in creating contact with residents often through processes resembling anthropological fieldwork, particularly employing anthropological field tools such as a range of communication, negotiation and cooperation processes to generate rapport and data, including conversation and the creation of visual records. These tools for understanding the cultural and social conditions at IJburg produce different ways of 'seeing' people in their cultural context according to visual anthropologist David MacDougall (2006: 242). However,

a distinct epistemological difference between the members' methods and formal anthropology was that documentation and projects were activated for participants and members' benefit or aims, rather than reported for synthesis and development of specialized knowledge.[4]

Previous criticism of artists acting as ethnographers in art discourse has become less relevant as art education increasingly encourages collaborative and social practice, as culture is understood as inherently relational, and as anthropologists are looking to art for new ways to open methodology to the embodiment of research (Schneider and Wright 2006). In the mid-1990s Hal Foster argued that ignorance of social science principles and short contact periods with communities had the effect of limiting artists' critical engagement, resulting in stereotypical representations of their subjects (Foster 1996: 171–204). A decade later, artists engaged in long-term social practices, such as van Heeswijk, have developed self-reflexive and critical practices based on experience with ethical and cultural issues. Projects such as *The Blue House* are stimuli to rethink the relationships between art and anthropology (Desai 2002; Schneider and Wright 2010).

As a result of employing processes from anthropology to facilitate participation by IJburg residents in social art or research, *The Blue House* involved residents with its members in complex networks 'of mainly informal social relationships ... which enhance the local innovative capability through synergetic and collective learning processes' and promote communication, understanding and knowledge transfer (Hospers 2008: 385–86). At different moments, members and residents found themselves in the roles of participants, subjects and observers. Members' projects problematized and blurred the lines between control and agency and, at times, the divides between public and private interests. Being uninvited guests on IJburg, *The Blue House* members were in tune with Patricia Reed's concept of being simultaneously host and 'un-host' (Goldenberg and Reed 2008), gaining an awareness of the ethics of hospitality through the giving and receiving of the experience. This understanding resonates with that of the participant-observer of anthropology and the everyday strategies for bridging cultural difference, or processes of 'ordinary cosmopolitanism' (Lamont and Aksartova 2002), that the membership found lacking in culturally-diverse Amsterdam.

As well as producing information and cultural understanding, *The Blue House* members' research led to active interventions in the urban and cultural fabric of IJburg. Tangible examples were the generation of new libraries, a youth programme and acceleration of community facilities, surveys, workshops, tours, social activities, public and media discussions, teaching, films, web-based documents and forums for information exchange. More conventional art outcomes were the exception, such as the drawings produced in art workshops organized by artist member Silvia Rusel at the instigation of local mothers (*She-power* in 2005–6) or posters collaboratively created by the residents of each block organized by member Tere Recarens. However, residents were able to participate and overlook the fact that *The Blue House* failed to fulfil commonly-held understandings of art. The exclusion of conventional forms of art from van Heeswijk's definition of research was apparent in her rejection of a resident's proposal to hold an art exhibition in the house.

History and Responsive Urbanism

The Blue House members Dennis Kaspori and Hervé Paraponaris, along with van Heeswijk, provided three platforms for members' research: history, instant urbanism and hospitality in order to stimulate questioning of how these conditions might be created at IJburg (van Heeswijk 19 May 2010 interview). A number of members explored the geographical imagining of IJburg and the individual and communal embodiment of spatial relations by residents. Interviews documented in the film, *IJbuild* (2009) by British artists Ella Gibbs and Amy Plant, offered a perspective on the people and materials gathered from around the world to build IJburg and created a record of its early history.

Transparadiso (artist Barbara Holub and architect Paul Rajakovics) proposed a design for a new housing block model titled, *Blue Fiction – The Blue Block (An Anachronistic Centre)*. With Timon Woongroep they also installed a 12-metre high periscope on a roof terrace used by residents to observe the promised lake views that had disappeared as building progressed. Ensuing discussions led to a petition to the Projectbureau regarding future building. Dutch art historian Marianne Maasland and sociologist Marga Wijman surveyed residents' responses to the ongoing transformation of public spaces during the period from 2005 to 2008. Members also instigated many discussions on the nature of public space, citizenship and immigration. These included a local TV programme debating the merits of mixed social and private housing and a conversation series entitled *Chat Theatre* (2006-09) organized by Mauricio Corbalán and Pio Torroja, from the architecture collective m7red, incorporating a live debate from Porto Alegre.

Members utilized private space to create impromptu public amenities and encourage social connectivity in response to residents' stated or perceived needs. In 2006 artist member Rudy J. Luijters established an edible garden in 2006 on land around *The Blue House* as a communal food source to be maintained and enjoyed by the residents of Block 35. In the absence of a motel, artist member Eveline de Munck Mortuer conceived an ecological hotel employing patrons' parked cars supplemented by use of a resident's bathroom and lounge. Prior to the opening of IJburg's public tram, members provided bikes for free use and during 2007 resident Peter van Keulen offered passage on his boat for a small charge. Despite the spirit of autonomy, soon his *IJboot* was identified by a real estate agent as a feature to promote to new home buyers.

Other communitarian responses included an improvised outdoor *Blauwe Huis Cinema* coordinated by resident Usha Mahabiersing and other members after gaining collective agreement from the block to utilize their courtyard for seating. The films that were screened examined the theme of neighbours and communities. The cinema screen, hung on a temporary structure employing scaffolding, entitled *Pump Up the Blue* (2007) was designed by Paraponaris, and effectively doubled the volume of the house with space at the front and top of the building. Atop Paraponaris' structure, the *Chill-ROOM* was proposed as a meeting and activity space for local teenagers in the absence of a formal youth community centre (to be built in 2012). The concept was initiated by Ingrid Meus,

Figure 1: Pump up The Blue 2007, Herve Paraponaris, with Recycloop by 2012 architects at *The Blue House* (*Het Blauwe Huis*). Image: Ramon Mosterd.

a student in social art seminars run for a Dutch art institution at *The Blue House. Pump Up the Blue* and the *Chill-ROOM* were more intrusive forms of cultural production compared to the objective of information gathering in anthropological fieldwork. Both projects provoked a controversy that revealed the misalignment between private and public interests in Block 35.

Pump Up the Blue and the *Chill-ROOM* raised concerns for the Block 35 Housing Association (the residents' decision-making body), who had the potential to close down *The Blue House*. Residents disliked the reappearance of scaffolding in their area. More significantly, since the IJburg's commencement, the presence of youngsters had raised heated debate with residents who disapproved of teenagers in the area, associating their presence with social problems.

In order to gain collective resolution to this issue, the youths, block residents and *The Blue House* members needed to place trust in each other in order to find a mutual tolerance and recognition of others' needs in sharing their joint courtyard. The reflexive responses generated by residents to come to agreement on the issues evoked the possibilities of a local dialogic capacity based on social responsiveness to a cross-cultural situation, while not implying the resolving of dissensus requiring a universal democratic consensus. This event motivated further independent responses and acts of agency: a number of previously-recalcitrant residents offered equipment to the *Chill-ROOM* once it demonstrated it could operate without causing social problems (Kaspori 2008: 5), a care institution collaborated

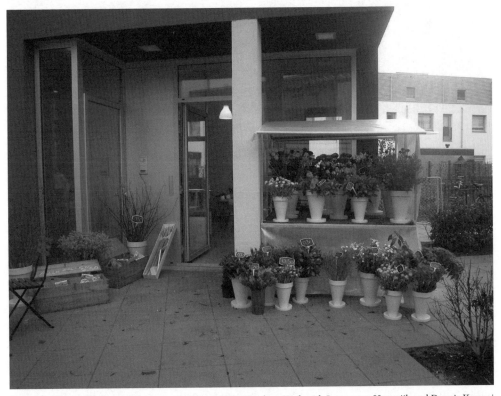

Figure 2: Flowers for IJburg (*Bloemen voor IJburg*) 2005, Nicolene Koek with Jeanne van Heeswijk and Dennis Kaspori at *The Blue House* (*Het Blauwe Huis*). Image: Producer of *Het Blauwe Huis*.

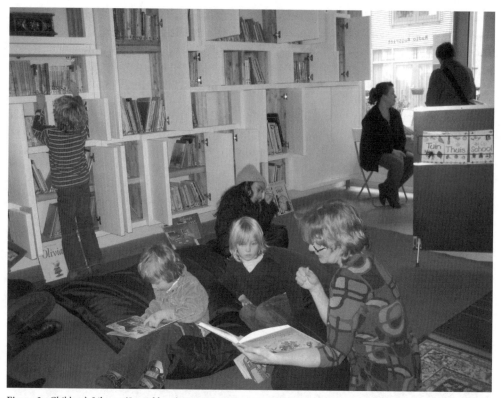

Figure 3: Children's Library (*Leesjeblauw*) 2009, Marthe van Eerdt with Jeanne van Heeswijk and Dennis Kaspori at *The Blue House (Het Blauwe Huis)*. Image: Marthe van Eerdt.

with the teenagers to set up a formal space for activities, and the Amsterdam Projectburo advanced the realization of the official community centre to 2009.

Oversights in planning addressed by *The Blue House* also included commercial or private provision of services not yet established on Haveneiland. To overcome oversights in legislation and delays in granting business licences and establishing street trading, Nicolene Koek was invited to situate her weekly flower stand *Bloemen voor IJburg* (Flowers for IJburg) on the eight square metre frontage of *The Blue House*. Established in 2005, her business continues today in other areas of IJburg. Apart from generating an income, she originally considered that her stall played a significant role in generating social interaction in a neighbourhood without retail spaces (Koek 27 June 2011 interview with author).

Libraries were another social service that arose from the social interactions and collective agency generated by *The Blue House* membership (van Eerdt 15 June 2011 interview with author; Roovers 2007: 7).[5] Van Heeswijk supported Marthe van Eerdt, a librarian and an early resident of IJburg, to operate a children's library in advance of the children's centre

planned for post-2015. The weekly *Leejeblauw* operated in a dedicated space on the ground floor. Initially stocked with van Eerdt's own books, it attracted 80–100 children a week between 2006 and 2008, also providing social interaction for parents (van Eerdt 15 June 2011 interview). It moved to the newly-opened Parents Children Centre in 2009 and contained over 2000 books donated by residents. Resident Johan Bakker also worked with *The Blue House* from 2007 to initiate a book exchange, as the official library service would await a larger popluation. Another planning omission was a community restaurant, Kaspori and van Heeswijk addressing this need in 2008 by providing a weekly, affordable, catered meal for residents at the House.

Hospitality

The third research strand, hospitality, evoked the global and local context in which *The Blue House* operated. IJburg had residents from a range of cultural backgrounds. *The Blue House* members were uninvited guests in Block 35 and hosts to large numbers of visitors from beyond IJburg who were curious to experience the project. Members brought an anthropological and cosmopolitan imagination to this cross-cultural situation, and a concern to generate an experiential, intuitive or analytical understanding of the ideas, beliefs, values and practices of subjects encountered (Strang 2006). This anthropological perspective informed the research of a new population taking residence in Amsterdam's soft or localized globalism.

The recent transformation of the Netherlands from a white, western culture to a heterogeneous population is an increasingly-common phenomenon in western Europe that is made more intense by the Netherland's small population base. During the last three decades the Dutch population has absorbed two million new migrants, including one million Muslims, primarily arrivals from the former African Dutch colonial of Suriname, as well as Turkish and Moroccan workers upgraded to permanent settlement.[6] One-third of the populations of Amsterdam and Rotterdam now comprise people of non-western backgrounds and half of the inhabitants are aged under 20 (Duyvendak, Hendriks and van Niekerk 2009: 12).

Institutions in the Netherlands take a conservative attitude toward cultural identity and citizenship, and show a lack of hospitality in not extending full rights to immigrants.[7] The government requires three generations of continuous citizenship in order to be legally recognized as Dutch. The racial and religious (Islamic) discrimination displayed at IJburg conveyed the failure of the utopian promise of this new suburb. Newspaper reports by early IJburg residents protesting that their neighbours included Moroccans (van Heeswijk 17 June 2011 interview with author). replayed Dutch debates on immigration of the last decade that have weakened the Netherland's reputation for being a tolerant and pluralistic society. An extreme example of the polarization of opinions along cultural and religious fault lines were the murders of Pim Fortuyn in 2002 and Theo van Gogh in 2004 (Duyvendak, Hendriks

and van Niekerk 2009: 14–15). Scholars and politicians have argued that the residues of the pillarized organization in Dutch social policy overvalue cultural difference and neglect the 'urgent need' for newcomers to integrate into society (Duyvendak, Hendriks and van Niekerk 2009: 14). Other social commentators characterize these events as an urban calamity, a citizen revolt against elitist powers divorced from the reality of frictions evident within the changing population mix (Duyvendak, Hendriks and van Niekerk 2009: 9, 16).

The Blue House member Jo van der Speck, an independent journalist and activist for improved immigrant conditions in the Netherlands, delivered undocumented immigrant Cheikh 'Papa' Sakho to *The Blue House* to undertake a residency in 2006. Pushing legal boundaries, *The Blue House* offered Sakho asylum after he escaped the fire in the Schiphol migrant detention centre the previous year. The Dutch media broadcast the news of Sakho's arrival at night. Together, Speck and Sakho organized *Migrant to Migrant* (M2M) radio, an Internet programme broadcast to migrant communities from *The Blue House* every Friday night, which also welcomed the participation of locals and members in residence (see m2m.streamtime.org). In providing a forum for different cultural voices and promoting the well-being of immigrants, van der Speck and Sakho challenged the embrace of more open concepts of nationality and citizenship by all, including members.[8]

In order to further address the challenge of how to offer cultural hospitality in the IJburg environment, van Heeswijk organized The 'Frida project' (van Heeswijk 17 June 2011 interview). Between 2008 and 2009 she offered full-time employment to a number of undocumented women migrants from countries such as Brazil and Bangladesh who worked illegally by day on IJburg as cleaners. They were employed individually as the resident host of *The Blue House*, all under the pseudonym 'Frida'. In hosting guests and preparing meals, including the M2M dinners, the Fridas made apparent the invisible economy of undocumented workers. The reversal of normative positions in the Frida project necessitated that these women, their guests and neighbours confront expectations and negotiate power relations. The presence of the Fridas further blurred the lines between the roles of Reed's host and un-host, or participant and observer. The 'Frida project' potentially pointed to the false divisions between the roles and responsibilities of nationality and citizenship in the Netherlands and its systematic effect on economic opportunity, access to resources and well-being. It questioned the definition of a good neighbour and indicated the fluctuating nature of hospitality between the possibility of unconditional individual or collective hospitality and the legal and political instruments of states in soft globalization.[9]

Conclusion

Writers such as David Harvey and Arjun Appadurai argue that an examination of the disjunctive economic, cultural and social flows of economic globalization make visible local contestation of official domains (Harvey 2006; Appadurai 1996: 33).

The Blue House offers a local response to the realities of a globally-interconnected society, and an interrogation of the localized globalism manifest at IJburg. The participatory research of members revealed a number of temporal and structural misalignments in world class, holistic urban and social planning, and engaged with residents to imagine alternatives.

Locating gaps in the formal development of IJburg, *The Blue House* members demonstrated the possibilities of responsive, autonomous and productive interactions in social life. They did not aspire to a consensual model of the public sphere but confronted residents' differences and antagonisms, creating opportunities for self-reflexivity alongside other tangible and cultural changes.[10] The significant conflicts of opinion between members and residents, such as the debates over *Pump Up The Blue* and the youth presence in the *Chill-ROOM*, demonstrated the reconciliation of disjunctive private expectations and individual embrace of responsibility toward others. Overall, the communication, empathy, trust and other qualities that arose during the negotiation and establishment of a diversity of outcomes during the five years of *The Blue House* suggest the generation and employment of social capital and other potential intellectual and physical resources in the re-imagining of life at IJburg.

The social art processes involved in re-imagining aspects of IJburg by members of the project resembled many procedures of anthropological research, such as embeddedness, communicative interactions or recordings and documentation, which led to an embodied and conceptual synthesis of existing knowledge with new information. Subsequently many members have published or presented findings in artworks, public forums and web sites. In doing so, they follow an anthropological research model of hypothesis, preparation, fieldwork, data collection and publishing. These processes assist in facilitating relationality and allow for greater potential for self-reflexivity in social art. Ironically, in this case, they also inadvertently enhanced the appeal of certain social art projects to economic industries including urban planning, development and property.

The Blue House interventions in the urban space (new libraries, the acceleration of community facilities and possible changes in future IJburg development) and the cultural fabric of IJburg resulted in more intrusive changes than normally attributed to academic forms of social science research. As intended, after five years, in 2009 *The Blue House* concluded as the island became more established. While confounding as art, residents acknowledged the immediate contribution this social art project made in generating a community feeling, as well as contributing to the creation of a history of IJburg (van Eerdt 15 June 2011 interview; Koek 27 June 2011 interview). Members absorbed the experience of the heuristic research into their practices, the dispersed members of *The Blue House* forming an international network called the 'Migratory Blue Points'. Their mobility supports the notion of globality, acknowledging that the world can be both unbounded and uneven (Eriksen 2003: 10). The 'Migratory Blue Points' are the residual nodes through which the learning from the self-organized creative agency of

The Blue House can continue to disburse into the complex flows of a globalizing world: ultimately demonstrating the possibilities of, and proposing some methodologies for, re-imagining the urban geographies that shape culture.

References

Appadurai, A. (1996), *Modernity at Large: Cultural dimensions of globalization*, Minneapolis: University of Minnesota Press, pp. 27–47.

Bishop, C. (2006), 'The Social Turn: Collaboration and its discontents', *Artforum*, 44: 6, pp. 178–84.

Bourriaud, N. (2002), *Relational Aesthetics*, (trans. S. Pleasance and F. Woods with M. Copeland), Dijon: Les presses du réel. First published in 1998.

Castells, M. (2010), 'Globalisation, Networking, Urbanisation: Reflections on the spatial dynamics of the information age', *Urban Studies*, 47: 13, pp. 2737–745.

Dekker, K., Torenvlied, R., Völker, B. and Lelieveldt, H. (2009), 'Explaining the Role of Civic Organisation in Neighbourhood Co-production', in J.M. Duyvendak, F. Hendriks and M. van Niekerk (eds), *City in Sight: Dutch dealings with urban change*, Amsterdam: Amsterdam University Press, pp. 223–49.

de Lange, L. and Milanovic, M. (2009), *De afronding van IJburg, PlanAmsterdam 2*, 15: 2, Amsterdam: Dienst Ruimtelijke Ordening, pp. 27–28.

de Rooy, F., Val, W. and Vierboom, G. (2002), *IJburg in uitvoering*, 8: 2, Amsterdam, De Zuiderkerk, pp. 23–4.

Derrida, Jacques. (1999), *Adieu to Emmanuel Levinas*, (trans. Pascale-Anne Brault and Michael Naas), Stanford, California: Stanford University Press.

Desai, D. (2002), 'The Ethnographic Move in Contemporary Art: What does it mean for art education?' *Studies in Art Education*, 43, pp. 307–23.

Dobricic, I. (2008), 'Paul O'Neill interviews Igor Dobricic', in *Locating the Producers, Case Study One – The Blue House*, 12 March (unpublished).

Duyvendak, J.M, Hendriks F. and Niekerk M. van (2009), 'Cities in Sight, Inside Cities: An introduction', in J.M. Duyvendak, F. Hendriks and M. van Niekerk (eds), *City in Sight, Dutch Dealings with Urban Change*, Amsterdam: Amsterdam University Press, pp. 9–24.

Eriksen, T.H. (2003), *Globalisation: Studies in Anthropology*, London: Pluto Press, p. 5.

Flew, T. (2009), 'Beyond Globalism: Rethinking the scalar and the relational of technology', *Global Media Journal, Australian Edition*, 3, http://www.commarts.uws.edu.au/gmjau/2009_3_1_toc.html. Accessed 21 August 2009.

Foster, H. (1996), 'The Artist as Ethnographer', in *The Return of the Real, The Avant-Garde at the Turn of the Century*, Cambridge, Mass.: MIT Press, pp. 171–204.

Goldenberg, D. and Reed, P. (2008), 'What is a Participatory Practice?', *Fillip*, Fall, n.p.n., http://fillip.ca/content/what-is-a-participatory-practice. Accessed 29 June 2010.

Harvey, D. (2006), *Spaces of Global Capitalism*, London: Verso.

—— (2000), *Spaces of Hope*, Edinburgh: Edinburgh University Press.

Heeswijk, J. van (2008), 'Profile: The ECF and the Blue House host difference', in I. Dobricic (ed.), *Managing Diversit: Art and [the art of] organisational change*, Amsterdam: ECF, Mets & Schilt, p. 35.

Hospers, G. (2008), 'What is the City but the People? Creative cities beyond the hype', in M. Heßler and C. Zimmermann (eds), *Creative Urban Milieus: Historical perspectives on culture, economy, and the city*, Frankfurt and New York: Campus Verlag, pp. 354–86.

Johnson, L.C. (2009), *Cultural Capitals: Revaluing the arts, remaking urban spaces,* Farnham, UK: Ashgate.

Jongmans, D.G. and Gutkind, P.C.W. (1967), *Anthropologists in the Field*, Assen: Van Gorcum & Comp. N.V.

Kalb, D., Pansters, W. and Siebers, H. (2004), *Globalization and Development: Themes and concepts in current research,* Dordrecht: Kluwer Academic Publishers.

Kaspori, D. (2008), 'Paul O'Neill interviews Dennis Kaspori', in *Locating the Producers, Case Study One – The Blue House*, 12 March (unpublished).

Keane, J. (2003), *Global Civic Society?*, Cambridge: Cambridge University Press.

Kester, G. (2004), *Conversation Pieces: Community and communication in modern art*, Berkeley: University of California.

Knulst, M. (2008), 'Paul O'Neill interviews Marius Knulst', in *Locating the Producers, Case Study One – The Blue House*, 11 April (unpublished).

Kwon, M. (2004), *One Place After Another: Site specific art and locational identity*, Cambridge, Massachusetts: The MIT Press.

Lacy, S. (1995), *Mapping the Terrain: New genre public art,* Seattle: Washington Bay Press.

Lamont, M and Aksartova, S. (2002), 'Ordinary Cosmopolitanisms: Strategies for bridging racial boundaries among working class men', *Theory, Culture and Society*, 19: 4, pp. 1–25.

Leão, D.P. (2005), 'Letter', http://www.blauwehuis.org/blauwehuisv2/?news_id=1917. Accessed 23 June 2010.

Leorke, D. (2009), 'Power, Mobility, and Diaspora in the Global City, An Interview with Saskia Sassen', *PLATFORM: Journal of Media and Communication,* 1, pp. 103–108.

Living, J. (2006), 'Density in Planning' *Mill Hill Preservation Society*, http://www.mhps.org.uk/articles/density.html. Accessed 30 August 2011.

Maasland, M. (2008), 'Paul O'Neill interviews Marianne Maasland', in *Locating the Producers, Case Study One – The Blue House*, 12 April (unpublished).

MacDougall, D. (2006), *The Corporeal Truth*, Princeton, New Jersey and Oxford: Princeton University Press.

Ministry of Education, Culture and Science, (2006), *Cultural Policy in the Netherlands*, The Hague: Ministry of Education, Culture and Science.

O'Neill P. and Doherty, C. (2011), *Locating the Producers: Durational approaches to public art*, Amsterdam: Antennae, Valiz.

Robertson, R. (2004), *The Three Waves of Globalization. A history of a developing global consciousness,* London: Zed Books and Nova Scotia: Fernwood Publishing.

Roovers, I. (2007), 'Paul O'Neill interviews I. Roovers', in *Locating the Producers, Case Study One – The Blue House*, 1 December (unpublished).

Santos, B. (2006), 'Globalizations', *Theory, Culture and Society*, 23, pp. 393–99.

Sassen, S. (1994), *Cities in a World Economy*, Thousand Oaks, California: Pine Forge Press.

Schneider, A. and Wright, C. (2010), *Between Art and Anthropology: Contemporary ethnographic practice*, Oxford: Berg.

—— (eds) (2006), *Contemporary Art and Anthropology*, Oxford: Berg.

Strang, V. (2006), 'CA Forum on Theory in Anthropology – A Happy Coincidence? Symbiosis and synthesis in anthropological and indigenous knowledges', *Current Anthropology*, 47: 6, pp. 981–1008.

Yeoh, B.S.A. (2005), 'The Global City? Spatial imagineering and politics in the (multi)cultural marketplaces of South-East Asia', *Urban Studies*, 42: 5/6 May, pp. 945–58.

Notes

1 Designed by Teun Koolhaas Associates, the unsold house was offered by de Alliante Housing Corporation to be used for cultural activities for five years in exchange for the mortgage payments.

2 The 51 members included 22 artists or art collectives (O'Neill and Doherty 2011: 10).

3 Funds and in-kind support were sourced from the European Council Foundation (ECF), Amsterdam Funds for the Arts (AFK), de Alliante (Private Housing Corporation), the Mondriaan Foundation, the Prince Bernhard Culture Fund, Stichting DOEN and VSB Fonds (O'Neill and Doherty 2011: 30).

4 Research from *The Blue House* was presented at the conclusion of the project at a public two-day seminar in IJburg, in a website, lectures and publications (O'Neill and Doherty 2011) including a forthcoming book. The connections between social art practice and anthropological methodology will be discussed in more length in my forthcoming Ph.D. dissertation at the Australian National University, Canberra.

5 Nicoline Koek's flower shop 'bloem & zee' and the children's library remain in existence.

6 Holland's colonies included the Dutch East Indies (Indonesia), and the territories of Suriname, Antilles and Aruba in the Caribbean. The latter two remain part of the Kingdom of the Netherlands. Turkish and Moroccan immigrants were recruited to work in the country from the mid-1970s, and a large number of Dutch national Surinamese immigrated after Suriname gained independence in 1975. In 2006 the 'foreign population' comprised 19 per cent of the total Netherlands population (16.3 million), with just more than half of those having non-western backgrounds (Ministry of Education, Culture and Science 2006: 21).

7 The Dutch word *allochtoon* (meaning 'originating from another country') reflects an official discrimination between ethnic Dutch (autochtoon) and the allochtoon or first and second generation immigrants.

8 Working from *The Blue House*, Sakho and van der Speck continued to advocate for the rights of the victims of the fire, predominantly detainee Achmed Al-Jeballi who was accused of arson.

9 The 'Frida project' highlighted the duplicity of the guest/ host relationship and the distinction between and ethical and political hospitality addressed by Jacques Derrida in *Adieu to Emmanuel Levinas* (1999).

10 There were diverse attitudes as to what *The Blue House* had achieved. Many residents preferred the house to operate as a social space rather than what some perceived to be the increasingly-exclusive use of the members. Some members were disappointed at the difficulty of generating local dialogue and participation, and others at the incapacity of residents to sustain projects they had jointly initiated.

Conclusion

Chapter 14

Cities as Limitless Spaces of Simultaneity and Paradox

Chris Hudson
RMIT University

The chapters in this book bring into sharp focus certain aspects of contemporary processes of globalization and the transformation of cultural experiences. Artistic interventions can generate a re-imagining of the urban and help to renegotiate the connection between the local and the global. What is critical and new in global practices, according to Arjun Appadurai, is the imagination as a social practice:

> No longer mere fantasy … no longer simple escape … no longer elite pastime … and no longer mere contemplation … the imagination has become an organized field of social practices, a form or work … and a form of negotiation between sites of agency … and globally defined fields of possibility.
>
> (Appadurai 1996: 31)

It is, therefore, to the agency of the aesthetic, the artistic and the work of the imagination that we turn in this volume to understand the urban condition in the global era.

The city is the locus of the transition from the national to the global. It can be argued that life in cities can be constituted by an engagement with the global, the national and the local simultaneously, and that urban consciousness increasingly demands an accommodation of all three. For Saskia Sassen (2005, 2007) the hierarchical, nested scales of the global, national and local have now collapsed and the sites of the national and the local can be destabilized by the global. The forms of this destabilization have implications for urban transformations, the uses of public space and for the ways in which cities imagine themselves. This transformation has brought about new creative practices and new discursive and narrative interventions. It has had a powerful effect on the consciousness of space and place, and has been a factor in the rise of the global imaginary, so eloquently outlined by Manfred Steger (2008). The intention of this volume is to go beyond the triad of spatial scales to investigate the ways in which contemporary cultural practices and productions in art, architecture, design and technology can reconfigure our urban imaginary, and mediate our engagement with the global through the processes of urban transformation.

Urban Imaginaries

It seems appropriate to conclude a book on re-imagining the city with several representations of the urban condition. While chosen at random, each vignette – written approximately 50 years apart, and from three different hemispheres – articulates a consciousness of place

appropriate to the historical period and cultural disposition. The first is an observation by a well-known chronicler of urban life in one of the most globalized of cities. In 1879, Charles Dickens published this description of a district of London in his *Dictionary of London*. It was then known as Ratcliff Highway, part of the docks area, and close to present-day Wapping:

> Ratcliff Highway – This, which until within the last few years was one of the sights of the metropolis, and almost unique in Europe as a scene of coarse riot and debauchery, is now chiefly noteworthy as an example of what may be done by effective police supervision thoroughly carried out. The dancing-rooms amid foreign cafés of the Highway … are still well worth a visit from the student of human nature, and are each, for the most part, devoted almost exclusively to the accommodation of a single nationality. Thus at the 'Rose and Crown,' near the western end of the Highway, the company will be principally Spanish and Maltese. At the 'Preussische Adler,' just by the entrance into Wellclose-square, you will meet, as might be anticipated, German sailors; whilst Lawson's, a little farther east, though kept by a German, finds its *clientele* among the Norwegian and Swedish sailors, who form no inconsiderable or despicable portion of the motley crews of our modern mercantile fleet. Over the way, a little farther down, is the Italian house, a quaint and quiet place, full of models and 'curios' of every conceivable and inconceivable des cription, and nearly opposite the large and strikingly clean caravanserai, where a pretty, but anxious-looking Maid of Athens receives daily, with a hospitality whose cordiality hardly seems to smack of fear, any number of gift-bearing Greeks. … Hard by Quashie's music-hall is a narrow passage, dull and empty, even at the lively hour of 11 pm., through which, by devious ways, we penetrate at length to a squalid *cul-de-sac* … At the bottom of this slough of grimy Despond is the little breathless garret where Johnny the Chinaman swelters night and day curled up on his gruesome couch, carefully toasting in the dim flame of a smoky lamp the tiny lumps of delight which shall transport the opium-smoker for awhile into his paradise. If you are only a casual visitor you will not care for much of Johnny's company … But if you visit Johnny as a customer, you pay your shilling, and … pass duly off into elysium.
>
> (Dickens 1879)

What will be obvious immediately to the reader from this version of Victorian London is that Dickens' representation of urban space concerns itself with some of the same features we note in the city today. While it articulates the attitudes and sensibilities of nineteenth-century Britain, it also encapsulates a number of themes about cities that have been discussed in this book. London is a world city with connections to distant places; it is a space of transience; it is a node for the distribution of goods from elsewhere; it is the location of cultural diversity and difference; it is a zone of heightened senses (including those aided by narcotics); and, it is the threshold of an imagined realm requiring an aesthetic response. It speaks of the politics of representation, urban consciousness, life in the space of flows, modernity and mobility, global interconnections, geographies of class, race and gender and a global sense of place.

The city is, for Dickens, a laboratory for the student of human nature. He discovers in it, as the *flâneur* does, 'a landscape of voluptuous extremes' (Sontag 1977: 55).

Dickens' depiction of London exhibits an ambivalent topophilia of the sort described by Elizabeth Grierson in her writing on place-making in *Urban Aesthetics* (forthcoming). In considering the relations between aesthetics, subjectivity and urban space in his imaginary of place, Dickens also highlights a feature of the nineteenth-century urban landscape that has been intensified in the twentieth and twenty-first centuries. Ratcliff Highway, the Wapping Docks, Limehouse – London's nineteenth-century Chinatown and the space of the 'other', 'Johnny the Chinaman'– and other districts in the docks area of London are transnational localities. The distinguishing feature of these localities is that, while they are local spaces, they are constituted by their engagement with the global. Through nodes of global connectivity such as London, the global manifests and is articulated through the everyday practices of the local. I start with this quotation to give a sense of the intensity of the urban and its significance as place in a wider global environment. Dickens' London was a lived, globally-connected, social space teeming with possibilities, both nefarious and otherwise.

The city has long held a grip on the cultural imagination, and there is an enduring tradition of ambivalence towards cities and their effects. Gary Bridge and Sophie Watson's collection of essays on the city highlight two standard opposing views of cities: on the one hand they are exciting, vibrant places most conducive to the realization of the self and, on the other, they are places of alienation and estrangement (Bridge and Watson 2002: 3). The city may be creative or destructive and, while the juxtaposition is extreme, most responses, literary and otherwise, vacillate between these two poles. The city is, as Deyan Sudjic puts it, never entirely comfortable (1992: 31). Even though Ratcliff Highway was an unstable realm of infamy and moral turpitude – the sex and drugs described by Dickens – it nevertheless invokes a romantic response. J. Ewing Ritchie, a contemporary of Dickens, recognizes the promise the city holds out against the suffocating constraints of the Victorian social order, despite the series of brutal murders committed in Ratcliff Highway in 1811. The excitement of the city, never completely free of a certain frisson of danger, would have a salutary effect on a man:

> [T]here would be a charming independence in his character, a spurning of that dreary conventionalism which makes cowards of us all, and under the deadly weight of which the heart of this great old England seems becoming daily more sick and sad, a cosmopolitanism rich and racy in the extreme.
>
> (Ritchie 1857)

Cities are key sites for the generation of a global cultural economy, as Malcolm Miles points out in his discussion of culturally-led urban renewal. They are the sites of historical cultural transactions, and conduits for a range of powerful forces, not just financial. Urban geographers Ash Amin and Nigel Thrift's description of cities as 'relay stations in a world of

flows' (Amin and Thrift 2002: 51) is fitting. The grimy Despond of London's Chinatown, and the multi-cultural experience of a walk through the Ratcliff Highway district is the result of a world of cultural as well as economic flows. To live in and experience the city requires a 'poetics of knowing' (Amin and Thrift 2002:14) and the romance of a walk through the city is a poem come to life (de Certeau 1984: 101). Cities are no longer simply geographical locations but urban contexts; a city is a shifting set of conceptual possibilities (Barley 2000:13) in which a rich and racy cosmopolitanism is in perpetual tension with the slough of grimy despond. It is the complexity and extravagant profusion of experiences of the city that demands sophisticated strategies for understanding the multifarious meanings of space and place, and is the motivation for this book. Architecture, art, literature, performance, communications media, cultural events and design are the aesthetic responses to these experiences that endeavour to give meaning and deeper understanding to urban space in a global environment.

It is for this reason that Mike Featherstone reminds us that the city is not only an object of investigation but, because of its powerful hold on the imagination as the location of myriad contradictory experiences, it is also a metaphorical device with deep cultural power for the West (Featherstone 1998: 911). However, this power is not confined to western imaginaries of the city. Shanghai, for most of the last century, held a place in the imagination of both China and the West as a space of feminized, eroticized modernity. The English writer J.G. Ballard, in a juxtaposition of the sensual and the vulgar, described Shanghai before World War Two as 'this lurid and electric city more exciting than any other in the world' (Ballard 1984: 23). Chinese writer Mao Tun, in his novel *Midnight*, describes Shanghai in the 1920s thus:

> Whenever a tram passed over the bridge, the overhead cable suspended below the top of the steel frame threw off bright, greenish sparks. Looking east, one could see the warehouses of foreign firms on the waterfront of Pootung like huge monsters crouching in the gloom, their lights twinkling like countless tiny eyes. To the west, one saw with a shock of wonder on the roof of a building a gigantic neon sign in flaming red and phosphorescent green: LIGHT, HEAT, POWER!
>
> (Mao 1957: 120)

This excerpt depicts an urban space dedicated to the aesthetics of modernity, new forms of mobility, transnational connections and a global sense of place. This is the forerunner of Maggie McCormick's Chinese city characterized above all by transience. Shanghai has been a node in a series of global flows since the early nineteenth century. Shanghai is known for its Art Deco constructions, and the Shanghai Bund is the site of many examples of an architectural style associated with the High Modernist period. Perhaps the most significant architectural expression of the power of European globalizing modernity and transformation of the riverfront into globalized space and deterritorialized fragment of Europe is the Customs House. Built in 1927 at number 13, the Bund, in the neo-classical style, it is a

replica of London's Big Ben. The architectural elegance of the Shanghai Bund is perhaps an example of the unforeseen consequences of enterprise transition.

Deploying the trope of the car – critical to the urban culture experience, as Kristen Sharp points out in her discussion of sonic urban conditions – Shu-May Shih's essay on the Chinese novelist Liu Na'ou describes the 'modern girl' in 1930s' Shanghai, the quintessential denizen of the modernizing, quixotic, globally-connected city. The 'Shanghai Girl'

> seeks pleasure, speed (she loves the 1928 Viper sports car), and money; she is attractive and precocious, but most importantly, unfaithful ... Lodged in her are the characteristics of the urban culture of the semicolonial city and its seductions of speed, commodity culture, exoticism, and eroticism.
>
> (Shih 1996: 947)

Liu's novel represents the modern girl as a 'desirable embodiment of antipatriarchal, autonomous, urban and hybrid modernity' (Shih 1996: 935). She is the incarnation of modernity itself expressed through eroticized behaviour and a dedication to consumer culture and sensual gratification, located in an urban environment which provides a space for the development of a transnational, globalized subject. It is an environment in which it is possible to form an aesthetic response to the urban condition through the mobility afforded by the car, as Ashley Perry explains in his research on the imaginative driving experiences of reconfigured geographies.

Dickens' lyrical imaginary of London and Mao Tun's picture of Shanghai's modernist aesthetic and dedication to speed and consumerism may be contrasted with William Gibson's post-capitalist, postmodern American city described in his novel *Neuromancer*. For his main protagonist, Case,

> [h]ome was BAMA, the Sprawl, the Boston-Atlanta Metropolitan Axis. Program a map to display frequency of data exchange, every thousand megabytes a single pixel on a very large screen. Manhattan and Atlanta burn solid white. Then they start to pulse, the rate of traffic threatening to overload your simulation. Your map is about to go nova. Cool it down. Up you scale. Each pixel a million megabytes. At a hundred million megabytes per second, you begin to make out certain blocks in midtown Manhattan, outlines of hundred-year-old industrial parks ringing the old core of Atlanta are all one elongated, spatially dispersed urban space.
>
> (Gibson 1984: 43)

This futuristic, pixelated world is 'home' without locality, a post industrial, almost post-human, imagined world of technologically-generated images, reminiscent of Deyan Sudjic's (1992) 100 mile city spreading in every direction where buildings, boundaries and even lives morph into one incandescent glow. It threatens to explode and it is difficult to ascertain if it is real or imagined. Like Mao Tun's modernist

Shanghai, the BAMA is a city of technological excess. It is a dimension of data exchange, strangely devoid of people. Case's real home is anywhere and nowhere. He has a consciousness of distant connectivity, mobility and transience, and the unnerving unreality that too much of all these can generate, like ceaseless jet-lag, permanent detachment:

> Case woke from a dream of airports, of Molly's dark leathers moving ahead of him through the concourse of Narita, Schipol, Orly ... He watched himself by a flat plastic flask of Danish vodka at some kiosk, an hour before dawn.
>
> (Gibson 1984: 43)

Gibson describes a vast mega-city, an out-of-control sprawl imagined through the metaphor of digitized information. His character has a global consciousness, even in his dreams.

The imagining of the urban experience has been the setting for many novels, and the *mise-en-scène* of countless films. Joyce's Dublin in *Ulysses* (1922), Hemingway's Paris in *A Moveable Feast* (1964), Döblin's Berlin in *Berlin Alexanderplatz* (1929), Rushdie's Mumbai in *The Ground Beneath Her Feet* (2000) or Wei Hui's Shanghai in *Shanghai Baby* (1999) come to mind if we seek examples of literary versions of the urban imaginary in which the city is a metaphorical device that articulates the inherent tension between cosmopolitanism on the one hand and the slough of grimy despond on the other.

Theorizing the Re-imagining of the City

Art, design, communication, architectural values and textual representations all play a role in producing and reinterpreting the local/urban in a global environment. All artistic and aesthetic elements are implicated in this process, for, as Lefebvre argues,

> [s]pace does not eliminate the other materials or resources that play a part in the socio-political arena, be they raw materials or the most finished of products, be they business or 'culture.' Rather, it brings them all together and then in a sense substitutes each factor separately by enveloping it.
>
> (Lefebvre 1991: 410)

Elizabeth Grierson and Kristen Sharp introduce Henri Lefebvre's *The Production of Space* (1991) as a seminal text for the considerations of re-imagining the city. Lefebvre outlines a spatial triad as the central epistemological framework for understanding space: *spatial practice* refers to the production and reproduction of spatial relations between objects and products. Each person in social space has a relationship to that space, a level of competence in moving around it and uses specific performances to get around; *representations of space are* tied to the relations of production and to the 'order' which

those relations impose; it involves knowledge, signs and codes, and is the space of bureaucrats and social engineers and the people responsible for order in a society; *representational space as the space of inhabitants and users is directly lived* through its associated images and symbols. It is the space where meaningful symbols and images of a community are located. It is also, therefore, the space of artists; the space the imagination seeks to change (Lefebvre 1991: 38–40). Edward Soja (1996) reappropriates Lefebvre's trialectics of space to define a new critical understanding of what he defines as 'Thirdspace'. Rejecting the classic binary of historicity and sociality, he argues that the third important epistemology is spatiality. He posits 'Firstspace' (the lived space of reality, the city itself, fixed on the concrete materiality of spatial forms and spaces that can be mapped) and 'Secondspace' (ideas about space, cities understood through discourses, literary forms, imagined space, representatations of space, mental or cognitive maps). 'Thirdspace', integrates the first two to create a new epistemology. A 'thirdspatial imagination' emerges that understands space as simultaneously real and imagined. As Soja argues:

> *Everything* comes together in Thirdspace: subjectivity and objectivity, the abstract and the concrete, the real and the imagined, the knowable and the unimaginable, the repetitive and the differential structure and agency, mind and body, consciousness and the unconscious, the disciplined and the transdiscplinary, everyday life and unending history.
>
> (Soja 1996: 56, emphasis in original)

But the unknowable and unimaginable are, by their very nature, not always obvious to the observer. The search to reveal this dimension – the concealed space, the 'other' space – is compounded by the limitations of language to describe something of such infinite complexity. Soja turns to Jorge Luis Borges' story 'The Aleph' to help unravel the problem. 'The Aleph' is 'the only place on earth where all places are, a limitless space of simultaneity and paradox, impossible to describe in less than extra-ordinary language' (Soja 1989: 2). The complexity of cities, where excitement and vibrancy exist simultaneously with alienation and estrangement – Thrift's 'roiling maelstroms of affect' (2004: 57) – is difficult to express in the context of one city. Borges' attempts to describe the city are reminiscent of Dickens' London and are confounded by its limitless simultaneity: 'In that single gigantic instant, I saw millions of acts both delightful and awful; not one of them amazed me more than the fact that all of them occupied the same point in space, without overlapping or transparency' (Borges 1971: 13). Italo Calvino's novel *Invisible Cities* (1997) describes cities of memory, cities of desire, cities of signs, cities and the dead, cities and the sky, cities and names, thin cities, trading cities, hidden cities and continuous cities; and yet all these cities are one and the same complex city. In the book, the main character Marco Polo describes the cities of his travels – which are also the cities of his imagination – in his conversations with the Emperor Kublai Khan. The Khan's response is similar to ours when we read Dickens',

Mao Tun's or Gibson's vision of the city: he does not always believe Marco. At least one of Marco's cities encapsulates the dilemma of Borges' city of 'limitless simultaneity and paradox' where all places are, and that is the city of Trude. Marco recounts his experience of Trude to the Khan:

> If on arriving at Trude I had not read the city's name written in big letters, I would have thought that I was landing at the same airport from which I had taken off ... Why come to Trude? I asked myself. And I already wanted to leave. 'You can resume your flight any time you like,' they said to me, but you will arrive at another Trude, absolutely the same, detail by detail.
>
> (Calvino 1997: 116)

And in a statement uncannily prescient of Gibson's transient world, Marco was told that '[t]he world is covered by a sole Trude which does not begin and does not end. Only the name of the airport changes' (Calvino 1997: 116).

Soja considers the difficulty of imagining cities by turning to the reality of Los Angeles. While Los Angeles is all very real, it is peculiarly resistant to conventional description:

> It is difficult to grasp persuasively in a temporal narrative for it generates too many conflicting images, confounding historicization, always seeming to stretch laterally instead of unfolding sequentially ... it too seems limitless and constantly in motion, never still enough to encompass ... too filled with 'other spaces' to be informatively described.
>
> (Soja 1989: 222)

It may be argued, however, that Los Angeles is not unique in its ability to confound perception and defy description. The Tokyo-Yokohama-Nagoya triad stretches laterally instead of unfolding sequentially; New York is constantly in motion; Mumbai generates conflicting images; Chongqing confounds historicization; Shanghai is never still enough to encompass, and Jakarta is too filled with others' spaces to be described informatively. All mega-cities resist conventional description, but are unique in their forms of resistance.

How can we, then, express the complexity and the limitless simultaneity of cities, if language is inadequate to the task as Borges and Soja suggest? Art, broadly defined, and creative enterprises generally, are cultural activities through which a thirdspatial imagination that can encompass conflicting epistemologies may be developed. To *know* aesthetically, as Elizabeth Grierson and Kristen Sharp point out, is to perceive through something beyond reason, beyond ordinary language. It is through art that the beguiling mysteries of the city can be perceived, or sensed, by fusing the imagined with the real in a thirdspace. Artistic and imaginative responses may be a key feature of our re-imagining of urban life, but the city's ability to defy adequate description also precludes predictability

of responses. As Amin and Thrift put it, 'each urban moment can spark performative improvisations' (2002: 4).

Re-imagining the City through Performance

It would be difficult to conceive of a more innovative example of the power of the performative and artistic to generate a re-imagining of the city than a performance devised by German theatre collective Rimini Protokoll. First appearing as Rimini Protokoll in 2002, a team of designers, directors and sound and video artists came together under the creative direction of artists Helgard Haug, Stefan Kaegi and Daniel Wetzel. It is now well known that the three had joined forces during the 1990s in a practice-oriented, theatre studies programme at Angewandte Theaterwissenschaft (Applied Theatre Science & Performance Studies) at Giessen University, Germany, of which Hans-Thies Lehmann and Andrzej Wirth were key instigators. Haug, Kaegi and Wetzel have worked together, since then, in various combinations to produce forms of 'post-dramatic theatre' – theatre characterized by a performative aesthetic that dispenses with the play text and focuses on the specific material realities of the staging. A key feature of post-dramatic theatre is that it no longer *represents* the world as a surveyable whole (Jürs-Munby 2006). The radical departure from traditional text-based theatrical productions, and liberation from the proscenium stage in favour of the staging of performances in urban space itself, has opened up a new approach to the problem of how to represent the unknowable, unimaginable, limitless space of simultaneity and paradox that is the city. Hans-Thies Lehmann argues that 'the category appropriate to the new theatre is not action but *states* ... Theatre here deliberately negates or at least relegates to the background, the possibility of developing a narrative ... The state is an aesthetic configuration of the theatre, showing a formation rather than a story' (Lehmann 2006: 68 emphasis in original). The aesthetic dimension is determined by the 'state' of being in the everyday world in the register of the ordinary; the audience comes to *know* the city aesthetically through the performance. The spatial dimension is foremost in determining the 'state' or aesthetic configuration of the performance. Thomas Irmer has pointed out that by locating the political firmly in the quotidian through the use of techniques appropriated from experimental theatre and contemporary exhibition aesthetics instead of conventional theatrical representation, Rimini Protokoll, are able to explore aspects of the unknown present (Irmer 2006: 26).

Rimini Protokoll's 'site specific performances' respond to the particularities of a site and make sense only within that site. One such performance is *Call Cutta*. In this theatrical experiment, the audience in Berlin – consisting of one person – is given a mobile phone instead of a ticket. The ringing of the phone signals the beginning of the performance. The call-centre worker in Kolkata (Calcutta) – that is, a real call-centre employee, not a trained actor – chats with the participant in Berlin, breaking down

barriers by talking about herself and connecting with the participant by describing the room in Berlin, commenting on the appearance of the participant, and turning lights on and off. The performance becomes a mobile investigation of urban space when, for the next two hours, the participant is directed through the streets of Berlin by a person who has never been outside India. A dialogue about the historical and political conditions in India and Germany is interspersed with explicit directions to the participant to negotiate the known and unknown spaces of Berlin. The caller asks intimate questions such as: 'Have you ever fallen in love on the phone'? The participant walks through unfamiliar car parks and other pockets of the lesser known, encountering strangers, pieces of refuse, lost objects, traffic lights and the usual plethora of unexpected obstacles and spectacles found in the everyday reality of urban life. The caller points out the tracks that carried the trains to Auschwitz. The experience is unpredictable and, as in real life, no two urban performances are the same. At the end of the performance, the participant finally sees the caller, waving goodbye on a screen in the window of a computer shop in the Postdamer Platz shopping mall.

The relationship that develops between the caller and participant and the physical mobility of the performance is mediated by various technologies such as mobile phones and live internet streaming. It presents, like Dickens' London, a 'polyrhythmic ensemble' (Crang 2000) where times and spaces overlap. As Jon May and Nigel Thrift put it, in their examination of time and space, 'the picture that emerges is less that of a singular or uniform social time, than of various (and uneven) networks of time stretching in different and divergent directions across an uneven social field (May and Thrift 2001: 5). A performance such as this goes beyond language to re-imagine the city as a globalized space which links two cities in different spaces and times. We can imagine it only as thirdspace, a space both real and imagined.

This performance – directed from Kolkata and played out in Berlin – relies on aspects of the realities of the international economy with its flows of media and global division of labour. It allows both the caller and the participant to experience the limitless spaces of simultaneity and the paradoxes of urban life, and together negotiate the unknown present. Paradoxes abound: the space is both limited and expanded; local and global; known and unknown; rhythmic and arrhythmic; and chaotic and ordered. From the malevolence of the rail line to Auschwitz to the excitement of consumer-oriented Postdamer Platz, the participant makes his or her way through an uncertain terrain, never quite knowing where they will end up, via a mediated relationship between two people who are at once strangers and confidants. The relationship is both intimate and public; familiar and unfamiliar; and present and distant. These complexities can be imagined through a combination of the concrete materiality of a 'Firstspace' combined with the cognitive maps and cultural representations of a 'Secondspace,' amalgamated into a new epistemology – a thirdspatial dimension that is experiential. It provides for a new way to re-imagine the city that goes beyond language to become an aesthetics of presence – Amin and Thrifts 'poetics of knowing' (2002:14). This present is so complex in

its limitless simultaneity and paradox that it is unrepresentable and must be experienced if it is to be re-imagined in the global era.

References

Amin, A. and Thrift, N. (2002), *Cities: Reimagining the urban*, Cambridge: Polity.

Appadurai, A. (1996), *Modernity at Large: Cultural dimensions of globalization*, Minneapolis: University of Minnesota Press.

Ballard, J.G. (1984), *Empire of the Sun*, New York: Simon and Schuster.

Barley, N. (2000), *Breathing Cities: The architecture of movement*, Basel: Birkenhäuser, p.13.

Borges, J.L. (1971), 'The Aleph', *The Aleph and Others Stories: 1933–1969*, New York: Bantam Books, pp. 3–17.

Bridge, G. and Watson, S. (2002), *The Blackwell City Reader*, Oxford: Blackwell.

Calvino, I. (1997), *Invisible Cities*, London: Vintage.

Crang, M. (2000), 'Urban Morphology and the Shaping of the Transmissible City', *City*, 4: 3, pp. 303–15.

de Certeau, M. (1984), *The Practice of Everyday Life*, Berkeley: University of California Press.

Dickens, C. (1879), *Dickens Dictionary of Victorian London*, http://www.victorianlondon.org/dickens/dickens-r.htm. Accessed 2 May 2012.

Featherstone, M. (1998), 'The *Flâneur*, the City and Virtual Public Life', *Urban Studies*, 35: 5–6, pp. 909–25.

Gibson, W. (1984), *Neuromancer*, New York: Ace Books.

Grierson, E.M. (forthcoming), *Urban Aesthetics*.

Irmer, T. (2006), 'A Search for New Realities: Documentary theatre in Germany', *The Drama Review*, 50: 3, pp. 16–28.

Jürs-Munby, K. (2006), 'Introduction', in Hans-Thies Lehmann *Postdramatic Theatre*, Oxon: Routledge, p.12.

Lefebvre, H. (1991), *The Production of Space*, Oxford: Blackwell.

Lehmann, H-T. (2006), *Postdramatic Theatre*, (trans. K. Jürs-Munby), Oxon: Routledge, p. 24.

Mao, T. (1957), *Midnight*, Boston: Cheng and Tsui Company.

May, J. and Thrift, N. (2001), *Timespace: Geographies of temporality*, London: Routledge.

Ritchie, J.E. (1857), 'Ratcliff Highway', *The Night Side of London*, p. 77, http://www.victorianlondon.org/publications3/nightside-07.htm. Accessed 2 May 2012.

Sassen, S. (2005), 'The Many Scales of the Global: Implications for theory and for politics', in R.P. Appelbaum and W.I. Robinson (eds), *Critical Globalization Studies*, New York and London: Routledge, pp. 155–66.

—— (2007), *A Sociology of Globalization*, New York and London: W.W. Norton and Company.

Shih, S-M. (1996), 'Gender, Race and Semicolonialism', *Journal of Asian Studies*, 55: 4, pp. 934–56.

Soja, E. (1996), *Thirdspace: Journeys to Los Angeles and other real-and-imagined places*, Malden, MA: Blackwell.

—— (1989), *Postmodern Geographies: The reassertion of space in critical social theory*, London and New York: Verso.

Sontag, S. (1977), *On Photography*, New York: Picador.

Steger, M. (2008), *The Rise of the Global Imaginary: Political ideologies from the French Revolution to the global war on terror*, Oxford: Oxford University Press.

Sudjic, D. (1992), *The 100 Mile City*, London: Andre Deutsch.

Thrift, N. (2004), 'Intensities of Feeling: Towards a spatial politics of affect', *Geografiska Annaler Series B*, 86: 1, pp. 57–78.

Author Bionotes

Professor Tom Barker Mdes(Eng) RCA MSt(Cantab) BSc(Hons) DIC FRSA FRCA Design Fellow Royal Commission of 1851. Tom has worked as a consultant, researcher, strategist, designer and serial entrepreneur in the fields of architecture, art, technology and design for over 20 years. His work covers both the built environment and the digital domain. He is Chair of the Digital Futures Initiative at OCAD University Toronto and adjunct professor of innovation at the University of Technology Sydney.

Professor Elizabeth Grierson is a research leader at RMIT University Melbourne where she was head of the School of Art for seven years up to 2012. She is a Fellow of the Royal Society of Arts (UK), has served on national and international boards for art education, and worked as visual arts advisor for the *Australian Curriculum: The Arts*. As a professor of art and philosophy with a PhD in the philosophy of art education, Elizabeth is executive editor of *ACCESS* journal and well published in art, education, aesthetics and the public sphere. Co-authored books include *Designing Sound for Health and Wellbeing* (ASP 2012); *A Skilled Hand and Cultivated Mind* (RMIT Press 1st ed. 2008, 2nd ed. 2012); *Creative Arts Research* (Sense 2009); and edited books, *De-Signing Design* (Lexington forthcoming); *Supervising Practices for Postgraduate Research in Art, Architecture and Design* (Sense 2012); *A Life in Poetry* (ASP 2011); *Thinking Through Practice* (RMIT Press 2007); *The Arts in Education* (Dunmore 2003). Website: www.elizabeth.grierson.com.

Dr Larissa Hjorth is an artist, digital ethnographer and associate professor in the games programmes, School of Media & Communication, RMIT University. Since 2000, Hjorth has been researching and publishing on gendered mobile media, gaming and virtual communities in the Asia-Pacific, studies outlined in her book, *Mobile Media in the Asia-Pacific* (Routledge). Hjorth has published widely on the topic in national and international journals, such as *Games and Culture journal*, *Convergence journal*, *Journal of Intercultural Studies*, *Continuum*, *ACCESS*, *Fibreculture* and *Southern Review* and, in 2009, co-edited two Routledge anthologies, *Gaming Cultures and Place in the Asia–Pacific Region* (with Dean Chan), and *MobileTechnologies: From telecommunication to media* (with Gerard Goggin). In 2010 Hjorth released *Games & Gaming* (Berg).

Dr Chris Hudson is co-research leader (with Professor Manfred Steger) in the Globalization and Culture programme of the Global Cities Research Institute, and associate professor of Asian Cultural Studies in the School of Media and Communication at RMIT University in

Melbourne. She takes a transdisciplinary approach to the study of Asian societies and has published widely in the areas of theatre and performance, urban space, discourses of the nation, gender, and communication, with a focus on South-East Asia. She was a Chief Investigator on an Australian Research Council-funded Discovery Grant (2009–11), *Theatre in the Asia-Pacific: Regional Culture in a Modern Global Context*. Her most recent publication (with Denise Varney) is 'Transience and Connection in Robert Lepage's *The Blue Dragon*: China in the Space of Flows', in *Theatre Research International*, 37: 2.

Dr Maggie McCormick lectures at the School of Art (Art in Public Space) at RMIT University, Melbourne and tutors at The University of Melbourne. Her research focuses on the relationship between urban consciousness and cultural conceptualization and how this is evidenced in contemporary art practice. The research forms the basis of exhibitions, presentations and publications in Australia, Asia and Europe. She has a particular interest in contemporary China, where she has undertaken a research residency, presented papers and exhibited in Hangzhou, Shanghai and at the 798 Art District in Beijing. Her chapter draws on her doctoral thesis, *The Transient City: Mapping urban consciousness through contemporary art practice* (2009), which investigated the changing nature of urban consciousness through a study of contemporary Chinese artistic and curatorial practice, both within and outside of China. Website: maggiemccormickcv. blogspot.com.

Professor Malcolm Miles convenes the Culture-Theory-Space research cluster in the School of Architecture, Design & Environment at University of Plymouth, UK where he is a professor of cultural theory. He is author *of Herbert Marcuse: An aesthetics of liberation* (2011), *Urban Utopias* (2008), *Cities & Cultures* (2007), *Urban Avant-Gardes* (2004) and *Art Space & the City* (1997). Website: www.malcolmmiles.org.uk.

Dr Leslie Morgan is a Melbourne-based artist and writer of Anglo-Indian heritage. His painting and writing engages with themes of race, migration, diaspora, transnationalism and whiteness. He is a lecturer in education at La Trobe University.

Dr Kevin Murray is adjunct professor at RMIT University and visiting professor at Australian Catholic University. His PhD was in the area of narrative psychology. In 2000–2007 he was director of Craft Victoria where he developed the Scarf Festival and the South Project. He is currently coordinator of Sangam: the Australia India Design Platform as part of the Ethical Design Laboratory at RMIT Centre for Design. Website: www.kevinmurray.com.au.

Ashley Perry is a PhD candidate and tutor in the School of Media and Communication, RMIT University. His project-based doctoral research *Visual Car-Tography: A critical examination of automobilities* examines the temporal, spatial and material realities of the

car within the urban geography of Melbourne, Australia. His research practice focuses on the representation of automobility through the production of unique graphic, photographic and filmic artefacts. One of Perry's multi-screen video installations, *Four Approaches to the City*, was included in the 2008 Victorian State of Design Festival. He has published his research in the *Spaces and Flows* journal (2011).

Dr Kristen Sharp is a senior lecturer and coordinator of Art History and Theory in the School of Art at RMIT University, Melbourne. Since 2007, she has been researching contemporary art and urban space, collaborative practices in transnational art projects, and contemporary Asian art. She is currently working on an Australian Research Council Linkage Project (2010–13), *Spatial Dialogues: Public Art and Climate Change*, located in Melbourne, Shanghai and Tokyo. In 2012, Kristen was an international visiting researcher at Musashino Art University, Tokyo. In 2013, she is co-curating *The Sonic City* for Liquid Architecture Sound Art Festival. In addition to her publications, Kristen has co-convened a number of innovative inter-disciplinary research symposiums on contemporary art and global urban space. Contact: kristen.sharp@rmit.edu.au.

Zara Stanhope is an art curator and is completing a PhD at the Australian National University, Canberra. Professional positions have included deputy director and senior curator at Heide Museum of Modern Art, Melbourne (2002–08), inaugural director of the Adam Art Gallery, Victoria University of Wellington, New Zealand (1999–2002), and assistant director, Monash University Gallery (1993–99).

Professor Manfred B. Steger holds appointments as professor of political science at the University of Hawai'i-Manoa and professor of global studies at RMIT University, Melbourne. He is research leader of the Globalization and Culture programme in RMIT University's Global Cities Research Institute. He has served as an academic consultant on globalization for the US State Department and is the author or editor of 21 books on globalization, global history, and the history of political ideas, including: *The Rise of the Global Imaginary: Political ideologies from the French Revolution to the global War on Terror* (OUP 2008), and *Justice Globalism: Ideology, crises, policy* (Sage 2013).

Professor SueAnne Ware is director of research in the School of Architecture and Design at RMIT University, Melbourne. As a professor of landscape architecture, her exhibited works, awarded built projects, curatorships, scholarly and professional publications, have contributed to a growing discourse in landscape architecture, spatial intelligence, and design practice research. Her built work explores provocative and ephemeral memorials and the ways in which contemporary memorial design can reflect ephemeral conditions of site and memory while maintaining its importance in the public landscape. She has published widely in this field.

Dr Pamela Zeplin is an Adelaide-based writer and artist and leader of research education (Art, Architecture & Design) at the University of South Australia. She regularly publishes on Asia-Pacific, Tasman-Pacific and Southern Hemisphere research, participating in international events including *South Project* gatherings in Melbourne, Wellington, Santiago, Soweto and Yogyakarta. In 2009 she was a guest lecturer and essayist for Taiwan's Kaohsiung Museum of Fine Arts Austronesian art programme, The Great Journey. With Paul Sharrad, Pamela won an ARC Asia-Pacific Research Futures Network grant to conduct the first national workshop on contemporary Australian Pacific art, which inaugurated a special edition of *Art Monthly Australia* in 2010. She holds a distinguished research award from the Australian Council of University Art and Design Schools, and is a chief investigator on a multi-institutional ARC LIEF Grant, *Design and Art Australia Online.*

Index